THE ARCHITECTURE
OF THE MUSEUM

MANCHESTER
UNIVERSITY PRESS

CRITICAL
PERSPECTIVES
IN
ART HISTORY

SERIES EDITORS
Tim Barringer, Marsha Meskimmon
and Shearer West

EDITORIAL CONSULTANTS
Nicola Bown, John House, John Onians,
Marcia Pointon, Alan Wallach and Evelyn Welch

The architecture
of the museum

Symbolic structures, urban contexts

EDITED BY

MICHAELA GIEBELHAUSEN

Manchester University Press

Manchester and New York

distributed exclusively in the USA by Palgrave

Published by Manchester University Press
Oxford Road, Manchester M13 9NR, UK
and Room 400, 175 Fifth Avenue, New York, NY 10010, USA
http://www.manchesteruniversitypress.co.uk

Distributed exclusively in the USA by
Palgrave, 175 Fifth Avenue, New York,
NY 10010, USA

Distributed exclusively in Canada by
UBC Press, University of British Columbia, 2029 West Mall,
Vancouver, BC, Canada V6T 1Z2

British Library Cataloguing-in-Publication Data
A catalogue record for this book is available from the British Library

Library of Congress Cataloging-in-Publication Data applied for

ISBN 0 7190 5609 8 *hardback*
 0 7190 5610 1 *paperback*

First published 2003

11 10 09 08 07 06 05 04 03 10 9 8 7 6 5 4 3 2 1

Typeset by
D R Bungay Associates, Burghfield, Berks

Printed in Great Britain
by the Alden Press, Oxford

C (GIE)

Contents

List of illustrations

List of contributors

Jan Birksted is Senior Research Fellow at the Leicester School of Architecture at De Montfort University and Chair of the International Specialist Committee for Urbanism and Landscape of DoCoMoMo (Documentation and Conservation of the Modern Movement). He has edited two collections of essays – *Relating Architecture to Landscape* (Routledge 1999) and *Landscapes of Memory and Experience* (Spon Press 2000) – and is finishing a monograph on the Maeght Foundation designed by Sert with Miró, Giacometti and Braque to be published by Ashgate.

Valerie Fraser is Professor in Art History and Theory at the University of Essex. She specialises in the art and architecture of Latin America and is Co-Director of UECLAA, Europe's only public collection of Latin American art. She has published on a range of colonial and modern topics. Her most recent book is *Building the New World: Studies in the Modern Architecture of Latin America 1930–1960* (Verso 2000).

Michaela Giebelhausen is Lecturer in Art History and Theory at the University of Essex. She has published widely on the development of prison architecture and on Pre-Raphaelite painting. She is currently working on her forthcoming monograph entitled *Painting the Bible: Representation and Belief in mid-Victorian England* (Ashgate 2004).

Hannah Lewi is an architect and Senior Lecturer in architectural history, theory and design at Curtin University of Technology, Western Australia. She completed her PhD titled *Post Terra Nullius: The Re-making of Antipodean Place* in 1999, which explores urban place-making techniques from the colonial to the post-colonial. Current research and publications include theoretical investigations in architectural and landscape heritage, the conservation of modernism, and an interactive CD-ROM titled *Visualising the Architecture of Federation*, 2001.

Debora J. Meijers is Associate Professor of Art History at the University of Amsterdam. She has worked on several topics relating to the history of collecting. Her publications include *Kunst als Natur: Die Habsburger Gemäldegalerie um 1780* (Vienna 1995). Currently she is supervising the Russian–Dutch research project *The 'Painted Museum' of the Academy of Sciences in Saint Petersburg (c.1730–1760)*.

Nicole Pohl is Lecturer at University College Northampton. Her research and publications concern early modern women's utopias and utopian architecture. She has edited, with Rebecca D'Monte, *Female Communities 1600–1800: Literary Visions and Cultural Realities*

(Macmillan 2000) and is currently completing *Architectures of Transformation: Women's Utopian Thought 1600–1800*.

Neil Sharp is an independent scholar living in London. He has published on the history of art education and museums. He is currently working on a study of the paintings of Morris Louis.

Chris Stephens is an art historian and Senior Curator at Tate Britain. Areas of particular interest include the art and culture of St Ives, and twentieth-century British sculpture. He has published widely in these areas. His most recent book is *Peter Lanyon: At the Edge of Landscape* (21 Publishing 2000) and he is now preparing a 'critical history' of St Ives.

Anthony Vidler is Professor and Dean of the Irwin S. Chanin School of Architecture, Cooper Union, New York. He has taught at the University of California, Los Angeles, where he was Professor of Art History and Architecture, and before that at Princeton University where he was Professor of Architecture. He has published widely on eighteenth-century architectural theory, and modern and contemporary architecture. His most recent book is *Warped Space* (The MIT Press 2000).

Volker M. Welter is an architectural historian, who has studied, worked and taught in Berlin, Edinburgh, Glasgow and Reading; he is now Associate Professor at the University of California Santa Barbara. His main research interests are debate about the city in the nineteenth and twentieth centuries; history, theory and historiography of modern and contemporary architecture; architectural history of Zionism; and architectural representations of public space. His most recent book is *Biopolis – Patrick Geddes and the City of Life* (The MIT Press 2002). Currently he is working on a book about early modernist Zionist architecture in Palestine.

Introduction:
the architecture of the museum –
symbolic structures, urban contexts

Michaela Giebelhausen

> Layer upon layer, past times preserve themselves in the city until life itself is finally threatened with suffocation: then, in sheer defense, modern man invents the museum. (Lewis Mumford)[1]

In *The Culture of Cities*, Lewis Mumford constructed an intrinsic relationship between the city and the museum: it became a reservoir for the city's overpowering accumulation of history. An invention of the Enlightenment, the museum as we know it was not only ideally equipped to deal with the surplus of history that it would order, store and display, it was also a relatively recent building type and a newcomer to the city. While the development of the building type has been a recurrent theme in the study of museums, its metropolitan connections and urban contexts have been less fully explored.[2] The present collection draws attention to the museum's complex relationship with the city. The essays are united in their endeavour to investigate the museum's symbolic functions and its role in the urban context. In Part I, the authors survey some of the ways in which the museum has been used to reimagine the city. They reveal very different and at times fictitious capital aspirations such as the new capital built on a *tabula rasa*, or forgotten and might-have-been capitals, or the marginalised capital of the arts. They further explore the museum's different yet related roles as emblem of a western cultural tradition, formative tool of modernity, a means to reconfigure colonial pasts, and accomplice to the touristic rediscovery and exploitation of place. The authors in Part II continue the investigation of the museum's relationship with the city. They analyse its potential as a didactic instrument and the possibilities of extending the notion of the museum to the city itself. Rooted in the genre of literary utopias, the museum is not only a perfect instrument for the fashioning of the ideal subject, but it also supplies a range of vital qualities to the whole urban environment. The museum invokes a classical tradition that resonates with an idealised past, both

remote and Arcadian. The essays explore the ways in which the museum helps to unlock urban memories and makes visible the city's hidden histories, raising questions about the notion of the city as text and about the logistics of legibility. They investigate various reconfigurations of the city as museum, ranging from the systematic insertion of museums and salvaged or reconstructed buildings into the urban fabric to the total exclusion of the museum from the modernist city.

Practically from the moment of its birth in the late eighteenth century, the museum has attracted critical attention: it has been praised and vilified in equal measure. Often repulsion and attraction were entwined in a critic's reaction to the museum. In a frequently cited passage from 'Le Problème des musées' of 1925, the French poet Paul Valéry criticised the 'cold confusion' of the displays in the Louvre where – in the words of Theodor Adorno – '[d]ead visions are entombed' and 'Venus becomes a document.'[3] However, the 'magnificent chaos of the museum' lingered on in Valéry's mind long after he had left the galleries. The museum's haunting quality has preoccupied cultural and architectural historians who have repeatedly attempted to define its special characteristics. It has been claimed that its cultural significance not only surpasses that of other building types but also possesses a genuine seismographic quality. For example, Michael Levin considered the museum an instrument that defines, represents and makes transparent changing cultural trends. In his opinion 'the museum, almost by definition, does more than express current social values and tastes; it also makes a cultural statement which goes beyond its own place in history.'[4] In *The Museum Transformed*, Douglas Davis not only reiterated that view – 'no building type can match the museum for symbolic or architectural importance' – but also highlighted the fact that the museum has repeatedly 'burst its categorical limits, nearly always redefining its capacity and expanding its audience.'[5] More recently, Charles Jencks has drawn attention to the diversified and increasingly conflicting cultural roles the museum has taken on during the 1990s, which have resulted in what he termed 'the museum of spectacular contradiction'.[6]

It seems that the diversification and proliferation of the museum has left the writers, scholars and critics, who are trying to analyse its increasingly schizophrenic nature, in a difficult position. In the preface to *Towards a New Museum*, Victoria Newhouse claims: 'I merely observe and assess what others have done and will be doing to report on the direction museum architecture is taking.'[7] The modesty of her claim reflects the difficulty of coping with the large number of new museums and their different conceptual roles. Since the 'museum of spectacular contradiction' poses a challenge for current scholarship, typological explorations have served as a means to chart the fragmentation of the building type. This is apparent in most of the recent literature which tends to opt for a panoramic view, presenting a wide range of different examples alongside each other.[8] Impressive developments such as the Bilbao Guggenheim or Tate Modern have generated an unprecedented degree of media attention and contributed to a new type of literature that is at once celebratory and concerned with design and building processes.[9]

The sustained interest in the museum has also spawned a growing market in souvenirs for the cultural pilgrim on sale in the indispensable museum shop. While the museum experience is undergoing total commodification, critical endeavours to explore the precise nature of the museum's cultural significance – often claimed and contested, rarely defined – continue unabated.

Establishing the museum as architecture

The shifting quicksand of cultural signification provides an unstable ground for the architecture of the museum that resulted in a diversification of roles. However, charting fragmenting typologies can only be regarded as a first, albeit necessary, step towards a deeper understanding of the subject. In contrast to the broadly typological approach, therefore, the present collection of essays proposes a focused intervention, concentrating on the symbolic structures and urban contexts that define the museum as architecture. In doing so the authors extend the claim for a complex set of preconceptions underlying the discipline of architecture that Aldo Rossi made in the preface to the second Italian edition of *The Architecture of the City*. He argued that

> to consider the city as architecture means to recognize the importance of architecture as a discipline that has a self-determined autonomy ..., constitutes the major urban artifact within the city, and ... links the past to the present. Architecture so seen is not diminished in terms of its own significance because of its urban architectural context or because a different scale introduces new meanings; on the contrary the meaning of the architecture of the city resides in a focus on the individual project and the way it is structured as an urban artifact.[10]

Rossi's observations on the city as architecture, which aimed to refute a simplified functionalist approach to urban design, are equally valid for the museum.

Admittedly such a claim is far from new; it has been made since the beginning of the nineteenth century when the museum finally graduated from the playground of architectural competitions such as the Prix de Rome to become a fully fledged building type. While the appropriation of the Louvre as Musée Français in 1793 demonstrated the museum's political potential, debates over the functionality of its architecture surfaced more clearly only in the design and execution of new buildings during the first third of the nineteenth century. Indeed, the lively controversy over the museum's significance was also partly premised on a conflicting understanding of its architectural form that accompanied the realisation of seminal early museums such as Karl Friedrich von Schinkel's Altes Museum in Berlin and Leo von Klenze's Glyptothek in Munich. The key issues rehearsed in both cases were surprisingly similar. While the scholarly advisors sought to replicate conditions for viewing traditionally associated with the academy and the studio, the architects persuasively argued for a different type of experience. Aiming to address a 'general' audience, they advocated an integrated approach that depended on a lavish decorative scheme

to frame the exhibits. Their desire to both entertain and educate represents the beginning of the modern museum; it joined the more traditional civic building types in a reconfigured geography of power that sought to shape and define a new bourgeois self. Consequently, the museum became 'a formidable model of civic membership, a ritual of social identification, in short, a technology of the subject.'[11] Karl Friedrich von Schinkel was adamant about the role architecture was to play in this process. The sight of the central rotunda, 'a beautiful and sublime space', he maintained, 'has to make one receptive for and attuned to the pleasures and understanding of that which the building really houses.'[12] It served as an emotive overture: a sophistication of function that transcended the utilitarian and economical thinking of scholars and academics.[13] The viewing of art was here complemented by a set of secondary functions that not only defined the museum as a civic building type where the 'civilising rituals' could be enacted but also established it as architecture, the one liberal art not otherwise represented.[14] Consequently, in the summer of 1829 the completed museum was shown to the public empty.[15] This emphasis on the architecture as autonomous has been revived in recent years: witness for example the opening of Peter Eisenman's Wexner Center for the Arts in 1989, where the building itself constituted the inaugural show, and more recently the extensive viewing period of Daniel Libeskind's symbolically charged building for the Jewish Museum in Berlin. Even Herzog and de Meuron's restrained transformation of Giles Gilbert Scott's power station into Tate Modern is characterised by a desire to 'show as much as possible of the structure.'[16] Schinkel's endeavour to foreground the symbolic functions also extended to the museum's urban role, so clearly expressed in his dictum that the museum was at once an object of innate beauty *and* an ornament to the city.[17]

The 'most typical institution of the metropolis'

Lewis Mumford claimed that the museum represents 'the most typical institution of the metropolis, as characteristic of its ideal life as the gymnasium was of the Hellenic city or the hospital of the medieval city'.[18] Granting the museum such central importance depended on the ability to address a wider audience which vindicated Schinkel's endeavours. Mumford's claim also adds a quasi-utopian dimension to the urban geography. Both the Altes Museum and the Glyptothek invoked a golden age modelled on classical antiquity and perpetuated through the preservation and contemplation of art. They also represent the museum as monument – monuments to the idealised power of civilisation and the paternalistic concerns of the nation state. Both are situated in significant urban contexts deliberately chosen to emphasise their monumental status. Thus – according to Tony Bennett's Foucauldian reading of museums – 'they stood as embodiments, both material and symbolic, of a power to "show and tell" which, in being deployed in a newly constituted open and public space, sought rhetorically to incorporate the people within the processes of the state.'[19]

Fully developed as a building type only at the turn of the nineteenth century, the museum was a relative newcomer to the city, which was itself undergoing a gargantuan transformation to become the metropolis of the industrial age. The Altes Museum occupied a prominent place in Berlin's symbolic geography of power redrawn to accommodate the 'civilising rituals' of culture. Their enactment was not confined to the museum's interior spaces but firmly inscribed in the wider urban context. Located at the far end of the Lustgarten – where the Kupfergraben had been filled in to provide a suitable plot – it faces the royal palace and is in close proximity to the cathedral, the arsenal and the university.

By contrast, the Glyptothek was one of several museums that were built in Munich's newly laid-out suburban development. Striking solitaires in 'a sort of wilderness', the new museums helped to define a marginal urban wasteland designed to transform the Bavarian capital.[20] The Glyptothek formed the centre piece of the Königsplatz, a square that commemorated the formation of the Bavarian monarchy in 1806 and marked the new approach to the city. Leo von Klenze's design – symbolic, resonant and aiming to create 'a picture of pure Hellenism in our world' – was informed by contemporary architectural theory.[21] In his damning description of mid-eighteenth-century Paris first published in 1753, the Abbé Laugier had highlighted the importance of impressive approaches to the city to convey the capital's status to foreign visitors.[22] In his seminal *Précis des leçons* of 1802–5, Jean-Nicolas-Louis Durand invoked antiquity as the blueprint on which to model interventions in the contemporary city. He reflected more broadly on the grandeur of the ancient city, drawing particular attention to the public square as a space for the symbolic representation of religion, the military and the state.[23] Yet, Klenze's proposed final triad of church, military and culture signalled an important departure.[24] He fully recognised the symbolic potential of the new building type and consequently cast it as the only constant in the square's protracted period of gestation. Since the museum shares – in the words of Carol Duncan and Alan Wallach – 'fundamental characteristics with traditional ceremonial monuments', it proved the perfect tool for reconfiguring the city and fostering the formation of the bourgeois subject.[25]

The new building type not only seemed to satisfy the city's need for symbolic signification but was also indicative of its metropolitan aspirations. According to Durand truly great cities have several museums, 'some to hold the rarest productions of nature, others to contain the masterpieces of the arts.'[26] If such a simple correlation defined metropolitan status, the proliferation of museums witnessed during the nineteenth and twentieth centuries became a clear sign of metropolitan competition and rivalry. Among the most impressive examples are those that clustered museums into designated cultural precincts. Situated behind the Altes Museum, the Museumsinsel was conceived as a 'centre for the highest spiritual interests of the people that perhaps no other capital city possesse[d]'; it once again redefined Berlin's symbolic geography.[27] This 'sacred and tranquil sanctuary for the sciences and the arts' embodied the city's metropolitan ambitions but was also

set apart from its daily bustle: urban, ceremonial yet Arcadian and ideal. In August Stüler's evocative drawing of the early 1840s the scheme's lively outline seen from the river Spree was reminiscent of the Athenian Acropolis.

From the middle of the nineteenth century onward, similar developments were occurring all over Europe. Vienna's radical makeover may serve as a classic example: the razing of the fortifications and the layout of the Ringstrasse not only provided space for a whole range of civic buildings but was also symptomatic of large-scale metropolitan transformations. The Kaiserforum was conceived as part of this urban expansion. Located in proximity to the imperial residence, the impressive Kunsthistorisches Museum and the Naturhistorisches Museum face each other across a square. As in Berlin, the Kaiserforum expands the city's symbolic centre with its traditional geography of power to include the civilising rituals of culture. But the design's fearful symmetry seems to emphasise the representational qualities rather than aim to invoke picturesque historic resonances.

Although arguably among the most spectacular examples, Berlin, Munich and Vienna merely reflected a wider trend in the development of the nineteenth-century metropolis in which the museum as a recent building type came to play a prominent role. So prominent in fact, scholars have argued that the often-invoked metaphor of the museum as cathedral for the arts is not simply a facile comparison but reflects the fact 'that museums are, like cathedrals, fundamentally urban phenomena.'[28] While the museum has continued to be an important urban feature throughout the twentieth century, it also acquired several new roles. Increasingly the 'neutral' viewing of art that early academic advocates had demanded reasserted itself against the civic, commemorative and monumental functions. Philip L. Goodwin and Edward Durell Stone's building for the Museum of Modern Art (MoMA) in New York (1939) epitomised modern museum practices and inaugurated the flexible white box. Architecturally it also signalled a new departure: the museum no longer claimed an isolated and resonant place in the city; instead the modernist building was sitting alongside traditional New York brownstones. The opening of the Centre Pompidou in 1977 marked another important development. Renzo Piano and Richard Rogers conceived a multi-purpose cultural centre where the viewing of art became simply one of a range of activities for visitors to choose from. The building's massive scale and colourful exuberance indicated a total break not only with the urban syntax of Paris but also with the traditional museum. Its high-tech exterior embodied the concept of the 'cultural factory', emphasising processes of production and consumption rather than quiet contemplation as well as making visible the circulation of visitors along the transparent escalator tubes. The carnivalesque elements of the Centre Pompidou responded to a desire to enliven the city and reconfigure it as marketplace and spectacle. Although subjected to changes, the museum's relationship with the city has remained central. Charles Jencks has also suggested a similar metropolitan significance for the postmodern 'museum of splendid contradiction': 'If inventively combined', he argued, 'the disparate parts may provide just the kind of experience to cure museum fatigue

and make this building type a fitting centre for the global city of contradictions. The museum as cathedral might then become more than a convenient cliché.'[29]

Current developments continue to reflect some of the points I have made so far. In the wake of postmodernism the museum as architecture has been reinstated in all its complexity and contradiction. After decades devoted to the white box – allegedly neutral, devoid of symbolic significance and simply functional – the museum building is again being conceived as an evocative entity that is in dialogue both with its content and urban context. It is even being given sculptural form as for example in the work of Coop Himmelb(l)au in Groningen, Daniel Libeskind in Berlin and London, and Frank Gehry for the Guggenheim in Bilbao and New York. The museum's relationship with the city also continues to be an important concern. Two recent examples demonstrate different but related forms of urban regeneration. While Tate Modern helps to consolidate London's reputation as one of Europe's leading cultural capitals, the Bilbao Guggenheim facilitates a complete urban facelift.

Along the south side of the river Nervión the traces of heavy industry are being erased by a cultural precinct intended to put the Basque capital on the map of international tourism. Gehry's building provides a spectacular focal point on the waterfront, which has been transformed into a ceremonial approach complete with lighted walkways and a pedestrian bridge designed by the Spanish architect Santiago Calatrava. It also anchors new cultural institutions such as the Euskalduna Conference Centre and Concert Hall further downstream and reinforces the city's traditional cultural triangle of nineteenth-century museum, university and opera house. The 'titanium artichoke' has attracted critical hyperbole, spawned purple prose, graced the covers of weekend supplements and featured in a recent James Bond movie.[30] Although only one of several urban interventions deployed in the regeneration of Bilbao, which include Norman Foster's metro system and Calatrava's new airport terminal, the Guggenheim furnishes the main reason for visiting Bilbao. The *Observer* Travel Shop regularly advertises four-day trips to see the 'architectural masterpiece of the late twentieth century'.[31] Not only has the museum monopolised media attention, its planning process has also been recast in terms that invoke Christian legend. Thomas Krens, the Guggenheim's director, recalls how, during a recreational run through the city, the search for the right site was suddenly decided: 'there was this moment when I had this epiphany'.[32] Several years later Bilbao's new cathedral of modern and contemporary art rises on that very spot and the art pilgrims are queuing all the way round the building and along the waterfront.

Tate Modern shares some characteristics with the Guggenheim in Bilbao. Located on the banks of the Thames in a run-down area of London, it plays a vital role in regenerating the local infrastructure of Southwark. The former power station is tied into a network of ceremonial pedestrian approaches including Norman Foster's Millennium Bridge, which connects the museum to St Paul's Cathedral and thus to the city. The link creates a new symbolic balance between cathedral and

museum, which has been described as 'looking a little like a cathedral of power', and rewrites the urban geography in surprisingly traditional ways.[33] The reuse of the defunct industrial building constitutes a form of urban regeneration that extends to the preservation of neglected landmarks and contributes to the 'museumification' of the city. In turn the museum replicates urban modes; 'It is', in Jacques Herzog's words, 'like a city on a reduced scale.'[34] Consequently, the museum is primarily defined as a space for social encounters where the contemplation of art furnishes merely one of several options. Here the boundaries between the museum and the city have become fluid.

The city as museum: text, collection, oeuvre

The notion of the city as museum has accompanied this complex relationship from the very beginning. At the end of the eighteenth century, Quatremère de Quincy, one of the museum's first critics, opposed the decontextualising of art works installed in the recently opened Louvre and instead advocated Rome as the ideal museum. In *The Manifesto of Futurism* of 1909, Filippo Tommaso Marinetti extended his battle cry for the destruction of the museum and other cultural institutions to encompass the whole city: 'Take up your pickaxes, your axes and hammers and wreck, wreck the venerable cities, pitilessly!'[35] Marinetti's attack on the venerable city is also an attack on the city as museum, a relationship that Mumford has described in the following way:

> But if the big city is largely responsible for the invention and public extension of the museum, there is a sense in which one of its own principal functions is to serve as a museum: in its own right, the historic city retains, by reason of its amplitude and its long past, a larger and more various collection of cultural specimens than can be found elsewhere.[36]

While the museum occupied an important place in the geography of the nineteenth-century metropolis, investing it with idealised historic resonances as well as authenticating its metropolitan reputation, increasingly the city itself did not escape 'museumification'. Mumford's use of the term collection suggests an ordering of the city's accumulated layers of history which is not dissimilar to Henri Lefebvre's claim that 'the city is an *oeuvre*, closer to a work of art than to a simple material product.'[37] In defining the nature of that product, Lefebvre draws parallels with language and consequently compares the city to a book. This comparison, of course, implies an interpretative agency.

> On this book, with this writing, are projected mental and social forms and structures. Now, analysis can achieve this context from the text, but it is not given. Intellectual operations and reflective approaches are necessary to achieve it[38]

The museum made a clear and resonant statement in the urban syntax and hence contributed to the city as text. However, while to conceive the entire city as museum

was a logical extension of the museum's potential for resonance and meaning, it required an unprecedented degree of interpretation that conflicted with the fragmented perception of the built environment, which – according to Walter Benjamin – 'is consummated by a collectivity in a state of distraction.'[39] Consequently, the task of interpretation was made doubly difficult. To enable citizens and visitors to read the city's layers successfully required the intervention of an interpreter.

'Self-conscious beyond a doubt', according to Colin Rowe, the city as museum does not only need to be interpreted but it needs to be explored and scanned.[40] This is best done walking the streets or from on high. If the museum is the archetypal urban building type of the nineteenth century and an indicator of true metropolitan status, the *flâneur* is the street walker par excellence, at once constructing and consuming the city. Following a wave of modernist urban planning and extensive rebuilding after World War Two that reconfigured the city for the use of the motorcar, the *flâneur* has finally made a reappearance. Since the city has recently been reclaimed for pedestrian ambling, efforts are being made to enhance the readability of the urban fabric. London has been furnished with one hundred and fifty signs alerting visitors to historic attractions such as Buckingham Palace and providing a historic sound bite (in addition to the sponsor's disproportionately large logo).[41] The notion of the city as museum has also extended to new museum developments such as Vienna's Museumsquartier. A continuation of the existing axis of culture that stretches from the Hofburg to the Kaiserforum, the redevelopment is both urban and conservative, almost invisible. The magnificent baroque façade of Fischer von Erlach's royal stables, which have been transformed to house gallery spaces, screens the museum quarter from view. It comprises reused and new buildings adding a whole cultural quarter to the city's infrastructure that demands to be discovered on foot.

By contrast, the panoramic view furnishes a more detached and picturesque perception that turns the city itself into an exhibit to be consumed visually and from a distance. This perspective renders the viewer at once a reader and godlike: according to Michel de Certeau, '[i]t transforms the bewitching world by which one was "possessed" into a text that lies before one's eyes.'[42] The vantage point not only provided an opportunity for panoramic views but it was also a deliberate control mechanism that rendered the crowd transparent and visible. This Foucauldian technology of surveillance was first introduced in the design of the 1851 Crystal Palace and also repeatedly applied to entire fairgrounds. The Eiffel Tower, built for the Paris World's Fair of 1889, remains the most famous example. The panoramic view continues to flourish in recent museum architecture. However, it is no longer dictated by a need for surveillance, which is now being met by the ubiquitous CCTV cameras in our city centres, but by the fascination with the city as spectacle. Ever since the Centre Pompidou's external escalators have been providing spectacular views over Paris for visitors on their way to the permanent collections, new museum buildings have been concerned with furnishing urban views. In particular the 1990s have been dominated by the desire for the urban view; witness for

example Tate St Ives, which provides panoramic views of the town, or the National
Portrait Gallery's recent infill development topped with a café overlooking the
centre of London, or Tate Modern's plan to install an elevator in the power sta-
tion's chimney stack to create a veritable outlook tower.

Over the past two centuries, the museum has made a significant contribution to
the city. It not only added historic, cultural and utopian resonances but also con-
tributed to the creation of the bourgeois subject, and bestowed and confirmed met-
ropolitan status. When the city itself is reconfigured as museum, the boundaries
between the two become fluid. Hence the museum is either defunct because the
city itself takes on the full set of didactic functions or it becomes an interpretative
headquarters from which to unlock the city's historic layers and meanings. When
Schinkel first attempted to establish the museum's symbolic functions he argued
for it to be both a thing of beauty and an ornament to the city. Similar demands are
still being made of contemporary architects today: they are asked to create
museums 'that would actually add something to the city.'[43]

Capital aspirations, urban reimagings, visible and invisible histories

The volume brings together authors from different disciplines to explore the com-
plex nature of the museum's relationship with the city. In the first part of the collec-
tion they focus on the capital aspirations and modes of urban reimaging that the
museum facilitates. Their essays cover a wide chronological and geographical
range from early eighteenth-century Russia to late twentieth-century Australia.
Debora J. Meijers investigates the political motivations behind Tsar Peter the
Great's Kunstkamera, erected in early eighteenth-century St Petersburg. Here tra-
ditional western culture was imported wholesale to assert the modernity of
Russia's new capital, constructed on a *tabula rasa* and in need of symbolic markers.
The difficulties surrounding the creation of a cultural tradition are also explored in
Neil Sharp's analysis of Hugh Lane's attempt to establish a Gallery of Modern Art
in early twentieth-century Dublin, a colonised city struggling to reassert its capital
status. He shows that architectural expression played a fundamental role in the
search for a specific Irish national identity and argues that the classicist rhetoric of
traditional museum architecture was inappropriate for the delicate political situa-
tion. Hannah Lewi focuses her attention on a different part of the British Empire
and explores the colonial legacy inscribed in the museum complex in Perth, which
aims to make visible the layers of history and to create a sense of place. With its
transformation from colonial gaol to heritage site the Perth museum precinct rep-
resents a perfect opportunity to survey the Foucauldian legacies inherent in the
museum, which are also investigated in several other essays of the collection.
Different capital aspirations lie at the heart of the two remaining case studies. In
my essay, I explore the reimaging of Frankfurt during the 1980s, which relied
on an entire collection of museums not only to imbue the city with a fictitious cap-
ital status but also to turn it into a tourist destination. Similarly Chris Stephens

investigates the influence of Tate on the touristic and cultural infrastructure of St Ives, the self-styled neglected art capital. Together the essays in Part I demonstrate that the symbolic significance of the museum is instrumental in articulating the city's cultural and political aspirations and facilitating urban regeneration.

The essays in Part II also show a broad geographical reach, ranging from the 'nowhere' of literary utopias to modernist Brasília, and from late nineteenth-century Edinburgh to the French Riviera of the 1960s. The first essay explores the textual origins of the museum and the notion of the city as text. Nicole Pohl outlines the changing functions of the museum in the genre of literary utopias, tracing the development from seventeenth-century classics such as Francis Bacon's *New Atlantis* to William Morris's socialist *News from Nowhere* and H. G. Wells's bleak projected future in the *Time Machine*. Her Foucauldian analysis reveals the museum's ability to amplify the fashioning of the civic subject. She further draws attention to the utopian desire for the 'city as didactic instrument', which has remained an underlying concern for most urban reconfigurations.[44] Different variations of this theme are explored in the volume's following three case studies. Volker M. Welter assesses Patrick Geddes's attempt to reconfigure late nineteenth-century Edinburgh as a collection of historic and historicising buildings that unlock urban memories. He reveals the shortcomings of this approach and addresses the problem – raised by Lefebvre – of interpreting the city as text. In his essay, Anthony Vidler also investigates the relationship between the museum and memory. He analyses the demise of the nineteenth-century museum's main function as commemorative monument and scrutinises the modern museum's potential of becoming a '*machine à mémoire*' and its resulting complex relationship with the city. Vidler discussed the desire to conceive the city as didactic instrument in relation to Le Corbusier's radical proposals for Paris in which important historic buildings were freed from their suffocating surroundings. Monumentalised in splendid isolation they not only became museum pieces in their own right but also contributed to the partial 'museumification' of the city. While Le Corbusier's completely new city retained a sense of memory by inserting a collection of historic buildings into its reshaped fabric, Oscar Niemeyer's design for Brasília envisaged a thoroughly modern city unencumbered by the layers of history and constructed on a *tabula rasa*: an urban utopia that needed no museum. In her essay, Valerie Fraser argues convincingly that Brazil's new capital alluded to an invisible history, a mythical past independent of western notions of culture and memory signified by the museum. Jan Birksted explores a similar sense of hidden history. His analysis of the Maeght Foundation reveals a reliance on the complexities of myth to create an anti-museum that breaks with established tradition and presents a subtle inversion. Just as the modern city does not need museums, the modern museum is by definition an anti-museum, which takes its inspiration from cultural influences that predate the birth of western civilisation. Thus the essays in the collection explore various aspects of the museum's complex relationship with the city and trace the intricate threads of visible and invisible histories woven into the fabric of both the museum and the city.

Notes

My research for this project was supported by the British Academy, The Essex University Research Promotion Fund and Research Endowment Fund; their help I acknowledge gratefully. I would also like to thank my editors at Manchester University Press for their unwavering support and patience, especially Vanessa Graham and Alison Whittle.

1 Lewis Mumford, *The Culture of Cities* (New York: Harcourt Brace and Company, 1938) reprinted in Philip Kasinitz (ed.), *Metropolis: Center and Symbol of our Times* (New York: New York University Press, 1995), p. 22.

2 See for example Nikolaus Pevsner, *A History of Building Types* (London: Thames and Hudson, 1976); Giles Waterfield (ed.), *Palaces of Art: Art Galleries in Britain 1790–1990* (London: Dulwich Picture Gallery, 1991); Volker Plagemann, *Das deutsche Kunstmuseum 1790–1870* (Munich: Prestel Verlag, 1967); Otto Martin, *Zur Ikonologie der deutschen Museumsarchitektur zu Beginn des zweiten Kaiserreiches* (PhD thesis, Johannes-Gutenberg-Universität, Mainz, 1983); or monographic studies such as Beatrix Kriller and Georg Kugler, *Das Kunsthistorische Museum: Die Architektur und Ausstattung. Idee und Wirklichkeit des Gesamtkunstwerkes* (Vienna: Christian Brandstätter Verlag, 1991).

3 Paul Valéry, 'Le Problème des musées', in Valéry, *Pièces sur l'art* (Paris: Maurice Darantiere, 1931), pp. 147–56; p. 150. Theodor W. Adorno, 'Valéry Proust Museum', in Adorno, *Prisms*, trans. Samuel and Shierry Weber (Cambridge, Mass.: The MIT Press, 1981), pp. 173–85; p. 177, as is the following quotation.

4 Michael D. Levin, *The Modern Museum: Temple or Showroom* (Jerusalem, Dvir Publishing House, 1983), p. 1.

5 Douglas Davis, *The Museum Transformed: Design and Culture in the Post-Pompidou Age* (New York: Abbeville Press, 1990), p. 14, p. 12.

6 Charles Jencks, 'The contemporary museum', *AD Profile*, 130 (1997), pp. 9–13; p. 13.

7 Victoria Newhouse, *Towards a New Museum* (New York: The Monacelli Press, 1998), p. 8.

8 Some examples: Josep M. Montaner, *New Museums* (London: Architecture Design and Technology Press, 1990); James Steele (ed.), *Museum Builders* (London: Academy Editions, 1994); Gerhard Mack, *Art Museums into the Twenty-First Century* (Basle, Berlin and Boston: Birkhäuser, 1999).

9 See the television series on the making of Tate Modern, *Power into Art*, and the accompanying book by Karl Sabbagh. Also a whole range of titles such as Harold M. Williams *et al.*, *Making Architecture: The Getty Center* (Los Angeles: J. Paul Getty Trust, 1997); Coosje van Bruggen, *Frank O. Gehry: Guggenheim Museum Bilbao* (New York: Guggenheim Museum Publications, 1997); Rowan Moore and Raymund Ryan, *Building Tate Modern: Herzog & de Meuron Transforming Giles Gilbert Scott* (London: Tate Gallery, 2000); Marijke Martin, Cor Wagenaar, Annette Welkamp (eds), *Alessandro and Francesco Mendini, Philippe Starck, Michele de Lucchi, Coop Himmelb(l)au in Groningen* (Groningen: Groninger Museum, n.d.). Even the book's design tries to capture the architectural exuberance of the Groninger Museum.

10 Aldo Rossi, *The Architecture of the City* (Cambridge, Mass. and London: The MIT Press, 1982), p. 165.

11 Didier Maleuvre, *Museum Memories: History, Technology, Art* (Stanford: Stanford University Press, 1999), p. 3.

12 Quoted in Erik Forsman, *Karl Friedrich Schinkel: Bauwerke und Baugedanken* (Munich and Zurich: Schnell & Steiner, 1981), pp. 118–19 [my translation].

13 For a useful summary of this debate see, Douglas Crimp, *On the Museum's Ruins* (Cambridge, Mass. and London: The MIT Press, 1993), pp. 291–302.

14 The distinction of primary and secondary function is based on Umberto Eco, 'Function and sign: semiotics of architecture', in M. Gottdiener and Alexandros Ph. Lagopoulos (eds), *The City and the Sign: An Introduction to Urban Semiotics* (New York: Columbia University Press, 1986), pp. 55–86. The notion of the civilising ritual was first formulated in their original analysis of the museum as a ritualistic site: Carol Duncan and Alan Wallach, 'The universal survey museum', *Art History*, 3 (1980), pp. 448–69. Duncan has continued to draw out this concept in her more recent work, *Civilizing Rituals: Inside the Public Art Museum* (London and New York: Routledge, 1995). For a discussion of the museum representing architecture, see Werner Szambien, 'Die Berliner Museumsinsel und ihre Stellung in der internationalen Museumspolitik des 19. Jahrhunderts', in Zentralinstitut für Kunstgeschichte München (ed.), *Berlins Museen: Geschichte und Zukunft* (Munich: Deutscher Kunstverlag, 1994), pp. 45–50; p. 45.

15 Forsman, *Karl Friedrich Schinkel*, p. 117.

16 Interview with Jacques Herzog, in Mack, *Art Museums into the Twenty-First Century*, p. 42.

17 Schinkel in a letter to Sulpiz Boisserée, dated 29 December 1822; quoted in Plagemann, *Das deutsche Kunstmuseum*, p. 67 [my translation].

18 Lewis Mumford, *The City in History* (Harmondsworth: Penguin Books, 1975), p. 639.

19 Tony Bennett, *The Birth of the Museum: History, Theory, Politics* (London and New York: Routledge, 1995), p. 87.

20 Eye witness account of 1833; quoted in Dorothea Schmidt, 'Das "Leonische" Zeitalter: Notizen zur zeitgenössischen Kritik an Leo von Klenze', in Klaus Vierneisel and Gottlieb Leinz (eds), *Glyptothek München 1830–1980* (Munich: Glyptothek München, 1980), pp. 284–95; p. 291 [my translation].

21 Klenze in a letter to crown prince Ludwig, dated 13 September 1817; quoted in Eckart Bergmann, 'Der Königsplatz – Forum und Denkmal', in *ibid.*, pp. 296–309; p. 297 [my translation].

22 Marc-Antoine Laugier, *An Essay on Architecture* (London: T. Osborne and Shipton, 1755), pp. 237–46.

23 Jean-Nicolas-Louis Durand, *Précis of the Lectures on Architecture*, intro. Antoine Picon and trans. David Britt (Los Angeles: The Getty Research Institute, 2000), pp. 146–7.

24 Bergmann, 'Der Königsplatz – Forum und Denkmal', especially pp. 296–7 for a detailed description of the design stages.

25 Duncan and Wallach, 'The universal survey museum', p. 449.

26 Durand, *Précis of the Lectures on Architecture*, p. 160.

27 August Stüler quoted in Plagemann, *Das deutsche Kunstmuseum*, pp. 117–18, as is the following quotation [my translation].

28 J. Pedro Lorente, *Cathedrals of Urban Modernity: The First Museums of Contemporary Art 1800–1930* (Aldershot: Ashgate, 1998), p. 1.

29 Jencks, 'The contemporary museum', p. 13.

30 The derogatory epithet was coined by the Guggenheim's most ferocious critic who has repeatedly drawn attention to the sociological and political contexts of the enterprise, Joseba Zulaika, 'The seduction of Bilbao', *architecture*, 86:12 (1997), pp. 60–3; p. 61.

31 *Observer*, 28 October 2001, 'Escape', p. 17.

32 Van Bruggen, *Frank O. Gehry: Guggenheim Museum Bilbao*, p. 22.

33 Karl Sabbagh, *Power into Art: The Making of Tate Modern* (Harmondsworth: Penguin Books, 2001), p. 45. This juxtaposition was also picked up by the press, see *ibid.*, p. 328.

34 Mack, *Art Museums into the Twenty-First Century*, p. 44.

35 Filippo Tommaso Marinetti, 'Manifesto of Futurism', in Charles Harrison and Paul Wood (eds), *Art in Theory 1900–1990: An Anthology of Changing Ideas* (Oxford: Blackwell Publishers, 1992), pp. 147–9; p. 148.

36 Mumford, *The City in History*, p. 640.

37 Henri Lefebvre, 'The specificity of the city', in Lefebvre, *Writings on Cities*, trans. and ed. Eleonore Kofman and Elizabeth Lebas (Oxford: Blackwell Publishers, 1996), pp. 100–3; p. 101.

38 *Ibid.*, p. 102.

39 Walter Benjamin, 'The work of art in the age of mechanical reproduction', in Benjamin, *Illuminations*, ed. Hannah Arendt, trans. Harry Zorn (London: Fontana, 1973), pp. 219–53; p. 241.

40 *Ibid.*, p. 127.

41 *Time Out*, 1614 (25 July–1 August 2001), p. 15.

42 Michel de Certeau, *The Practice of Everyday Life* (Berkeley: University of California Press, 1988), p. 92.

43 Sabbagh, *Power into Art*, p. 41.

44 Colin Rowe and Fred Koetter, *Collage City* (Cambridge, Mass. and London: The MIT Press, 1978), p. 121.

PART I

CAPITAL ASPIRATIONS – URBAN REIMAGING

The Kunstkamera of Tsar Peter the Great (St Petersburg 1718–34): King Solomon's house or repository of the four continents?

Debora J. Meijers

Established in the first quarter of the eighteenth century, Peter the Great's Kunstkamera was an early example of a new kind of encyclopedic museum, an institution that can be regarded as a new variation on the princely Kunst- und Wunderkammer of the Renaissance (see figure 1). Compared with collections like those of the Medici in Florence or of the Emperor Rudolf II in Prague, the extent of the field covered around 1720 – 'every' manifestation of nature and of human dexterity and science – remained more or less unchanged, but the presentation had become more didactic. All the same, traditional, European allegories were still

1 The Kunstkamera, now the Museum of Anthropology and Ethnography, St Petersburg, 1718–34; architect: Georg Johann Mattarnovi

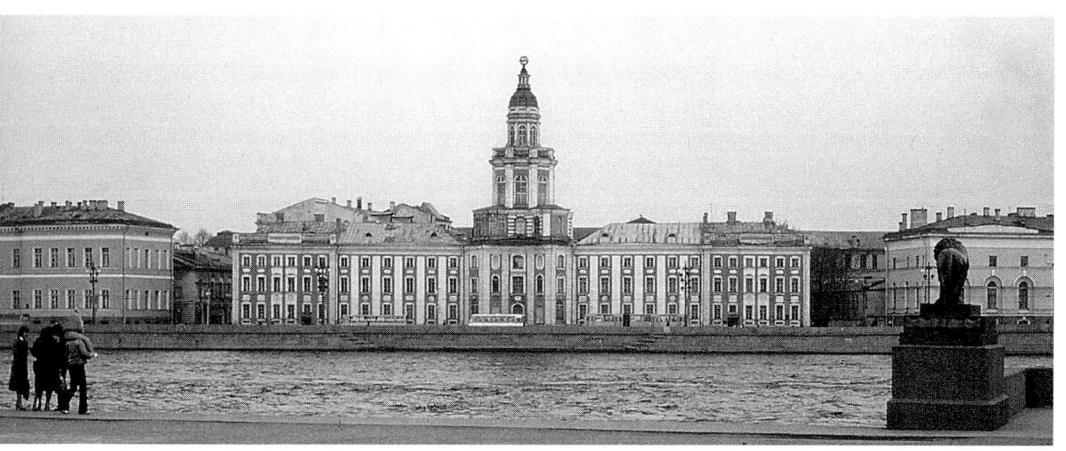

essential if the kinds of objects in the collection were to acquire coherence and elo-
quence, especially in the brand-new city of St Petersburg. It is to the way in which
the context of the new capital conferred meaning on the Kunstkamera that I shall
devote most of this chapter.[1]

Tradition and *tabula rasa*

When the Tsar decided to build up a scientific collection, he acted no differently
from many of his contemporaries, especially in the German-speaking world and in
northern Europe. Like the Electors of Saxony and Brandenburg, the Dukes of
Holstein-Gottorp and the Kings of Denmark, he was continuing a sixteenth-cen-
tury, European tradition: that of the princely collector who brings together every
possible product of nature and of humankind for the purpose of edification and to
demonstrate his *Sapientia* and *Curiositas*. Nor was the linking of the museum with
an Academy of Sciences, a model that flourished in Europe around 1700, an inno-
vation. However, while this scientific, encyclopedic museum was rooted in a long
tradition in the courts of Europe, Peter virtually had to start from scratch. To make
up for lost time, he rapidly bought up an enormous quantity of anatomical and
ethnographical objects, scientific instruments, gems and coins, paintings, draw-
ings, prints, maps and books, especially during his trips to the Netherlands in
1697–98 and 1716–17. This sometimes involved buying up an entire collection in
one swoop. Nowadays visitors to the building in which the Kunstkamera was
housed, the present-day Museum for Anthropology and Ethnography, can still
marvel at the malformed babies preserved in spirits that had once belonged to the
Amsterdam physician Frederick Ruysch. The collection of reptiles, snakes, shells
and East Indian curiosities purchased in the same year – 1716 – from his fellow
townsman, the apothecary Albert Seba, was also transported in its entirety to St
Petersburg, followed by albums of watercolours by the botanist and entomologist
Maria Sibylla Merian.[2]

As in the case of the Tsar's European predecessors and contemporaries, these and
similar objects were directly connected with research activities, which accounts for
the presence of a library, an anatomical theatre, laboratories and an observatory. But
nowhere in the Europe of around 1720 was a princely museum with these functions
accommodated in a single autonomous building specially designed for that purpose,
independent of the palace and relatively open to the public. The old Ashmolean
Museum in Oxford (founded in 1683) shared a number of these features, but it lacked
the character of a princely institution and all its political implications. Nothing sim-
ilar developed in Europe until after 1769, the year in which work started on the
construction of the Museum Fridericianum in Kassel, an institution that
closely resembles the Kunstkamera in terms of purpose and arrangement.[3] The
unusual position of the Kunstkamera as an independent building is immediately
connected with the exceptional origins of a city that was built on virtually uninhab-
ited territory within a few years. Construction on a *tabula rasa* created both literal

and metaphorical space for deviations from the traditions of urban planning in Russia and the rest of Europe, in order to meet new demands (see figure 2).[4]

Building activities commenced on the marshy estuary of the Neva in 1704, the year after the Tsar's expansionist military and commercial policy with regard to Sweden led to his decision to establish a port to provide access to the Baltic Sea. The state of being at war meant that the first priorities, besides a rudimentary wooden house for himself, were the Peter–Paul fortress and the Admiralty. These military and maritime buildings continued to form the representative heart of the city when it was officially proclaimed capital in 1713, even though a modest winter and a summer palace had been built in the meantime. Neither the first main thoroughfare, Nevski Prospect

2 Representation of the new Russian principal residence and sea port of St Petersburg, including her new fortress. Coloured engraving, Amsterdam, Wed. J. Ottens, c. 1720–26. The Nevski Prospect, orientated on a north–south axis, leads to the Admiralty, with the first Winter Palace on the right. The Kunstkamera was built opposite, at the tip of Vasilyevsky Island

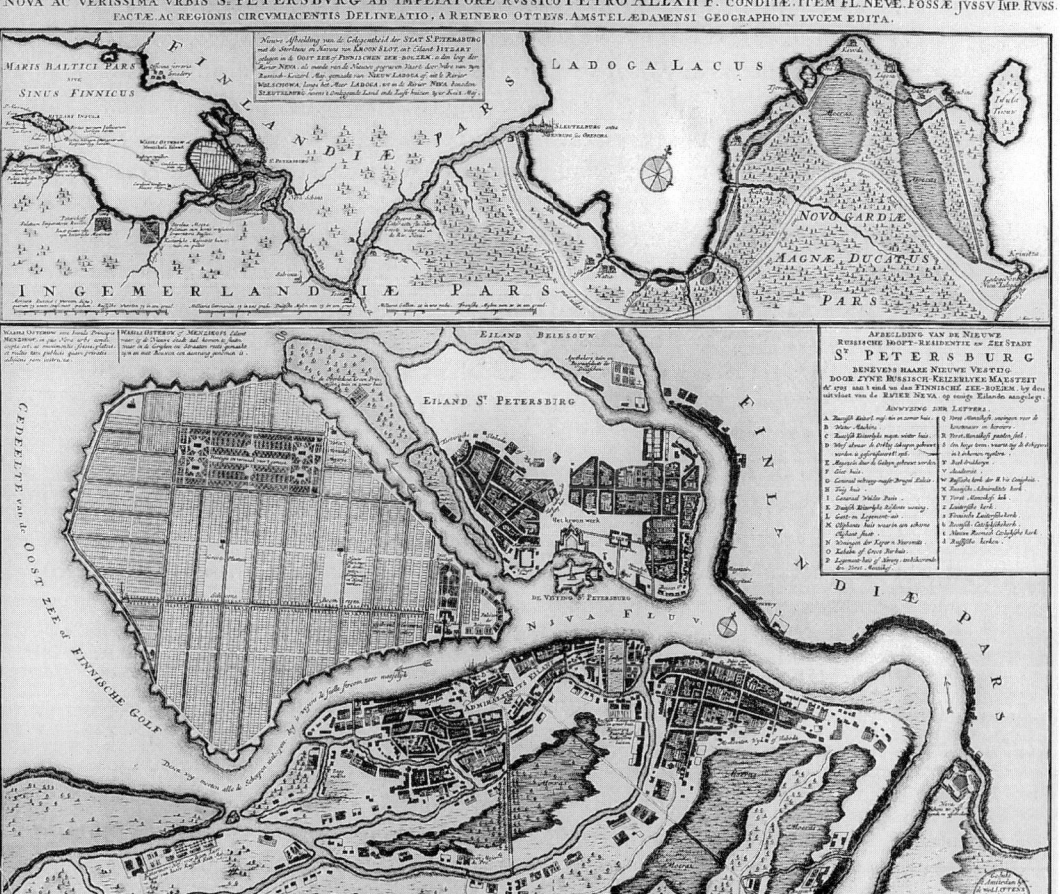

(laid out between 1712 and 1718), nor the radial main streets that were created later converged on the palace, as was customary in other European cities, but on the adjacent Admiralty. In fact, the streets did not play such an important representational role at first. The main route to the city was by sea, and from the water too the enormous Admiralty complex to the right dominated the skyline with its tall gilded spire. To the left the Kunstkamera and the Academy of Sciences, built at the tip of Vasilyevsky Island between 1718 and 1734, also faced the waterfront. This fork in the Neva was where the city centre developed. According to a contemporary (probably the secretary of the Academy, Schumacher, although not indicated as such on the source) it included 'the warehouses and the Commodities Exchange in the North, the imperial Winter Palace and the Admiralty in the South, the Peter-Paul fortress and the hospital in the East, and the Twelve College Building (the seat of government) in the West'.[5] Apparently he did not regard the wide and almost bridgeless river as a barrier between the different buildings but on the contrary as a way of connecting them as a city centre. This can probably also be explained by the fact that locally the primary means of transport was by boat or by sleigh. Nor should it be forgotten that these insular landmarks displayed a certain stylistic coherence and visual unity. Though separated by the river, the Kunstkamera and the (second version of the) Hermitage thus corresponded formally to each other because they were both designed in the same style by the same architect, the German Georg Johann Mattarnovi.[6]

The unusual character of the museum project in St Petersburg squared not only with this new city, populated by Russians who had been forced to move and by immigrants from abroad, but also with the Tsar's tendency to disregard protocol.[7] As is well known, he hardly followed a regular courtly life at all, but preferred to haunt shipbuilding yards and battlefields. If he took an interest in the arts and sciences, it was to gain European acceptance for the Russian Empire as quickly as possible. It is interesting to see how this progressive development was also expressed in the design of the Kunstkamera (see figures 3 and 4).

Mattarnovi decided on a central building with two wings, a form which resulted in functional rooms with a maximum of daylight. The whole of the right wing was taken up by a library, while the left wing housed the objects. Despite the numerous windows, sufficient exhibition room was created by installing a double row of cabinets; one was set against the four walls, the other was positioned in the middle of the main rooms. The cabinets in the left wing housed the orderly arrangement of minerals (see figure 4, PP, QQ, RR), coins (SS), gems and other precious items (TT), miniatures and drawings (UU), prepared fishes, reptiles and human organs (OO), vertebrates (LL), and curiosities, many of them from Siberia or China (BB, CC, DD). The central tower connecting the two wings accommodated an anatomical theatre and an observatory – facilities that point to the function of the building – and collections for scientific research. The same is true of the separate building for the Academy of Sciences that was erected next to the Kunstkamera. In the 1730s it came to incorporate not only a drawing and engraving workshop but also a press, bindery, type-foundry, glass grindery and stonemason's yard.[8]

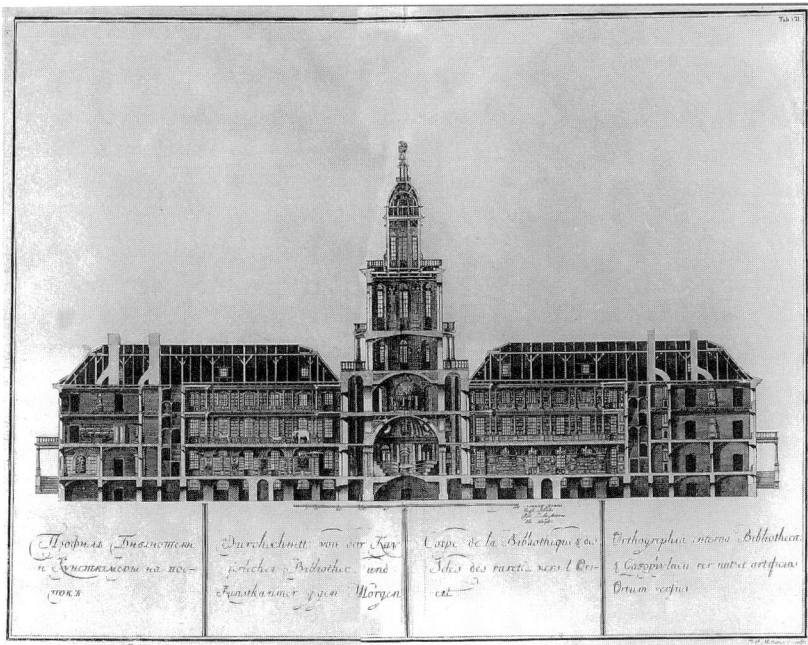

3 Cross-section of the imperial library and Kunstkamera, seen from the east, St Petersburg.
Engraving: P. G. Mattarnovy, 1741

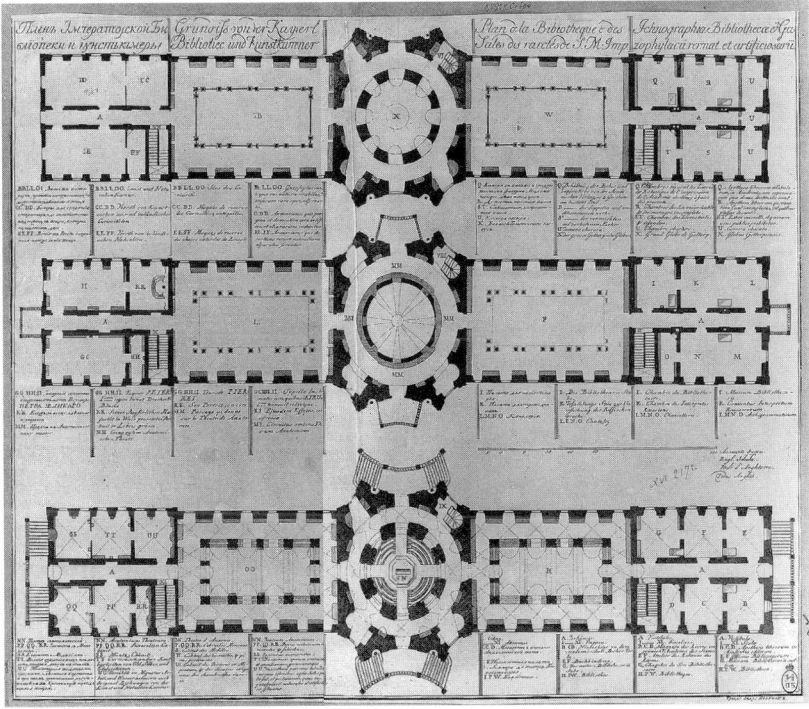

4 Ground plan of the imperial library and Kunstkamera, St Petersburg. Engraving: A. Poljakov, 1741

This practical orientation of the arts and sciences towards the handicrafts is also expressed in the rational design of the Kunstkamera. In spite of the sobriety of the building and the orderliness of the arrangement, however, a symbolic layer that could be understood and interpreted was still essential. The novelty and didactic function of the institution made the clear use of signs a necessity. But what were the appropriate symbols? Peter himself had not received any formal education since the age of ten, and the classical culture of the West was still a relatively new field even for more educated Russians. This must often have created problems for the foreign advisors whom Peter had taken into service, in the first place his Scottish physician Robert Areskin, who shared the responsibility for the collections with the German librarian Schumacher.

But that is exactly what makes this museum so interesting: it demonstrates the transplanting of a European tradition on to what was literally a new land, and it coincided with the attempt to rid that country of its own traditions, particularly by curtailing the power of the church. The result was the violent creation of a *tabula rasa*, which – precisely because of the speed in which everything took place – made it possible to outstrip the European originals. This modernity is manifested not only in the orderly arrangement, sobriety and autonomy of the building, but also in the decorations that were chosen to get the message of the museum across. Although they were taken from the traditional arsenal of European allegories, the specific *selection* is different from that made by the Tsar's European predecessors. Unlike the 'museums' of Rudolf II in Prague and the Medici in Florence, the symbolic presentation of the Kunstkamera in St Petersburg bears witness in a fairly literal way to the modern, no-nonsense political ambitions of its founder.

The use of allegory

The Tsar did not live to see the completion of the Academy and the Kunstkamera in 1734, nor even the transfer of the collections in 1728 to the building while it was still in an unfinished state. However, it is likely that the arrangement and decoration were based on earlier designs in accordance with his wishes. The production of graphic material to disseminate information about the museum also seems to be completely characteristic of him. The fact that a remarkable quantity of drawings and prints from the 1740s are still extant enables us to gain an impression of the contents and appearance of the Kunstkamera.[9]

The exterior already represents the combination of tradition and modernity that is so typical of Peter's political and cultural projects. The niches were to house sculptures, designed by one of the first Russian architects, Mikhail Zemtsov, who had been trained by the Italian Andrea Trezzini. That was probably why they personified the well-known qualities of Renaissance rulers, such as *Sapientia*, *Curiositas* and the related figure of *Memoria*.[10] On the other hand, the plans included sculptures of *Astrologia*, *Medicina* and *Justitia*, a range of sciences that were intended to express the intimate connection between the Kunstkamera and the Academy of Sciences and

which, to the best of my knowledge, had never before graced the outer walls of a 'museum'. Two of the proposals – *Humanitas* and *Cura pro patria* – appear even more unusual, which may explain their rejection by the librarian Schumacher. Although none of the sculptures for the outer walls was ever carried out, we do know the designs thanks to Oleg Neverov's pioneering research.[11]

However, neither he nor any other scholar has come up with a satisfactory explanation of the interior decoration. This is hardly surprising, as none of that decoration is extant except for the graphic material mentioned above. The main clue is an engraving of room OO on the first floor, showing two rows of cabinets, one against and the other in front of the eastern wall (see figure 5). The central area of the second row is occupied by an architectural construction with a seated figure holding a staff. A canopy adds princely allure to the figure, compounded by the effect of the two skulls peeping from the drapery. Each of the four corresponding areas between the windows on either side of this figure contains a medallion of the head of a man in profile. This was the room the visitor entered first and the one chosen for the display of the core of the collections: the anatomical and zoological preparations from the cabinets of Frederick Ruysch and Albert Seba. Here their

5 Wall cabinets of the naturalia room on the first floor, containing the preparations originally collected by Ruysch and Seba. Kunstkamera, St Petersburg. Engraving: G. Kachalov, 1741

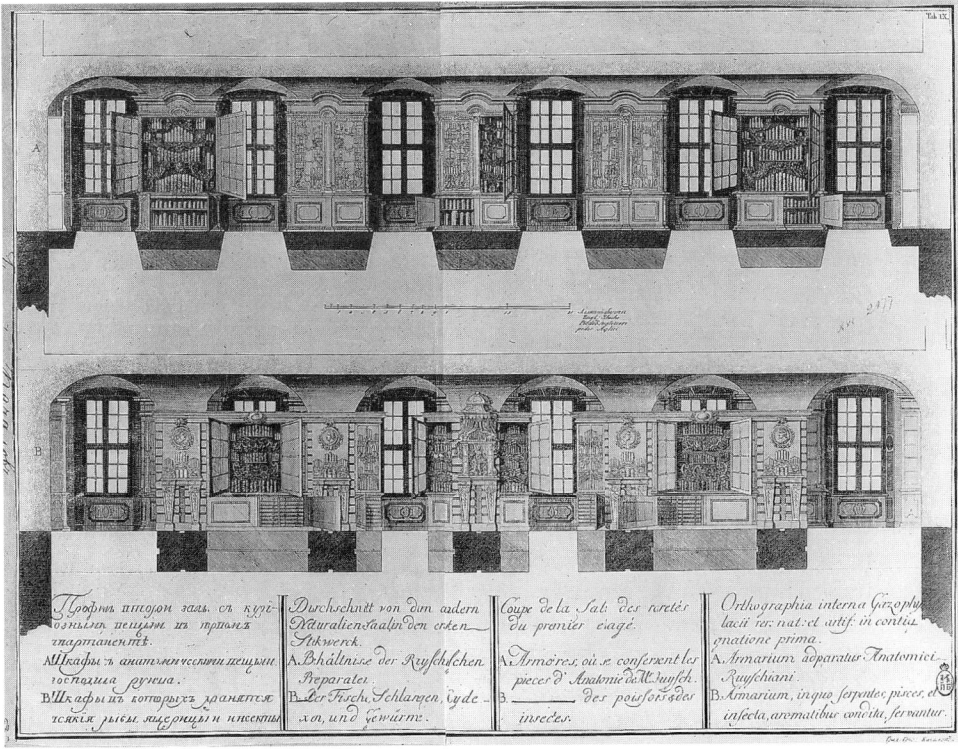

fishes, reptiles, human limbs and organs, and teratological objects could be studied by naturalists and physicians.

The only interpretation until recently was that offered by Tatiana Stanyukovich, the first author on the Kunstkamera in the 1950s. Ever since she identified the heads in the medallions as those of classical philosophers and the seated figure as King Solomon, everyone has followed her interpretation of the Kunstkamera as being modelled on 'Solomon's House', the ideal academy from Francis Bacon's utopia New Atlantis. The king would therefore be represented as the first collector of curiosities, a role assigned to him in C. F. Neickel's *Museographia* of 1727, where the series of archetypal collectors includes Noah as the first collector of animals.[12] There is nothing strange about this idea in itself: Arthur MacGregor traced a number of British versions of this type several years ago.[13] All the same, I believe that Stanyukovich's interpretation is without foundation. Not only does it fail to correspond to the engraving, but her identification of the medallions and the seated figure with objects from the collections of Ruysch and Seba is impossible to reconcile with the inventories.[14]

The alternative reading that I would like to propose has the merit of corresponding more closely to what we actually see in the engraving, both in the medallions and beneath the canopy, and in the museum as a whole. Closer examination of the pen drawings mentioned above reveals that the figures on the medallions are men in contemporary dress, probably scientists. And if the minute detail in the centre of the print is magnified, it turns out to be different from how one would

6 The seated figure, detail of the naturalia room on the first floor, Kunstkamera, St Petersburg. Engraving: G. Kachalov, 1741

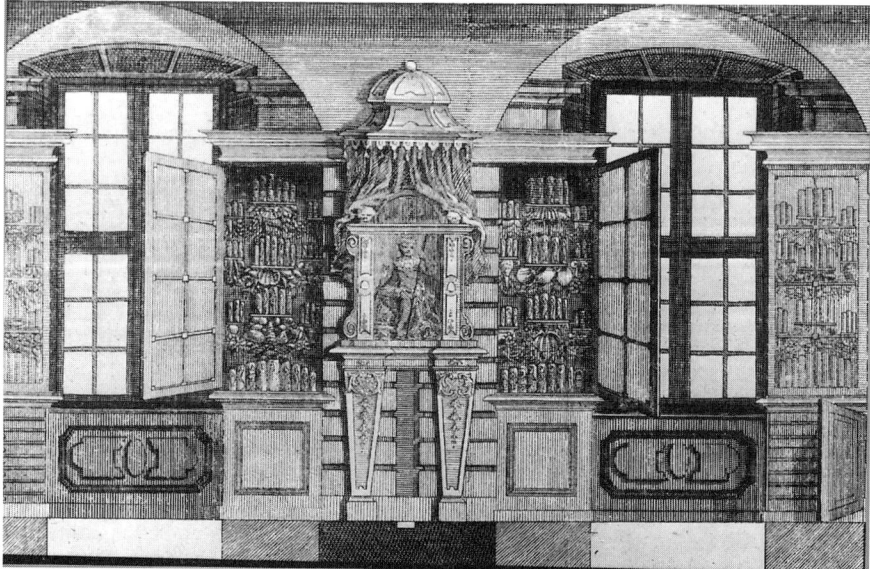

expect King Solomon to look (see figure 6). Instead of being dressed in traditional
royal garments, he is naked except for a feathered skirt and collar, and the hatching
suggests a dark skin pigmentation. The attribute in his left hand is more like an
arrow than a staff. In short, it all seems to point towards identification of the figure
as Native American. The skulls beneath the canopy, which are natural enough in
the proximity of an anatomical collection, would then refer to the spectre of canni-
balism, a conventional reference in representations of Native Americans from the
sixteenth and seventeenth centuries.[15] At first sight one would not expect to find a
Native American here, in the showcase of the museum, among Albert Seba's fishes
and reptiles. Closer inspection yields its meaning, however. It seems not improb-
able that this figure stood for America, forming part of a programme of the four
continents, a theme that was by no means uncommon in the context of encyclo-
pedic *Kunstkammern*. A programme of this kind, which contains the personifica-
tions of Europe, Asia, Africa and America, is quite in keeping with the function
that the Kunstkamera was supposed to fulfil within the Tsar's political and cultural
policy, especially here in the new sally-port of St Petersburg.

The four continents

At least two European collections visited by the Tsar made use of a similar pro-
gramme. The first is the *Kunstkammer* of King Frederik IV of Denmark, Peter's
ally in the war against Sweden for hegemony in the Baltic Sea. The frontispiece of
Oligerus Jacobaeus's catalogue of 1696 reveals an architectural construction
offering a prospect of Frederik's *Kunstkammer* in Copenhagen, including a number
of allegorical references (see figure 7). While in the foreground we see personifica-
tions of Nature and Art to honour the portrait of Frederik's father, sculptures of
the four continents with their attributes are mounted on top of the construction to
refer to the distant origins of the artificialia and naturalia in this collection. Europe
has her *tempietto*, cornucopia and crown; Asia is accompanied by a camel; Africa's
attributes are a lion, scorpion and ear of corn; and America holds an arrow, and has
a reptile at her feet.[16]

The Tsar must have been familiar with this *Kunstkammer*, because he spent
three months with his Danish ally in 1716, en route for Holland, England and
France to win them over to his side in the war against Sweden. As he had done on
his first trip, when he spent most of his time studying ship construction, he com-
bined his political mission with lengthy visits to the major collectors, especially in
Holland. In a number of cases matters proceeded hand in hand, as is shown by his
contacts with Nicolaas Witsen, mayor of Amsterdam, who was not only in charge of
the United East Indian Company but was also a collector of exotica from Siberia,
China and the East Indies, and a correspondent with various scholars, including
Leibniz. Another example is Jacob de Wilde, secretary at the Amsterdam
Admiralty and a collector of geographical and astrological instruments, coins, gems
and Egyptian antiquities.[17] These persons were not just of interest to the Tsar

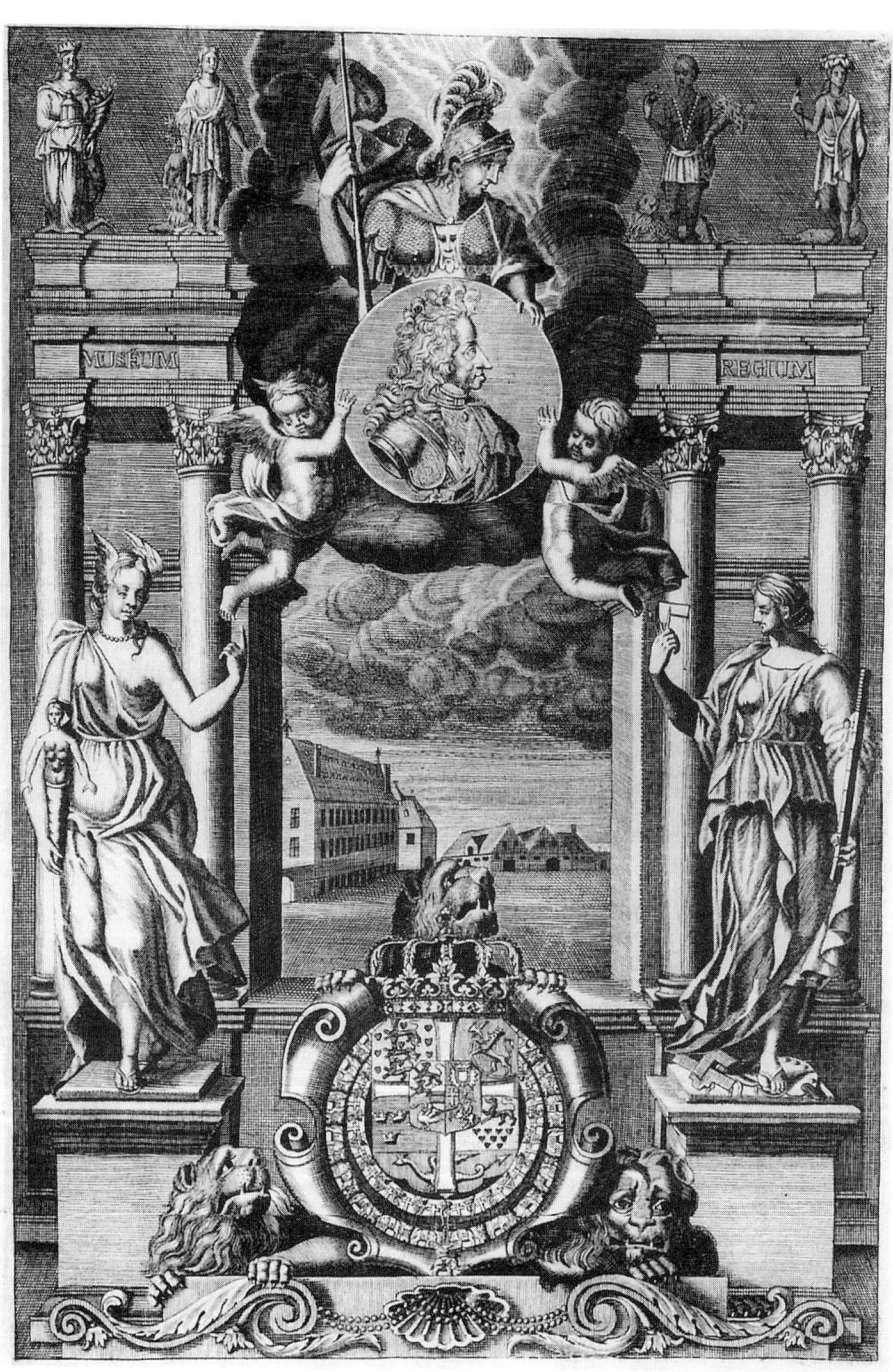

7 Frontispiece of Oligerus Jacobaeus, *Museum Regium* (1696). Engraving

because of their activities as collectors. The leading role that they played in commerce, shipbuilding and politics was closely connected with their collections, and it was precisely this practical combination which granted Peter access to knowledge about and control over parts of the world which were as yet little known.

It is therefore hardly surprising to come across the personifications of the four continents again in this milieu, but this time actually *in* a cabinet. An example is provided by the collection of the damask trader Levinus Vincent, whom the Tsar visited during his first trip to the Netherlands in 1697–98.[18] The frontispiece of Vincent's 1706 catalogue, the *Wondertooneel der Nature*, affords us a view of this cabinet, showing not only Vincent and his wife Johanna Breda, but also all kinds of allegorical figures, such as the art of Embroidery and Painting, the 'Naspoorder' (Curiosity), Navigation, Pastime and the fertility goddess Isis leaning against a globe. Above the cornice are reliefs of the four continents. Although only Africa and America are shown, the designer of the print, Romeyn de Hooghe, informs us that 'Europe and Asia ... are prevented from showing themselves by the small dimensions of the print'.[19] This formulation not only fills in the rest of the series; it suggests that in this respect the print is not based on fantasy but actually reflects the situation in Vincent's cabinet. We can identify the reclining figures as those of a black woman and a Native American, with attributes referring to the precious objects in the collection: Africa with an elephant's tusk alluding to the role of this continent as a source of ivory, and America with a basket 'full of curiosities' and a bow and arrow to shoot birds for their beautiful feathers. This can hardly have escaped the Tsar's notice when he visited Vincent's collection. Although the figure in St Petersburg is not identical, this visual way of representing global power may well have served Peter or his advisors as a source of inspiration. Of course, there was hardly any need for an explanation, for a damask merchant like Vincent no doubt owed his collection of objects from all over the world to his commercial contacts.

These examples lend plausibility to the identification of the figure in the St Petersburg Kunstkamera as one of the four continents. The question remains of why it was placed in this particular room, and whether its three companions can be identified as well. If we combine the engraving with information provided by the catalogue, a logical connection appears. Most of Albert Seba's fishes and snakes to the left and right of the Native American did come from Brazil.[20] They bear witness to the important place occupied by American flora, fauna and ethnographic objects in the Dutch collections. It was not by chance that Peter gave such a prominent place to the preparations that he had bought from Seba: he too was particularly interested in that continent, spurred on by his physician Robert Areskin, who possessed an impressive collection of exotica, including the publications on the flora and fauna of Brazil by Georg Markgraf and Willem Piso.[21] As mentioned above, Peter himself bought several albums of watercolours by Maria Sibylla Merian, who had worked in Surinam for two years. All the same, if this figure represents America, the question remains of where the other three continents were placed. The cross-section of the building, which offers a view of the opposite wall, reveals a

second niche in the corresponding position, but we do not know what it contained (see figure 3). Unfortunately, there are no niches of this kind in the main room of the right wing, which housed the library, so if there were personifications of the remaining continents, they must have been somewhere else in the building.

Global ambitions

Even if the other three continents were probably not portrayed in the museum, it still remains very likely that the figure in question should be identified as a personification of America. Despite the fact that Solomon was seen as the archetype of the collector at the end of the seventeenth century, the figure in the niche is clearly *not* this legendary king. Besides, he would hardly have matched Peter's mentality: in the last resort, what the Tsar was after was not wisdom but world domination. This was the vision behind his war against Sweden in the north, against the Turks in the south, and his diplomatic negotiations with the Dutch and with England in the west, and China in the east. His programme to improve the arts, crafts and sciences in the Russian Empire was part of that vision. The Kunstkamera, strategically located in the city, was to present both the study material and the symbolic digest of this enterprise.

The key to this interpretation may lie, not only in the figure of the Native American, but in the centre of the building. The ground plan shows an axis around which the museum was designed, a cavity and a sphere, that is, the anatomical theatre and a trophy: the enormous, double globe that the Duke of Holstein-Gottorp had presented to the Tsar in return for protection against Sweden. This wonder, which arrived in St Petersburg on 20 March 1717 on two sleighs drawn by 'hundreds' of peasants, was renowned far and wide for its format and its mechanical construction. It was large enough to admit eleven people at a time to observe the course of the planets in real time. The gift even exerted a determining influence on the architecture of the Kunstkamera. As if to underline his global ambitions, the Tsar placed the globe in a specially designed, circular room at the centre of the museum, midway between the earthly domain of the anatomical theatre and the observatory with its gaze fixed on the stars.[22] Although it no longer rotated automatically, the globe thus functioned as the point of reference for the collections that surrounded it. Representing the world on the outside and the firmament on the inside of its casing, it summarised the encyclopedic range of the museum, probably in a way that everyone could understand. The allegories applied at other points in the building merely supplemented this powerful statement.

However, the encyclopedic function of the Kunstkamera was soon eroded. This process was already under way in the 1760s when Catherine the Great showed more interest in the paintings, sculptures and furniture that she collected in her palaces than in what had come to be seen as 'rarities' in the sober building beyond the Neva. In her eyes, the museum that had once embodied vital cultural and political values both through its form and contents and through its location in the city had now lost much of its former importance.

Notes

1 For a fuller discussion see D. J. Meijers, 'De Kunstkamera van Peter de Grote. De Nederlandse bijdrage aan een nieuw type museum', in R. Kistemaker, N. Kopaneva, A. Overbeek (eds), *Peter de Grote in Holland: Culturele en wetenschappelijke betrekkingen tussen Rusland en Nederland ten tijde van tsaar Peter de Grote* (Bussum: Thoth and Amsterdams Historisch Museum, 1996), pp. 22–36.

2 See the contributions by O. Neverov (curiosities), J. J. Driessen (Seba), A. Radzjoen (Ruysch), A. M. Luyendijk-Elshout (Ruysch), J. N. Lebedeva (Merian), J. Kagan (gems), M. Maaskant-Kleibrink (gems), G. Komelova (prints), N. A. Kopanev (books), P. G. Hoftijzer (books), E. Okhuizen (maps) and J. van der Veen (paintings) in Kistemaker *et al.* (eds), *Peter de Grote in Holland.* The contributions by A. Reiman and E. A. de Jong deal with Dutch influences on gardens in St Petersburg.

3 H.-Chr. Dittscheid, 'Le Musée Fridericianum à Kassel (1769–1779): un incunable de la construction du musée au siècle des Lumières', in E. Pommier (ed.), *Les Musées en Europe à la veille de l'ouverture du Louvre: Actes du colloque organisé par le service culturel du musée du Louvre à l'occasion de la commémoration du bicentenaire de l'ouverture du Louvre les 3, 4 et 5 juin 1993* (Paris: Klincksieck, 1995), pp. 157–211.

4 The use of the term *tabula rasa* with reference to Russia goes back to Gottfried Wilhelm Leibniz. As a librarian, historian and diplomat in the service of the Dukes of Braunschweig-Lüneburg, the famous philosopher advocated for decades the establishment of a network of Academies of Science in Berlin, Dresden, Vienna and elsewhere to eventually provide the material for a 'world encyclopedia' of all the knowledge that had been acquired. Since Leibniz had the total organisation of the exercise of the arts, crafts and sciences in mind, his plans were rejected as impractical by the Elector of Saxony and by the Emperor. Perhaps encouraged by the positive results that he achieved in Berlin, however, Leibniz tried his luck with the Tsar by persistently sending him his comprehensive proposals between 1697 and 1716. The Russian Empire was particularly attractive in Leibniz's eyes because it was not yet weighed down by Western traditions. He considered that Russia was a *tabula rasa*, a 'pan that has not yet taken on any foreign flavour', which enabled the 'designer' to avoid the mistakes that had been made in Europe. See the source material published in W. Guerrier, *Leibniz in seinen Beziehungen zu Russland und Peter dem Grossen* (St Petersburg and Leipzig: Kaiserliche Akademie der Wissenschaften, 1873), especially numbers 73 and 212. Although the Tsar apparently never replied to Leibniz, there are indications that he took his recommendations seriously. See Meijers in Kistemaker *et al.* (eds), *Peter de Grote in Holland*, pp. 24ff.

5 [Johann Daniel Schumacher], *Gebäude der Kayserlichen Academie der Wissenschaften, Bibliothec und Kunst-Cammer in St Petersburg* (St Petersburg: Kayserliche Academie der Wissenschaften, n.d. [1744]), p. 8.

6 Mattarnovi's Winter Palace, the second one built in 1719–21, is illustrated in James Cracraft, *The Petrine Revolution in Russian Architecture* (Chicago and London: The University of Chicago Press, 1988), figure 107. See also I. A. Egorov, *The Architectural Planning of St Petersburg* (Athens: Ohio University Press, 1969), p. 31.

7 In 1712 and 1714 the Tsar ordered 1,350 noblemen (with the peasants they owned), 1,300 merchants from the upper and lower classes, and 1,300 craftsmen from all trades to move to St Petersburg, presumably with their families. The city can hardly have

been an attractive place to live and work in during these early years. The hastily erected residential districts were lacking in comfort, and the streets were dangerous because of the criminals imported as forced labourers and the wolves attracted by the sudden emergence of human activity (Egorov, *Architectural Planning*, pp. xxii–xxiii). Bearing in mind the harsh climate and the regular floods, foreign immigrants must have had pressing reasons to leave home and settle in this remote city.

8 Anonymous, *Gebäude der Kayserlichen Academie*, pp. 5–6; James Cracraft, *The Petrine Revolution in Russian Imagery* (Chicago and London: The University of Chicago Press, 1997), pp. 244–5.

9 The guide *Gebäude der Kayserlichen Academie*, probably written by Schumacher and published in German, Latin and Russian in 1744, contains twelve illustrations. The prints were made from a series of larger engravings dating from 1741, on which the ground plans, elevations, cross-sections, several interiors and even walls can be seen in more detail (see figures 3–5). In addition, Oleg Neverov and Jan van der Waals have discovered more than 2000 watercolours (some of which were also executed as engravings) of 'all' of the individual objects in the collection. This unique source of information is currently the object of a joint Russian–Dutch research project and will be published in 2004 by Renée Kistemaker, Natalja Kopaneva and Debora J. Meijers. Besides these drawings and prints there is a catalogue, *Musei imperialis Petropolitani vol. i–ii*, 2 vols (St Petersburg: Typis Academiae Scientiarum Petropolitanae, 1741–45), which makes it possible to determine the locations of the objects, although it does not contain any illustrations. A different category of illustrative material consists of the interior and exterior designs, which were never meant to be circulated. Of particular interest are the partly coloured pen drawings of separate cabinets (including Saint Petersburg Architectural Museum, inv.no. A14830–A14838); see Meijers 'De Kunstkamera van Peter de Grote', figures 13–16.

10 E. Scheicher, 'De vorstelijke Kunst- und Wunderkammer', in E. Bergvelt, D. J. Meijers, M. Rijnders (eds), *Verzamelen: Van rariteitenkabinet tot kunstmuseum* (Heerlen and Houten: Open University and Gaade, 1993), pp. 15–36; pp. 15–18, pp. 25–6.

11 The approved designs are in the manuscript collection of the Academy of Sciences (fond III, opus 1, k.5, 1.631); the rejected designs are in the collection of drawings of the Russian State Museum (inv. no. P 38001–38002). Neverov introduced the Kunstkamera to European scholars through his lecture given at the conference *The Origins of Museums*, held in Oxford in 1983, see Oleg Neverov, '"His Majesty's cabinet" and Peter I's Kunstkammer', in Oliver Impey and Arthur MacGregor (eds), *The Origins of Museums: The Cabinet of Curiosities in Sixteenth- and Seventeenth-Century Europe* (Oxford: Clarendon Press, 1985), pp. 54–61.

12 T. V. Stanyukovich, *Koenstkamera peterboergskoj Akademii Naoek* (Moskow and Leningrad: Academy of Sciences USSR, 1953), p. 53 and pp. 102ff.; C. F. Neickel, *Museographia oder Anleitung zum rechten Begriff und nützlicher Anleitung der Museorum oder Raritäten-Kammern* (Leipzig and Breslau: Michael Hubert, 1727).

13 Arthur MacGregor, '"A magazin of all manner of inventions": museums in the quest of "Solomon's House" in seventeenth-century England', *Journal of the History of Collections*, 1:2 (1989), pp. 207–12. See also Jim Bennett and Scott Mandelbrote, *The Garden, the Ark, the Tower, the Temple: Biblical Metaphors of Knowledge in Early Modern Europe* (Oxford: Museum of the History of Science, in association with the Bodleian Library, 1998).

14 P. Pekarski, *Naoeka i literatoera v Rossii pri Petre Velikom* (St Petersburg: 1862; reprinted by Oriental Research Partners, Cambridge, 1972), p. 558: *Notitiae Seba*, no. 108 (Library of the Academy of Sciences, St Petersburg, inv. no. RUK.188).

15 Native Americans were often portrayed with decapitated heads or amputated limbs as attributes. See Sabine Poeschel, *Studien zur Ikonographie der Erdteile in der Kunst des 16.–18. Jahrhunderts* (Munich: Scaneg, 1985), e.g. no. 7 (Crispijn de Passe) and no. 75 (Theodor de Bry). I am grateful to Roelof van Gelder and Peter Mason for their valuable suggestions regarding the interpretation of this figure.

16 See Impey and MacGregor, *The Origins of Museums*, fig. 55. On the attributes of the four continents see Poeschel, *Studien zur Ikonographie*, cat. no. 54, pp. 367ff.: Carlo Grandi (after Carlo Mariotti), 'The four continents', illus. in Cesare Ripa, *Iconologia* (Rome: appresso Lepido Faeii, 1603). The reputation of the Kunstkammer of the Danish king was largely based on the collection of exotica of Ole Worm and the series of larger than life-size portraits of Brazilians painted by Albert Eckhout that formed part of a gift to the king by Prince Johann Moritz von Nassau-Siegen in 1654.

17 E. Bergvelt and R. Kistemaker (eds), *De wereld binnen handbereik: Nederlandse kunst- en rariteitenverzamelingen 1585–1735* (Zwolle: Waanders and Amsterdam: Amsterdams Historisch Museum, 1992). M. Peters, 'Nicolaes Witsen and Gijsbert Cuper: two seventeenth-century Dutch burgomasters and their Gordian knot', *Lias*, 16:1 (1989), pp. 111–50. K. Müller, 'Gottfried Wilhelm Leibniz und Nicolaas Witsen', *Sitzungsberichte der deutschen Akademie der Wissenschaften zu Berlin, Klasse für Philosophie, Geschichte, Staats-, Rechts- und Wirtschaftswissenschaften*, 1:1 (1955) pp. 1–45. On Leibniz see also note 4.

18 L. Vincent, *Het tweede deel of vervolg van het Wondertooneel der Natuur* (Amsterdam: François Halma, 1715), p. 3.

19 Romeyn de Hooghe, 'Uitlegging der Tytelplaat', in L. Vincent, *Wondertooneel der Nature* (Amsterdam: François Halma, 1706), p. 10. Bergvelt and Kistemaker (eds), *De wereld binnen handbereik*, fig. 63.

20 *Musei imperialis*, vol. 1, pp. 479–506 and pp. 551–76. [Schumacher], *Gebäude der Kayserlichen Academie*, p. 20.

21 J. H. Appleby, 'Robert Erskine: Scottish pioneer of Russian natural history', *Archives of Natural History*, 10:3 (1983), pp. 377–98; p. 389 and p. 392 cite from the catalogue of Areskin's library (probably drawn up by Schumacher) no. 28: 'Piso Guil: de Indiae utriusq. Renat. et Med. Amst. 1658'; no. 29: 'Marigravii Georg: de Liebstadt Topograph et Meteorolog. Brasiliae'; no. 30: 'Bontii Jac: Hist: nat: et Med. Indiae Orient.'

22 Minutes of Schumacher to Areskin of 21 March and 10 May 1717 (Archive of the Academy of Sciences, St Petersburg, fond I, opus 3, no. 2, L. 45 and L. 490b-50). I am grateful to Jozien Driessen for this reference. On the earlier history see Felix Lühning, *Der Gottorfer Globus und das Globushaus im "Newen Werck": Dokumentation und Rekonstruktion eines frühbarocken Welttheaters* (= *Gottorf im Glanz des Barock: Kunst und Kultur am Schleswiger Hof 1544–1713*, vol. 4) (Schleswig: Schleswig-Holsteinisches Landesmuseum, 1997). For a comparison of the observatory of the Kunstkamera with other European examples see Johann-Christian Klamt, *Sternwarte und Museum im Zeitalter der Aufklärung: der Mathematische Turm zu Kremsmünster 1749–1758* (Mainz: Verlag Philipp von Zabern, 1999).

The *wrong* twigs for an eagle's nest? Architecture, nationalism and Sir Hugh Lane's scheme for a Gallery of Modern Art, Dublin, 1904–13

Neil Sharp

In December 1904, Lady Augusta Gregory, playwright and at this time co-founder with W. B. Yeats of the Abbey Theatre in Dublin, wrote an article about her nephew Hugh Lane and his plans to found a new public collection of modern and contemporary art for the city and for the Irish nation as a whole. Her remarks were made at the time of an exhibition organised by Lane, which not only announced his ambitions to the Dublin public but also provided the chance to begin to acquire such a collection. The exhibition consisted of a large selection of paintings by nine-teenth-century French artists on loan from a private collection with an offer for their sale at reduced rates should such an institution be established.[1] There was also a smaller number of key 'Impressionist' works loaned from the Paris-based dealer Paul Durand-Ruel, as well as a collection of works donated in support of Lane's cause by leading Irish and British artists. As it would remain throughout the trou-bled history of his gallery scheme, Gregory's support for Lane was not merely a familial one. She perceived a link between the gallery and her wider cultural vision for Ireland. The securing of the collection and the institution of a new public gallery to house it, she suggested, 'would be an advance in the dignity of our country in its place among nations, a worthy building-stone laid upon its wall.'[2]

As we shall see, this recourse to architectural metaphor or symbol in reference to Irish nationhood, and of their relationship with the proposed art gallery's physical coming into being, will be central to this chapter. In the first instance, we would be mistaken here to read Gregory's words merely as typically high-principled lan-guage about new museums and galleries, of the kind emanating from practically every city and town across Europe and America by this time. Clearly, it is not that Gregory's remarks do not aspire to something. However, the advancement of dig-nity she foresaw was more accurately one of recovery: the recovery of Ireland's

independent national status from Britain's continuing colonial occupation of it. Since the 1890s Gregory herself had played a central role in the broad literary and artistic movement that had sought in diverse ways to re-establish a national consciousness. The Celtic Revival, as it became known, was endeavouring to reconnect a presently troubled and divided Ireland, especially since the failure of the Home Rule Bill in the 1880s, to a past that showed a country in possession of its own flourishing language, mythology and visual culture.

It is in this context of recovery that the doubling of prolepsis in Gregory's metaphor becomes more apparent. In other words, there is an anticipation of *two* things that did not yet exist. For a wall (i.e. the nation) that requires a building-stone (a gallery) is clearly not yet fully built, and its significance is that it establishes a synecdochic link between nation and cultural institution. But how and why could Gregory perceive that the building of this new institution would help in the re-establishment of Ireland's national dignity? And just what kind of vision was this and did it disclose a particular set of views or identifications shared by Lane's project?

In one sense, Gregory's support is curious. For Lane's venture might be registered for its anomalousness in the immediate context of the cultural nationalist vision that she and the movement as a whole espoused. In bringing the apparent sophistication of French modern art into a national frame of reference, Lane's venture could hardly be connected to that Celtic heritage so predominantly a resource for the Revival. Moreover, quite unlike other projects and activities of the movement, it also sought to inaugurate a new and highly formalised institution, one requiring purpose-built accommodation in Dublin. These two factors were to make Lane's gallery scheme a very different institutional proposition and controversy to other developments at this time; to that, say, of the founding of the new National University, or the informal development of the Gaelic League, and even of the Abbey Theatre itself. For the time being, however, the hubbub surrounding the introduction of modern art to Dublin grew to a broadly appreciable crescendo by the time Lane opened a temporary gallery in January 1908. Much of that first show from the winter of 1904–5 was now safely purchased and on display. This gallery had also been approved by the city's local authority, the Dublin Corporation, as a provisional measure in the negotiations for a permanent space. After this brief period, however, opinions progressively turned sour, especially following the appearance in early 1913 of Edwin Lutyens' design for a permanent gallery to span a central section of the River Liffey (see figure 8). In the course of that year this proposal became embroiled in political controversies focusing upon the city's severe housing problems, and also heightening labour unrest caused by the infamous Dublin 'lock-out'.[3] This was a situation manipulated above all by Lane's (and practically everyone else's) nemesis, William Martin Murphy, a Dublin newspaper and tramway magnate, and a powerful figure in the city's local politics. Amidst this high drama, in late September 1913 the Dublin Corporation finally rejected Lane's permanent scheme.

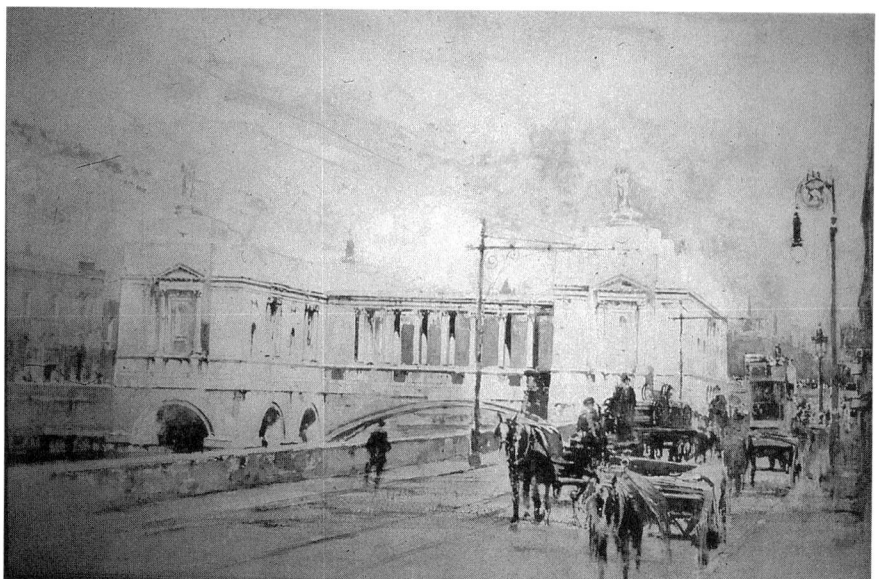

8 Edwin Lutyens, design for an art gallery across the river Liffey, Dublin, 1913. Illustrated by William Walcott

In most accounts, Lane's failure to inaugurate has most often been levelled at the 'meanness and philistinism' ascribed to a small but powerful sector of Dublin's Catholic nationalist community, with Murphy at its centre.[4] Such readings pit a clear confrontation between, on the one hand, the higher, liberal values and aesthetic pleasures underpinning modern art's institution and, on the other, narrow-minded, provincial interests. But the fact that these events took place within a colonised city and nation is clearly central to their very occurrence and has to be registered as such. As I hope to show, this factor presents problems within and between the twin claims most often made for Lane's importance, i.e. to the causes of both modern art and cultural nationalism.

In what follows, I will argue that it is the processes and forms of architecture that provide the best means of understanding the controversy from this colonial perspective. This is not as an examination of differing opinions about architectural style as such. It is more an awareness of architecture becoming the key figural resource of language in various media (written/visual), and in this sense Lady Gregory's article of 1904 appeared to initiate this kind of response. Following the opening of the 1908 gallery, in fact, any problems Lane was facing in gaining public support on the issue of modern art, were to become somewhat secondary to the idea of the proposed new gallery as a potential architectural imposition upon, and spatial disruption of, the city. That this had to take place as a set of conflicting rhetorical images is fairly obvious; stone and mortar were never to be laid for Lane's scheme.

 In this sense, therefore, Lane's 'failure' enables us to examine the inauguration process itself under some highly specific conditions: ones that certainly exceeded a mere breakdown in civic procedures.[5] In the development of local government in nineteenth-century Britain such procedures might become attached to the founding of a new institution through the finance and regulation of building practices. However, in this case we must consider not only the asymmetrical development of local government in Ireland,[6] but also the sublimation of all events and issues at this time to the 'national question'. Of course, the *national* status Lane desired for his gallery was signalled most loudly and clearly by the prestigious siting and classicism of Lutyens' design. But what I want to show is the complex and intriguing way the very *proposition* of the bridge scheme as an architectural form or monument generated a conflict over Ireland's future as a nation (and indeed of its other temporal dimensions). The emergence of a language around and about architecture, of architectural figuration, placed Lane's scheme most revealingly amidst the crisis over Ireland's independence. This made it a formative part of an already deepening entrenchment of religious and political sectarianism in this period, and a significant part also of a decisive split in the anti-colonial nationalist movement.[7] Perhaps the key question underlying this chapter is: just what kind of nation did Lane envisage the building of a gallery would help determine?

 To begin to address these issues I want firstly to come to some understanding of the role architecture played in the temporary Municipal Gallery of Modern Art (MGMA) Lane opened in January 1908. This was the gallery Lane secured from the Dublin Corporation in the hope of demonstrating the importance of his collection as a public venture. What is interesting here is the nature of this provisional meeting between the works Lane had assembled over the previous four years, and the domestic, though nevertheless grand structure into which they were installed; Clonmell House, a late eighteenth-century terraced town-house in Harcourt Street, on the south side of the city near St Stephen's Green (see figure 9). To address how Clonmell House came to affect the display of its objects, we will have to suspend a customary expectation about the relationship between the architecture of galleries and the art they display. This transitory meeting had to be something other than fully intentional or purposeful. In fact, the particular accommodation Lane made between the collection and the building can be shown to be important to the later controversy.
 Despite its provisional nature, however, the MGMA was without doubt the pinnacle of Lane's achievements since his first return to Dublin in around 1900. Born in Ireland in 1875 into a long-standing Anglo-Irish Ascendancy family, Lane's early years were spent on the Continent and in England. His initial reputation and wealth was made as a picture dealer of Old Masters in London, and he continued to work and live in that city throughout the Dublin period. Although at first Lane's return (in fact no more than a series of extended visits) was spent enjoying the rituals of Anglo-Irish high society, after meeting the leading figures of the literary

9 Clonmell House,
17 Harcourt Street,
Dublin

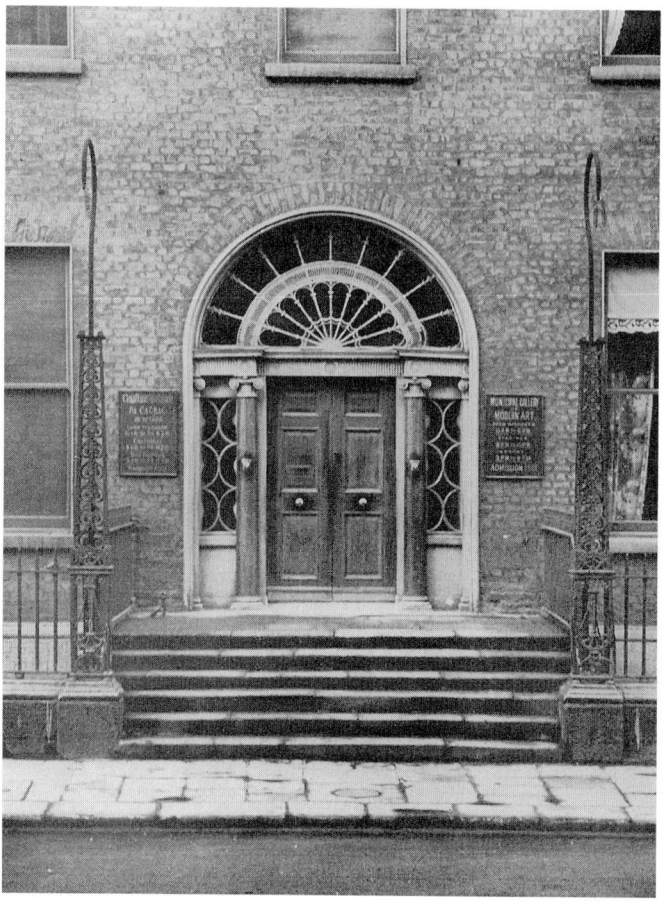

revival through his aunt, Lady Gregory, Lane underwent a quite rapid conversion
to the Irish patriotic cause. The aims of the early exhibitions he then took upon
himself to organise quickly changed from an attempt to revive an active interest in
the fine arts for the Dublin public, to the ambitious definition and promotion of a
national identity for Irish painting; that is, the formation of a coherent and contin-
uing tradition. But if these shows can be seen to measure Lane's growing commit-
ment to Irish cultural nationalism as it had developed from the 1890s (as well as the
increasing support he was gaining from the Revival's leading figures), his early
actions can nevertheless be examined in different ways.

Comparatively speaking, Lane's conversion was not exactly all consuming. To
paraphrase Declan Kiberd, he continued to live on the hyphen between Anglo and
Irish.[8] More accurately, perhaps, as a particular reflex of his social class, Lane's free-
lance curating served as a form of cultural philanthropy. For the idea of 'working for
Ireland' in his case appeared to be an explicitly voluntary and non-commercial com-
mitment to his country's betterment.[9] In other words, the benefaction of an art

collection was an act of amelioration marked out this time for the country's culture and not its poverty. And yet these actions contrasted dramatically with that other entrepreneurial identity he pursued in London. This division in identity, however, primarily indicates how carefully Lane had to tread in the turbulent spheres of Dublin political and cultural life. Discourses against England's materialism and industrialisation were common in Ireland at this time, particularly within the politics of the Celtic Revival itself, and to many opponents, therefore, Lane's interests were denounced as an unwarranted and romantically inflected largesse, supported from the proceeds of his English business practice.

And yet another indication of Dublin's changing political climate was that Lane's very need to seek approval for his gallery from the Dublin Corporation was itself a mark of the latter's increased power. After the Home Rule crisis of the 1880s, and up to the Bill's final re-introduction into Parliament by the Liberals in 1912, successive British Governments had attempted to allay nationalist opinion by a number of reforms.[10] One of which was the belated enfranchisement of local administrative structures. As a result, the Corporation, by now dominated by a Catholic middle class promoting a conservative brand of nationalism, had gained a number of new freedoms.[11] In this context, the practical circumstances of organising the MGMA forced Lane to gain a broad consensus of opinion able to appreciate the gallery's value for Dublin and for the future Irish-born artist. In another sense, however, this need for consensus appears to conflate with what F. S. L. Lyons has termed a strategy of 'cultural fusion' that from the 1880s had been favoured by those in the Anglo-Irish community who addressed the national question.[12] In fact, culture itself was believed to provide a common ground for the reconciliation of political differences. Although, in the context of the increasing isolation felt by an Anglo-Irish community positioned between the colonial administration and the Catholic majority, it is possible that these beliefs were generated because culture was 'one of the few territories ... which they still *could* occupy.'[13]

It is outside the concerns of this chapter to address in detail how the problems of cultural nationalism, philanthropy and a politics of reconciliation may have been registered by the basic curatorial divisions of the collection Lane installed in the MGMA in January 1908. Save to say that Lane's investment in the tradition of nineteenth-century French painting, and Manet and the Impressionists in particular, both added to and disrupted these issues. However, if the possession and display of these works made the gallery the envy not only of London but of Europe, as the press reception debated, its humbler 'municipal' naming and temporary housing in Clonmell House brought it back into a provincial and colonial perspective. Likewise, Lane's confidence both in the 'accomplished fact' of the gallery's institution and thus in its setting of a new 'standard' through its prestigious range of objects, none the less remained provisional claims.[14]

In fact, the opening of the MGMA confronted these uncertainties in spatial and architectural terms. The characteristically uniform and domestic appearance of the Georgian terrace exterior, as well as the bustling mixture of small businesses, and

private and tenant housing that dominated Harcourt Street, positioned the gallery somewhat confusedly between the concepts of a public and private space. Ideally, Lane had conceived it as the institutional complement to the historical collections in the National Gallery of Ireland, as well as adding to the other public institutions clustering nearby the latter around Leinster House, to the north-west of St Stephen's Green. With a train station at its southern end, however, Harcourt Street was as much a convenient route for the fashionable shopping facilities around Grafton Street, making the MGMA perhaps all the more too informal and unorthodox a siting for Lane's ambitions. But the factor that placed the MGMA all too palpably within its municipality, so to speak, was the recently opened headquarters in Harcourt Street of the nationalist party, Sinn Fein. As Lady Gregory later noted, these offices were subjected to the 'sudden raids and searches' by the British army.[15]

These uncertainties over the MGMA's status were perhaps more subtly manifest on the inside of Clonmell House. A rare image of Lane's collection on display there can be found in a page of hand-drawn sketches which appeared in the *Irish Independent* newspaper on the day following the MGMA's opening (see figure 10).[16] The page depicts three different views of the gallery. In one sketch, entitled 'A Corner of the French Room', Manet's *Portrait of Eva Gonzales* hangs beyond a decorative arrangement of tables and flowers or plants, which appear to be placed on top of a large rug or carpet, and to the left is a portable screen hung with a painting. Interestingly, the two other views depict connecting spaces rather than actual gallery rooms and in doing so focus on conspicuous features of the interior architecture. In the lower sketch, for example, there is a perspectival view in which the ascending stairs, a double line of paintings (which were the portraits of Irish notables) and the arabesque sweep of the banister rail have preoccupied the illustrator. The drawing leads us to a lighter gallery space, which appears to be top-lit perhaps by daylight from the high-angled eves of the roof. The light falls upon Rodin's *The Age of Bronze*. Similarly, the illustration of a doorway focuses in detail upon its recessed and opulent ornamentation. On the right-hand side of this scooped-out interior feature hangs a picture. On the left, in the room proper, is a column of three paintings. A narrow carpet on the floor runs through the doorway into the next room, leading the eye again into a distant space. A possible two further rooms leading off this are blocked by closed doors.

These sketches appear to be relatively quick responses – acts of reportage in this sense – significantly determined by the gallery's provisional status or identity. This is not simply because they depict the temporary displaying of Lane's collection. Rather it is the very framing of the views and their selective, focused detailing of doorways, stairs, cornicing, tables, plants and other features that might be said to convey this. If these formed some kind of interest or even distraction for the illustrator, there is a sense that the sketches may represent more specifically something of Lane's orchestration of spectacle through the juxtaposition of, or accommodation between these works and the given Georgian setting. Therefore, the question

the sketches problematise is whether certain paintings and sculpture were placed strategically to testify to their importance within art. Or whether their arrangement was determined to some significant extent by the need to embellish or to 'set off' the vacant, given shell of the architectural structure itself.

Of course, the MGMA's decorative accessories, the pictures' arrangement by national schools and their hanging into close groups, were all features intrinsic to current curatorial practices following the development of the national and regional art museum in the nineteenth century. In this sense, the temporary gallery had something in common with the recent renovation of Hertford House, London, to reinstall the Wallace Collection.[17] This was another former aristocrat's residence, like Clonmell House, and both these converted galleries testify to the architecture and decor of eighteenth-century classicism as a common standard of taste by this time. However, if it did make use of this standard, the MGMA must also be seen as an early contribution to a mode of display in which the decorative achievements of the Georgian period were thought to be the most appropriate domestic environment for the aesthetic experiences offered by modern art.[18]

However, these general points do not enable us to register the temporary gallery as the improvised and uncertain encounter we might still insist upon here. For it does seem that rather than being especially attuned to the well-advancing technologies of gallery design and display, the new gallery was more a case of making-do, of coping with given circumstances and restrictions of space. In fact, a sense of the 'DIY' becomes vividly apparent in this retrospective account from Thomas Bodkin, who assisted Lane with what was clearly an extensive renovation of Clonmell House prior to its opening.

> There was a great deal to be done; rooms to be papered and painted, floors to be stained, crates to be opened, screws to be driven, pictures to be hung, furniture to be arranged and photographs to be taken ... The old Georgian rooms, with their fine stucco ceilings, mahogany doors and marble mantle pieces, were beautified not only by the great collection of pictures, but by a few choice eighteenth-century couches and chairs, and side-tables on which Lane had set porcelain bowls and bronze vases full of flowers and foliage.[19]

What is denoted by the term 'beautified' here is not only the filling-up of an empty shell and of giving it another, unique identity through the display of work. It posits also the orchestration of a naturalised encounter, that is one historically concordant, between its architectural structure and interior decoration, notwithstanding the works themselves. The interior's given shape and available space, its renovation and beautification have significantly imposed themselves upon Lane's intentions. The question that is raised by this is whether this significantly hampered or interfered with Lane's intended orchestration of meaning through the display of the collection. For our concerns, however, this is an open question that begins to position the role of architecture, and of Georgian architecture in particular, as an important one to the inauguration of a permanent gallery.

By 1912 the search for a permanent site had gained momentum. Many were suggested by Lane, his supporters (who by late 1912 had organised themselves into a committee), and in the Dublin press. However, only two appeared to meet enough of Lane's criteria for him to ask the architect Edwin Lutyens to prepare designs.[20] The first, for St Stephen's Green, a relatively new public space in Dublin, was mocked up in late 1912 into colour illustrations of the gallery in its setting (rather than plan and elevation designs) by William Walcott, the architect's assistant. However, the scheme contravened the terms set out by the Green's benefactor, Lord Ardilaun, and was quickly rejected. The second, the bridge scheme, was also depicted in its setting, and these images were again done by Walcott from Lutyens' initial sketches (see figure 8). This scheme became public in January 1913 and was put forward by Lane to the Dublin Corporation for approval.[21]

The design for the bridge gallery by Lutyens appeared to be a basic 'H' plan of two parallel blocks on the north and south quays – intended to be the main gallery spaces – linked by a gallery-corridor mounted into the main arch. Over the arch was a colonnaded walkway. The building was to be entirely faced with stone, with aediculed niches on each gallery end and statues mounted atop. The bridge gallery's position was to lay between O'Connell Bridge and Grattan Bridge and to replace the Wellington (or 'Metal') footbridge, the pedestrian walkway universally derided at this time as an eyesore, unpopular both for its advertising hoarding and toll charge. The bridge gallery's provision of a walkway thus retained the pedestrian access currently offered by the metal bridge, but Lane had no plans to continue the toll.

Described as a 'Palladian bridge', Lutyens' scheme drew obvious comparisons with other bridge buildings in Europe; the Ponte Vecchio, the Rialto, and the Pulteney Bridge in Bath.[22] The design was part of a dramatic shift in Lutyens' architectural practice, marking his turn away from predominantly domestic commissions and a move towards, if not a practice run for, the high classicism he was soon to pursue in New Delhi.[23] However, as far as gallery design was concerned there was little to remark on here. Through its development across Europe in the nineteenth century the museum and its requisite classical order had become a standard exercise of architectural training. However, the classicism of the scheme was clearly intended to harmonise with and augment the other notable buildings on Dublin's riverfront: the Four Courts and the Custom House, both built in the late eighteenth century at the height of architectural development in the city. The gallery served to punctuate the intervening space between these buildings, occupying as they do opposite ends of the north side of the central riverfront section.

That the bridge scheme was intended to make this connection to Dublin's Georgian past, via the reintroduction of Palladianism, may be confirmed by Lane's remark, cited by Lady Gregory, that the scheme's importance was because '[i]t is more than a hundred years since a good piece of architecture has been raised in Ireland.'[24] In fact, Lane's words appeared to dovetail with a wider discourse about the city's surviving architecture, and how this projected Dublin's past glory and high national status. As the newly formed Georgian Society pointed out in 1909,

this heritage could show to the early twentieth century that Dublin was 'not a provincial town, but a fading capital. The great public buildings of the eighteenth century which are its glory make that fact evident.'[25] Echoing this view a Dublin Corporation guide from around 1913 stated of the Georgian legacy: 'There is no better index of the high position which Dublin once held in European social life.'[26]

Not surprisingly, much of this regard for the Georgian period was shared by the architectural and building professions of Dublin, although there was a good deal more historical rigour in its praise. In late March 1913, for example, the *Irish Builder and Engineer* wrote of the 'Georgian' era as one benefiting from a more systematic improvement, especially by the Wide Streets Commissioners set up in 1757. However, development of the city from the nineteenth century was, it continued, 'marked by haphazard, and too often ignorant methods, at variance with the principles of town planning, artistic feeling and, indeed, common sense.' Yet it was pleased to note that things were changing, observing how recently town planning 'has become fashionable ... awakening [a] sense of civic responsibility.' All the same, it considered Lane's bridge scheme an unsatisfactory and costly solution to the city's improvement. In a remark clearly emphasising its more robust technical and practical expertise, it stated: 'Everyone with the least practical knowledge knows that of all the structures in the world, a bridge is one of the most difficult things to build beautifully, and nothing will mar the beauty of the river as an ugly bridge.'[27] The bridge scheme was evidently a major factor in crystallising the renewed interest in the city's architecture, but it was also somewhat inevitable that Lutyens' design would draw such a cautious response from Dublin's architects. In the first instance, an implicit criticism of their collective competence had been raised over what was deemed Lane's importation of an English architect. As far as alternative schemes were concerned, however, the *Irish Builder* placed its support in a plan for a new bridge of a more conventional order, forming part of a new highway to run north and south of the River Liffey, that had been unveiled in the *Irish Times* earlier the same month (see figure 11).[28] In this version, a new gallery was sited on the southern section of the new road, forming part of a much-needed redevelopment of slums in the Temple Bar district. The accompanying article to the plan put forward its advantages over the Lane scheme – primarily that it avoided the obstruction to the view of the river the latter would cause, 'however beautiful in itself'. It continued, '[w]e seek new open spaces and vistas. Let us at all events preserve the old ones.' The bridge gallery, it proclaimed, would spoil 'the most beautiful vista we possess' when on O'Connell Bridge at sunset.[29]

Although this alternative scheme was ostensibly attuned to the immediate pleasures of the city, we can note how the bridge scheme was prompting and promoting an essentially imaginary or fictional dimension to the discourses about Dublin's architecture; the present need to give architectural shape to the future was coupled to a vision of the past. As if prompted by this new trend for envisioning, the supporting article to the highway scheme took the reader on a literary journey through past, present and future time. Travelling along the new highway from Henry Street

A CENTRAL HIGHWAY FOR DUBLIN.

11 'A central highway for Dublin', *Irish Times*, 19 March 1913

to the north of the Liffey to Dame Street in the south, it pinpointed by turns the fallen grandeur, the current eyesores and their potential for improvement. To the north and south of the river, it told the reader, the new highway scheme would cut a significant channel through some of the city's typical slum tenements which were evidence only of a 'departed prosperity' and should thus be pulled down.[30] The residents of these tenements were assured by the author that their eviction would only be a temporary one, with the prospect on completion of living in a new street with a gallery of modern art facing them. Imaginary indeed.

All the same, what this article made clear was that the sense of Dublin as a 'fading capital' with a distinguished past was largely to do with the existence of slums in such close proximity to, and yet of the same historical period as, Dublin's venerated public buildings. In complete contrast to the architectural professions, however, the Georgian Society had mounted a campaign to conserve what it saw as that era's equally prestigious domestic architecture. Although these buildings formed much of the infrastructure of the slums, the Society evocatively described them as plain-fronted dwellings withholding interior decorative secrets.[31] Recognising their imperilled state, it set out to record these buildings through a lavishly produced photographic archive, published in five volumes over the period 1909 to 1913. The Society hoped to raise general awareness to the plight of this disappearing heritage, and also to induce those occupying such a building 'to take care of it'.[32] Clonmell House, Lane's gallery in Harcourt Street, was featured in volume four of the series.[33] As we noted earlier, Lane had indeed taken care of Clonmell House, and in this sense the temporary gallery was more than a sympathetic response to the Society's project; it exemplified the kind of conservation it had in mind. However, this form of occupancy was clearly untypical and the Society projected its anxieties and actions on to houses that were 'once occupied by a wealthy aristocracy' but were now converted into warehouses or tenement housing for the poor.[34] The first volume of the series contained a number of photographs of this type of occupancy, focusing upon the resulting neglect to the exterior façades.

These emerging connections between Dublin's Georgian architecture, Lane's venture, and the Georgian Society have important consequences for any interpretation of what the gallery was trying to achieve as an institution. In the first instance, it is important to point out that the Georgian Society was a largely Anglo-Irish concern. Its membership had a high proportion of titled gentry, professionals and officials with such connections or backgrounds. In fact, we might view its formation as part of the Anglo-Irish community's growing confidence in the assertion of its interests and identity at this moment. This confidence was one primarily established through the available range of artistic and cultural practices, and Lane himself, of course, was an important if not catalytic figure in this.[35] Therefore, if Lane's temporary gallery and his proposal for a permanent scheme can be read as an effort, by turns, to renovate and prospectively enhance Dublin's former high standing as a capital city, they did so as vital and influential contributions to a broader Georgian revivalism with architecture as its prime focus. This interest in the Georgian period

demonstrated not just a flourishing set of interests and organisational capacities within the Anglo-Irish community. More crucially, it served to reconnect with their once esteemed position in European society, through which their now often threatened sense of belonging to the Irish nation could be verified or authenticated.

To do so, however, the term Georgian was stretched to rather paradoxical limits, although significantly this was where a certain symbiosis occurred between architecture and nation. In its more conventional usage, as now, Georgian denoted both the succession of British sovereigns between the early eighteenth and the early nineteenth century, and also the architecture of this period through all its manifest styles. For Dublin and Ireland in general, however, the Georgian period was (and is) considered as a distinct architectural tradition from that in England.[36] In Dublin from about the middle of the eighteenth century there was massive reconstruction, including the building or rebuilding of major state institutions and the laying and widening of some of its main thoroughfares and squares. Along these latter were built the prestigious private houses of Dublin's new elite, like Clonmell House. However, as a signifier for Dublin as the *capital* of a nation rather than of an occupied marginal backwater, Georgian brought forth a more specifically political but also possibly somewhat idealised reference to the period of parliamentary independence from England in the decades immediately before the Act of Union of 1800. This was a period moreover marking the pinnacle of the Anglo-Irish Ascendancy's power and achievement. Therefore, if 'Georgian' conventionally meant both British sovereignty and its architecture, in Ireland it somewhat paradoxically served as the (mis)name for an independent architectural tradition that was implicitly connected to a period of relative national independence, and a formative era of what has been termed the Anglo-Irish tradition.[37]

What I have been suggesting, then, is that once the discussions about a permanent gallery gathered momentum around the bridge scheme, the ancillary or merely contingent factor of the Georgian architecture of Clonmell House became a primary point of identification for those in Anglo-Irish circles. Both the need for and partiality of this identification without doubt registers the sectarian conflict over the national question and its intensification in this period. Sectors of the Catholic nationalist movement began to argue a case for militant action. For them, even with the reintroduction of the Home Rule Bill in 1912, a parliamentary course to independence seemed unlikely, especially in view of northern Unionism's own increasing militancy with the formation of the Ulster Volunteer Force in January 1913.[38] If Lane's 1908 Gallery had avoided any serious controversy, the divisions between cultural and political nationalist strategies and beliefs had in fact already been signalled by the riots at the Abbey Theatre in 1907 at the opening of J. M. Synge's *Playboy of the Western World*. In *The Leader*, a Catholic nationalist journal, Lane and his supporters had taken up the mantle of the 'playboy gang'.[39] However, what the gallery scheme brought specifically to the conflict over Ireland's national future was the way architecture could provide a key figural resource across the

three temporal dimensions of nationhood: the future always drew upon identifica-
tions with the past and present, and a reference to national status could always be
deciphered or elicited in these.

By early 1913, the nationalist party Sinn Fein was among many voicing its oppo-
sition to the bridge scheme. Surprisingly, they were not against Lane's activities in
principle. In fact, they thought it reasonable that he should ask for a gallery to
house his pictures. Like the architectural professions, however, Sinn Fein consid-
ered the present scheme would block 'one of the finest views in Dublin'.[40] It seemed
that the city's Georgian heritage was not something to reject out of hand, but cru-
cially here it was part and parcel of the aesthetic pleasure the city offered to the pre-
sent, not for its historical identification. Yet the measured tone of Sinn Fein's
editorials was not always evident elsewhere in its journal. For one commentator,
Dublin's still visible and imposing Georgian history was viewed with contempt. An
abhorrent connection to Ireland's domination by England lived on all over the city
in the form of street names after leading Ascendancy figures: 'the Harcourts,
Westmorlands, Dorsets, Rutlands, and all their tribe, commemorations of men
who, insignificant in themselves, and workers of evil to the country, are mental and
moral disfigurements of the Irish capital.'[41] The call here was for the Dublin
Corporation to take hold of its new powers and alter these deformations. But this
practical demand towards achieving self-definition, to erase one set of names in
favour of another more meaningful and appropriate to the national cause, was also
clearly mobilised by a belief that the city was already and always the capital of
Ireland. Not in a nominal or statuary sense however, nor even in precise historical
terms. It is clear from the notion of the city's 'disfigurements' that this plea arose
from yet another but fundamentally different imaginary order of conviction. In this
case, Dublin as the capital of Ireland defined a past that was *prior* to the invasion and
crippling of the nation. That is, before its material existence was disfigured by
colonisation, where such a disfigurement included the violence of a re-naming that
was complicit with its rebuilding. Moreover, in recognising this the article attached
such physical and still readable evidence to an identifiable grouping: the 'tribe' of
the Anglo-Irish. Of course, the importance placed on naming and re-naming here
does suggest a pragmatic acceptance of Dublin's existing architectural order. But
the ideological connections between a regard for the Ascendancy era in all of its
manifestations and the range of unionist positions seen or thought to be held by the
Anglo-Irish over the national question would have been explicit enough. In effect,
the co-existence of those street names with Georgian architecture defined a com-
peting symbolic space to the demands of nationalist discourses. And by August,
Sinn Fein's leading articles were coming round to the view of this earlier commen-
tator. The gallery was now a mere advertisement for Lane and his 'free gift', and his
insistence on the scheme going ahead was effectively an insult to 'the capital of an
ancient nation and a dignified people.'[42]

The scheme, then, was extending an already volatile conflict into one about the
control of the symbolic and material spaces of Dublin's architectural order. And

this was not just a battle over names. On the city's main thoroughfares and squares colonial monuments or ones identified with the British occupation, such as Nelson's Pillar on O'Connell Street and the statue of Queen Victoria in front of Leinster House, unveiled as late as 1908, were symbolically and physically competing for space with nationalist monuments: for example, statues erected to the memory of Daniel O'Connell in 1870 and more recently to Charles Stuart Parnell, completed in 1911. Within the context of such a divided space and the polarisation of political identities to their most reductive, convenient forms, the simple aesthetic pleasures both Sinn Fein and others had derived from the city's vistas perhaps could not remain independent of such an insistence for national meaning.[43]

In a certain way this may be confirmed by a closer examination of Walcott's image of Lane's proposed gallery (see figure 8). This kind of image (known as 'rendering'), forming part of architectural and civic envisioning, had not quite become the professional convention it now is and was usually reserved for larger projects.[44] The image of Lutyens' design must clearly have held a strategic place within the inaugural process, functioning not only as a presentation of the architect's ideas but also as the primary instrument of persuasion. The persuasive force of the image is that it attempts to naturalise the gallery within its proposed setting, whereby the city is visualised at work around it in order to show how it would appear as a familiar part of Dublin life. Therefore, it is important to register the temporal play occurring here. By depicting the gallery within a spectacle of the city's recursive daily patterns, what the image attempts to do is to naturalise its *future* imposition upon the city as an architectural form. The persuasive intention of this presentation (that is, presenting the future as present) was an effort to allay the gallery's impact on the city as an irreversible unsettling of the environment.

However, the question of just how persuasive Walcott's image was is possibly answered by a certain ambivalence or vagueness about it. The classicism of the scheme may have been entirely appropriate to the requirements of a public gallery (even if in bridge form it was not), but it is interesting to note how Walcott's image leaves the gallery's statuary, the sculptures dramatically perched on top of the two main wings, so vaguely delineated. Evidently, Walcott was following Lutyens' own sketches (see figure 12). Here they are the merest squiggles, entirely complementary perhaps with the perfunctoriness of the requisite but unspecified classical forms, and do not disclose any clue as to the building's function or siting. The more important point here, however, is that there was nothing in the classical order of the scheme that might have been symbolically persuasive in national terms. At such a decisive moment, its future imposition was not symbolically partisan to the Irish nation. And it is important to note how widespread the imagery of Irish nationalism was by this time. The search for a symbol that would instil a national consciousness in the Irish people against their oppressors had been central to the emergence of the Irish literary revival, and especially to the early poetry of W. B. Yeats. By the second decade of the twentieth century, however, a whole range of popular Celtic and Irish imagery, emblems and iconography was utilised by various

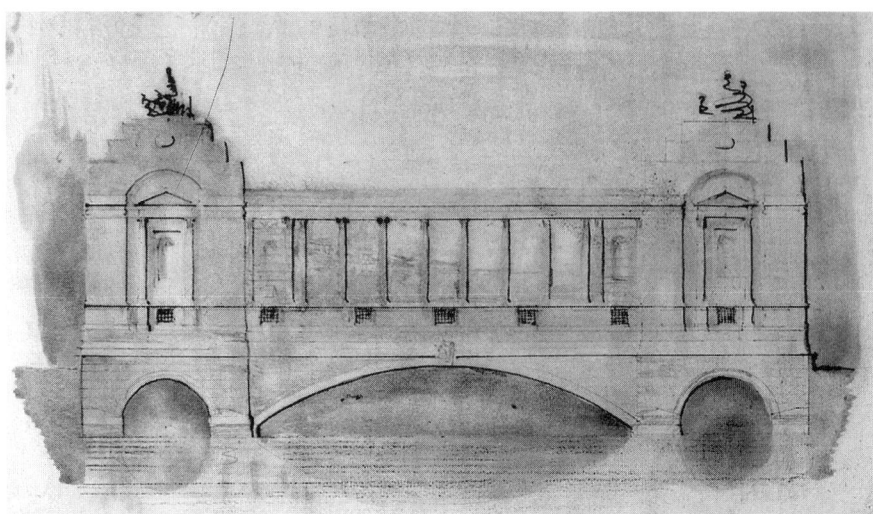

12 Edwin Lutyens, design for an art gallery across the river Liffey, Dublin, 1913

Arts and Crafts practitioners, as well as by many commercial enterprises and civic services. In fact, it would have been difficult not to confront this on a daily basis in Dublin's urban centre.

For symbols to be national, however, they have to be, as David Lloyd has defined them, 'consubstantial with the nation which they represent'.[45] As a sub-category of the symbol in general, there has to be an intrinsic identification between signifier and referent, a harmonious and self-evident relation between the image or object and what it means. Therefore, in the increasingly polarised conflict over Dublin's architectural order, Lutyens' perfunctory and notionally pure classicism remained outside this symbolical insistence on a national frame of meaning and reference. Like the modern art Lane was importing and whose value (both aesthetic and monetary) remained at issue in the course of the dispute, classical architecture pointed again to an outside source, an unwarranted importation, like Lutyens himself was seen to be. On the one hand, this was partly raised by the scheme's emerging identification with the Georgian era, but on the other its classicism would also have been seen as complicit with the continuation of British occupancy through major new building projects such as the government buildings on Upper Merrion Street, designed by Aston Webb and Thomas M. Deane, and begun in 1904.

What we have suggested here is that the dispute over Lane's gallery contributed to and made manifest through architecture the entrenchment of identity and symbol across race and religious difference. In fact, with respect to this, what the bridge scheme confirmed was that nationalism's insistence on national meaning had divided irredeemably between cultural and political strategy. Architecture had helped to define a conflicting language about the spatial and material futurity of the nation, not the mere housing of a new cultural institution.

One particularly vivid way in which these points can be comprehended is through W. B. Yeats' poetic contributions to the Lane dispute. If the support from Yeats has been especially important in recent accounts for the ascription of Lane's project to cultural nationalism, then it is of interest to note how this period has been seen to mark a change in Yeats' own poetic practice, one in which he appeared to lose ground to others over the very power to define the terms of the national symbol.[46] Contributing to this change was his increasing sympathy for the Anglo-Irish tradition through his admiration for Lady Gregory and Hugh Lane. But Yeats' loss of symbolic relevance can also be measured by the character of the metaphors and symbols he brought to the relation between architecture and nation.

His poem 'The Gift' appeared in the *Irish Times* in January 1913 just as Lane's bridge scheme was about to go public. The poem was an act of persuasion by Yeats addressed to an unnamed wealthy Irish patron over his equivocal approach to the proposed gallery, and especially his notion of public opinion deciding its fate. Yeats pitted the values of 'Biddy' and 'Paudeen' – derogatory terms in Dublin parlance for the poor, philistine, or rabble – against the legacies of Renaissance Italy. Italy itself was depicted as a 'turbulent' country, but one that had drawn 'Delight in Art whose end is peace / By sucking at the dugs of Greece.' However, in seeking to emulate this Greek classical heritage, Italy's renowned Dukes had not sought the opinion of 'th' onion sellers' or 'shepherds' when coming to employ the likes of the architect 'Michelozzo'. Thus, in its final lines the poem made a direct and impassioned plea to the patron:

> Look up in the sun's eye, and give
> What the exultant heart calls good
> That some day may breed the best
> Because you gave not what they would
> But the right twigs for an eagle's nest.[47]

So what are the *right* twigs here, as opposed to the wrong ones? Yeats' final metaphor of the eagle's nest added a supplementary if not altogether compatible metaphor to those drawn from the Renaissance. But this moral imperative appears not to make a plea for patronage alone. Rather, it invoked the values enshrined in the act of building a modern art gallery. In essence, twigs are the building stones that structure the architectural order of the nest, and, as the achievements of the Renaissance proved, the building of monuments in stone for art would offer a legacy to the future. Therefore, if the nest is to be a built structure in which to breed the next generation, it serves also as a metaphor for the building of the nation. However, if this is so, what then serves to link Italy and the eagle is a recourse to things identified by their 'height' – architecture, intellect, social class, the nests of birds of prey! – in order to invoke an essentially *aristocratic* vision for the nation. Such a 'height' evidently unfolds on to the lessons offered to Dublin (and the patron) by the gallery and its classical order. For the Renaissance had proved its rightness to following generations, and thus Yeats, Lane and Lutyens were laying claim to a higher or the 'best' knowledge and offering it to Ireland's future.

On the face of it, then, it was hardly surprising that Yeats' imagery might be countered in the Dublin press. A lampoon in the *Saturday Herald* in April 1913, for example, was not a direct reply as such but it certainly brought forth a more localised scaling of heights (see figure 13).[48] By placing a classically ordered gallery on top of Nelson's Pillar in O'Connell Street the illustrator's primary intention was to resolve comically that widespread objection raised to Lane's scheme – its potential obscuring of Dublin's most picturesque views. But its sense of ridicule has also unwittingly replied to what was *wrong* about Yeats' architectural metaphor of the nest as far as political nationalism was concerned. For the cartoon poses the question of the gallery's physical taking up of space in the city, its future imposition. However, in doing so it was not by chance that it depicted the gallery hiked to the top of what was seen as one of the many enduring monuments to colonial occupation. Nelson's Pillar, like the range of Yeats' metaphors, was brought in from another land; it belonged to another time and place whose history was essentially foreign to the insistent symbolic focus upon the Irish nation. In this sense, the lampoon was able to achieve its critical, satiric bathos only by performing on the same rhetorical dimension of architectural and national envisioning inaugurated by Walcott's images of Lutyen's designs. That is, the image confirms that the gallery's inauguration as a future architectural imposition upon the city appeared inseparable from, but ultimately antagonistic to, the question of its symbolic significance for the inauguration of an independent Irish state.

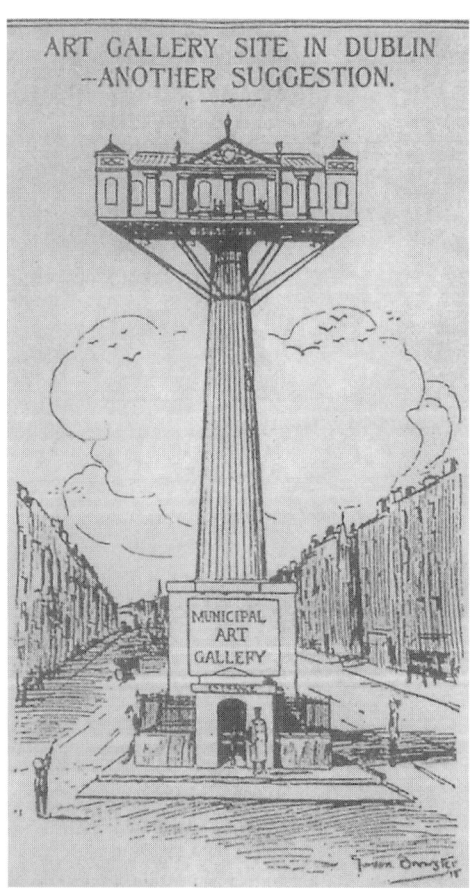

13 Gordon Brewster, 'Art gallery site in Dublin – another suggestion', *Saturday Herald*, 12 April 1913

Of course, much of the blame for the final rejection of Lane's scheme in the dramatic circumstances of September 1913 has been laid squarely with the Dublin businessman William Martin Murphy. Murphy attacked both Lane and the Trade Union leader Jim Larkin by utilising his newspaper, *Irish Independent*, to vilify each of their causes in turn: gallery and transport strike. The decisive blow to Lane's cause was the coverage in his newspaper of the collapse of old tenement buildings in Church Street in the heart of Dublin, which killed seven people. The story, as it was relayed, moved rapidly from one of reporting the buildings' collapse and

the funerals of the victims, to an investigative exposure by news photographers of the plight of Dublin's poor, living in the Georgian slums, that at the same time sought to outline the immoral extravagance of Lane's gallery scheme.[49] Yet even in the case of the Church Street disaster we can be aware of a figural manipulation by the *Irish Independent* of images of Dublin's more perilous architectural infrastructure. Moreover, it is one that might certainly be seen to join Lane, Lutyens' scheme, the Georgian Society, Sinn Fein, and Yeats in the conflict over the definition of the city's past, present and future as this was manifest in the meeting of architectural form with the conflict over Ireland's national status.

Notes

I would like to thank Allan McLeod, Chris Stephens, Chris Stone and Michaela Giebelhausen for their comments on earlier versions of this text.

1 This was the Staats-Forbes collection. Lane's exhibition was held at the Royal Hibernian Academy, Dublin from November 1904.

2 Lady Gregory, 'A stone of the building', *Freeman's Journal*, 13 December 1904; quoted in Jeanne Sheehy, *The Rediscovery of Ireland's Past: The Celtic Revival 1830–1930* (London: Thames and Hudson, 1980), p. 107.

3 See Joseph V. O'Brien, *'Dear Dirty Dublin': A City in Distress 1899–1916* (Berkeley and London: University of California Press, 1982).

4 F. S. L. Lyons, *Culture and Anarchy in Ireland 1890–1939* (Oxford: Oxford University Press, 1979), p. 75. See also Sheehy, *The Rediscovery of Ireland's Past*, p. 111. For another account, see Hugh Lane Municipal Gallery of Modern Art, *Images and Insights* (Dublin: HLMGMA, 1993), pp. 23–9.

5 Isabella Augusta Lady Gregory, *Hugh Lane's Life and Achievement with some Account of the Dublin Galleries* (London: John Murray, 1921), p. 45.

6 The 1908 temporary gallery is a case in point. A special act of parliament (passed in 1911) was needed for the Dublin Corporation to raise money from taxation to support the project. This provision had been available to mainland local authorities since the 1840s, followed by further acts in the 1890s.

7 There is some agreement about these developments by historians of this era, and a number have included the Lane controversy in their accounts (e.g. Lyons, *Culture and Anarchy*; O'Brien, *'Dear Dirty Dublin'*. See text for other references). My own approach here, however, is to characterise what was irreducibly brought into play by the Lane dispute.

8 Declan Kiberd, *Inventing Ireland: The Literature of the Modern Nation* (London: Vintage, 1995), p. 368.

9 The phrase is from Thomas Bodkin, *Hugh Lane and his Pictures* (Dublin: Stationery Office, 1956), p. 4. It may be possible to examine Lane's initiatives within the wider philanthropic provision of museums in Britain from the late nineteenth century, but I would argue that philanthropy in Ireland, inevitably structured by colonialism, raises a radically different set of issues.

10 See especially Margaret O'Callaghan, *British High Politics and a Nationalist Ireland: Criminality, Land, the Law under Foster and Balfour* (Cork: Cork University Press, 1994).

11 See especially Mary E. Daly, *Dublin, the Deposed Capital: A Social and Economic History 1860–1914* (Cork: Cork University Press, 1984), pp. 277–319.

12 Lyons, *Culture and Anarchy*, pp. 27–83. Lyons refers to the fusion of different 'cultures', i.e. the different religious/political communities of Ireland. This clearly over-essentialises identity and their divisions, and what I would insist upon here is a more temporally specific production of and reliance upon 'essential' identity.

13 Terry Eagleton, *Heathcliff and the Great Hunger: Studies in Irish Culture* (London: Verso, 1995), p. 300.

14 Hugh Lane, 'Prefatory Notice', in Municipal Gallery of Modern Art, *Illustrated Catalogue with Biographical and Critical Notes* (Dublin: Municipal Gallery of Modern Art, 1908), pp. vii–ix. In this catalogue, Lane referred to three separate 'representative' national collections on display in the main rooms: French, Irish and British painting. There were additional displays of drawings, prints and sculpture, and a series of portraits of recent and living Irish personalities hung on the stairs.

15 Lady Gregory, *Hugh Lane's Life*, p. 101.

16 'Dublin Municipal Art Gallery', *Irish Independent*, 21 January 1908, p. 7.

17 See Giles Waterfield (ed.), *Palaces of Art: Art Galleries in Britain 1790–1990* (London: Dulwich Picture Gallery, 1991), pp. 117–19.

18 Such a juxtaposition was utilised by later collectors of modern art. See Andrew Stephenson, '"An anatomy of taste": Samuel Courtauld and debates about art patronage and modernism in Britain in the inter-war years', in John House *et al.*, *Impressionism for England: Samuel Courtauld as Patron and Collector* (London: Courtauld Institute Galleries, 1994), pp. 35–46; pp. 36–7.

19 Bodkin, *Hugh Lane*, pp. 18–9.

20 Lutyens had worked previously for Lane, laying out the garden of his house in Chelsea, London. They appear to have cemented their friendship when both were hired in 1912 by Lady Florence Philips (as architect and curator respectively) to help found a new art gallery in Johannesburg, South Africa. On Lutyens and Lane, see Jane Brown, *Lutyens and the Edwardians: An English Architect and his Clients* (London: Viking, 1996), pp. 145–58.

21 The Corporation agreed only to provide £22,000 towards the cost of building, the total of which was estimated at £45,000. From this time until September it debated the approval of the bridge site.

22 See Christopher Hussey, *The Life of Sir Edward Lutyens* (London: Country Life Ltd, 1950), pp. 231–4.

23 Lutyens was officially appointed to work on the Viceroy's House in New Delhi in January 1913.

24 Lady Gregory, *Hugh Lane's Life*, pp. 107–8.

25 The Georgian Society, *Records of Eighteenth-Century Domestic Architecture and Decoration in Dublin*, 5 vols (Dublin: Dublin University Press, 1909–13) vol. 1, p. xi. The Society was formed on 21 February 1908.

26 Dublin Corporation, *Dublin Ireland's Capital: The Official Handbook to the City of Dublin* (Dublin: Dublin Corporation, c.1913), p. 63.

27 Editorial, 'The improvement of Dublin', *Irish Builder and Engineer*, 55:7 (29 March 1913), pp. 200–3; all quotations p. 200.

28 *Irish Times*, 19 March 1913, p. 7.

29 E. A. A., 'Modern art and a modern highway', *Irish Times*, 19 March 1913, all quotations p. 7. Another scheme appeared later in the year. See *Irish Architect*, 30 August

1913, p. 383. On these schemes and Lutyens' bridge design see also Sean Rothery, *Ireland and the New Architecture 1900–1940* (Dublin: Lilliput Press, 1991), pp. 49–53.

30 *Irish Times*, 19 March 1913, p. 7.

31 Georgian Society, *Records*, vol. 1, p. xi.

32 *Ibid.*, p. xii.

33 *Ibid.*, vol. 4 (1912), pp. 34–7. Lane was a founder member of the Society.

34 *Ibid.*, vol. 1, pp. xi–xii.

35 See, for example, the 'Irish Art' show held at the Whitechapel Art Gallery, London, in 1913. This show built upon Lane's earlier efforts to construct a national identity for the arts. Lane was on the organising committee and the Georgian Society exhibited a collection of its photographs.

36 See K. C. Kearns, *Georgian Dublin: Ireland's Imperilled Architectural Heritage* (Newton Abbot: David & Charles, 1983), especially pp. 17–50. Also Irish Georgian Society, *Some Irish Georgian Architecture 1715–1830* (Dublin: Irish Georgian Society, 1970).

37 See J. C. Beckett, *The Anglo-Irish Tradition* (Belfast: Blackstaff Press, 1976), also Terence De Vere White, *The Anglo-Irish* (London: Victor Gollancz, 1972).

38 For a recent assessment of this period see, Paul Bew, *Ideology and the Irish Question: Ulster Unionism and Irish Nationalism 1912–1916* (Oxford: Clarendon Press, 1994).

39 See *The Leader*, 13 September 1913, p. 108.

40 Editorial, *Sinn Fein*, 15 January 1913, p. 1.

41 'On street names', signed 'Dubliner', *Sinn Fein*, 15 January 1913, p. 3.

42 *Sinn Fein*, 9 August 1913, p. 5.

43 On the subject of nationalism's extreme demand upon meaning and reference, see David Lloyd, *Nationalism and Minor Literature: James Clarence Mangan and the Emergence of Irish Cultural Nationalism* (Berkeley and London: University of California Press, 1987).

44 Leavitt Dudley, *Architectural Illustration* (New Jersey: Prentice-Hall Inc., 1977), pp. 3–9. The plan and elevation of the design have not been published in the standard works on either Lutyens or Lane. To my knowledge they do not exist, and this suggests perhaps that Lane was already cautious about Lutyens' time and his own expense in hiring him, should the scheme not be approved.

45 David Lloyd, *Anomalous States: Irish Writing and the Post-Colonial Moment* (Dublin: Lilliput Press, 1993), p. 71.

46 The power to invoke the national symbol passed from the literary/artistic project to forms of militancy and martyrdom, encapsulated in the Easter Rising in 1916. On this see David Cairns and Shaun Richards, *Writing Ireland: Colonialism, Nationalism and Culture* (Manchester: Manchester University Press, 1988), pp. 89–113.

47 *Irish Times*, 11 January 1913. Reproduced in R. F. Foster, *W. B. Yeats: A Life*, vol. 1, *The Apprentice Mage* (Oxford: Oxford University Press, 1997), p. 480.

48 *Saturday Herald*, 12 April 1913, p. 3.

49 See 'Dublin tenement disaster', *Irish Independent*, 4 September 1913, magazine page; 'Funeral of the Church Street victims', *Irish Independent*, 6 September 1913, magazine page; 'Dublin's crying evil', *Irish Independent*, 16 September 1913, magazine page; 'And they still think of art galleries', *Irish Independent*, 17 September 1913, magazine page.

Exhibiting antipodean narratives: tracing the Perth museum site

Hannah Lewi

Some sixty years after the founding of the town-site of Perth in Western Australia, a building was proposed to serve as museum, library and gallery. Speaking in 1891 at the opening of the first stage – a museum housing the state geological collection – the Governor of the colony remarked:

> It is a small beginning, a very small one, I am sorry to say, but I believe that it is a beginning which is to be the forerunner of something far better in the future. The want of a museum in Perth, the capital of the colony is one of the very many wants we feel in a young and growing colony; but I hope in the very near future something may be done to give the people of this colony and to the inhabitants of Perth, a museum worthy of its name.[1]

It was only towards the end of the nineteenth century that the building of such cultural institutions could be realistically contemplated in Western Australia. This new opportunity for civic improvement was precipitated partly by a sudden mineral-driven economic boom, and partly by the very passing of time. Living memory of the founding of the colony and its somewhat lowly beginnings was fading, and history would begin to appropriate the representation of the ever more distant past.

The location chosen for the museum was an elevated site to the north of the predominantly flat town-site of Perth. The site was already occupied by the colonial Perth gaol built in the 1850s. Between 1890 and 1913, the museum wing, an art gallery, a library and further extensions to the museum were completed. From the late 1970s, a 'cultural centre' complex – encompassing a new library, museum and gallery buildings – was added to the expanded site, substantially superseding the colonial institutions. Most recently, conservation strategies have inscribed new significance over this now listed 'heritage precinct'. Commonly organised around the exhibition of power and *civitas*, these waves of architectural and institutional interventions have constructed a complex urban site, which is rare in Western Australia where such architectural juxtapositions and historical dialogues have largely been demolished.

In order to excavate and reveal this temporally collaged site, I have identified – through text, images and plans – a stratified series of spatial traces. Through this mode of architectural tracing, the cultural programmes, institutions and practices of the individual traces, and the erasures and interactions between traces, have been identified and rendered viewable. This spatial and historical tracing has illuminated the coincidence of the collection of museum buildings inspired by the nineteenth century, and the signification of a contemporary heritage precinct. Not only is their physical adjacency explored, for the chapter also proposes more generally that museology and architectural conservation practices engage in common 'techniques' of constructing, representing and exhibiting time and place.[2]

In this chapter, I explore this juxtaposition of colonial and post-colonial techniques of representation to investigate the process of making significant places from antipodean space. Michel de Certeau elucidates this ongoing relation between 'spaces' and 'places'. Significant places, suggests de Certeau, are inscribed from spaces through the collective telling and showing of stories.[3] In this sense, the colonial institution of the museum is considered as one important apparatus in the transformation of antipodean spaces into recognisable places, within the dominant frame of imported imperial narratives. And, as will be elucidated in this study, contemporary conservation continues to preserve, to reinvent and represent these contextual narratives in order to confirm our contemporary notions of significant place.

The making of places is explored here through the detailed case study of the Perth museum site, and through two larger thematic concerns. The first theme explores the antipodean condition I will call *post terra nullius*, describing the invention of European places within the perceived vacuum of imperially constructed Australian spaces. The second theme concerns the proposition that both museology and heritage practices engage the common technique of 'exhibitionary narratives', which collect, arrange and exhibit 'real' things (artefacts or buildings) and historical stories, thereby composing an *aide memoire* to the occupation and signification of place. These thematic threads will be briefly elaborated before proceeding to a detailed study of the Perth museum site.

Post terra nullius

British colonisers of the Australian continent fabricated the legal (yet fictitious) notion of *terra nullius* to assert that the land possessed no recognisable indigenous prior ownership or permanent settlement. Colonisation was thus fundamentally figured on forgetting, and built on the misrepresentation of a blank and unknown space.[4] This spatial–cultural vacuum appeared a necessary invention upon which to justify and inscribe the marks of occupation. In referring to a condition of *post terra nullius*, I am suggesting here that the imperial process of negotiating and occupying an empty terrain – seemingly devoid of all recognisable natural, cultural or historical precedents and narratives – went far deeper than its legal implications and persisted far longer than the first stage of colonial settlement.

The first campaign in the process of occupying the antipodean void was predominantly a visual one. The sight lines of European exploratory vision cast a projective trace on the indigenous landscape. Through exploration, as Paul Carter and Simon Ryan have elucidated, antipodean space was first described and became known within a European frame of vision.[5] Subsequent colonial campaigns employed an armoury of place-making techniques including urban planning, and the building of civic institutions attempted further to counter the cultural vacuum. The construction of monumental buildings such as the Perth museum, gallery and library, around the turn of the nineteenth century, were crucial in the effort to invent and represent recognisable and 'authentic' images of a new city located in the collective of Empire. Yet, at this time, the colony's anxiety over its isolated setting and short history was quelled, not so much by commemorating indigenous or parochial settler identities, but more through the importing of imperial narratives and imagery. The Australian art historian Bernard Smith writes of antipodean cultural colonisation: 'the real nomads came from abroad, and brought their placeless imperial history with them.'[6] Predominantly transported representations thus served to 'anchor the wandering heart and mind'.[7] Illuminating the fragility of the endeavour of collecting Australian cultural narratives, David Lowenthal has commented:

> For Australia to have museums at all strikes some as a contradiction. It seems perverse to secure and display legacies in this forward-looking land, to curate the past of a continent scarcely scarred by history; an antipodean oxymoron.[8]

Despite such claims of perversity, the Perth museum precinct did successfully compose an important site of locally significant buildings and collections, which contributed to the mythologising of place until well into the twentieth century. An extract from Randolf Stow's novel *Merry-Go-Round in the Sea* evokes the perceptions of Perth in the 1940s through the eyes of a small country boy:

> It's really only about twenty years older than Geraldton, his mother said. But that meant nothing, emotively Perth was ancient, an ancient civilisation. Soot-darkened buildings proved it, and the existence of a museum, and the fact that it was a seat of government. And it was a special city cut off from other cities by sea and by desert, so that there was not another city for two thousand miles.[9]

Within local collective consciousness, the role of the museum precinct in the representing and making of place, has, for the last twenty years of the twentieth century, been seen to have fallen away. In an attempt to counter this decline, in the 1990s the whole site was re-evaluated under the scrutiny of conservation assessments and redevelopment schemes. These urban conservation and heritage strategies turned their attention to the reactivating of memories and stories associated with the museum through the preservation, interpretation and display of its buildings and spaces. This latest inscription on the site may be seen therefore as part of an ongoing campaign of antipodean place-making. In the case of the museum, the site

is being currently reconfigured through the archaeological techniques of classifying, excavating and exhibiting of past traces. And these new techniques are reorientating the recent modernist trace, which drew its inspiration from looking forwards, towards a new backwards-looking vision. Perhaps still caught in the after-effects of *post terra nullius*, conservation strategies are endeavouring to inscribe and reconstruct what are assumed as appropriate and 'authentic' postcolonial representations of place.

Exhibitionary narratives

The second theme of this investigation proposes that museology and conservation practices are closely allied through the shared spatial–visual technique of exhibiting. This is investigated in a number of related ways. Firstly it is proposed that both museum and conservation practices construct 'exhibitionary narratives' of place. Narrative is used here in its broadest sense to imply what Hayden White has described as the translation of 'knowing' into telling and showing in order to convey 'assimiliable structures of meaning'.[10] Characterising the museum or heritage site as a narrativised space, or what Tony Bennett in *The Birth of the Museum* has described as a 'narrative machine or performance', rests on the participatory role of the visitor, around whom historical and cultural stories are constantly re-enacted and displayed.[11] In most traditional museums, visitors are guided through a structured sequence of visual display, and know that they have reached the end of this participatory spatial story when they find themselves at the exit (or perhaps in the coffee shop of today's museum). Similarly, the heritage visitor sees, walks and experiences an authored and narrativised space.

The particular type of narrative created by the museum and heritage precinct is described here as 'exhibitionary'; engaged in the art of display, or the spatial and visual organising and presenting of 'real' things and places. As Mieke Bal elaborates, the *raison d'être* of the museum is to show the visitor semblances of how it really is. Exhibitionary techniques fortify the belief that what one is looking at must be 'real, true present or otherwise reliable'. 'After all', writes Bal, 'it is visible, you see it there, before you'.[12] As many commentators have described, the nineteenth-century museum became an all-pervasive force in representing the very visibility of culture.[13] It inscribed a new 'way of seeing'.[14] For the museum invited the public to come and look at culture, history and nature in a newly structured and particular way. And the implication that this mode of looking could tell society about itself was, and remains, intrinsic to the power of the modern museum and the heritage site. This technique of exhibition is further reinforced by the authority of the museum or heritage institution to persuade and inform of the veracity of their displays. Thus exhibitionary narratives are both mimetic and diegetic. For as Michael Baxandall describes, visitors seek not only to see things, but also to be told what exactly it is they are looking at, and its functional and historical significance.[15] However, in order to maintain the illusion of the unmediated

presentation and evidential reliability of displayed things and places, orchestra-
tion within the narrative remains largely implicit. In illustration of this point, the
Australian conservation charter, for example, states:

> Doing less to the fabric is favoured, rather than more. The fabric of the place should
> be allowed to tell its own story, even if some of the physical evidence of that story has
> gone. Keeping change to a minimum protects the evidence of history.[16]

Museums and heritage sites thus share the wider modern fascination with the pre-
sentation of the 'realness' and the authenticity of events, places and artefacts.[17] For,
in a similar sense to White's definition of history as the narrativised ordering of real
events of the world, nineteenth-century museums evolved as institutions which
took real things from the world and arranged them in narrativised spatial orders,
either taxonomical or historical. Similarly, contemporary architectural conserva-
tion practices attempt to transform ordinary, chaotic urban spaces and architec-
tures into more recognisable representations of historical narratives.

Another thematic thread of the technique of exhibiting relates more particularly
to the Perth museum. In undertaking a tracing of the site, it appears that modes of
exhibition, or exposure, play an integral role in its spatial and visual structuring.
Techniques of exhibiting – both of showing and conversely of hiding – have shaped
the institutional design of each trace from the gaol, museum, gallery, library to her-
itage precinct. Similarly, techniques of exhibiting have shaped the evolving exterior
design of the whole urban precinct; each architectural aspect undergoing a series of
spatial–visual transformations, at times being hidden from view and at other times
revealed. A final point on the theme of exhibiting is brought to bear in the proposi-
tion that all the institutional traces are commonly organised around the exhibition of
governmental power, *civitas* and improvement. As will be elaborated, the exhibition
of disciplinary control and reform within the gaol was transformed into a different
apparatus of cultural improvement with the building of the museum, library and art
gallery. For the enculturation of populations in the nineteenth century, both ethical
and aesthetic, was achieved not so much through the exercise of direct state
authority, but rather through such cultural institutions or apparatuses, which aimed
to shape the self.[18] Similarly, heritage institutions engage in a kind of contemporary
practice of exhibiting self-identities, memories and collective aspirations.

Trace one: disciplining space

The building of a colonial convict depot and gaol inscribed the first trace on our
site. The Perth gaol was completed in 1856, and it stands as material testament to
an imperial government's resolve to bolster and discipline the faltering Western
colony with the introduction of convict transportation in 1847. Western Australia
was the last major colony to agree to transportation, despite derision and resistance
from the older East, who now saw it as a moral 'stain', able to 'cross deserts, conta-
minate seas, seep its noxious way thousands of miles east and surface on the newly

purged coast of Australia.'[19] However, labour was desperately needed to establish and extend the social and material structuring of the then stunted town, and to finally make an impression on the sandy, local landscape with some confidence of permanence.[20]

The elevated ground just to the north of the town-site of Perth was chosen for the siting of the gaol so that it would be visible throughout the newly formed neighbouring suburbs, its display a stark reminder of the consequences of criminal transgressions. The small and sombre building was designed by R. R. Jewell, Superintendent of Public Works. Jewell had designed a number of English civic institutions including churches, prisons and fortifications, and had worked as clerk of works in the offices of Sir Charles Barry, before emigrating to Western Australia.[21] He was well versed in the eclectic architectural language of nineteenth-century institutional design, and his commissions varied from Gothic Revival to the 'free Italianate style' of the gaol.[22] The building was designed to be constructed of local jarrah hardwood and massive limestone walls, detailed with blank arcading and arched recessed windows (see figure 14).

The building programme was hampered by lack of funds, and during its slow construction public regrets were already reported about the prominence of the gaol, and of the impact of convictism on the previously free settler colony.[23] Yet local police and citizenry were keen to have a gaol completed in central Perth in order to gain a designated place for public executions, which up to this time occurred haphazardly near the river foreshore. Upon completion of the building, a gallows was erected in the gaol yard on the elevated site, and a report from *The Enquirer* of 1855 commented on one of the first hangings:

14 The Old Perth Gaol, 1862

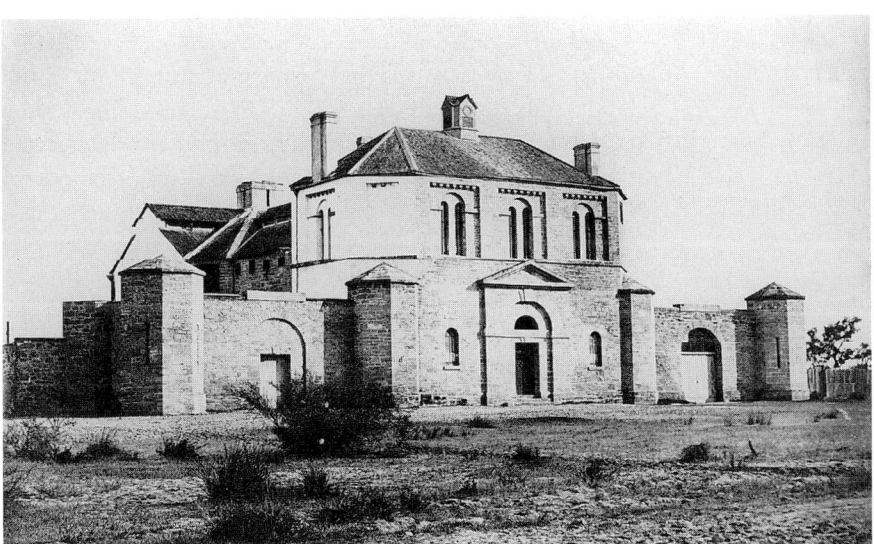

If henceforth criminals are to be executed at the new gaol, more publicity will be given to the punishment than ever, as it is within easy distance of every part of the town. It would have been better on the present occasion if the gallows had been erected at the back of the gaol, as in that case most of the houses of Perth would not have commanded a view of the execution, nor their inmates shocked by the revolting exhibition.[24]

By 1884, due in part to complaints from nearby residents, this macabre spectacle was obscured by the boarding up of the gallows and the heightening of the gaol yard walls.[25]

Through these alterations and other reforms, including the building of isolation cells, the Perth gaol marks a very late transition from the 'spectacle of the scaffold' or the visibility of punishment, to the closed, internally surveyed and isolated institutional space of the panopticon prison.[26] The design of the Perth gaol in fact reflects a hybrid disciplinary type, possessing aspects of these two contradictory models; both the spectacle of public punishment, and strategies of security and surveillance as embodied in the architectural design of prisons and penitentiaries. Jewell's ambitious design (only partially realised) proposed a foreboding central entrance marked by imposing portico and gates and flanked by two octagonal watchtowers.[27] The proposed radial and symmetrical plan – typical of English late eighteenth- and nineteenth-century prisons – configured octagonal cellular rooms and walled yards nested around a central space and bounded by a perimeter wall (see figure 15).[28] This design type, modelled on the English penal system of surveillance and security, was directly translated to the antipodes via English architects posted to the colonies. For example, Henry Willey Reveley – Jewell's predecessor as the colony's architect – was the son of Willey Reveley who had worked directly with Jeremy Bentham in designing and drawing a number of his architectural propositions such as the 'Penitentiary Panopticon' illustrations of 1791.[29]

The architectural instrument of Bentham's 'inspection-house', and its associated disciplinary and social principles, was to weave a powerful thread through the history of nineteenth-century institutional spaces. As Robin Evans and Michel Foucault have elaborated, Bentham envisaged the application of the inspection-model for a plethora of spaces of moral and educational reform including prisons, schools, hospitals, asylums and factories. And it has been subsequently suggested that museums and galleries can be thought of as part of this institutional typology.[30] Evans writes of nineteenth-century prisons, 'instead of the prisons condensing and distorting the wider world, the wider world began to borrow characteristics from the prisons.'[31] The panopticon mechanism of surveillance was to impact upon the whole enterprise of colonialism itself. As Foucault has described, the necessary complement of institutional surveillance and seeing was that of hiding, and this implied relation played a substantial role in the mechanisms of colonial power and transportation.[32] For example, Robert Hughes notes how Bentham projected the ideal scenario of a disciplinary experiment on a mass scale where convicts could be projected 'as far out of sight as possible'.[33] The

antipodes indeed provided an unseen and unknown setting for such an experi-
ment; the whole continent forming what Hughes has described as a vast, natural
prison.[34] Returning to the Perth site, through the highly visible location of the
gaol and through its centralised planning, the importance of the techniques of
exhibiting – both display from without and surveillance from within – were
thereby inscribed in this first spatial trace.

Trace two: collecting and showing narratives of place

The second trace to occupy the site encompasses the building of the museum, art
gallery and library between 1892 and 1913. Upon closure of the gaol in 1887, calls for
its demolition were quickly made, so as to publicly remove and overwrite the 'stain'
of transportation. At this stage of late colonial history, a period orientated towards
national federation, Australian colonies wished to forget rather than venerate their
convict past. The elevated, prominent gaol site was identified as a suitable setting for
a museum institution, now seen as an alternative, perhaps less stern advocate of
social order, and a more appropriate signification of the colony's new-found wealth

TRACE 1. THE PERTH GAOL

◼ Gaol as built
◼ Proposed Gaol Extentensions - unbuilt
☐ Exercise Yards

◄◄— N

15 Trace 1: plan of the Perth gaol, illustrating
both the intentional and built scheme,
1853

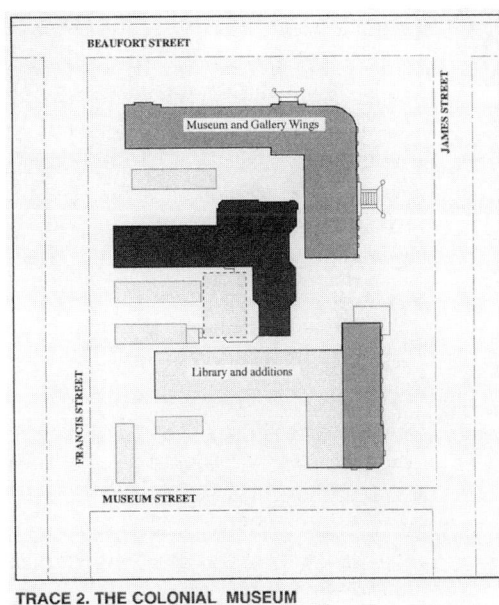

TRACE 2. THE COLONIAL MUSEUM

◼ Former Gaol and Extensions
◼ Colonial Museum, Art Gallery and Library
☐ Temporary Museum and Library Extensions

◄◄— N

16 Trace 2: plan illustrating the composition
of the Perth colonial museum complex, and
subsequent additions, 1892–1950

and independence. Due largely to economic constraints, however, the gaol was not immediately demolished and a prime planning imperative therefore became the hiding of the building. The gaol was wrapped and obscured by new museum buildings, which gradually composed a screen around the convict past (see figure 16). Reminders of the gaol's tangible existence were further lessened by the lowering of the original building. Far from being preserved as a monument to convict legacies, it was intended that the gaol would be thoroughly transformed and absorbed into the museum and gallery facilities. No vestiges of the recently purged convict era were acquired or displayed in the early museum collections.[35]

Many nineteenth-century moral and social reformers came to characterise modern institutions such as prisons, asylums and factories as epitomising the harshness of the modern urban realm. As Evans notes, for example, Pugin among others attempted 'to devise a picturesque social landscape to correspond with the art of good building'.[36] And in the specific context of the antipodean colonies, the transformation of convict into cultural and pedagogical institutions was a part of this attempted urban 'civilisation'. The transformation of the Perth site can be compared to the London Millbank prison site, on which the Tate Gallery was built in the 1880s. These two cases differ in that the Millbank prison was demolished (although, as Brandon Taylor has remarked, it remained alive in public mythology[37]) and the Perth gaol was to remain physically. Yet the spatial coincidence of a prison and museum upon these two sites renders all the more apparent what has been described as 'a nexus of seeing and reforming'.[38] However, although arising out of comparable concerns for the reform of society – whether criminal or cultural – as Bennett has suggested, connections between prisons and museums were not direct or simple. In some ways they inscribe opposing strategies. The prison structured a closed, internally surveyed space hidden from the outside world, and the museum housed collections that relied upon being accessible to all. Thus the museum in many ways inverted the spatial model of the prison; throwing open its hidden, internalised space to the gaze of the public.[39] Via the museum, the body-public was traced, both scientifically and historically, as a subject to be exhibited. And it composed a civic setting where the public could gather and look at themselves, both directly as an urban crowd, and indirectly through representations of their place.

The actual building programme for the construction of the museum began in 1887 with the laying of the foundation stone of the Jubilee Wing, followed by the Government Geologists Galleries in 1902. At this stage, with no other separate buildings yet completed, the museum housed all natural history, geology, art, ethnology and book collections. Gradually as new buildings were constructed – the art gallery in 1908, and the library in 1913 – the collection and exposition of art, nature and books became fractured across the site. Stylistically, the site took shape as an eclectic collection of buildings, which have received the somewhat troubled labels 'free-style Italianate' or 'Victorian Romanesque'.[40] The fabric of the buildings incorporates a great diversity of materials including local red brick, light stones,

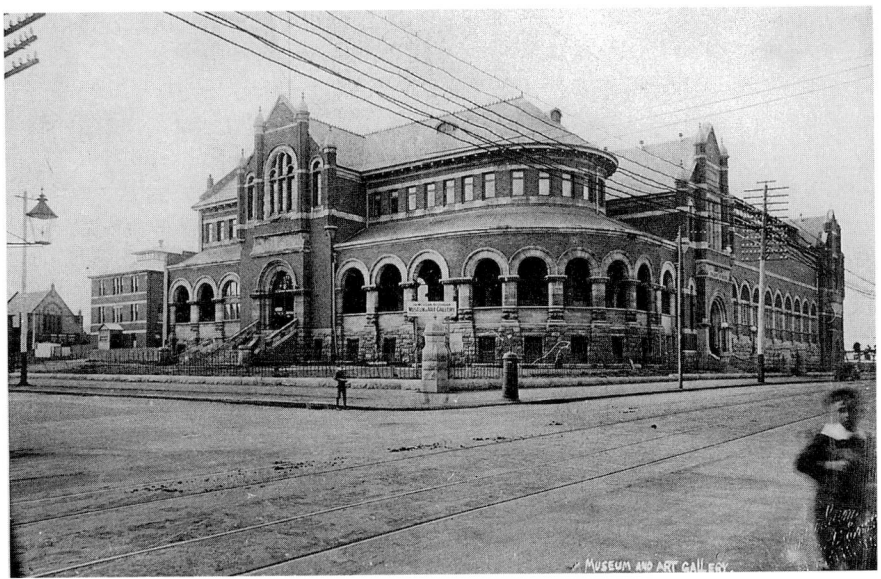

17 The Perth museum and art gallery wings, as completed in 1911

hardwood timbers and ceramic floors. Intricate decorative friezes, porticoes and arcading of stone and ceramic define street façades and entries (see figure 17).

The formation of the Perth museum buildings and its collections can be considered as part of a broad network of relations, forged in the nineteenth century, between wealth, culture and the regulation and instruction of populations. For, concurrent with the general discourses of cultural and pedagogical institutions, museums, galleries and libraries were encouraged as publicly accessible places of instruction, and the museum-goer figured as the target of self-improvement and self-regulation.[41] By improving man's inner life, as Bennett has elucidated, the museum contributed to the general strategies of shaping a more cultured, productive and manageable citizenry.[42] Local news articles and parliamentary debates reporting arguments justifying the spending of significant public funds on the museum project reveal a number of widely held beliefs in the pedagogical benefits of these kinds of popular cultural institutions.

Firstly, it was envisaged that the local social and civic environment would be 'improved' by the public and visual display of collections of nature, art and historical artefacts. This opinion is exemplified in a number of letters, published in the Perth newspapers of 1902, debating the worth of extending the museum. One editorial asserts: 'It is hardly conceivable that any man can make a practice of visiting a well appointed museum without becoming, in consequence, a better man and a more useful citizen.'[43] Whilst the first museum director turned to the writings of John Ruskin to make his point in a reported commentary of 1902:

> A museum is (says Mr Ruskin) ... primarily not at all a place of entertainment but a place of education ... The first function of a museum is to give an example of perfect order and perfect elegance to the disorderly and rude populace. Everything in its own place, everything looking its best because it is there, nothing crowded, nothing unnecessary, nothing puzzling.[44]

This association of moral improvement and instructive activities undertaken within orderly architectural institutions thus parallels, in many ways, the rhetoric of improvement embodied in earlier English penitentiaries and reformed prisons.[45]

Secondly, the museum was seen to represent a new kind of visual and spatial, rather than textual, pedagogical experience in which narratives of (normative) culture, history and nature would be rendered visible and vivid. For example, *The West Australian* newspaper reported in 1884 of the then proposed museum:

> The miner and the mechanic come seeking, each in his own line, an ocular demonstration teaching them more in an hour, than they could have learned in a life time, or through the perusal of a thousand books ... The value of a museum is the vast amount of information it can convey in a pleasing and effective form through direct observation, in the time only required to grasp it.[46]

And the founding curator of the Perth museum describes the natural and geological collections in a museum guide of 1900 as 'a consultative library of objects where people can see for themselves the things of which they can read in books.'[47]

Thirdly, it was hoped that the museum, and later the art gallery, would usefully serve to reinforce imperial *a priori* models and expectations of the economic productivity of the land and its citizenry: 'The museum would be neither a show, nor a bazaar, but an institution in which our national wealth in every known form, natural or industrial might be studied.'[48] However, despite such persuasive rhetoric, not all were swayed, and the then Minister for Education saw proposed extensions to the museum in 1902 as educationally worthless and 'merely a counter attraction to the hotels.'[49] A published reply countered his attitudes as follows: 'It is as Minister for Education however, that he excels himself. A Minister for Education who regards a public library as a luxury and a museum as a toy must be without parallel in any British community.'[50]

In respect of the accumulation of collections (which will only be very briefly touched on here) the Perth museum, like other nineteenth-century museums, aimed to carefully select, order and exhibit its collections of artefacts in taxonomical arrangements. Although drawing on local knowledges, collections were generally modelled on imported narratives reflecting imperial understandings of the world. A substantial collection of flora and fauna from outside Australia was formed; these collections – established through the extensive network of specimen swapping – were facilitated by the plethora of museums springing up in all parts of the world in the late nineteenth century. Imperial museology thus constituted a powerful network of cultural and scientific communication and exchange.[51] As

Anne Delroy aptly describes, 'little bits of England' were imported and displayed, and early local collections were arranged and shown in comparison to these foreign collections.[52] This comparative display concurs with Simon Ryan's interpretation of the reliance of observational comparisons and nostalgic allusions to the familiar European world in the representation of the unfamiliar and 'inverted' territory of the antipodes.[53] Thus through the activities of collecting and exhibiting 'real' things and places, the condition of *post terra nullius* was gradually further occupied and countered.

Similarly, the separate art gallery, constructed in 1908, formed a collection predominantly around the importation of prefigured cultural narratives, with little attention given to local works in the early years. Reproductions and casts of canonical works were gathered from Britain, and as far afield as the Louvre, the Vatican, Florence and Japan.[54] These works were displayed in the painting gallery, which was lit by an ambitious roof lantern and decorated by casts of the Elgin marbles. The governor's earlier speech of 1891 had prefaced these curatorial attitudes with his comment that 'inevitably' the Perth exhibitionary complex would 'follow – of course at some distance – the great efforts made in other parts of the world.'[55]

Over and above the simple pleasures of looking at nice things, art was also justified from a social and educational perspective. *The West Australian* newspaper reported in 1884 that 'even a larrikin of the roughest type is awed into either a momentary or permanent observance of a correct order of things in Art.'[56] These comments reflect far wider-held attitudes on the educational and moral strategies of museums and galleries. The writings of John Ruskin appear particularly influential in terms of local rhetoric affirming the gallery and museum as a tool of instruction and social reform. It is interesting to note the influence in colonial cultural debates of cultural 'prophets' such as Ruskin who expounded the moral benefits of cultural institutions, and, as Ian Hunter has elaborated, they also embodied in themselves the figure of 'ethical exemplar'.[57] Ruskin's claims of the redemptive capacities of museums and art galleries – that they could make up for the lack of beauty in contemporary times – appears particularly apt in the case of Perth.[58] Examples of art works were acquired to form instructive displays in a wide range of manufacturing techniques, including English water colouring, metal, glass, ceramics and woodworking. These pedagogical aims were reinforced by public lectures and practical demonstrations of techniques. Imported and copied works of recognised artistic canons were therefore regarded as practically useful, in the sense that they provided an aesthetic language of description through which local artists could learn to 'see' and represent their local landscape within the recognised frame of European artistic narratives. As Mieke Bal has suggested in terms of American colonial art, local artistic production was seen as an instrumental tool: 'anonymous, necessary, natural'.[59] At this time, indigenous arts were not recognised as having any place in the art gallery and were confined to the ethnographical section, which was, regrettably, housed in the converted gaol. Extending the cultural implications of *terra nullius* still further through

the erasure of indigenous signification, aboriginal artefacts were often swapped in exchange for European works of art.

The final major component of the colonial museum trace was completed with the building of the Hackett Library in 1913 (see figure 16). In defence of the proposition of a separate larger library, and perhaps seizing the chance to claim a little moral ground over the Eastern Australian colonies, local reports stressed the potential educational and social values of the existing library resource:

> A better class of people used the institution [i.e. the library] in Perth than in the other States. The fact that there was such a large attendance regularly in the evenings was sufficient to show that the library was being used by people who worked throughout the day and took advantage to study in their spare time.[60]

The completed library contained public reading, newspaper and patent rooms, a children's library, and two-tiered book space, it was clothed in 'late nouveau' architectural styling. The library greatly contributed to the making of local historical and fictional narratives of place through the extensive collection of archives and texts.

Trace three: expanding place

Only fairly minor or temporary changes were carried out on the site until the late 1960s, when, in line with changes to the whole city fabric, a radically new urban design scheme was proposed for the site. This third trace added new state museum, art gallery and library buildings, constructed between 1972 and 1985. These new institutions greatly expanded the precinct, and for the most part replaced the then seemingly antiquated and unfinished colonial institutions. The exterior spaces of the precinct underwent dramatic spatial and visual reconstruction through the inscription of a completely new sixty-degree geometry over the site. And this skewed geometry, governing both new buildings and landscaping, was noticeably antithetical to the prior Cartesian, colonial trace. The definition of bordering streets, axes and levels were also altered, further blurring the underlying colonial blueprint (see figure 18). However, these modern buildings, arguably completed towards the twilight of their era, were quickly criticised both aesthetically and functionally.[61] What was seen as a necessary rebuilding of a colonial legacy was within a decade described by conservation reports as dysfunctional, disastrous additions, illustrating the rapid fall from grace of late modernist planning.[62]

Trace four: conserving and representing place

Conservation-inspired interventions in the architecture of the museum precinct form the fourth and most recent trace in the strata of the site. Since the 1980s, all the prior traces have come under the scrutiny of conservation research. As a result, a number of significant conservation studies and heritage programmes are being

carried out. This fourth trace is thus manifest more in terms of strategies in the re-evaluation and representation of existing buildings and landscape, rather than in major new building works.

In the early 1990s, Australian conservation bodies identified the Perth gaol as being of 'world heritage significance', reflecting dramatic changes in attitude to the convict legacy. Subsequently, conservation classifications have also been undertaken on the colonial museum buildings. This has precipitated the desire to recover the underlying colonial traces, and correspondingly to lessen the dominance of the modernist trace.[63] Heritage reports suggest that colonial buildings are to be reconsidered as central rather than incidental to future urban design contexts, and building façades described as aesthetically 'deactivated' are to be repaired and restored back to their original, or idealised and embellished form.[64] The gaze of heritage has also extended outwards from the boundaries of the museum precinct into neighbouring streets. A small migrant worker's cottage has been retrieved and rebuilt as an outdoor exhibit within the museum precinct. The reconstructed cottage, which was also a brothel at some time in its existence, is intended to set the

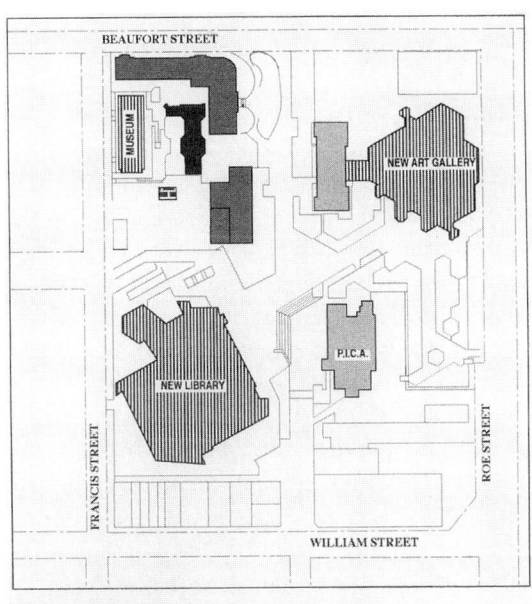

TRACE 3. THE EXPANDED 'CULTURAL CENTRE'

- Restored Gaol
- Colonial Museum and Alterations
- Modern Museum Building
- Cottage reconstruction

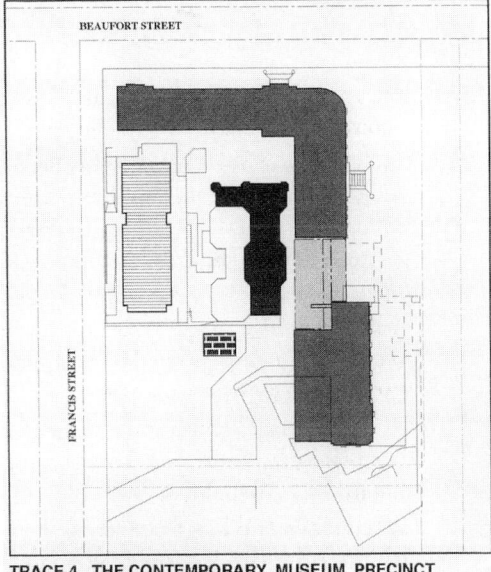

TRACE 4. THE CONTEMPORARY MUSEUM PRECINCT

- Restored Gaol
- Colonial Museum and Alterations
- Modern Museum Building
- Cottage reconstruction
- New entrance and Discovery Centre

18 Trace 3: plan illustrating the modern reconfiguration and expansion of the Perth 'cultural centre', 1960–present. Perth

19 Trace 4: plan illustrating the Perth contemporary museum complex, recent changes and additions

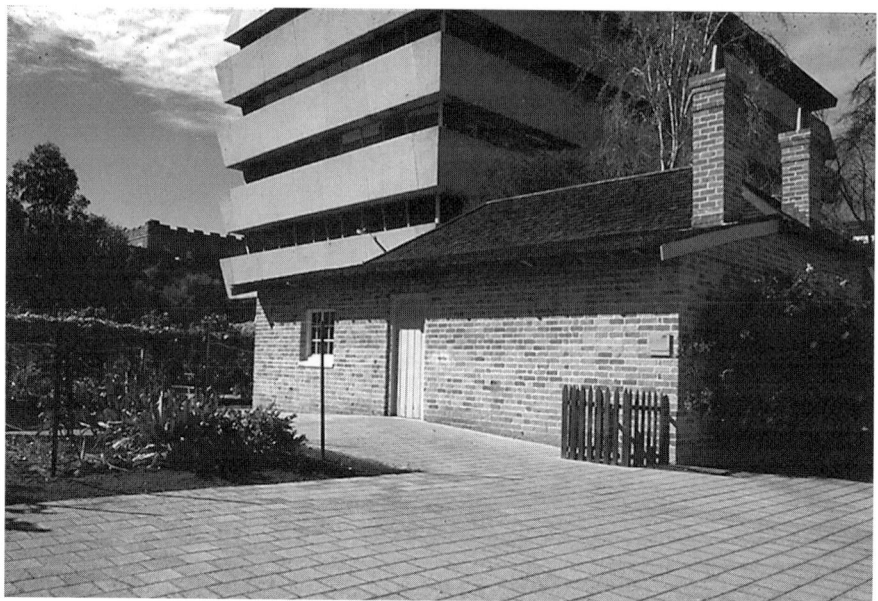

20 The Roe Street cottage framed by the 1972 modern museum building, Perth

scene for the re-enacting of narratives about everyday, 'authentic' Australian vernacular histories. Through this performative space, the previously hidden dramas of private, inner-city, domestic life are exposed and exhibited for contemporary visitors (see figures 19 and 20).

In excavating past traces, a spatial–visual pattern has emerged. Spaces and buildings have been successively transformed and rendered either more or less visible by architectural inscriptions. This process is exemplified in the case of the gaol building, originally prominently sited as a signification of law and order, and subsequently hidden behind the museum as a legacy to be forgotten. In the recent past, conservation re-evaluations have precipitated a reversal in attitude. The architectural fabric of the gaol has been painstakingly restored, and the building filled with exhibits about this conservation process and convict artefacts, which although once shunned are now showcased.

Conservation practices inevitably change the character of things and places being conserved. In many cases former functionality, context and occupation are often unavoidably distanced, and cultural artefacts are turned into aesthetic objects. Both the exhibitionary techniques of conservation and museology engage the viewer in a different kind of looking at artefacts and buildings that emphasises their aesthetic and craft values. This process of aestheticised viewing can be clearly seen in the Perth site. Previous descriptions of the gaol as being 'squat and ugly' have been revised by recent conservation assessments, refiguring it as a fine example of colonial 'grace, harmony and simplicity'.[65] This conflation of historical

and aesthetic evaluation is also reflected in comments regarding the 'pleasing' and 'picturesque' urban scene composed by the glimpsing of the whitewashed walls of the gaol through the gaps in the red-brick museum.[66]

The most recent wave of renovations has still further rendered the gaol as a visible and accessible display. The new entry wing and 'discovery centre', which has filled in the gap between the colonial museum and library wings, has created a light, bright glazed aperture focusing the view of the gaol behind. Through the language of this architectural intervention, which was driven primarily by conservation objectives, the gaol has been transformed into a treasured exhibit within an heritage collection (see figure 21). Now sufficiently distanced from its convict associations, the gaol has thus become fully appropriated into contemporary national myths and stories. As Tony Bennett has remarked, the Australian penal past has been transformed into a general device of nationing,[67] and the gaol serves as an unlikely and 'unintentional monument' to that national past.[68] Yet in this commemorative role, the gaol has generated problematic and paradoxical readings; serving not only as the material evidence of a history of harsh social control, but also as an aesthetically pleasing urban setting, and a valued heritage monument. As Foucault has pointed out, sites of historical origins are perhaps too often invested with qualities of the precious, rather than exposing the historical beginnings of things as 'lowly', and 'derisive and ironic'.[69]

Multiple traces of difference – the colonial, the modernist, the post-colonial – are juxtaposed on our site. Each trace has reinvented and inscribed a vision of

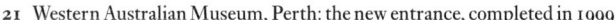

21 Western Australian Museum, Perth: the new entrance, completed in 1999

presentness, and each has dealt with perceived anachronistic legacies. However, heritage recommendations have expressed a desire to overcome and render smooth these apparently incongruous layers, so as to exhibit a more coherent historical narrative, and a more unified semblance of a colonial urban space.[70] Accordingly, it has been suggested that the previous modernist trace be severely altered by removing the skewed landscape footprint and resculpting a series of open rooms or piazzas, to create a legible hierarchy of exterior spaces supposedly in a manner in which colonial designers would have wished to complete the site.[71] It appears that here, as elsewhere, perhaps beguiled by things furthest from the present, the recent is superseded in favour of rearranging a less contradictory and more assimiliable version of what is seen as an authentic historical place.

In conclusion, the latest architectural trace inscribes a narrative of introspection; a museum looking inwards and backwards to conserve and represent its former self. Bal's comments on the status of the New York Museum of Natural History are applicable to our site: 'it is also a museum of the museum, a reservation, not for endangered natural species, but for an endangered cultural self, a meta-museum.'[72] Colonial buildings are being transformed from architectural containers housing collections into an exhibition of treasured artefacts in themselves. Through conservation strategies of mimetic exhibition and diegetic interpretation, as borrowed from museology, today's visitor is invited to look again at the colonial museum precinct.

This specific account of one heritage and museum site may be seen as a microcosm of the general process of the making and representing of colonial spaces, places and narratives. If the colonial exploration of Australia is figured as the final episode in the imperial conquering of the space of the external and unknown world, gradually (even in the antipodes) this space became all seen, spatially described, and known. *Terra nullius* became occupied, and its externality was consumed by the internality of the modern and familiar world. In one nineteenth-century inspired architectural metaphor, this interior has been likened to an 'absurd' unbounded prison.[73] In a comparative architectural metaphor, conservation practices are currently imposing the ordered and arranged interior of the museum on to the exterior spaces of Australian cities. This metaphor of the city-as-museum is long standing. For example, in Daniel Sherman's interpretation of the thinking of Quatremère de Quincy in the 1790s, he summarises Quatremère's hostility towards the new museum institution. Quatremère suggested that, rather than museums, it was actual real places that created the best environment for viewing artefacts. He saw a city such as Rome as the ideal museum, writing of 'places, sites, mountains, quarries, ancient roads, the respective positions of ruined cities, geographic relationships, the connections between objects, memories, local traditions, still extant uses, parallels and comparisons that can only be carried out in the country itself'.[74] Through contemporary architectural conservation, the preserved and exhibited place of the city, within the narratives of national identities, may be thought of as continuing to define an un-bounded urban museum.

Notes

This text is an elaboration of an earlier article; 'Showing and hiding' published as *Working Papers in Australian Studies*, no. 112 (1998). I am most grateful to the staff of the Sir Robert Menzies Centre, Institute of Commonwealth Studies, University College London, and also to Michaela Giebelhausen and co-contributors to the Association of Art Historians Conference, 1997 for their comments and suggestions.

1 Extract cited from the speech of the Governor of Western Australia, Sir John Forrest, on the occasion of the opening of the Geological Museum. Reported in *The West Australian*, 11 September 1891, p. 6.

2 Technique is used here in reference to Ian Hunter's discussion of the construction and representation of 'culture' through explicit techniques or apparatuses. See Ian Hunter, *Culture and Government: The Emergence of Literary Education* (Basingstoke: Macmillan Press, 1988), p. ix.

3 Michel de Certeau, *The Practice of Everyday Life* (Berkeley: University of California Press, 1988), p. 118.

4 See Simon Ryan, *The Cartographic Eye: How Explorers Saw Australia* (Cambridge: Cambridge University Press, 1996), pp. 101–27.

5 See Paul Carter, *The Road to Botany Bay: An Essay in Spatial History* (London: Faber and Faber, 1987), pp. 99–135, and Ryan, *The Cartographic Eye*, pp. 1–25.

6 Discussed and cited in Tom Griffiths, *Hunters and Collectors: The Antiquarian Imagination in Australia* (Cambridge: Cambridge University Press, 1996), p. 26.

7 Bruce Bennett, *Place, Region and Community* (Townsville: James Cook University Press, 1985), p. 1.

8 David Lowenthal, *Antipodean and Other Museums* (*Working Papers in Australian Studies*, no. 66) (London: Sir Robert Menzies Centre for Australian Studies, University College London, 1991), p. 1.

9 Randolf Stow, *The Merry-Go-Round in the Sea* (Harmondsworth: Penguin Books, 1980), p. 135.

10 See Hayden White, 'The value of narrativity in the representation of reality', in J. Appleby, E. Covington, D. Hoyt, M. Licham and A. Sneider (eds), *Knowledge and Postmodernism in Historical Perspective* (London and New York: Routledge, 1996), pp. 395–407.

11 Tony Bennett, *The Birth of the Museum: History, Theory, Politics* (London and New York: Routledge, 1995), p. 179.

12 Mieke Bal, *Double Exposures: The Subject of Cultural Analysis* (London and New York: Routledge, 1990), p. 5.

13 Daniel Sherman, 'Quatremère/ Benjamin/ Marx: art museums, aura, and commodity fetishism', in Irit Rogoff and Daniel Sherman (eds), *Museum Culture: Histories, Discourses and Spectacles* (London and New York: Routledge, 1994), pp. 123–43; p. 123.

14 Svetlana Alpers, 'The museum as a way of seeing', in Ivan Karp and Steven D. Lavine (eds), *Exhibiting Cultures: The Poetics and Politics of Museum Display* (Washington: Smithsonian Institute Press, 1991), pp. 25–32; p. 27.

15 Michael Baxandall, 'Exhibiting intention: some preconditions of the visual display of culturally purposeful objects', in Ivan Karp and Steven D. Lavine (eds), *Exhibiting*

Cultures: The Poetics and Politics of Museum Display (Washington: Smithsonian Institute Press, 1991), pp. 33–41; pp. 34–5.

16 Peter Kyle and Meredith Walker, *The Illustrated Burra Charter* (Sydney: Australian ICOMOS, Australian Heritage Commission, 1992), p. 7.

17 'Real' is used in the sense of Barthes' description of the 'effect of the real', in modern narratives, as cited also by Bal, *Double Exposures*, p. 54 and Seymour Chatman, *Story and Discourse: Narrative Structure in Fiction and Film* (Ithaca and London: Cornell University Press, 1978), p. 144.

18 For an elaboration of cultural 'apparatus', see Hunter, *Culture and Government*.

19 Robert Hughes, *The Fatal Shore: A History of the Transportation of Convicts to Australia 1787–1868* (London: Collins Harvill, 1987), p. 579.

20 In the period of transportation between 1850 and 1868, some 9,600 convicts, predominantly from Pentonville Prison, arrived on West Australian shores. The Perth gaol accommodated approximately 150 prisoners at any one time.

21 Howard Tanner (ed.), *Architects of Australia* (Melbourne and New York: Macmillan Press, 1981), pp. 38–42.

22 *Ibid.*, p. 40.

23 *The Old Perth Gaol* (Perth: Western Australian Museum Publication, 1982), p. 6.

24 Report cited in *ibid.*, p. 10.

25 The gallows were removed shortly before the prison's closure in 1888.

26 See Michel Foucault, *Discipline and Punish: The Birth of the Prison*, trans. Alan Sheridan (Harmondsworth: Penguin Books, 1991), pp. 200–10.

27 Charles Thomas Stannage, *The People of Perth: A Social History of Western Australia's Capital City* (Perth: Perth City Council, 1979), pp. 136–7.

28 Changes to Jewell's initial design clipped the plan to just two wings of cells, and future intentions to complete the symmetrical design with a women's prison were never realised. A second storey accommodated courthouse functions and two tiers of cells and prisoners' facilities visible from internal corridors.

29 See Robin Evans, *The Fabrication of Virtue: English Prison Architecture 1750–1840* (Cambridge: Cambridge University Press, 1982), p. 202, documenting Reveley's involvement with Bentham.

30 See Eilean Hooper-Greenhill, *Museums and the Shaping of Knowledge* (London and New York: Routledge, 1992).

31 Evans, *The Fabrication of Virtue*, p. 404.

32 See Foucault, *Discipline and Punish*, pp. 200–10.

33 Hughes, *The Fatal Shore*, p. 2.

34 *Ibid.*, p. 2.

35 For a comprehensive study of the Perth museum collections, see Anne Delroy, 'Pragmatics and progress: the evolution of the Perth museum at the turn of the century', *Museums Australia Journal*, 2–3 (1992), pp. 9–18. See also, Bernard Woodwood, 'The Western Australian Museum and Art Gallery, Perth', *Museums Journal*, December 1903, pp. 180–7.

36 Evans, *The Fabrication of Virtue*, p. 395.

37 Brandon Taylor, 'From penitentiary to temple of art: early metaphors of improvement at the Millbank Tate', in Marcia Pointon (ed.), *Art Apart: Art Institutions and Ideology across England and North America* (Manchester and New York: Manchester University Press, 1994), pp. 9–32; pp. 12–19.

38 Douglas Crimp, *On the Museum's Ruins* (Cambridge, Mass.: The MIT Press, 1993), p. 48.

39 See Bennett, *The Birth of the Museum*, pp. 92–5.

40 *A Report on the Assessment of Cultural Heritage Significance for the Western Australian Museum – Historian's Report* (Perth: Heritage Council of Western Australia and University of Western Australia, 1992), p. 43.

41 The museum as library may be described in terms of techniques of 'moral supervision', in a similar sense to Ian Hunter's analysis of literary education. See Hunter, *Culture and Government*, p. ix.

42 See Bennett, *The Birth of the Museum*, pp. 18–24.

43 *The Morning Herald*, 14 June 1902, p. 4.

44 *The West Australian*, 17 June 1902, p. 3.

45 See Evans, *The Fabrication of Virtue*, pp. 118–31.

46 *The West Australian*, 30 October 1884, p. 4.

47 See Delroy, 'Pragmatics and progress', p. 9, and Woodwood, 'The Western Australian Museum', for the Perth museum curator Bernard Woodwood's comments.

48 *The West Australian*, 30 October 1884, p. 4.

49 *The Morning Herald*, 14 June 1902, p. 4.

50 *Ibid.*, p. 4.

51 The international sources of the museum specimen collection are elaborated in the *West Australian*, 14 June 1909, p. 3 and cited by Delroy, 'Pragmatics and progress', p. 9.

52 *Ibid.*, p. 11.

53 Ryan, *The Cartographic Eye*, pp. 110–11.

54 *The West Australian*, 14 June 1909, p. 3.

55 *The West Australian*, 11 September 1891, p. 6.

56 *The West Australian*, 30 October 1884, p. 4.

57 Hunter, *Culture and Government*, p. 100.

58 Ruskin is quoted in the Perth *History Society* newsletter editorial of 1892.

59 Bal, *Double Exposures*, p. 16.

60 *The West Australian*, 14 June 1909, p. 3.

61 *Western Australian Museum Site Redevelopment Report* (Perth: Building Management Authority of Western Australia and the Heritage Council of Western Australia, 1995–96), pp. 6–7.

62 I have summarised this modern architectural trace in a cursory fashion, which is not to say that I am at all dismissing its importance or value. However, although the modern provided a necessary break across which conservation was seen to bridge, it does not figure largely in present attempts to retie a thread linking the colonial to the present.

63 As proposed in *Hackett Hall: Detailed Conservation Policies Report* (Perth: The Western Australian Building Management Authority, 1995), p. viii.

64 *Cultural Centre Development Framework* (draft report) (Perth: The Western Australian Building Management Authority, 1995), p. 32. Other commissioned Conservation Reports consulted in the preparation of this research include: *Conservation Plan: Western Australian Museum: Historical Significance and Historical Conservation Policies* (Nedlands: Centre for Western Australian History, University of Western Australia, 1992); *The Museum of Western Australia: A Statement of Significance and Conservation Proposal* (Perth: Building Management Authority of Western Australia, 1990).

65 *A Report on the Assessment of Cultural Heritage Significance for the Western Australian Museum*, pp. 44–59.

66 *Ibid.*, p. 42.

67 Bennett, *The Birth of the Museum*, p. 155.

68 Unintentional monument refers here to the Austrian art historian Alois Riegl's classification of a modern typology of monumental value, which included a new type of 'unintentional monument' or commemorative building. Alois Riegl, 'The modern cult of monuments: its character and its origin', trans. Kurt W. Forster and Diane Ghirardo, *Oppositions*, 25 (autumn 1982), pp. 21–51.

69 Michel Foucault, 'Nietzsche, genealogy, history', in P. Rabinow (ed.), *The Foucault Reader: An Introduction to Foucault's Thought* (Harmondsworth: Penguin Books, 1984), pp 76–100; p. 79.

70 *Cultural Centre Development Framework*, p. 4.

71 *Ibid.*, p. 30.

72 Bal, *Double Exposures*, p. 17.

73 Hughes, *The Fatal Shore*, p. 2.

74 Cited by Sherman, 'Quatremère/ Benjamin/ Marx', p. 127.

Symbolic capital:
the Frankfurt museum boom of the 1980s

Michaela Giebelhausen

During the 1980s Frankfurt, West Germany's financial capital and a moderately sized city of 650,000 inhabitants, commissioned thirteen new museum buildings. Some were new foundations, some were spectacular extensions, and others were more modest in scale and intellectual endeavour.[1] But taken together, this mushrooming of museums on the Main was a truly unprecedented phenomenon, even in the decade of worldwide museum mania. When asked how this had come about, Heinrich Klotz, prominent architectural critic and founding director of the Deutsches Architekturmuseum (DAM), remarked:

> It was first of all a conservationist idea: we wanted to preserve some very fine historical buildings. At first we didn't even really dare suggest using all those villas as museums. It was too daring, funny and incredible: it couldn't actually happen. Then we got support from a Social Democrat politician, Hilmar Hoffmann, and we all went to the newly elected Christian Democrat mayor, Walter Wallmann, and presented this whole programme to him. And he said: 'We are going to do it'. It was very funny. We drove in a Mercedes up and down the road along the River Main and decided well, this one is going to be the Post Museum, this one is going to be the Ethnological Museum and that one is going to be the Film Museum ... 'Which one do you want for the Architecture Museum, Heinrich?', they said, and I replied, 'Well, the smallest one'. That was how things happened. It was a bit like a fairy tale.[2]

This playful version of events captures the essence of the Frankfurt museum boom. It was produced by the unlikely collusion of a cross-party alliance which decided to act on an idea considered 'too daring, funny and incredible' even by its originators. The idea itself was simple: to designate a series of historic villas along the riverfront for museum use in order to preserve a unique urban landscape. While critics have repeatedly identified Frankfurt's enterprise as 'a collection of architectural set-pieces', they have not fully explored the potential of this parallel.[3] The elements of seriality and play, and a desire to shape the world contained in Klotz's account suggest that this accumulation of museums was at least partly governed by the complex dynamics of collecting.[4]

Many studies have been devoted to collecting and its underlying motivations. While this is not the place to add to these explorations and speculations, I nevertheless want to draw on just two complementary observations on the nature of collecting to gain a better understanding of the forces that drove Frankfurt's museum boom. Susan Pearce has argued that collecting is a way of fictionalising our existence:

> Like fiction, too, their [the collectors'] ways of creating the narrative flow are open to analysis, and prove to be not a reflection of the nature of things, but a social construct in which apparent sense is created from a range of possibilities and discontinuities. ... Like all fictional narratives, it offers the scope to play games and experience magical transformations[5]

Werner Muensterberger has identified another important, albeit very general, motivation for collecting, which Pearce has aptly summarised as 'a quest for comfort and reassurance'.[6] These were precisely the qualities that Frankfurt, notorious for its '380 banks, an appalling post-war rebuilding plan and the reputation for being the BRD's ugliest city', lacked.[7] Frankfurt's quest – the classic narrative drive of fairy tale and collecting alike – has been compared to the plot of Cinderella, which epitomises the desire for transformation and vindication.[8]

This essay charts the reshaping of Frankfurt through the single big idea of a series of museums from the playful beginnings described by Heinrich Klotz to the quasi-surgical interventions attested by Vittorio Magnano Lampugnani.[9] I investigate the transformation of Frankfurt's historic urban fabric – which aimed to remove the scars left behind by extensive war damage, ruthless post-war rebuilding and property speculation – and explore the role the museum played in this complex process. The swift and pragmatic rebuilding of German cities adopted a consciously modernist paradigm to effect a break with the recent past it sought to repress and negate. Although this strategy prevailed throughout Germany, the sheer scale of Frankfurt's single big idea not only helps to cast these practices into sharper relief, it also highlights the changing nature of the museum that emerged during the urban reinvention. The global shift of the dominant urban paradigm from modernism to postmodernism, which reconfigured the city as marketplace and spectacle and rediscovered the historic dimension of the *genius loci*, provided the larger context in which the reshaping of Frankfurt took place. The institutional landscape of the museum, systematically neglected in Frankfurt since World War Two, became a powerful tool in the city's widely publicised reimaging campaign precisely because of its ability to respond to these three important urban modes.

Lost: city, history, memory

From 1372 to 1866, Frankfurt had been autonomous – first a Freie Reichsstadt (free imperial city) governed by the city council and accountable only to the Emperor, and from 1815 a Freie Stadt within the Deutscher Bund (German

federation). In 1356 it had become official host of the imperial elections and from 1562 onward it also hosted the coronations. In addition to these imperial privileges, which contributed to the city's distinctive identity, Frankfurt developed as a centre of commerce and banking. Although both traditions can be traced back to the late Middle Ages, Frankfurt gained international importance as a banking centre during the nineteenth century when the banking houses of Bethmann and Rothschild prospered and the stock exchange started trading in 1820. Although politically far less significant during this period – especially after 1866 when it became a provincial Prussian outpost – the city flourished in the areas of commerce and banking, growing in wealth and size. Frankfurt's architectural fabric reflected the stages of its historic development. However, literally overnight the symbolic markers of its past were lost; in late March 1944 the city suffered extensive bomb damage. Its historic centre, the largest late medieval cityscape in Germany, was burnt to the ground.

The stark pragmatism of post-war rebuilding did little to remedy this. As in other German cities, immediate efforts concentrated on housing, hospitals and schools.[10] However, there were two notable exceptions. The Paulskirche (St Paul's Church), meeting place of the first, freely elected German parliament of 1848–49, was rebuilt in time for the centenary. In a divided post-war Germany this event gained truly national importance, reaffirming a democratic German past annihilated during the Nazi dictatorship. The rebuilding of the Paulskirche also helped to strengthen Frankfurt's bid to become the capital of Western Germany. However, the final decision did not rest on the strength of symbolism, and in 1949 Bonn was proclaimed the new capital. The sympathetic, but simplified reconstruction was quickly followed by another symbolic act, which held even stronger significance for Frankfurt: the hotly debated, complete and detailed rebuilding of the house Großer Hirschgraben No. 23 – childhood home of the city's most famous son, the poet Johann Wolfgang von Goethe.

The recreation of these two buildings, both major markers of Frankfurt's past, highlighted the complex issues of urban reparation. The Paulskirche had survived the war as a burnt-out shell, while the Goethehaus lay in total ruins. The neo-classical church, begun in 1787 from the designs of the city architect Johann Andreas Liebhardt and completed in 1834 by his successor Johann Friedrich Christian Hess, was not reconstructed in detail, rather it was reinterpreted. The replacement of the mansard roof and dormers with a shallow, domed roof together with the significantly simplified interior gave the Paulskirche an austere character that has been read as symbolic of post-war conditions.[11] By contrast, the Goethehaus was completely rebuilt. The contents of the house had been removed before the bomb attacks and the reconstruction itself was based on photographs and drawings. However, the total reconstruction was severely criticised on ideological grounds. It was regarded as a negation of history and a dangerous form of nostalgic make-believe that precluded a meaningful coming to terms with the recent past. Consequently, it was felt that the destruction of this culturally significant site was a

direct result of Germany's Nazi past for which a Goethehaus in ruins should atone. The animated debate demonstrates that the rebuilding of Frankfurt, and indeed any other German city, was not simply a matter of pragmatic economy, but a significant symbolic act.

In Frankfurt, reconstruction remained the exception. Instead, the city's post-war rebuilding subscribed to a modernist idiom, which denoted a break with the past and a new beginning. In the case of Frankfurt, the return to modernism was also a means to revive the city's generic urban planning tradition of the 1920s during which it had enjoyed international fame as the *Neues Frankfurt*, even hosting the second Congrès Internationaux d'Architecture Moderne (CIAM) in 1929. In the early 1950s, the inner city's medieval layout was substantially altered to provide swift automobile access, both along an east–west and a north–south axis. Frankfurt's post-war housing shortage was also solved in truly modernist fashion with the construction of *Zeilenbau* housing in the inner city and along the periphery.

Frankfurt swiftly regained its former role as international banking centre: in 1957 the Deutsche Zentralbank (German Central Bank) took up its headquarters in the city, and by the late 1960s it had become the financial capital of Western Germany. But it was also beginning to feel the downside associated with this meteoric rise. The ever-increasing demand for office space bred ruthless property speculation that threatened to destroy the Westend, a leafy, residential borough which had survived World War Two mostly intact. Students and citizens started campaigning against the wanton destruction of the historic urban fabric. Various highly politicised and publicised action groups sprang up, whose members squatted in threatened buildings, petitioned, and protested in the streets. The city was showered with such negative epithets as Mainhattan, Bankfurt or Krankfurt ('sickcity').[12] In his piercing and polemical analysis of the current conditions of German cities, the psychologist Alexander Mitscherlich used Frankfurt as the prime example of what he famously called 'die Unwirtlichkeit unserer Städte' (the inhospitability of our cities). Post-war rebuilding, Mitscherlich argued, had not only caused the unprecedented impoverishment of human relationships, which resulted in a severely reduced quality of urban life, but was itself 'an embarrassing consequence of the collective psychosis that had been National-Socialism'.[13] He regarded the unsatisfactory reparation as symptomatic of the collective guilt generated by the Nazi regime, which had been repressed and negated rather than confronted and resolved. Consequently, the derisory epithet Krankfurt ceases to be a somewhat far-fetched pun; instead it captured the post-war condition. Increasingly social and cultural inadequacies threatened to make the city unattractive for new investors. The lack of cultural provisions is evident in a glossy pamphlet published by the city council in the late 1960s. It brashly advertised the joys of urban living, celebrating a diverse range of opportunities in areas such as work, housing and learning, placing particular emphasis on shopping and outdoor recreation. It also claimed euphemistically that 'culture in Frankfurt is not ostentatious'.[14] In fact, Frankfurt's museums were not even mentioned. However, fully

aware that some positive cultural image needed to be projected, the authors sum-moned up the city's imperial past, which – so they claimed – still overshadowed its contemporary cultural activities! Rethinking the effects of post-war rebuilding generated a revaluation of the city's historic identity. This provided the context for a renewed interest in its museums, which had languished in rather desolate conditions since the start of World War Two.

The history of Frankfurt's museums is somewhat unorthodox. As a Freie Reichsstadt it lacked the traditional princely collection that would provide the nucleus of public museums as for example in Berlin, Munich or Stuttgart. By con-trast, Frankfurt's museums were the creation of its citizens. The Städelsches Kunstinstitut, founded by the merchant Johann Friedrich Städel in 1816, was paradigmatic for the city's museums. It functioned as Frankfurt's art gallery, but was in fact a private foundation administered by a board of five eminent citizens. Most of Frankfurt's museums owed their existence to the endeavour of individual citizens or to culturally and scientifically minded societies.[15] However, by the beginning of the twentieth century the city council was catching up with these pre-dominantly private museum initiatives.

Not one of Frankfurt's twenty-two or so museums – approximately half pri-vately run, the other half administered by the city council – survived World War Two intact.[16] The collections had mostly been evacuated in 1939 but all the build-ings either suffered substantial damage or were completely destroyed. While the city concentrated on rebuilding the basic urban infrastructure, Frankfurt's pri-vately run cultural institutions reopened swiftly and with great determination. In October 1947 the Städelsches Kunstinstitut exhibited highlights from the collec-tion in eight hastily refurbished rooms, and the Goethehaus – administered by the Freies Deutsches Hochstift – reopened in May 1951.[17] However, the restoration of the entire museum landscape to pre-war standards was slow and protracted. The city council showed little commitment to the municipal museums; instead, it hatched plans to cut posts and merge collections.[18] Although eventually shelved, these were indicative of the city's attitude to the collections in its care. Throughout the 1960s the local press campaigned for the urgent restitution of all the museums, arguing that a whole generation had grown up without knowledge of the city's true cultural capital and pointing out that Frankfurt compared badly with the efforts of other German cities to rebuild their cultural landscapes.[19]

The city reinvented: marketplace, spectacle and *genius loci*

During the 1960s, the tenets of the modernist city, which had provided the blue-print not only for the rebuilding of Germany but for urban planning throughout the western world, were being re-examined. Writers with such different agendas as Jane Jacobs and Alexander Mitscherlich criticised modernist urban planning and advocated a humanised city where public space – modelled on the ancient agora and the marketplace – would provide an opportunity for social encounters and new

forms of urban living.[20] Density, diversity and the aesthetisation of the urban fabric
– key concepts of the new urbanity – were to reverse the alleged crisis of the city
and to 'respond[ed] to the challenge of placelessness'.[21]

The city as marketplace found its ideal user in the strolling shopper thus resus-
citating notions of the most urban of individuals: the *flâneur*. Admittedly the
flâneur deployed in the rhetoric of city planners had little to do with his complex
nineteenth-century forebear immortalised by Charles Baudelaire and lovingly
botanised by Walter Benjamin.[22] However, given that he (historically it is a he) had
thrived in the most metropolitan of cities, Paris and Berlin, his invocation not only
lent a cosmopolitan aura to the attempt of the post-war city to reurbanise itself but
it also ennobled the contemporary pedestrian. The *flâneur* had one great and
simple virtue: he traversed the city on foot, a true pedestrian who was anything but
pedestrian. Not only would the historic depth of this enigmatic figure help to chal-
lenge the recent supremacy of the motor car, his leisurely, aimless stroll would also
set a desirable behavioural model for urban movement.

For Benjamin the *flâneur* is at once 'the observer of the marketplace' and
someone who 'takes the concept of marketability itself for a stroll'.[23] As an artist he
was not simply a consumer of urban life but was himself contributing to its fictional
production and consumption.[24] His latter-day incarnation, although a mere pedes-
trian, has inherited the complexity of that relationship in the form of a 'historic link
between the playfulness of the *flâneur* and modern/postmodern consumerism'.[25]
Benjamin's claim that the department store was the last hunting ground of the
flâneur found its modern equivalent in the pedestrianised city centre, which also
conflated seduction and consumption.[26] The marketplace depended on consump-
tion and helped to create the city as event.[27] Benjamin distinguishes between
Erfahrung (experience) and Erlebnis (immediate experience): 'Experience is the
outcome of work; immediate experience is the phantasmagoria of the idler.'[28] An
increased alienation from the processes of production and a concomitant prioritisa-
tion of consumption characterised Frankfurt's swift post-war recovery, which
depended on the growth of banking, retail and other service industries.[29] The polit-
ical magazine *Der Spiegel* identified 1969 as the turning point in post-war urban
development.[30] With the first phase of rebuilding accomplished, it argued,
demands for a richer visual and aesthetic urban experience (Erlebnis) were being
made and needed to be met.

From 1969 onward significant parts of Frankfurt's inner city were pedestri-
anised. The initiative focused on the 'Freßgasse' and the Zeil, two streets that pro-
vided one of the main east–west axes through the centre.[31] They had been
substantially widened during the 1950s to accommodate large volumes of
motorised traffic. This policy therefore marked a complete reversal in urban plan-
ning. The temporary pedestrianisation of the Zeil went ahead in 1973. While the
turnover of West Germany's leading commercial mile soared, users complained
about the blatant monoculture of commerce and the lack of opportunity for social
encounters that would make ambling worthwhile.[32] There was also a wider

rethinking of the public sphere. Frankfurt was trying to create an urban feel: it commissioned works of public art and invited people to linger in open spaces. In 1972 the city established a flea market held every Saturday along the south bank of the river, and encouraged street cafés and open-air concerts. The city was beginning to reshape itself as spectacle and increasingly aimed to provide the fledgling *flâneur* with visual stimuli. It also started to cherish the endangered remnants of its historic urban fabric.

In 1977 mayor Walter Wallmann, whose election ended the city's long social-democrat rule, launched a large-scale campaign to assess Frankfurt's image, locally, regionally and nationally. In 1979–80 the city commissioned a detailed study whose findings confirmed the continued negative perception of Frankfurt.[33] The study identified image deficits in the areas of culture, culinary delights and high-class retail. The campaign's crucial question concerned the 'ideal German city'. Participants awarded the top slot to Munich (30.4 per cent), Berlin came second with 14.4 per cent, followed by Hamburg (11.5) and Düsseldorf (5.6). Frankfurt scored a measly 5.3 per cent. The research identified Frankfurt's ideal citizen as someone working in banking or related industries with a high disposable income and a desire to actively participate in an urban lifestyle. To this group of upwardly mobile thirty-somethings Frankfurt aimed to market itself as Germany's 'secret capital'.

The city started mobilising its hidden assets to combat the negative image. Consequently, its historical urban fabric, damaged and vanished buildings alike, became an important image factor. During the late 1970s, the nineteenth-century opera house, built by the Schinkel disciple Richard Lucae, was restored to its former glory with a hi-tech, multi-purpose concert hall at the core. The widely publicised opening took place on the anniversary of Goethe's birthday, 28 August 1981.[34] The city's historic heart – the Römerberg, lovingly nicknamed the 'gut Stubb' (inadequately translated as the 'front room') – was finally rebuilt after several design campaigns had vanished into the cupboards of the municipal planning offices, among them an ambitious project for a cultural mega-centre.[35] The historic area between the town hall and St Bartholomäuskirche (St Bartholomew's Church) – respectively the sites of imperial election and coronation – was redeveloped for mixed use, which included the multi-purpose Kulturschirn housing a temporary exhibition hall, the Jugendmusikschule (youth music school), a café and a bookshop. The central building was surrounded by a diverse range of smaller buildings for combined domestic and retail use. The architects emphasised 'the idea of urban space as imaginary museum' and claimed that their design tied in with the heterogeneous place and its layered history.[36]

The most controversial aspect of the project was the reconstruction of the so-called Ostzeile, a row of sixteenth- and seventeenth-century half-timbered houses at the eastern end of the Römerberg (see figure 22).[37] Some forty years after their destruction, these houses were restored although the historical documentation was at best scant. Therefore the intended reuse of salvaged fragments – jettisoned in

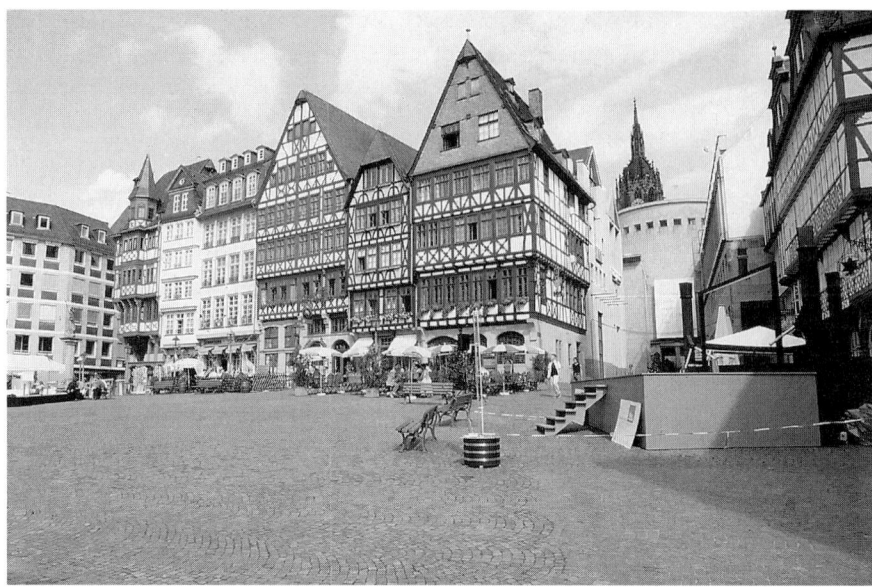

22 Reconstructed Ostzeile, Römerberg, Frankfurt. Visible in the background are the rotunda of the Schirn Kunsthalle and the spire of the Bartholomäuskirche

the end – was to lend authenticity and turn this part of the Römerberg into a living museum.[38] The pristine row screens the adjoining postmodern architecture. Seen from the side or the back it is revealed as a deliberate stage set that, according to Heinrich Klotz, resonates with the city's past but could never be confused with it.[39] However, such subtle irony is lost in the snapshots of thousands of tourists who pose before this picturesque backdrop and are likely to mistake the simulacrum for the real historic urban fabric. In an attempt to counter the city's bad image, boost its retail economy and increase its marketability as investment location, Frankfurt's centre became progressively more spectacular and commodified. This transformation, which generated a perfect habitat for the latter-day *flâneur*, is best captured in Guy Debord's words:

> Similarly, different star commodities simultaneously promote conflicting approaches to the organization of society; thus the spectacular logic of the automobile argues for a perfect traffic flow entailing the destruction of the old city centers, whereas the spectacle of the city itself calls for these same ancient sections to be turned into museums.[40]

Tied in with the spectacle of the commodified city theorised by Debord there was also a quieter exploration of its historic dimension, which had been ignored by functionalist post-war rebuilding. Aldo Rossi critiqued 'naïve functionalism' and drew attention to the city as a multi-layered, symbolic artefact.[41] He argued that 'memory becomes the guiding thread of the entire complex urban structure', which 'the concepts of *locus*, architecture, permanences, and history together help

us to understand'.[42] Advocating the *genius loci*, he proposed a link between the individual and the past premised on collective memory:

> The value of history seen as collective memory ... is that it helps us to grasp the significance of the urban structure, its individuality, and its architecture ... Thus the union between the past and the future exists in the very idea of the city that it flows through in the same way that memory flows through the life of a person[43]

Rossi's concept of the analogous city found a parallel in the urban experience of the *flâneur*, whose meanderings shifted evocatively between the present and the past. Even the soles of his shoes remember: 'In the asphalt over which he passes, his steps awaken a surprising resonance.'[44] These intricate notions of memory – collective and individual – provided an imaginative way of dealing with the city's post-war rootlessness, which in Germany's case was coupled with a desire to repress a dark chapter in its history. In this context, Gottfried Fliedl's perceptive analysis of the museum as an 'organ of memory' gains significance. While for Rossi and Benjamin the whole city is steeped in history which is accessible through individual remembering, Fliedl has argued that the museum's chief function lies in its ability to compensate for the destruction of the past. Compensation is 'a term, which attempts to capture the strange movement between continuity and break, destruction and conservation, forgetting and remembering'.[45] In its ambiguity and fluidity the act of compensation that the museum facilitates is akin to the forms of remembering represented by the analogous city or the ambling *flâneur*. After the continuous destruction of Frankfurt's urban fabric, the city was ready to acknowledge a deep crisis, and in its desire to reshape the urban map it wholeheartedly adopted the strategy of compensation. Consequently, the re-membering of the city was played out through the restitution and re-collecting of its museums.

The museum rediscovered and reinvented

The regeneration of Frankfurt's museum landscape formed part of the city's endeavour to remodel itself. The year 1969, which according to *Der Spiegel* marked the watershed in post-war urban policy, did not only see the beginning of inner-city pedestrianisation, it also witnessed a wide-ranging debate about the role of the museum, which claimed the attention of Frankfurt's daily papers.[46] In 1970 Hilmar Hoffmann took over the city's cultural department, where he remained until 1990. He brought a radical 'culture for all' approach to the job that sought to democratise access to traditional institutions of high culture such as the theatre, the opera and the museum. In 1972 – twenty-seven years after the end of World War Two – the Historisches Museum was the first municipal museum to be reinstated, on the south side of the city's main square, the Römerberg. A brutalist concrete box tacked on to a sequence of historic buildings was built to house the museum as well as the Kommunales Kino (an ambitious repertory cinema) and a restaurant. The controversial permanent displays, which contextualised objects in

a critical, historical narrative, exemplified the museum's new role as a place of learning. The heated debates over the reopened Historisches Museum marked an important shift in museological practices, from the museum as a temple dedicated to aesthetic contemplation to the museum as a means of communication.[47] The controversy also heralded a change in the fortunes of Frankfurt's long-neglected museums: finally they made headlines.

Hoffmann emphatically called for a 'democratic museum' that provided physical and intellectual access for ever larger sections of the population.[48] Aiming to make the museum an essential part of urban life, he introduced extended opening hours and promoted the staging of, for example, jazz concerts and plays to give people different reasons for going to the museum and to encourage return visits. By incorporating a wide range of cultural activities, the democratic museum seemed poised to deliver Frankfurt from its cultural limbo and enhance the quality of urban life. Hoffmann's progressive museum policy was validated by the recommendations made jointly by the Deutscher Städtetag (association of German cities) and the Kultusministerkonferenz (conference of secretaries of cultural affairs) in 1977. In their view, museums should be integral to the urban fabric, urging them to deploy the strategies of the marketplace and advertise their collections and activities through showcases and poster campaigns around the city.[49]

As part of Frankfurt's colossal transformation, its museums assumed a key role in municipal cultural politics. In the late 1970s, mayor Walter Wallmann launched the ambitious redevelopment programme for the city's dismal museum landscape contained in one 'magic' word: Museumsufer.[50] The project was fuelled by a number of conflicting motivations. It aimed to consolidate an eclectic and accidental accumulation of museums along the south side of the river on Schaumainkai. Simultaneously it sought to preserve Frankfurt's unique landscape of bourgeois suburban villas in their generous garden settings. During the previous hundred years a number of museums had come to be situated along the river. The Städelsches Kunstinstitut moved to its impressive neo-Renaissance building on the river front in 1878. In 1907 the Liebieghaus, the city's museum of sculpture, followed, which was installed in Baron von Liebieg's magnificent neo-medieval villa. From the late 1950s onward, the Deutsches Postmuseum (1958), Museum für angewandte Kunst – MAK (1965) and the Museum der Weltkulturen (1973), all displaced during World War Two, were rehoused in villas along the river. What had originally been considered an *interim* solution – marrying empty historic houses with collections in need of display space – was now to be made permanent and required sensitive architectural interventions. The gradual accumulation of museums along the river was consolidated with the foundation of DAM and the Deutsches Filmmuseum in 1979. Both institutions were hugely significant because they were the first of their kind in Germany and dedicated to media that seemed to defy classic museum treatment. They revealed the true scale of the reshaping of Frankfurt's museum landscape, which from the start focused on a national, if not international, perspective.

The ambiguities inherent in the ambitious museum project are beautifully cap-
tured in two documents commissioned by the city: the *Museumsentwicklungsplan* of
1979 and the *Gesamtplan Museumsufer* of 1980–81. The authors of the former were
mostly museum practitioners who viewed the situation of the municipal museums
largely from an internal perspective. They had been asked to review the current situ-
ation and assess the individual needs of Frankfurt's museums, which included
listing staff provisions and measuring the square footage of display and storage
spaces. Their report showed that not all of the municipal museums had regained
their pre-war levels of provision, in particular MAK, the Museum für Vor- und
Frühgeschichte and the Museum der Weltkulturen. Given this situation, the
authors were extremely critical of the city's intention to found several entirely new
museums such as DAM, the Deutsches Filmmuseum and the projected
Musikinstrumente-Museum (Museum of Musical Instruments). They feared that
such additional museums would aggravate the situation even further. They also crit-
icised the use of historic, domestic buildings for multi-functional museum purposes,
arguing that the necessary changes to their architectural fabric would be cost-inten-
sive and ultimately restrictive.[51] Although the report was predominantly inward-
looking and cautioned against the overbearing influence of external factors such as
reimaging the city and fostering a programme of urban reparation, its authors never-
theless made very pertinent suggestions for the improvement of Frankfurt's
museum landscape. Theirs was a vision that depended on dialogue and collaboration
to counter the fragmentary tendencies inherent in overly specialised museum collec-
tions. They recognised that the accumulation of museums on the south bank pro-
vided a unique chance to develop an urban 'cultural zone', but they also argued for
intellectual coherence and cultural diversity, warning against a complacent prolifer-
ation of museums.[52]

The *Gesamtplan Museumsufer* – presented by the Frankfurt-based architectural
practice Speerplan – shared the vision of the urban cultural zone. However,
Speerplan's analysis focused on the scheme's overall urban impact rather than on a
museum-led perspective.[53] In accordance with the recommendations made by the
Deutscher Städtetag in 1977, Speerplan emphasised the museum's urban role,
claiming that the strong individuality of Frankfurt's museums guaranteed diver-
sity and an ability to respond to the marketplace.[54] Speerplan considered the
suburban villas along the south bank as ideal locations for the municipal
museums. Their judgement, which contradicted the findings of the earlier
Museumsentwicklungsplan, was driven by the desire to preserve the south bank con-
sidered crucial for the city's reimaging campaign.[55] Although the museums added a
highly desirable cultural flavour to the Museumsufer, they fulfilled an even more
important function: museum-use safeguarded the area's historic, suburban ambi-
ence otherwise threatened by property speculation.[56] In their view, this strategy
would not only remedy the city's inadequate museum situation, but it would also
improve its national and international cultural ratings. Furthermore, the project
would offer a rich urban experience which also depended on measures such as

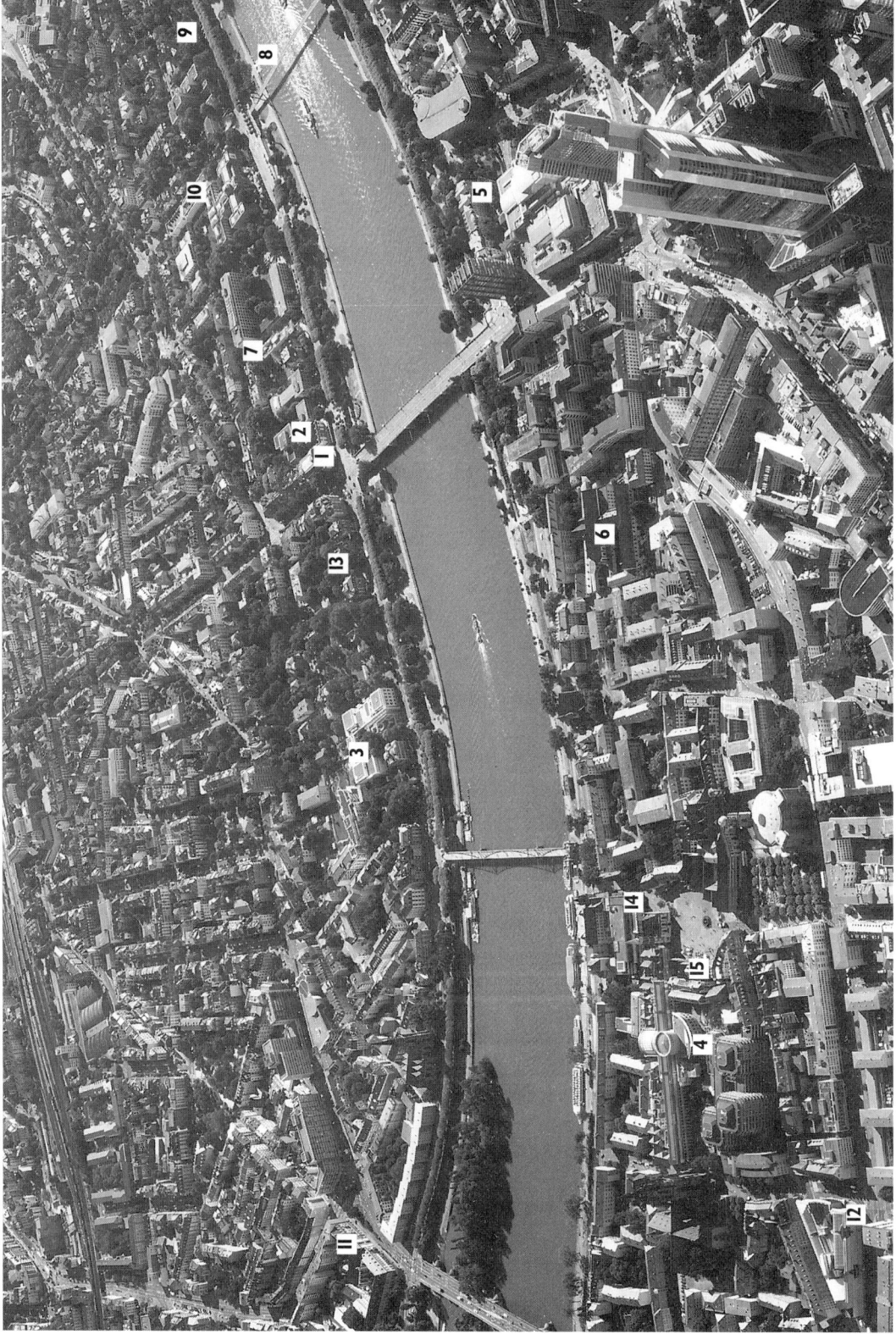

traffic calming, adequate parking provisions and sensible public transport links. If carefully managed, it also provided a truly awesome opportunity for museum architecture to transform the scarred city.

The Museumsufer: between marketplace, spectacle and *genius loci*

Due to its gargantuan scale, the Museumsufer was realised in several stages (see figure 23). The first stage was completed over a period of six years from 1979 to 1985; it included the foundation of the Deutsches Filmmuseum (1) and DAM (2), and the monumental extension of MAK (3). From 1983 onwards, while these three were nearing completion, attention shifted to the north side of the river where four new museum spaces were established: the Kulturschirn (4) for international travelling shows; the Portikus (just out of the picture to the left), a small contemporary art space; the Jüdisches Museum (5) installed in the Rothschild Palais; and the Museum für Vor- und Frühgeschichte (6), which moved to the restored Carmelite monastery. All of these developments were completed by 1987. During this period the main activity on the south side focused on the hi-tech extension of the Deutsches Postmuseum (7) opened in 1990. At the same time, Frankfurt's second pedestrian bridge, the Holbeinsteg (8), was completed to allow an unbroken stroll between the museums south and north of the Main. From 1987 onward efforts were divided equally between the two sides of the river. Between 1987 and 1991, the south side saw extensions to the Liebieghaus (9) and the Städelsches Kunstinstitut (10), and the establishment of the new Ikonenmuseum (11); on the north side the Museum für Moderne Kunst (MMK) (12) was built. Located at the heart of the Museumsufer, the Museum der Weltkulturen (13) was destined to be the final jewel in the crown. Building was scheduled to start in 1991; however, a drastic change in policy put the project on hold.

The first phase of Frankfurt's magical transformation displayed the full scope of its ambition. The two newly founded institutions – the Deutsches Filmmuseum and DAM – claimed national significance, while the limited competition for MAK demonstrated international calibre. The Deutsches Filmmuseum and DAM were installed in adjoining historic villas built at the turn of the century (see figure 24). Both buildings were gutted and their interiors completely redesigned. Helge Bofinger was responsible for the Deutsches Filmmuseum and Oswald Mathias Ungers created DAM's symbolic interior – the famous house inside the house that exemplified the fundamental laws of architecture and invoked Laugier's primitive hut. The two shared a specialist bookshop dedicated to film and architecture, and a

23 Aerial view of the Museumsufer, Frankfurt, 1997

(1) Deutsches Filmmuseum	(6) Museum für Vor- und Frühgeschichte	(11) Ikonenmuseum
(2) DAM	(7) Deutsches Postmuseum	(12) MMK
(3) MAK	(8) Holbeinsteg	(13) Museum der Weltkulturen.
(4) Kulturschirn	(9) Liebieghaus, Museum alter Plastik	Also visible are the Historisches Museum (14)
(5) Jüdisches Museum	(10) Städelsches Kunstinstitut	and the controversial Ostzeile (15)

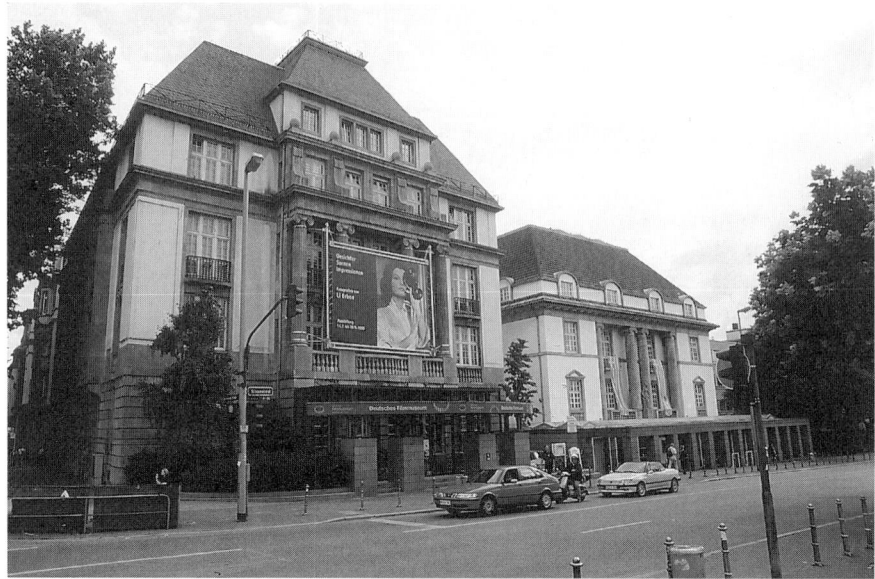

24 Left: Deutsches Filmmuseum, 1981–84; architect: Helge Bofinger.
Right: Deutsches Architekturmuseum, Frankfurt, 1981–84; architect: Oswald Mathias Ungers

café. The Deutsches Filmmuseum also inherited the Kommunales Kino, the repertory cinema previously housed in the Historisches Museum. Thus they continued the tradition of Hoffmann's democratic museum, aiming to incorporate a range of different functions to attract a wider audience. They also contributed to the safeguarding of the historic urban fabric on the south bank: the villa to house the film museum had been earmarked for demolition when the city council decided to step in. In the Festschrift published to mark the opening of DAM, mayor Wallmann summarised the twin aims of the Museumsufer: to improve the city's cultural infrastructure and to enhance its aesthetic qualities. He considered the whole project as principally an act of urban reparation and compensation intended to make Frankfurt 'beautiful once more, and loveable'.[57] In his contribution, Hoffmann presented the Museumsufer as a contextualised version of the democratic museum: the setting for pleasurable cultural and educational experiences that should encompass catering outlets, playgrounds and concert pavilions. In parallel with the Römerberg, the city's historical and cosy 'gut Stubb', he termed the location of the new museums along the south bank 'eine Art "grüne Stubb"' (a kind of green room/conservatory).[58] Hoffmann here invoked a local vernacular version of Benjamin's *flânerie* that had the power to give urban settings the intimacy of the domestic interior,[59] thus confirming the Museumsufer's affinity with the new urban concerns.

The architectural competition for MAK was held in 1980. Among the six architectural practices invited to participate were the Americans Richard Meier,

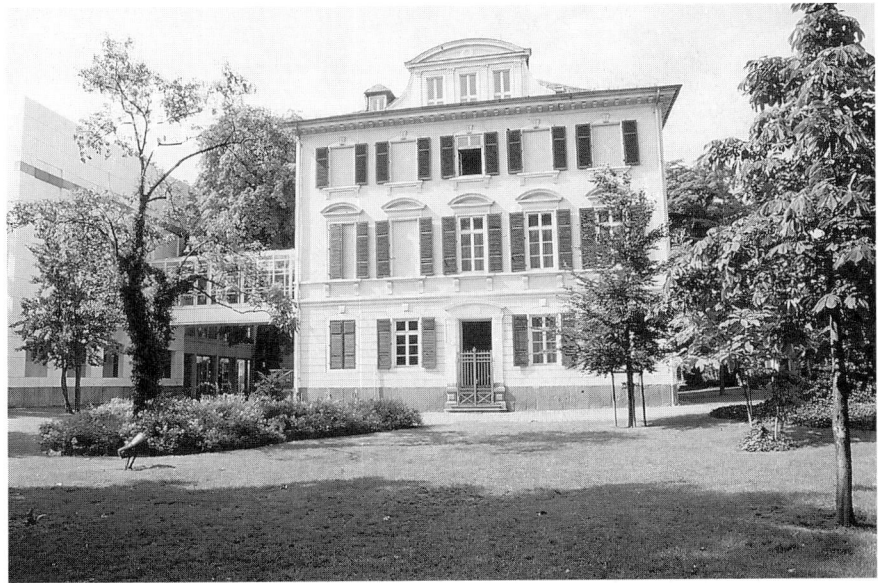

25 Villa Metzler, now part of the Museum für angewandte Kunst (MAK), Frankfurt, 1982–85; architect: Richard Meier

Venturi and Rauch, and the Austrian Hans Hollein.[60] The limited invitation together with the selection of the judging panel, which included Heinrich Klotz and the architect Josef Paul Kleihues, was an early indication of Frankfurt's transformation into 'the Eldorado of postmodernism'.[61] Since the 1960s, MAK had been housed in the Villa Metzler, a grade-one-listed, neo-classical building of intimate scale set in a landscaped garden (see figure 25).[62] The ensemble constituted an important architectural landmark. Given the complex topography of the site, the challenge therefore was how to integrate the substantial new building – capable of fulfilling the requirements of a modern museum as well as offering sufficient temporary and permanent display space – into this historically significant urban context.

Richard Meier's winning design was based on an L-shaped groundplan with three corner pavilions, whose floor measurements replicated those of the villa. The classicist solitaire thus became the fourth pavilion completing an imaginary square. Meier orchestrated a subtle dialogue between his uncompromisingly modernist architecture and the historic building, which simultaneously constructed the villa as independent of and integral to the new building.[63] However, despite such arithmetic reverence and the considerate positioning of the extension into the depth of the plot, the relationship between old and new is severely compromised in the visitor's experience. For the sake of smooth visitor circulation, a footbridge connects the villa to the main building at first-floor level, thus reducing the conceptual centrepiece of Meier's design to a mere appendage. Stripped of its

functional integrity, the Villa Metzler provides a picturesque *point de vue* to be glimpsed through the large windows along the ascending ramps of Meier's building (see figure 26).[64]

At the heart of the project lies an interesting paradox that reflects the diverging view points expressed in the *Museumsentwicklungsplan* and the *Gesamtplan Museumsufer*. The extension shows consideration for the urban context, but is far less respectful of the collections it was built to house. Meier's building is flirtatious, granting the visitor frequent vistas of the surrounding park, the villa and of itself, which is exactly what the architect intended.[65] It is the perfect habitat for the *flâneur* whose curiosity and historicising gaze would be gratified by such views. The vista – in the words of Rosalind Krauss – 'is simultaneously one of interest and of distraction: the serendipitous discovery of the museum as flea-market.'[66] By the same token, however, the building represents a curator's worst nightmare. Galleries flooded with daylight and littered with cumbersome show-cases and plinths – immutable features designed by the architect – make the display of light-sensitive objects difficult and changes to the layout impossible.[67] The museum, like the reurbanised city, internalises the *flâneur*'s stroll and creates an ambience reminiscent of the flea-market that takes place on the adjacent river front every Saturday morning.

Hailed as the cornerstone of the first phase of the Museumsufer, the building put Frankfurt on the cultural map and attracted considerable attention in the national press and in architectural journals. The official opening in April 1985 had

26 View of Villa Metzler glimpsed from the ramps inside MAK, Frankfurt

a distinctly international flavour: both the Federal President, Richard von Weizsäcker, and the American ambassador were present.[68] By the end of the year the museum welcomed its 300,000th visitor, with a photo shoot and a big bouquet.[69] In spring 1986 the local paper *Frankfurter Rundschau* could rave about the success of the 'Museumsbummel' – an undirected stroll akin to *flânerie*, which led from the Filmmuseum to DAM and on to MAK.[70]

Frankfurt's reimaging campaign also relied on other events which helped to contextualise the enterprise. In the inaugural exhibition in 1984, DAM drew extensively on its collections and brought recent trends in postmodernism to the attention of a broad public.[71] The show promoted postmodern architecture as the necessary revision of modernism and as a solution to the stalemate in contemporary architectural practice. The narrative of the exhibition culminated in Ungers' conceptual drawings for DAM displayed in the museum's symbolic centre. The show not only drew attention to Frankfurt's contribution to postmodernism it also attracted international interest and subsequently travelled to the Centre Pompidou.[72] To mark the opening of MAK in 1985, DAM staged a show on contemporary museum architecture in Germany, which helped to frame the city's recent achievements and drew attention to its growing collection of museums.[73] The sixth Deutscher Architektentag (German congress of architects) devoted to the topic 'Großstadt als Lebensraum' (metropolis as living space) was held in Frankfurt in October 1985 and predictably focused on recent achievements such as DAM, MAK, Römerberg and the Alte Oper.[74]

While three museums opened in quick succession on the south bank, the concept of the Museumsufer was being extended to the north side of the river. Here the multi-purpose Kulturschirn, which was to serve as a venue for international travelling shows, the Museum für Vor- und Frühgeschichte, the Jüdisches Museum and MMK were being planned.

The Museum für Vor- und Frühgeschichte, which moved to its new building in June 1989, represented a significant moment of urban reparation. The designated site was part of the former Carmelite monastery and included the church, which dated back to the late thirteenth century, but which had sustained severe war damage. In 1980, Josef Paul Kleihues won the competition with a sensitive design tracing in outline the lost contours of the monastery along Alte Mainzer Gasse (see figure 27).[75] The new galleries embraced the church and sheltered it from view behind the windowless façade. Inside the museum, the glazed north front reveals the church whose interior was transformed into the central display space and seamlessly joined to the new galleries (see figure 28). Minor lapses apart, Kleihues' design makes visible the historical layers accumulated on the site and evokes the *genius loci*.[76] The museum sympathetically reinterprets the historical setting and aims to compensate for the destruction by inviting the visitor to participate in an act of recollection that mediates between the past and the present. Kleihues described his design in words that recall Rossi's idea of the city.

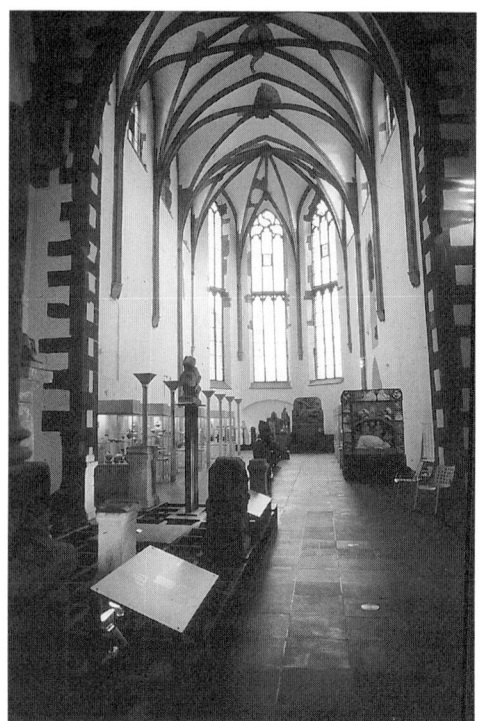

27 Exterior view of the Museum für Vor-
und Frühgeschichte, Frankfurt, 1985–89;
architect: Josef Paul Kleihues

28 Interior view of Museum für Vor- und
Frühgeschichte, Frankfurt

> What I intended with this programme for a critical reconstruction of the city, i.e. to
> retrace the steps of the recollection of the life-story of a town which the naïve plan-
> ning rationalism of post-war Modernism had attempted to wipe out, to reveal the his-
> torical structure, the demonstrative memory of the city as constructed reality and to
> work on them anew … For what I am looking for is the city and, by analogy, the
> Museum as a space for reflection.[77]

The analogy between the city and the museum is also implied in the interior where
'[t]he spatial grouping of the showcases results … in avenues'.[78] Once again, the
modes of display rely on urban patterns; however, the reinterpreted historical frag-
ment suggests a more complex form of *flânerie* than the gratification of the histori-
cising gaze afforded by the aestheticised Villa Metzler. It enables a remembering
that is analogous to the *flâneur*'s dreamlike and emotive rediscovery of the past
hauntingly described by Benjamin: 'The street conducts the flâneur into a vanished
time. For him, every street is precipitous. It leads downward … into a past that can
be all the more spellbinding because it is not his own, not private.'[79] As a site of his-
toric importance, the church lends symbolic depth to the museum and also invokes
classic resonances of museum visiting. The rediscovery of the past is facilitated by

the reinterpreted architectural fragment and the collection's strong local connota-
tions.[80] The museum thus proves a multi-layered organ of memory.

A most evocative example is the Jüdisches Museum – the first of its kind in
Germany – installed in the Rothschild Palais on the north side of the river. The
museum was founded in 1980 and was opened by Federal Chancellor Helmut Kohl
on 9 November 1988 to commemorate the 50th anniversary of the Nazi pogrom
known as Reichskristallnacht.[81] The date also recalled the Museum jüdischer
Altertümer (Museum of Jewish Antiquities) founded in 1922 and vandalised
during the pogrom along with a range of Frankfurt's Jewish institutions.[82] The
Rothschild Palais consists of two neo-classicist patrician houses – Untermainkai 14
and 15 – built in 1820–21 by Johann Friedrich Christian Hess, who had trained in
Paris with Durand (see figure 29).[83] In 1846 the Rothschild family bought the
house at no. 15 and commissioned Friedrich Rumpf to extend the building and
design lavish interiors. From 1895 it housed the Freiherrlich Carl von
Rothschild'sche öffentliche Bibliothek (public library), which expanded into the
adjoining house at no. 14 in 1906. After merging with the city library in 1928, the
Rothschild public library finally moved to the new premises of the Stadt- und
Universitätsbibliothek (city and university library) in 1967. Subsequently the
Historisches Museum shared the Rothschild Palais with the Frankfurter
Figurentheater (Frankfurt puppet theatre) and used it for temporary exhibitions
and as storage space for its extensive collections.

The sympathetic adaptation and restoration of the two buildings – carried
out by Ante Josip von Kostelac between 1985 and 1988 – reflects their dual past as
private residence and public institution.[84] While no. 15, the original Rothschild res-
idence, retains some of its impressive mid-nineteenth-century interiors, no. 14
has been more radically altered to accommodate a bookshop and café as well as

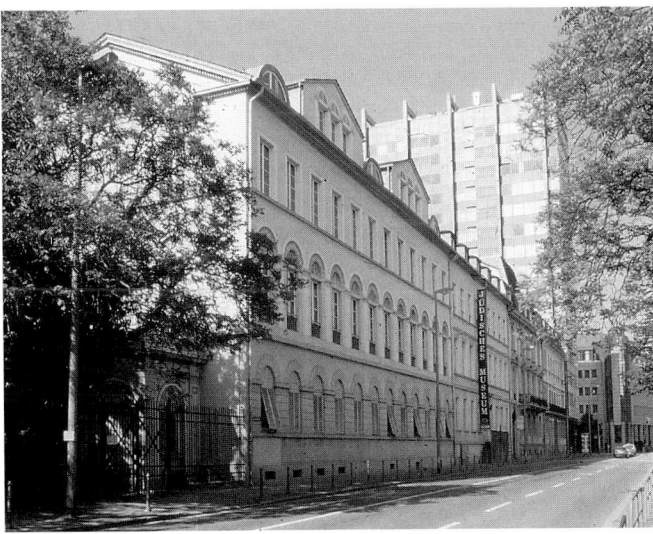

29 Rothschild Palais,
now Jüdisches
Museum, Frankfurt,
1985–88; architect:
Ante Josip von
Kostelac

permanent galleries (see figure 30). Thus the display spaces are very different in character: some are domestic and intimate; others modernist and purpose-built. The permanent display focuses on Frankfurt's Jewish community and traces its rich history while also sketching a general picture of Jewish life in Germany. The display addresses the atrocities of the Nazi regime and highlights the fate of Frankfurt's Jewish citizens, who are commemorated in a poignant roll call inscribed along the wall of the main corridor. The museum not only reveals the city's lost Jewish life, it also contributes to an understanding of the past and plays an active role in the Jewish community today. Despite its confusing layout, the Jüdisches Museum discloses hidden and repressed layers of Frankfurt's history. The close match between container and content – unlike most of the city's museums installed in historic houses – gives the displays added resonance. The re-use of the Rothschild Palais represents a complex act of urban reparation, which transcends the façadism of the Deutsches Filmmuseum and DAM.[85]

Opened in 1991, the Museum für Moderne Kunst (MMK) was the last major new museum on the north side of the Main and the only one that did not have to accommodate existing buildings.[86] Here the site itself provided the urban challenge: it is awkwardly shaped, bounded by two busy roads and devoid of significant historic resonances. Hans Hollein's building fills the entire triangular site and evokes a local architectural vernacular (see figure 31). With its rendered walls and red sandstone cladding it gestures across the street to the scarred houses of pre-war Frankfurt, whose ornate ground floors provide the base for sparse post-war rebuilding. In a further contextual effort, Hollein dramatised the awkwardness of the plot, using the building's sharp edge to mark the imaginary threshold of the lost medieval city.[87] While the exterior struggles to invoke a meaningful historic context, the interior provides spectacular spaces.[88] A large piazza-like atrium overlooked by balconies constitutes the central space (see figure 32). Two staircases give on to further intriguing views of the atrium and adjoining galleries. Hollein's interiors oscillate between concentrated intimacy on the top floor and more flexible, visually connected spaces on the other floors, which privilege the viewing of visitors over the focused viewing of the art on display (see figures 33 and 34). The interiors exude an

30 Staircase in the Rothschild Palais, now Jüdisches Museum, Frankfurt

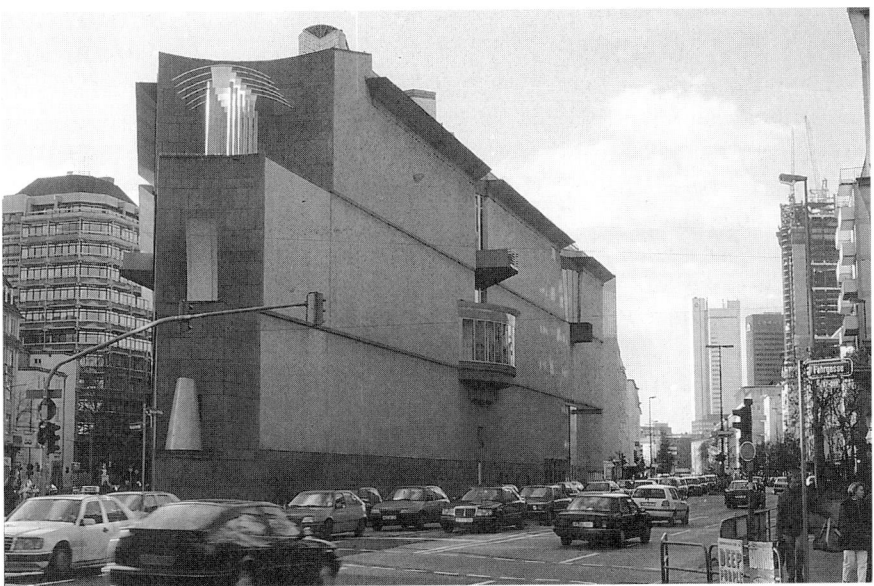

31 Exterior view of Museum für Moderne Kunst (MMK), Frankfurt, 1987–91; architect: Hans Hollein

urban flair that invites a *flâneur*-like con-
sumption of the space and the art: a dis-
tracted and disjointed window shopping
recreates the museum as spectacle.[89]
Although the museum invokes *flânerie* as the
preferred pattern it lacks the classic ingre-
dient: an evocative urban topography. To a
degree the exterior attempts to make up for
this by following the predominantly contex-
tual approach of Frankfurt's new museums.
However, the façade's historicising appliqué
is neither validated by the setting nor is it
particularly relevant for a museum dedi-
cated to modern and contemporary art. The
implicit criteria of Frankfurt's collection of
museums asserted themselves even in a situ-
ation that did not require them. This is a
classic incident of what Jean Baudrillard has
identified as the inertia driving the domi-
nant serial motivation of collecting, which
'take[s] precedence over the 'real' or dialec-
tical motivation in the identification of
preferences.'[90]

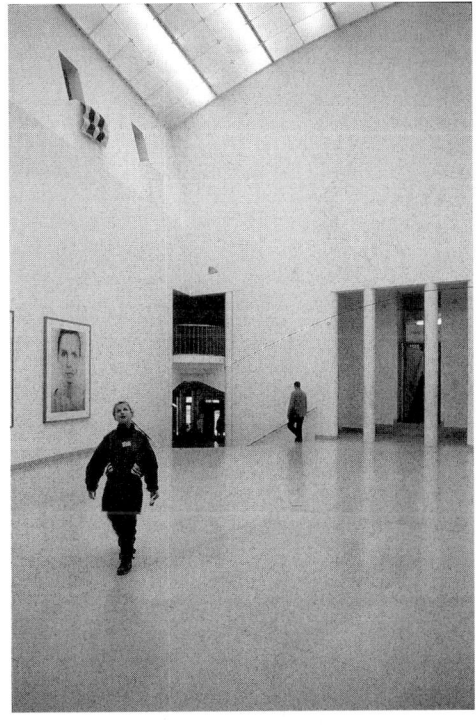

32 Central atrium of MMK, Frankfurt

33 View of ground-floor galleries, MMK, Frankfurt

34 View of first-floor galleries, MMK, Frankfurt

Serial motivation also dominated the planning stages of the Museum der Weltkulturen, the last municipal museum to be relocated on Schaumainkai in 1973. Installed in a villa a few hundred yards west of MAK it was to occupy a central position in the Museumsufer. In 1987 the local architects G. J. Meiler and Vural & Partner won first prize for their proposed extension of the Museum der Weltkulturen.[91] The design integrated three villas, underground display spaces and a large building at the back of the plot. In late 1988 the city council allocated funds for the new museum, and building was to begin the following spring.[92] However, a change in local government in 1989, which brought to power a social-democrat and green party alliance, precipitated a drastic change in policy. Mounting concern that the green spaces on the south side of the river were being eroded led to a review of the design.[93] As a result, Richard Meier won a limited competition and was asked to reapply the winning formula of his previous work for Frankfurt.[94] Although his proposal delivered less space than the museum required it saved more trees than those of the competitors did. However, just as with the previous competition winner, the very complex design was dictated by

the parameters of the Museumsufer and jeopardised the needs of the individual museum.[95]

The insistence on the location prevented an imaginative search for viable alternatives, which indicates the accelerated dynamic of serial motivation inherent in the criteria for Frankfurt's collection of museums. During the protracted planning process, the director of the Museum der Weltkulturen claimed that all he wanted was a large, simple box easily accessible by public transport.[96] However, his impassioned plea remained unheard. Although the *Museumsentwicklungsplan* had drawn special attention to the international importance of its collections and the inadequate conditions in which they were stored, the museum does not possess satisfactory display or storage spaces even today. The simple box that museum practitioners craved was realised in the Portikus (see figure 35). Since 1987 the unpretentious

35 Portikus, Frankfurt, 1987;
architects: Marie-Theres Deutsch and
Klaus Dreissigacker

space for contemporary art has been nestling behind the fragment of the neo-classical city library built by Hess in the 1820s and destroyed during World War Two.[97] The grand civic rhetoric of its columned portico, familiar from traditional museum architecture, ironically ennobles the decorated shed. The unlikely combination of the two also creates a moment of surprise, when one realises that the fragment is part of a functioning whole and not merely a façade. In its rawness and suggested impermanence, the disjuncture seems to capture a piece of the past.

Fairy-tale ending and happily ever after?

In 1990 DAM celebrated the city's new museum buildings with an exhibition entitled *Museum Architecture in Frankfurt 1980–1990*. The show presented the museums as an important collection of architectural set pieces and highlighted the substantial contribution they had made to improving the city's architectural fabric. Vittorio Magnago Lampugnani proudly claimed that other German cities were keen to follow the example.[98] It seemed the mayor's dream to make Frankfurt 'beautiful once more, and loveable' had come true. The exhibition signalled Frankfurt's cultural high watermark and was 'like a public relations event for the city's tourist board' according to one international reviewer.[99] With all projects but the Museum der Weltkulturen completed or nearing completion, Frankfurt

seemed to have achieved a truly magical transformation. In late 1989 the budget for the coming year projected an increase in spending on culture to 11.5 per cent, or a staggering 443.1 million Deutschmark; and eighty jobs were to be created in the museum sector alone.[100] This was a stupendous increase in the cultural budget over the past two decades from a mere 62.86 million Deutschmark in 1970 to 193.34 million in 1980, which more than doubled to 392.8 million by 1988.[101] Peter Iden, founding director of MMK, advocated the need to follow the massive expansion of Frankfurt's cultural infrastructure with a period of consolidation and inspired exhibition making.[102] However, Iden's timely call for consolidation reflected in the desire to create jobs and increase the cultural budget was overshadowed by larger events. During 1990 the true cost of German unification began to be felt. Frankfurt's national subsidies of about 60 million Deutschmark per year were withdrawn. At the same time the city was still recovering from the aftermath of the stock market slumps of 1987 and 1988. All of this was reflected in the cut of six million in the cultural budget during 1990 and in a projected zero growth rate of the city's total budget for 1991.[103] The exhibition intended to celebrate Frankfurt's museum landscape took place at a moment when the downward spiral had been set in motion irrevocably: playful expansion and seemingly unlimited growth in the cultural sector had come to an end.[104]

Hilmar Hoffmann's retirement in May 1990 marked the end of an era. His successor Linda Reisch was left to administer the gradual decline of Frankfurt's cultural scene. Between 1991 and 1994, the cultural budget was cut by 14 million Deutschmark, 33 jobs were axed and a further five frozen.[105] After the local elections in March 1993, the city's enormous deficit was finally brought to light, precipitating even more drastic adjustments.[106] In 1994 the cultural budget was cut by a further 43 million Deutschmark.[107] Municipal museums were no longer given funds for temporary exhibitions and publications. Entrance charges for the permanent collections were introduced, out of which activities such as exhibition and education programmes were to be financed.[108] Predictably, the introduction of entrance fees together with fewer temporary exhibitions not only resulted in a dramatic fall in visitor numbers of up to 40 per cent in the first quarter of 1994, but also destroyed the notion of *flânerie*, which depended on free access to the museums on the Main.[109] Jean-Christophe Ammann, the director of MMK, summarised the situation when he stated 'we are a museum that hasn't been thought through to its conclusion'.[110] This is true of the Museumsufer as a whole. Born in a climate of economic confidence the project showed little consideration for the increased long-term costs associated with the collection of museums.[111]

The Museumsufer was premised on the ambiguous concept of *flânerie* and internalised the urban modes of marketplace and spectacle. Consequently, the museum visitor was recast as the *flâneur* who was equally at home in the pedestrianised city centre or the museum. The museum also proved a flexible venue for an increasingly diverse range of cultural events. Furthermore, it not only enabled the reinscription of historical depth into the urban context but also functioned as a

tool of urban reimaging. However, the traces of memory woven into the sites to invoke the *genius loci* were at times superficial and feeble, hence the compensation that Frankfurt's museums effected was mostly aesthetic. The privileging of urban concerns also resulted in display spaces that were difficult to use from a purely curatorial perspective. With its string of safeguarded historic houses, dramatic extensions and essays in contextualised architecture, which displayed the dynamics of serial motivation, the Museumsufer proved a limiting concept. Nevertheless, Frankfurt's collecting and recollecting of museums contributed to the reordering of the urban fabric.

Like all collections, the Museumsufer represented a 'quest for comfort and reassurance' that hoped to put Frankfurt on the international cultural map and ensure its attractiveness to corporate investors. It is difficult to conclude whether this goal was achieved. According to a poll conducted by the magazine *Capital* in May 1989, which evaluated the quality of life that German cities offered top earners in industry, Frankfurt came fifth behind Düsseldorf, Cologne, Munich and Hamburg.[112] Compared with the large-scale image campaign carried out in 1979–80 in which Frankfurt got a disappointing 5.3 per cent of the votes for the ideal German city, the result was encouraging. Although hard to quantify, it seems that the museum collection contributed to the magical transformation of Frankfurt and helped to promote the fantasy of the secret capital. The strong investment in culture was intended to eradicate the city's bad reputation and complement the image of the financial capital with that of the cultural metropolis. In a recent issue of Buzz's in-flight magazine, for example, it was billed as 'the capital city Germany never had'.[113] The city's official website also plays on images such as the 'global village' and the 'capital of ideas', which emphasise its ambiguous status.[114] The desire to project Frankfurt as a symbolic capital was undeniably a strategy of compensation; some even claimed that it was over-compensation bordering on megalomania.[115] One such instance is Hoffmann's bracketed aside uttered in 1990: 'It remains to be seen whether Berlin, with the integration of the museum landscape of the once divided city, will become a serious competitor for Frankfurt.'[116] While there can be little doubt that Hoffmann's remark was over-optimistic, Frankfurt's cultural endeavours have nevertheless left their mark. When first considering Bankside power station as a site for Tate Modern, Nicholas Serota – daunted by the size of the building – recalled: 'then it occurred to me that if I was in Frankfurt or Cologne and saw this building and was told that it was being converted to be a Museum of Modern Art, I would not be surprised.'[117] His reference to Frankfurt would have pleased the authorities that commissioned the image report of 1979–80, which differentiated between the close-up and distant image the city desired to project. While a close-up view reveals a true case of the emperor's new clothes, a more distant perception has retained some intangible, Cinderella-like qualities of Frankfurt's magical transformation. The fictitious notion of the symbolic capital has been strong enough to inspire changes in the cultural landscape of one of Europe's leading cities.

I would like to thank Uwe Bennert, Almut Junker and Nicole Pohl for their comments on earlier drafts and for sharing their knowledge of Frankfurt's history, as well as Sarah Symmonds-Goubert and Mark Turner for helpful suggestions and for ironing out some linguistic idiosyncrasies.

Notes

1 The thirteen were, in chronological order: Deutsches Filmmuseum (German Film Museum), 1981–84, Helge Bofinger & Partner; Deutsches Architekturmuseum (DAM) (German Architecture Museum), 1981–84, Oswald Mathias Ungers; Museum für Kunsthandwerk, recently renamed Museum für angewandte Kunst (MAK) (Museum of Applied Arts), 1982–85, Richard Meier; Kunsthalle Schirn (Schirn Art Gallery), 1983–85, Bangert, Jansen, Scholz & Schultes; Deutsches Postmuseum (German Postal Museum), 1984–90, Günther Behnisch & Partner; Jüdisches Museum (Jewish Museum), 1985–88, Ante Josip von Kostelac; Museum für Vor- und Frühgeschichte (Museum for Pre-History and Early History), 1985–89, Josef Paul Kleihues; Portikus (Portikus Exhibition Hall), 1987, Marie-Theres Deutsch and Klaus Dreissigacker; Liebieghaus, Museum alter Plastik (Museum of Ancient Sculpture), extension, 1987–90, Scheffler & Warschauer; Museum für Moderne Kunst (MMK) (Museum of Modern Art), 1987–91, Hans Hollein; Ikonenmuseum (Icon Museum), 1988–90, Oswald Mathias Ungers; Städtische Galerie im Städelschen Kunstinstitut (Städel Art Institute), extension, 1988–90, Gustav Peichl. And finally the ill-fated Museum für Völkerkunde, recently renamed Museum der Weltkulturen (Museum of Ethnology, now Museum of World Cultures) originally part of the Museumsufer. However, it became the project's main casualty when Richard Meier's plans for extension were shelved in the early 1990s.

2 Charles Jencks, 'In the steps of Vasari: Charles Jencks interviews Heinrich Klotz', *AD*, 55 (1985), pp. 9–16; p. 10.

3 David Dunster, 'History city', *Architects' Journal*, 190:19 (1989), pp. 34–41 and pp. 46–55; p. 50.

4 Susan M. Pearce, *Museums, Objects and Collections* (Leicester: Leicester University Press, 1992), pp. 48–55 and pp. 68–88; see also Jean Baudrillard, 'The system of collecting', in John Elsner and Roger Cardinal (eds), *The Cultures of Collecting* (London: Reaktion Books, 1994), pp. 7–24.

5 Susan M. Pearce, *On Collecting: An Investigation into Collecting in the European Tradition* (London and New York: Routledge, 1995), p. 412.

6 Pearce, *On Collecting*, p. 10; Werner Muensterberger, *Collecting: An Unruly Passion* (Princeton: Princeton University Press, 1994).

7 Dunster, 'History city', p. 35.

8 Hans Erhard Haverkampf, 'Frankfurt: ein Aschenputtel-Mythos?', *Jahrbuch für Architektur* (1984), *Das neue Frankfurt*, vol. 1, p. 7.

9 Vittorio Magnago Lampugnani, 'The historical city: completion, reinterpretation, maintenance', in Lampugnani (ed.), *Museum Architecture in Frankfurt 1980–1990* (Munich: Prestel, 1990), pp. 9–12.

10 For a detailed account of post-war rebuilding, see Hans-Reiner Müller-Raemisch, *Frankfurt am Main: Stadtentwicklung und Planungsgeschichte seit 1945* (Frankfurt and New York: Campus Verlag, 1998); for a more political account, see Frolinde Balser,

'Frankfurt am Main in der Nachkriegszeit und bis 1989', in Frankfurter Historische Kommission (ed.), *Frankfurt am Main: Die Geschichte der Stadt in neun Beiträgen* (= Veröffentlichungen der Frankfurter Historischen Kommission, 17) (Sigmaringen: Jan Thorbecke Verlag, 1991), pp. 521–78.

11 Wolfgang Pehnt, 'Goethehaus versus Paulskirche. Wiederaufbau und Neugestaltung nach 1945', in Beat Wyss (ed.), *Bildfälle: Die Moderne im Zwielicht* (Zurich and Munich: Verlag für Architektur Artemis, 1990), pp. 127–36.

12 For a brief account in English, see Dieter Bartetzko, 'Money, mammon and the Frankfurt miracle', *World Architecture*, 3 (1989), pp. 52–5. For a detailed account of this period of unrest, see Carola Scholz, *Eine Stadt wird verkauft: Stadtentwicklung und Stadtmarketing – zur Produktion des Standort-Images am Beispiel Frankfurt* (Frankfurt: isp-Verlag, 1989), ch. 4, pp. 53–104; especially pp. 53–7.

13 Alexander Mitscherlich, *Die Unwirtlichkeit unserer Städte: Anstiftung zum Unfrieden*, special edition (Frankfurt am Main: Suhrkamp Verlag, 1996), p. 44 and p. 66 [my translation].

14 Hans-Reiner Müller-Raemisch, Joachim Peter and Erhard Weiß, *Frankfurt: Stadt in der Entwicklung*, Sonderdruck der Stadt Frankfurt am Main, Dezernat Planung und Bau (Basle and Berlin: Länderdienst Verlag, n.d. [1966–68]), pp. 77–8 [my translation].

15 Andreas Hansert, *Bürgerkultur und Kulturpolitik in Frankfurt am Main: Eine historisch-soziologische Rekonstruktion* (= Studien zur Frankfurter Geschichte, 33) (Frankfurt: Verlag Waldemar Kramer, 1992), pp. 34–5 and pp. 91–106. Focusing on the Städelsches Kunstinstitut, Hansert convincingly argues for the historic distinction between the museums set up by private initiative, which he traces back to the bourgeois culture characterising the Freie Reichsstadt, and the museums founded and administered by the city council.

16 For a useful summary of the post-war situation, see Birgit Weyel, *Ist Frankfurt eine amusische Stadt? Bildende Kunst und Kunstpolitik in Frankfurt am Main nach dem Zweiten Weltkrieg bis zum Ende der fünfziger Jahre* (Frankfurt: Peter Lang Europäischer Verlag der Wissenschaften, 1996), especially pp. 37–51.

17 *Ibid.*, p. 58. However, the full restoration of the Städelsches Kunstinstitut did not begin until 1959: see 'Ein Museum mit Weltruhm wird wieder aufgebaut', *Frankfurter Allgemeine Zeitung (FAZ)*, 4 June 1959, p. 10. It reopened in 1963: see Günther Vogt, 'Ein europäisches Museum in glücklicher Harmonie', *FAZ*, 11 November 1963. These and most subsequent newspaper references are taken from the press cuttings relating to museum and cultural issues that the Historisches Museum collected from the 1960s to 1995. This material is now held by the Institut für Stadtgeschichte; however, most cuttings do not give page numbers.

18 Hansert, *Bürgerkultur und Kulturpolitik*, pp. 253–5; Weyel, *Ist Frankfurt eine amusische Stadt?*, p. 39.

19 Günther Vogt, 'Zwanzig Jahre danach. Bürgerinitiative an der Spitze: Zur Situation der Frankfurter Museen', *FAZ*, 19 June 1964, p. 35; Eberhard Seybold, 'Wo sich Kunst und Geschichte begegnen', *Frankfurter Neue Presse (FNP)*, 19 August 1966; Johannes Grossmann, 'Dürer hinter Schloß und Riegel', *FAZ*, 28 December 1966, p. 23; Heinrich Heym, 'Frankfurter Museen hungern nach Licht, Luft und Ausstellungsräumen', *FAZ*, 7 October 1967; 'Frankfurter Museen – eine beengte Welt', *Frankfurter Rundschau (FR)*, 4 December 1969.

20 Jane Jacobs, *The Death and Life of Great American Cities* (New York: Vintage, 1961).

21 Nan Ellin, *Postmodern Urbanism*, revised edition (New York: Princeton Architectural Press, 1999), p. 155.

22 Gerwin Zohlen, 'Flaneure oder die Gegenwartsnarrheit der Schriftsteller', in Martin Wentz (ed.), *Stadtplanung in Frankfurt: Wohnen, Arbeiten, Verkehr* (Frankfurt and New York: Campus Verlag, 1991), pp. 177–83.

23 Walter Benjamin, *The Arcades Project* (Cambridge, Mass. and London: The Belknap Press of Harvard University Press, 1999), p. 427 and p. 448.

24 *Ibid.*, p. 446.

25 Zygmut Baumann, 'Desert spectacular', in Keith Tester (ed.), *The Flâneur* (London and New York: Routledge, 1994), pp. 138–57; p. 146.

26 Benjamin, *The Arcades Project*, p. 448; Werner Durth, *Die Inszenierung der Alltagswelt: Zur Kritik der Stadtgestaltung*, 2nd edition (Braunschweig and Wiesbaden: Friedrich Vieweg & Sohn, 1987), pp. 126–40.

27 *Ibid.*, pp. 41–9.

28 Benjamin, *The Arcades Project*, p. 801; see also Susan Buck-Morss, 'The flaneur, the sandwichman and the whore: the politics of loitering', *New German Critique*, 39 (1986), pp. 99–141; especially pp. 105–7.

29 Durth, *Die Inszenierung der Alltagswelt*, pp. 61–9.

30 'Zukunft verbaut – Wohnen in Deutschland' (cover story), *Der Spiegel*, 3 February 1969; quoted from *ibid.*, pp. 29–30.

31 Müller-Raemisch, *Frankfurt am Main: Stadtentwicklung und Planungsgeschichte*, pp. 336–79.

32 For a discussion of the critical reactions, see Durth, *Die Inszenierung der Alltagswelt*, pp. 140–1.

33 For a concise analysis of the report, see Scholz, *Eine Stadt wird verkauft*, pp. 66–72; this remained an ongoing issue: see Daland Segler, 'Kultur als Etikett', *FR*, 23 August 1990.

34 Scholz, *Eine Stadt wird verkauft*, pp. 73–8.

35 Müller-Raemisch, *Frankfurt am Main: Stadtentwicklung und Planungsgeschichte*, pp. 340–7; Lothar Juckel and Diedrich Praeckel (eds), *Stadtgestalt Frankfurt: Speers Beiträge zur Stadtentwicklung am Main 1964–1995* (Stuttgart: Deutsche Verlagsanstalt, 1996), pp. 90–2. For a brief English account, see Hans Erhard Haverkampf and Roland Burgard, 'Museums in Frankfurt-am-Main', *The International Journal of Museum Management and Curatorship*, 5 (1986), pp. 13–18.

36 Wilfried Ehrlich, 'Bauwerke im Dienst der Inszenierung von öffentlichem Raum', *FAZ*, 27 October 1984 [my translation]. For a critical analysis, see Peter Davey, 'Rationalism is not enough', *Architectural Review*, 182:10 (1987), pp. 71–4.

37 Scholz, *Eine Stadt wird verkauft*, pp. 82–6.

38 Rudi Arndt, 'Am Römerberg soll historisch gebaut werden', in Presse- und Informationsamt der Stadt Frankfurt am Main (ed.), *Zur Diskussion: Was kommt zwischen Dom und Römer* (Frankfurt am Main, 1975); quoted in Durth, *Die Inszenierung der Alltagswelt*, p. 97.

39 Heinrich Klotz, 'Das Neue Frankfurt', *Jahrbuch für Architektur* (1984), *Das Neue Frankfurt*, vol. 1, pp. 8–15; p. 14.

40 Guy Debord, *The Society of the Spectacle* (New York: Zone Books, 1995), pp. 42–3.

41 Aldo Rossi, *The Architecture of the City* (Cambridge, Mass. and London: The MIT Press, 1982), pp. 46–8.

42 *Ibid.*, p. 130.

43 *Ibid.*, p. 131.

44 Benjamin, *The Arcades Project*, p. 416.

45 Gottfried Fliedl, 'Testamentskultur: Musealisierung und Kompensation', in Wolfgang Zacharias (ed.), *Zeitphänomen Musealisierung: Das Verschwinden der Gegenwart und die Konstruktion der Erinnerung* (Essen: Klartext Verlag, 1990), pp. 166–79; p. 168 [my translation].

46 'Kulturpolitische Initiativen der FDP', *FAZ*, 21 April 1969; Eberhard Fiebig, 'Zwischen Kulturprotzerei und Anarchismus: Thesen zu einer neuen Funktion unserer Museen', *FR*, 14 June 1969; 'Werbung soll Museen füllen', *FR*, 3 July 1969; 'Raus aus dem Elfenbeinturm', *Nachtausgabe*, 3 July 1969; 'Museen sind nicht zum Bestaunen da', *FNP*, 7 July 1969; 'Museen haben den Anschluß verloren', *FNP*, 8 July 1969; 'Museumsdiskussion im Römer', *FAZ*, 8 July 1969; 'Das Museum der Zukunft soll lebendiger werden', *FR*, 8 July 1969; Günther Vogt, 'Frankfurter Museen noch ohne Zukunft', *Nachtausgabe*, 9 July 1969; 'Zehn Punkte zur Museumspolitik', *FAZ*, 13 September 1969, p. 34.

47 Frank-Olaf Brauerhoch, *Das Museum und die Stadt* (Münster: Westfälisches Dampfboot, 1993), pp. 83–5; Hilmar Hoffmann, 'Grußwort zur Jahrestagung des Deutschen Museumsbundes am 14. März 1974 in Frankfurt am Main', unpublished typescript, Institut für Stadtgeschichte. See also notice on the Arbeitsgemeinschaft der Frankfurter Museen: 'Museum und Öffentlichkeit', *FAZ*, 26 November 1970; Ellen Spickernagel and Brigitte Walbe (eds), *Das Museum: Lernort kontra Musentempel* (Giessen: Anabas-Verlag, 1976).

48 Hilmar Hoffmann, 'Das demokratische Museum', in Hoffmann, *Kultur für Alle: Perspektiven und Modelle*, extended and revised edition (Frankfurt am Main: S. Fischer Verlag, 1981), pp. 129–40.

49 Jochen von Uslar (ed.), *Kulturpolitik des Deutschen Städtetages: Empfehlungen und Stellungnahmen von 1952 bis 1978* (= Reihe C, DST-Beiträge zur Bildungspolitik, Heft 11) (Cologne: Deutscher Städtetag, 1979), pp. 102–3.

50 Gerhard Rohde, 'Ein Museumsufer für Frankfurt', *FAZ*, 1 December 1978. See also Walter Wallmann, 'Ein Ja zur Stadt: Fünf Schwerpunkte der Stadtentwicklung in Frankfurt am Main', in Juckel and Praeckel (eds), *Stadtgestalt Frankfurt*, pp. 45–51. For a selection of the press coverage, see Wiebke Fey, 'Der Museumspark am Main wird Wirklichkeit', *FNP*, 6 January 1978, p. 11; Hans-Helmut Kohl, 'Museumsufer: Jetzt warten auf den großen Wurf', *FR*, 20 August 1980; Wolfgang Peters, 'Eine enorme Chance für Frankfurt', *FAZ*, 31 July 1980, p. 27; Werner Strodthoff, 'Schöne Spaziergänge von Museum zu Museum', *Kölner Stadt-Anzeiger*, 13 December 1980. Amongst the first critical voices were: Eduard Beaucamp, 'Die Museumsträume drängen zur Entscheidung', *FAZ*, 12 February 1981; 'Störende Glieder in der Perlenkette', *FNP*, 12 March 1981; 'Der Kultusminister stellt Forderungen zum Museumsufer', *FAZ*, 17 October 1981; Ulrich Ritzel, 'Vielleicht bleibt nur eine Aneinanderreihung von Bauten', *FR*, 30 December 1981.

51 Margit Bauer, Herbert Beck, Arnulf Herbst *et al.*, *Entwurf für einen Museumsentwicklungsplan der städtischen Museen in Frankfurt am Main* (Frankfurt am Main: Dezernat Kultur und Freizeit, 1979), pp. 19–20 and pp. 44–5.

52 *Ibid.*, p. 39.

53 Speerplan, *Gesamtplan Museumsufer: Situationsanalyse, Oktober 1980*, 2nd, revised edition (Frankfurt: Der Magistrat, November 1980), p. 4. For a summary of the main ideas, see Juckel and Praeckel (eds), *Stadtgestalt Frankfurt*, pp. 106–9.

54 Speerplan, *Gesamtplan Museumsufer*, p. 20.

55 *Ibid.*, pp. 6–7.

56 *Ibid.*, pp. 16–17.

57 Walter Wallmann, 'Rede zur Eröffnung des Deutschen Architekturmuseums', in Deutsches Architekturmuseum (ed.), *Deutsches Architekturmuseum Frankfurt am Main: Festschrift zur Eröffnung am 1. Juli 1984* (Frankfurt am Main: Stadt Frankfurt am Main, Dezernat für Kultur und Freizeit, Amt für Wissenschaft und Kunst, 1984), pp. 5–10; p. 6 [my translation].

58 Hilmar Hoffmann, 'Erlebnisraum Museumsufer', in Deutsches Architekturmuseum (ed.), *Deutsches Architekturmuseum Frankfurt am Main: Festschrift zur Eröffnung am 1. Juli 1984* (Frankfurt am Main: Stadt Frankfurt am Main, Dezernat für Kultur und Freizeit, Amt für Wissenschaft und Kunst, 1984), pp. 13–18; p. 16.

59 Benjamin, *The Arcades Project*, p. 421.

60 For a good analysis of the competition and the strengths of Meier's design, see Kenneth Frampton, 'Richard Meier's Museum für Kunsthandwerk', in Der Magistrat der Stadt Frankfurt am Main (ed.), *Museum für Kunsthandwerk Frankfurt am Main*, third edition (Frankfurt am Main: Johannes Weisbecker, 1988), pp. 46–51; Frank Werner, 'Der Wettbewerb für das Museum für Kunsthandwerk in Frankfurt am Main', *Jahrbuch für Architektur* (1984), *Das neue Frankfurt*, vol. 1, pp. 22–52.

61 Frank-Olaf Brauerhoch, 'Das Prinzip Museum: Wechselwirkungen zwischen Institution und Kulturpolitik', in Brauerhoch (ed.), *Frankfurt am Main: Stadt, Soziologie und Kultur* (Frankfurt am Main: Vervuert Verlag, 1991), pp. 107–22; p. 107 [my translation].

62 In December 1967 it opened to the public: 'Ein altes Haus für schöne Dinge', *FAZ*, 16 December 1967; Manfred Müller, 'Auferstanden aus den Magazinen', *FR*, 27 December 1967.

63 Richard Meier, 'Architect's statement', in Der Magistrat der Stadt Frankfurt am Main (ed.), *Museum für Kunsthandwerk Frankfurt am Main*, 3rd edition (Frankfurt am Main: Johannes Weisbecker, 1988), pp. 63–80.

64 This criticism was voiced even before the completion of the building, Dieter Bartetzko, 'Statt Vorbild nur integrierter Bestandteil', *FR*, 19 March 1984, p. 15.

65 Meier, 'Architect's statement', p. 64.

66 Rosalind E. Krauss, 'Postmodernism's museum without walls', in R. Greenberg, B. W. Ferguson and S. Nairne (eds), *Thinking about Exhibitions* (London and New York: Routledge, 1996), pp. 341–8; p. 347.

67 Wilfried Ehrlich, 'Tempel der Baukunst in jungfräulichem Weiß', *FAZ*, 8 November 1984; Hanno Reuther, 'Das allerfliegendste Haus', *FR*, 25 April 1985; Arianna Giachi, 'Im Raum verlieren sich die Dinge', *FAZ*, 27 April 1985.

68 Claudia Michels, 'Fürs Kunsthandwerk ein Haus voll Licht', *FR*, 24 April 1985, pp. 9–10; Erich Helmensdorfer, 'Doppelfeier mit einem leicht verschnupften Meier', *FAZ*, 26 April 1985.

69 'Der 300 000. Gast kam eigentlich per Zufall', *FR*, 5 December 1985.

70 Clemens Kubenka, 'Ein Bummel der das Auge freut', *FR*, 7 April 1986.

71 The exhibition ran from 1 June to 10 October 1984. Heinrich Klotz (ed.), *Die Revision der Moderne: Postmoderne Architektur 1960–1980* (Munich: Prestel Verlag, 1984).

72 Wilfried Ehrlich, "'So Wundervolles haben wir noch nicht fertiggebracht'", *FAZ*, 30 May 1984, p. 49; Wilfried Ehrlich, 'Ein Frankfurter Ereignis wird international gefeiert', *FAZ*, 26 October 1984.

73 Heinrich Klotz and Waltraud Krase, *Neue Museumsbauten in der Bundesrepublik Deutschland / New Museum Buildings in the Federal Republic of Germany* (Stuttgart: Klett-Cotta, 1985).

74 Gerhard Bremmer, '6. Deutscher Architektentag', *Deutsches Architektenblatt*, 6 (1985), p. 759.

75 Der Magistrat der Stadt Frankfurt am Main (ed.), *Museum für Vor- und Frühgeschichte: Architekturwettbewerb für den Wiederaufbau. Eine Dokumentation des Hochbauamts der Stadt Frankfurt am Main* (Frankfurt: Hochbauamt, 1985); Wilfried Ehrlich, 'Der Entwurf für den Museumsneubau ist schon gefunden', *FAZ*, 3 December 1980.

76 Wilfried Ehrlich, 'Keine Vitrinen von der Stange', *FAZ*, 15 June 1989; Dieter Bartetzko, 'Die Frankfurter Mauer', *FR*, 24 June 1989. He was the first to point out the idiosyncratic exterior whose stripes invoked Frankfurt's neoclassical stock exchange destroyed during World War Two. For an altogether more hostile review, see Mathias Schreiber, 'Schwerthieb hinter der Klostermauer', *FAZ*, 1 July 1989.

77 Josef Paul Kleihues, 'Konzeption und Detail: conception and detail', in Der Magistrat der Stadt Frankfurt am Main (ed.), *Museum für Vor- und Frühgeschichte Frankfurt am Main* (Frankfurt am Main: E. Henssler KG Graphischer Betrieb, 1989), pp. 59–107; p. 63.

78 *Ibid.*, p. 102.

79 Benjamin, *The Arcades Project*, p. 416.

80 Walter Meier-Arendt, 'The Museum für Vor- und Frühgeschichte and its collections', in Der Magistrat der Stadt Frankfurt am Main (ed.), *Museum für Vor- und Frühgeschichte Frankfurt am Main* (Frankfurt am Main: E. Henssler KG Graphischer Betrieb, 1989), pp. 21–2; 'Fragmente bleiben erhalten', *FR*, 18 March 1986.

81 Claus Gellersen, 'Zeichen gegen das Vergessen', *FR*, 10 November 1988.

82 Hans Riebsamen, 'Ein Abglanz einstigen Reichtums', *FAZ*, 13 January 1989; Falk Jaeger, 'Das Jüdische Museum in Frankfurt am Main: Effekt und Aura', *Bauwelt*, 80 (1989), pp. 1478–84.

83 The houses originally served as residences for influential Frankfurt banking dynasties: no. 15 belonged to Joseph Isaak Speyer and no. 14 to Simon Moritz von Bethmann. See *Jüdisches Museum Frankfurt am Main* (Munich and New York: Prestel Verlag, 1997), pp. 7–9.

84 Ingeborg Flagge, 'Museum für Jüdische Geschichte', *Der Architekt*, 5 (1986), p. 214.

85 Claudia Michels, 'Oft eine schmerzliche Spurensuche', *FR*, 28 June 1989, comments favourably on the first six months of the museum's existence and the services it has rendered to the community in reclaiming an important part of Frankfurt's past.

86 Arguably this is also true of the Kulturschirn; however, it was always conceived as part of a larger rebuilding scheme.

87 Hans Hollein, 'Das neue Museum für Moderne Kunst in Frankfurt am Main', in Museum für Moderne Kunst (ed.), *Museum für Moderne Kunst Frankfurt am Main: Publikation zum Richtfest am 13. Juli 1988* (Frankfurt: Amt für Wissenschaft und Kunst, 1988), pp. 10–11; p. 10.

88 The building attracted a range of favourable reviews: Eduard Beaucamp, 'Kunst im
 Dreieck', *FAZ*, 5 June 1991; Peter Iden, 'Ein Haus für das veränderlich Dauernde',
 FR, 1 June 1991, p. ZB 3.

89 This was already noted at the opening: Verena Auffermann, 'Ein Haus mit vielen
 Zimmern fürs Denken und Sehen', *FR*, 8 June 1991; Matthias Schreiber, 'Das schräge
 Kunstschiff', *FAZ*, 8 June 1991.

90 Baudrillard, 'The system of collecting', p. 23.

91 'Luftige Fassade, harter Rücken', *FAZ*, 10 March 1987.

92 'Neubau für das Völkerkunde-Museum', *FAZ*, 28 November 1988; '80 Millionen für
 Völkerkunde', *FR*, 27 December 1988.

93 This debate had been going on since 1987: see 'Protest gegen Museumsbauten', *FR*,
 16 March 1987; 'Widerstand gegen den Erweiterungsbau wächst', *FR*, 8 May 1989;
 'SPD und Grüne wollen den Park erhalten', *FAZ*, 20 May 1989, p. 43; 'Umdenken beim
 Museumsbau', *FR*, 23 May 1989; 'Protest gegen Ausbau des Völkerkundemuseums',
 FR, 24 May 1989; Johann Michael Möller, 'Baumhaus', *FAZ*, 4 July 1989.

94 'Trotz Neubau wird der Museumspark gerettet', *FAZ*, 26 September 1989;
 'Neubauten entstehen am Rande des Parkes', *FR*, 22 December 1989.

95 This opinion was already voiced at the announcement of the competition results:
 Johann Michael Möller, 'Ein neues Aushängeschild städtischer Kulturpolitik?', *FAZ*,
 6 March 1987; for a good short summary of events, see Brauerhoch, *Das Museum und
 die Stadt*, pp. 97–100.

96 Quoted in Frank-Olaf Brauerhoch, 'Statt nebeneinander zu liegen, müßten die Perlen
 verknüpft werden', *FR*, 10 August 1991.

97 It was designed by the local architects Marie-Theres Deutsch and Klaus
 Dreissigacker. The Portikus is administered by the Städelschule whose then director,
 Kaspar König, initiated it.

98 Vittorio Magnago Lampugnani, 'Preface', in Lampugnani (ed.), *Museum Architecture
 in Frankfurt 1980–1990*, p. 7. For a useful assessment of the cultural changes in
 Frankfurt published in English, see David Galloway, 'From Bankfurt to Frankfurt: a
 cash & carry renaissance, *Art in America*, 75 (1987), pp. 152–9.

99 Layla Dawson, 'Museum Fest', *Building Design*, 1008 (19 October 1990), pp. 32–3;
 p. 32. for an uncritically favourable review, see also Paulgerd Jesberg, 'Das Frankfurter
 Museumsufer', *Deutsche Bauzeitschrift*, 38:10 (1990), pp. 1356–7.

100 'Die Stadt Frankfurt wird 1990 mehr denn je für Kultur ausgeben', *FR*, 7 December
 1989.

101 Scholz, *Eine Stadt wird verkauft*, p. 86 and p. 141.

102 Peter Iden, 'Kulturpolitik am Wendepunkt', *FR*, 3 November 1989, p. 22; see also
 Hendrik Markgraf, 'Kein Grund zur Eile', *FAZ*, 21 August 1989.

103 Claus-Jürgen Göpfert, 'Kämmerer signalisiert für 1991 "Nullwachstum"', *FR*, 23
 August 1990, pp. 9–10; Clauss Gettersen, 'Zinsen drücken den Etat', *FR*, 5 October 1990.

104 As early as autumn 1990, Peter Iden warned of the dangers of cutting Frankfurt's cul-
 tural provisions: Peter Iden, 'In Schräglage: Zur neuen Frankfurter Kulturpolitik',
 FR, 19 October 1990; Claudia Michels, 'Museen heute: Gehobenes Lebensgefühl oder
 Spirale nach unten?', *FR*, 25 August 1994; Sylvia Staude, '"Wir bekommen es mit der
 Angst zu tun"', *FR*, 30 May 1995; Hans Riebsamen, 'Zusammenlegung von Museen:
 Reisch und Direktoren winken ab', *FAZ*, 27 December 1995; Hendrik Markgraf, 'Ein
 launisches Jahr', *FAZ*, 30 December 1995.

105 Figures quoted in Konstanze Crüwell, 'Hinterher trinkt er gern eine Tasse Kaffee', *FAZ*, 9 December 1994; 'Mehr Ausstellungen im Städel und die Schirn als "Schaufenster"?', *FAZ*, 29 November 1992, p. 9; this article reported the depressing results of an opinion poll conducted among Frankfurt's museum directors and cultural administrators. For comments on Linda Reisch's plans, see Sylvia Staude, 'Karg, konzentriert, qualitativ hochwertig', *FR*, 15 March 1993.

106 'Wider grüne Illusion und inkompetente Politik', *FAZ*, 17 May 1993, p. 41; Michael Hierholzer, 'Aus dem kurzen Kunststadt-Traum erwacht', *FAZ*, 18 April 1993, p. 25; Gerhard Rohde, 'Ist Kultur zu groß für Frankfurt?', *FAZ*, 6 May 1993.

107 '47 Millionen weniger für Kultur', *FAZ*, 21 October 1993; 'Das kulturpolitische Streichkonzert', *FAZ*, 23 October 1993, p. 45; Michael Hierholzer, 'Mogelpackung', *FAZ*, 28 October 1993; 'Wir brauchen mehr Liebe zur Kultur in dieser Stadt', *Frankfurter Allgemeine Sonntagszeitung*, 16 January 1994, p. 27.

108 The debate over entrance fees had been going on for some time and Hoffmann had rejected individual charges in favour of a season ticket. Hilmar Hoffmann, 'Eintrittsgeld – eine Strafexpedition für Lernbegierige', *FAZ*, 10 May 1992; see also 'Paß für den Museumsbummel', *FR*, 8 May 1993; 'Frankfurter Museen verlangen von Januar an Eintrittsgeld', *FAZ*, 27 November 1993, p. 45; 'Mittwochs ist der Eintritt frei', *FR*, 29 December 1993; Michael Hierholzer, 'Kultur hat ihren Preis', *FAZ*, 1 May 1994, p. 25; 'Erheblicher Besucherrückgang', *FAZ*, 12 July 1994; Claus-Jürgen Göpfert, 'Der Eintritt hat seinen Preis: weniger Besucher', *FR*, 12 August 1994; 'Ja, wo bleiben sie denn – die Besucher der Museen?', *Frankfurter Nachrichten*, 4 January 1995; 'Palmengarten und Zoo legen zu', *FAZ*, 12 August 1995; 'Weniger Besucher in Theatern und Museen', *FAZ*, 23 December 1995. For accurate visitor figures, see Amt für Statistik, Wahlen und Einwohnerwesen (ed.), *Statistisches Jahrbuch Frankfurt am Main*, published annually.

109 An interesting study based on questionnaires and interviews conducted between March 1993 and February 1994 confirmed that the concept of *flânerie* was indeed working. The average respondent visited several museums, combining that with shopping and eating into a whole-day activity. Frank-Olaf Brauerhoch, Oliver Brüchert, Christine Resch, Heinz Steinert, *Die Frankfurter Museen und ihr Publikum: Eine Untersuchung an zehn städtischen Museen* (Frankfurt: Johann Wolfgang Goethe Universität, 1994), pp. 5–6.

110 Quoted from Claus-Jürgen Göpfert, 'Harte Zeiten für Museen', *FR*, 21 October 1993, p. 21.

111 A statistic showed that Frankfurt had the largest deficit of any German city: 6.7 billion Deutschmark, or 10,152 Deutschmark per capita. 'Frankfurts Spitzenplatz bei den Schulden', *FAZ*, 16 September 1994, p. 67.

112 The results were analysed in: 'Nur beim Geldverdienen Spitze', *FAZ*, 30 May 1989.

113 *the rough idea*, summer 2000 (Bishop's Stortford: MBS Advertising Limited in conjunction with The Partners and Rough Guides Ltd, 2000), p. 17.

114 www.frankfurt.de/sis/Stadtportrait.html.

115 Scholz, *Eine Stadt wird verkauft*, p. 106.

116 Hilmar Hoffmann, 'Frankfurt's new museum landscape', in Lampugnani (ed.), *Museum Architecture in Frankfurt 1980–1990* (Munich: Prestel 1990), pp. 13–20; p. 15.

117 Karl Sabbagh, *Power into Art: The Making of Tate Modern* (Harmondsworth: Penguin Books, 2001), p. 5.

On the beach: art, tourism
and the Tate St Ives

Chris Stephens

To locate a display of art works in the place where they were made is to suggest a particular relationship between them and that place. In the case of St Ives, one can see the various aspects of that relationship indexed in the form and function of the Tate Gallery. My intention here is, firstly, to consider the way in which the architecture of the Tate St Ives effects the reception of the art works it displays, locating them within a particular historical narrative. I want to go further, however, and suggest that it also frames a representation of the town St Ives that is partly determined by the imagery of the art and which helps fix that art in a particular interpretive framework. The gallery sets 'St Ives' art and the town of St Ives in conjunction, for which its architecture – by which I mean not only its physical make-up and visual characteristics, but also its siting – is a key means of mediation.

Rather than simply analyse the gallery's relationship to its contents in terms of text and context, I want to see the whole – the art works framed by the building within the space of the town – as a continuous discourse.[1] I wish, further, to consider the relationships within that discourse, which go beyond the visual to encompass the ideological, economic and cultural. In particular, I shall demonstrate how the Tate St Ives is the latest of high culture's series of interventions in local tourism and, as such, is, typically, defined and largely received by a constituency from without the spaces of St Ives. The 'St Ives' discourse embodies a complex matrix of inter-relations – between the so-called 'artist's colony' and the town, the town and the gallery, the metropolitan centre and the periphery, the state and the region, art and tourism. That complex is informed by and inscribed in the architecture of the Tate St Ives.

The Tate follows previous histories of 'St Ives' by placing a 'locational priority' upon the interpretation of the works on display, seeing 'St Ives' art as determined by the topography of the town and the surrounding landscape. However, rather than landscape, it is more instructive to consider the work in terms of the concept of place – meaning, not simply a geographical locale, but also associated socio-economic and historical processes and a 'structure of feeling' commonly signified as 'a

sense of place'.[2] Drawing upon theories of place is especially appropriate for two
reasons. Firstly, the gallery's representation of St Ives, the town, serves to con-
struct a particular 'place-image', the result, in Rob Shields's definition, of the ele-
vation of a place 'from the world of real space relations to the symbolic realm of
cultural signification'.[3] Secondly, the Tate reinserts 'St Ives' art into the town's
economic and cultural processes, demanding a conception of the art's relationship
with the town that is more than simply visual. The Tate does not just reiterate the
image of the town already postulated by painted representations, it unites that
imaging and the space of the town within a single construct.

Since its opening in 1993, the Tate St Ives has received considerable attention, not
least for its dramatic position over-looking Porthmeor Beach on the north-west
side of the town (see figure 36). Its shape – long and thin and rising sharply – was
dictated by the site, hard against a cliff, which, though derelict for some time, had
for many years housed the town's gasworks. This was not the only site to be consid-
ered for the gallery, however, and the range of alternative options is indicative of
some of the concerns that underpinned the establishment of the Tate. Equally, the
choice of this dramatic position, despite the considerable practical problems it
posed, reveals some of the values that informed the final conception of the gallery
and its displays. Potential sites included several outside St Ives, a disused Victorian

36 View of Tate St Ives, 1991–93; architects: Eldred Evans and David Shalev

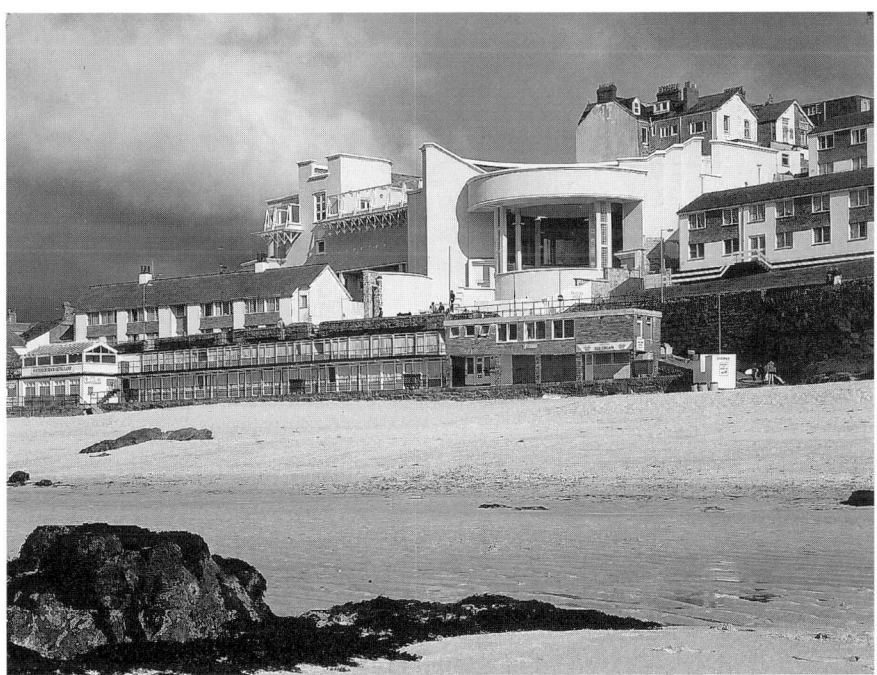

school on the town's western approach, open land above the town and adjacent to its main visitors' car park, a recreational area beyond the current site and a disused garage in the heart of old St Ives, which was particularly highly rated as it was positioned within an area that had for some time been associated with artistic production and display.[4] A feasibility study was commissioned from the architects Katherine Heron and Julian Feary, who had personal associations with 'St Ives' art, the former being the daughter of painter Patrick Heron and the partnership having designed the Pier Art Centre in Stromness, where the collection is dominated by the work of Ben Nicholson, Barbara Hepworth and others. It was Heron and Feary who proposed the gasworks site as a possibility, later observing that '[t]he potential is there to create a new building with panoramic views, totally relevant to the art shown within the museum'.[5] As Heron and Feary's observation suggests, the Tate St Ives project and design was unusual in the prominence given from an early stage to specific works of art and their perceived relationship with the building's environment. The gallery might be seen to emerge from a dialectic of the art objects and the nature of the building's position – the spaces of the town and the views from the site. The architects' brief, drawn up by Cornwall County Council in 1989, incorporated reproductions of paintings and sculpture from the catalogue of the Tate Gallery's 1985 St Ives exhibition as well as panoramic photographs of the view across Porthmeor Beach and the town's rooftops. Among the few prescriptions placed on the design was the advice that '[i]t should be equally attractive to the art enthusiast and to the family on holiday ... The view from the site is considered to be a major asset ... It is important that the building has a "cheerful" atmosphere.'[6] The priority placed upon the prospect from the site was reflected in the suggestion that 'the café may be on an upper floor in order to take advantage of the views'.[7]

The architects David Shalev and Eldred Evans were chosen from five invited submissions. The partnership had recently designed the award-winning Crown Court at Truro and much was made of their local connections: Evans's father, the painter Merlyn Evans, had had a flat in St Ives, which the couple still owned, and his daughter knew many of the artists whose work would be on display. In Evans and Shalev's self-definition one could hear strong echoes of the dominant construction of 'St Ives' artists: '[s]ingle-minded modernists with a conviction that a building, built to last, is rooted in its time and place.'[8] From the outset, they foregrounded the relationship between the town, the gallery and a particular interpretation of the art objects it would display: 'The experience of visiting the gallery ought to be a natural extension to visiting St Ives', they said, 'and thus provide some insight into the artists' inspirations and aspirations on this remote and magical island.'[9]

In plan, the Tate St Ives is an oblong running along the narrow site and ending in a large round loggia, which opens out westward and provides a grand entrance to the building. The ground floor is given over to circulation areas and storage, the galleries are on the first floor and the structure is topped with the café and roof terrace. The design shares several features with Truro Crown Court: a large circular

area, a finish of white marble chippings to the exterior walls and the use of glass bricks. Despite these precedents, the gallery's form and styling echo, and so serve to reiterate, a particular interpretation of the work it displays. As the architects predicted, this also contributes to the mediation of the gallery's position within its physical, cultural and economic environment. 'The building stems', we are told, 'from the same modernist search for naturalness and honesty of materials that inspired Leach, Hamada, Nicholson, Hepworth and Gabo' – some of the leading figures in 'St Ives' art histories.[10] A naturalised modernism is indicated by the texturing of the white walls – an implicitly human touch on an anonymous surface – reminiscent of the modulations of finish on Ben Nicholson's white reliefs of the 1930s. Like Nicholson's textured surfaces, Leach's pots and Hepworth's 'truth to materials' aesthetic, the building falls within a trajectory of modernism based on individual craft. Similarly, while the design of such details as the banisters refers back to the early modernism of Charles Rennie Mackintosh, their gentle limed wood inevitably evokes Peter Fuller's description of Kettle's Yard in Cambridge as a celebration of 'the sort of subtle pleasures – well-washed pebbles, scrubbed driftwood, white limestone and gentle pictorial illusions – which St Ives, at its best, had embodied.'[11] One commentator observed of the Tate, '[t]his is a building rooted not only in its context, but also, hauntingly, in the Arts and Crafts tradition.'[12]

The typical presentation of the art of 'St Ives' as a pragmatic modernism, in which the modern is combined with a rooted regional English culture, is thus reinforced by the fabric of the Tate. Like the artists, the gallery needs local validation and this is reflected in its supposed derivation from the spaces of the town. The architectural style and detailing announce its search for a synthesis of modernist and vernacular traditions and vocabularies. According to the architects, the building, 'relates to the works it exhibits in that both are inspired by St Ives and the peninsula' of West Penwith.[13] The gallery, which is designed to nestle in and continue the shapes and spaces of the town while also commanding panoramic views of the sea, combines its white walls with traditional local materials such as slate and granite. Its form, similarly, conjoins local and modernist references: a functionless granite 'window' that protrudes at the entrance echoes the derelict engine houses of the disused tin mines that pepper the surrounding countryside. The rotunda that dominates the gallery resonates with the seaside modernism of Mendelsohn and Chermayeff's De La Warr Pavilion in Bexhill (1935), as do internal details, such as the curving staircase. However, the frontage more literally echoes the gasometer that previously occupied the site – signalling at once continuity and renewal.

A relationship with the town is continued in the galleries themselves. For most of the exhibition spaces the archetypal modernist white box, with all its implicit claims of objectivity and flexibility, seems to have been adopted, but in fact the forms of the rooms carry obscured associations. According to the architects and the director, Gallery 1 lends itself, 'to an introduction to the St Ives School'.[14] Galleries 3 to 5 are similar, though each has its own scale and quality of light. None, we are

told, is larger than one of the nearby Porthmeor Studios which, under the occu-
pancy of the likes of Ben Nicholson, Terry Frost and Patrick Heron, were the site
of the production of a number of the works on display.[15] Again, the architects' claim
to local knowledge is important because, as a result of their familiarity with St Ives
and its painters and sculptors, '[t]he light and space of the different studios, and
associated memories of the differing personalities of the artists, informed their
designs.'[16] Thus, it is implied, the works may be seen here in an authentic setting as
the replication of the conditions of their production offers a privileged insight into
them.

The varying quality of light in the galleries reflects the way it is fetishised
throughout the building. It fills the large glazed cylinder at the heart and, on
entering the Tate, one passes through a lobby bathed in colour from Patrick
Heron's stained-glass window to a light-filled rotunda. The centrality of light
recalls the association of seaside, sunlight and health that informed the design of
buildings such as the De La Warr Pavilion. It also relates to the repeated assertion
of the importance of Cornwall's unique 'quality of light' to the art works produced
there. While we may see that belief as an artificial construct, the privileging of light
in the architecture implicitly establishes the gallery as the place to see the works in
the right conditions. That emphasis also reinforces the familiar association of St
Ives with the Mediterranean, typified by the epithet The Cornish Riviera. That
that association is extended to the artists is demonstrated by the comparison of
Heron's lobby to Matisse's chapel at Vence.[17] Thus, one can see a two-way relation-
ship by means of which the art of 'St Ives' is located within a modernist tradition
and the town is projected as sunny and exotic. However, the display is set between
and interrupted by dramatic views of the building's surroundings. Having
ascended two levels, as one approaches the first gallery, a window frames a view of
the sea and sky. From the 'introduction to the St Ives School', one emerges into the
huge, open Gallery 2, a semi-circular space set around the circular loggia and
offering panoramic views of the beach and cliffs beyond from its glazed external
face (see figure 37). Here the large gestural, semi-abstract canvases of Lanyon,
Heron, Frost et al. and the sculptures of Hepworth and her followers are off-set by
sand and surf. On a raised level, the view is shared by a long cabinet in which the
ceramic work of Bernard Leach and others is on display. If the location of the Tate
within St Ives were not sufficient, this dramatic space fixes the natural environ-
ment as a determinant in the cultural production of the town. As one reviewer
observed:

> On the balcony, with the long curving display of St Ives pots behind you, you get the
> most dramatic view of all and it is particularly moving to see the pots with such a
> backdrop. To look at the blue-grey shimmering horizon, as Leach did daily from his
> study window, is to understand something of what his pots were about.[18]

This is the focal point of the presentation from which the other galleries radiate,
but one reaches the climax of one's journey through the building by ascending

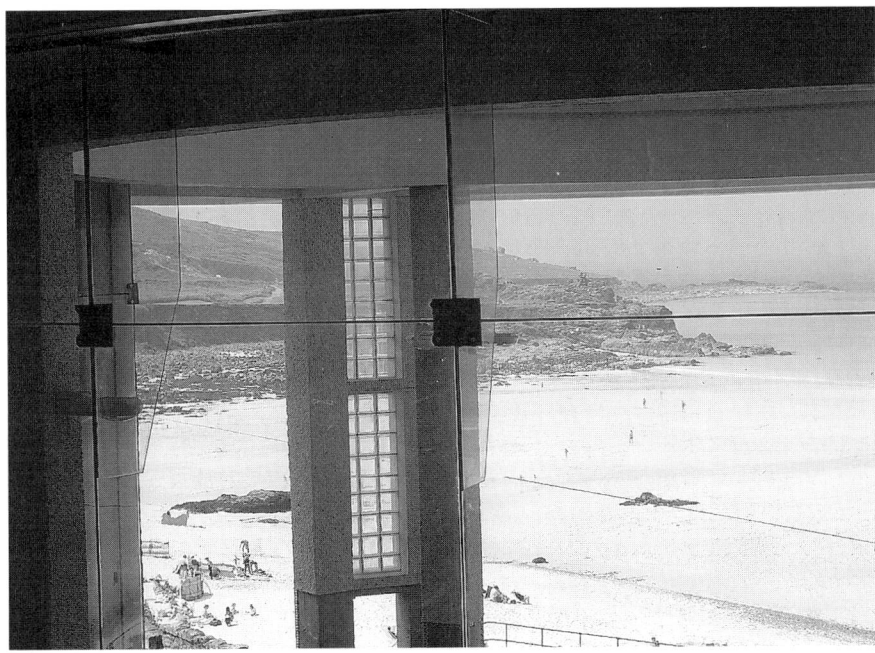

37 View from upstairs galleries across the beach, Tate St Ives

38 Ben Nicholson, *1943–45 (St Ives, Cornwall)*

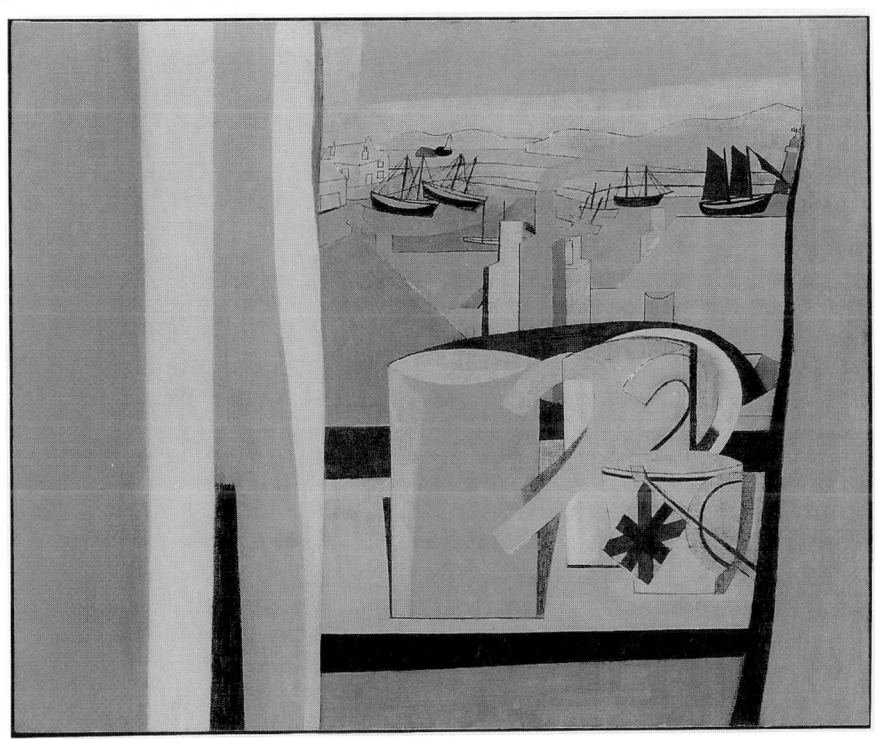

another level. There in the belvedere of the café, one is left in no doubt that it is St Ives – the town – spread out before one that is the principal object on display (see figure 39). One looks along the length of Porthmeor Beach and out to sea from one side and across the pattern of slate rooftops of 'Downalong' – the old village heart of the town – to the Island, the harbour and beyond to Godrevy lighthouse from the other. The architects' montages show how, from the start, the provision of such a panorama determined their plans for the top floor and roof just as it had for the round gallery downstairs.

The view is deliberately linked to the objects on display. As Eldred Evans explained: 'what you will see out of the window will be depicted in the very works hung on the walls'.[19] This point was emphasised in the gallery's pre-publicity, which employed Alfred Wallis's representation of the approximate site of the gallery and Ben Nicholson's view of the harbour (see figures 38 and 40). The architecture of the building frames the same view of the town as the painters: it is distanced, aestheticised and objectified for easy visual consumption (see figure 39). In Nicholson's mode of depiction, the landscape is both framed by a window which divides it from the viewer's space and, through the post-Cubist vocabulary of the painter, integrated with the domestic objects through which it is viewed. It is both set apart from and accommodated within civilised culture.

In the late nineteenth and early twentieth centuries the artists and the middle-class visitors to St Ives situated themselves in the Victorian terraces of 'Upalong' (such as Bellevue Terrace), from where they could enjoy the view over the town

39 View from Tate St Ives across the town to the sea

without suffering its stench and squalor. The Tate retains this view and, in mimicking painted representations of St Ives, defines the town as literally picturesque. Posited as one of Roland Barthes' *Mythologies*, the picturesque, like myth, can be seen to naturalise its subject through the removal of structural depth. That the view of St Ives from the Tate has been described as a Cubist pattern of roofs is appropriate because, like a Cubist landscape, such a viewpoint reduces the town to a two-dimensional pattern, freed of the labour and the gaudy trappings of tourism that actually dominate its spaces. Human presence, in particular economic activity, is obscured and denied. This follows the standard touristic construction of landscape that Barthes observed in 'The *Blue Guide*', in which natural beauty is defined by the sublime and all human life is reduced to stereotypical objects of the tourist gaze.[20] For Barthes, myth is 'depoliticized speech' and, as myth, the picturesque removes all political, historical and ideological contingencies from the town of St Ives.[21] Reciprocally, in focusing on the paintings' determination by landscape, the art too is naturalised and presented as autonomous, freed from its own contingencies. The distanced view of St Ives is the one most commonly used for such representations as postcards, souvenir calendars and brochures. The correlation of fine art and touristic representations echoes an established pattern of use of the artist as evidence of St Ives' picturesque quality. A post-war survey, for instance, saw 'the development of a substantial and well-known group of artists [as] evidence of the high quality of the town's scenic attractions'.[22] Similarly, in 1953 the official town guide asserted that '[h]aving stated that the town contains an art colony whose fame has extended to the ends of the earth, one has said all that need be said towards extolling its charms.'[23]

From 1958 to 1970 the cover of the town guide used the image of the painter to signify both the picturesque quality and exoticism to which St Ives laid claim. This was echoed by Denys Val Baker's seminal construction of St Ives as a centre of artistic production, *Britain's Art Colony by the Sea*.[24] On its cover, Peter Lanyon, brushes in hand, looks out across the harbour as town and painter are established in a relationship of mutual definition. Equally, the Tate manifestly presents the art as a tourist attraction, not least by the implicit claim to authenticity in the presentation of the works in the environment from which they came and in spaces based upon the conditions in which they were produced. Such a staged authenticity is an established touristic device.[25] The preservation or recreation of the artist's studio is a familiar sight, for example, and one need look no further than the Barbara Hepworth Museum, based in the artist's St Ives studio and garden and administered by the Tate, for a prominent example of the presentation of art in its place of origin as a tourist attraction. Dean MacCannell has identified the search for authenticity as a key desire underpinning tourism: 'For moderns', he writes, 'reality and authenticity are thought to be elsewhere: in other historical periods and other cultures, in purer, simpler life-styles.'[26] The Tate offers the suggestion of the authentic experience of 'St Ives' art, but it also

provides this more generalised authenticity as the picturesque's depoliticisation of the town presents the possibility of an idealised, lost world of nature and natural relations.

More subtly, this notion is suggested through the artistic allusions of the gallery's views. In its reframing of the distanced view of St Ives, the Tate invokes the figure of Alfred Wallis. In panning along Porthmeor Beach to the Island and across the town to the distant Godrevy Lighthouse, the view highlights those sites most prominent in Wallis's work (see figure 40). In so doing, the gallery associates its imaging of St Ives with a representation of the town that is perceived as genuine because rendered by a local resident, rather than a migrant, and a former 'mariner' to boot. The quasi-mythological figure of Wallis recurs in the history of art in St Ives as successive generations appropriated him as the embodiment of innocent creativity. Talismanic signifiers of the primitive, his paintings acquire the status of touristic objects, in that they offer an image of the place that suits visitors' (including artists') preconceptions and desires. Cornwall became a holiday destination that combined the carnival of the beach with a 'back to nature' wildness and, as a symbol of that naturalness, Wallis joined an established construct of the Cornish as Other.

MacCannell has suggested that, 'the first contact a sightseer has with a sight is not the sight itself but with some representation thereof.'[27] Wallis's paintings

40 Alfred Wallis, *The Hold House Port Mear Square Island Port Mear Beach*

become such images: defining St Ives before the event. In adopting his view-point, the Tate not only constructs the same nostalgic image of St Ives as a pic-turesque harbour village, but also validates that fiction through Wallis's claim to authenticity. Similarly, just as the gallery's design and position associates, say, Lanyon's 'abstract expressionist' paintings with the natural environment outside, so those paintings reassert the sublime aspect of this untrammelled nature. Gallery and artists are united within a single image of St Ives as both the site of artistic production and, in its picturesque timelessness, an appropriate object for the tourist gaze.[28] The construction of that image is one of a number of ways in which the gallery participates in the economy of tourism.

The Tate St Ives's immediate origins have been traced to the revival of interest in 'St Ives' art that was marked most obviously by the 1985 exhibition *St Ives 1939–64* at the Tate Gallery in London.[29] That same year, in the face of some of the highest unemployment figures in the country, Cornwall County Council published a report on *The Economic Influences of the Arts and Crafts in Cornwall*.[30] The authors argued that the post-war period of tourist expansion had ended, but suggested that the reduction in visitor numbers was not necessarily unwelcome. What Cornwall needed, they speculated, was 'not more visitors but bigger spenders. Its unique arts and crafts could be channelled towards the higher-value-added visitor and soften the harsh face of modern mass tourism.'[31] The Tate, which was initiated by the council, who still owns the building, may be seen as the primary response to that report.

In common with many recent galleries, notably the Tate Gallery Liverpool and Tate Modern in south London, the Tate St Ives was an engine for economic regen-eration. That function is indexed in the form of the gallery, which, with its allusion to the decrepit tin mines and its reconstitution of the form of the gasometer, is identified as a post-industrial edifice. As a strategy of improvement, its role was nicely symbolised by the decontamination of the poisoned ground of the site, which preceded the gallery's construction. Nevertheless, the fact the Tate, as a tourist site, was seen to cater primarily to visitors caused considerable opposition to the project from the local community. St Ives, like most of Cornwall, has long been torn by the conundrum of its dependency on tourism and the price it has to pay to satisfy tourists' needs and desires. The Tate fell into an established pattern as dis-senters called for the set-up costs to be spent on amenities for the local populace, such as a public swimming pool, and local artists lamented its fascination with the past. As a result, the institution placed great emphasis on local liaison, especially through education projects, and cynics have suggested that stickers worn by gallery-goers are to demonstrate to local shopkeepers how many extra visitors are attracted to St Ives by the Tate.

Plans for the Tate St Ives and its subsequent publicity have stressed its position within a popular, recreational tourism. The Architects' Brief called for a building that would attract families, and photographs of the gallery frequently show it as

the backdrop to the surfing for which Porthmeor Beach is famous (see figure 41). The much-publicised provision of storage for surfboards in the gallery's cloak-room is a clear symbol of the desire to appeal to a wide constituency. Nevertheless, the Tate has been described by its first director as a 'high quality visitor resource', and as such it continues a tradition of using 'St Ives' art and artists to attract visitors from a higher social level in order to counteract the decline and effects of popular tourism.[32] In 1957, for example, Ben Nicholson called for the building of artists' studios to permanently establish the town as a world artistic centre and so attract visitors the year round. If St Ives, he asserted, had 'a long-term plan for attracting ... more painters and sculptors of the right type', it would have 'a reliable trade throughout the year ... [for] an art centre that was world famous would attract a steady flow of visitors in all seasons – artists, art students, art dealers and collectors.'[33] Though the council resisted his appeal, the idea was soon taken up by private speculators and by November of that year the local press proclaimed the headline: 'First Living Studios Bring "Art Capital" Dream Closer'.[34] Over the following decade most of the redundant industrial buildings of old St Ives were redeveloped into luxury studio-flats: the old box factory was first, followed by the former smoke house; most prominently, the pilchard cellars of Barnaloft and the net-loft-turned-ramshackle-studios of Piazza were demolished and replaced by

41 View of Tate St Ives

luxury studio-apartments in the early 1960s. Finally, with the conversion of the former Crysede silk works into flats and of the old pilchard packing factory into new premises for the Penwith Gallery, the vicinity along Porthmeor Beach and around the Island was transformed as buildings were renewed and the area's function redefined. The light industrial zone became the focus of a tourist activity based around fine art and the romantic view of the Atlantic, in contrast to the mass tourism of the other side of the town.

The development of high-quality, high-priced studios was counter to the dominant forms of tourism in St Ives. High culture and its consumers and producers were drawn to the town to off-set the effects of, on the one hand, popular mass tourism and, on the other, a transgressive form of middle-class culture: the beatniks. Nicholson's original campaign had begun in response to a fear that a row of cottages opposite Hepworth's studio might be turned into what he described as 'some sort of jazzed up cafe ... or a petrol station – or even a pin-table bar'.[35] Such anxiety over the vulgarising of St Ives by the forms and functions of mass tourism had persisted since the inter-war period and continues today. Nicholson anticipated the County Council's 1985 report with his suggestion that fewer visitors, of a higher social class, might square the circle of tourism and the consequent damage to the town.

As the blocks of studio-flats on Porthmeor Beach were planned and built, St Ives was engaged in a debate over what constituted a true artist. From around 1959 to the mid-1960s, during the summer the town became a centre for beatniks – often art students and mostly middle-class – who came and camped on the beaches. The hostility with which they were met by much of the town appears to have been based on two things: their perceived grotesque bodies and self-management and their failure to contribute to the local economy. One local hotelier moaned about 'these filthy dregs, the slime and scum of the gutters ... coming here, spending nothing and keeping out the holiday makers who spend money in the town.'[36] However, anxiety was caused as the townspeople sought to repel the beatniks while maintaining the artist's colony label as a signifier, not only of St Ives's picturesque appearance, but also of its exoticism and liberalism. After all, the local paper observed in 1961, artists had been 'the town's chief publicity agents for about 75 years'.[37]

The beatniks were portrayed as filthy transgressors of the most basic norms: they 'turn night into day', warned a councillor. In contrast, proposed one resident, 'the real artists of St Ives are people who act and dress no differently from the townspeople'.[38] But it was not as simple as that and the chairman of the council's Public Health Committee was forced to reassure the town's artists that 'St Ives has always been tolerant and we do not object to beards, peculiarities of dress or difference in thinking, indeed they add charm to the town, but we do object to people to whom soap and water is apparently something unknown.'[39] That the definition of the true artist was at issue was demonstrated by a local judge's admonition to two London art students charged with petty theft:

For goodness sake put aside this nonsense of thinking you are heaven-born artists. Go and do some work with your hands or your brains. Only very few people can make a real job out of painting. Only geniuses or near geniuses can do it, and there is no evidence to show that you are geniuses or near geniuses. Do not play the fool.[40]

Anxieties about tourism's introduction of social transgression to St Ives were reinforced in August 1965 when violence broke out as, for several nights, over a hundred holidaying youths fought the police along the harbour front.[41] In this context, we may see the construction of luxury studios for what Nicholson had described as 'painters and sculptors of the right type' as a strategy to attract wealthier visitors in opposition to both the town's dependency on mass tourism and the threat of popular youth culture. Sure enough, the flats were initially purchased by established figures from the St Ives and London art scenes, such as Hepworth, Leach, Wilhelmina Barns-Graham, historian Frank Halliday and Merlyn Evans.

The establishment of the Tate St Ives continues that strategy. It is significant that the struggle between the beatniks and the luxury building schemes was conducted along Porthmeor Beach, where the Tate is the latest art-related structure. The beatniks' attraction to Porthmeor reflects its ambiguous, liminal status. Rob Shields has shown how the beach as a cultural product is an 'in-between' site, where the continuities of normal life are disturbed.[42] From the 1930s onward many local people feared that St Ives was becoming a carnivalesque site along the lines of Blackpool. While the harbour side of the town was increasingly dominated by mass tourism and its associated signs, however, Porthmeor retained another form of social marginality. The presence of the area's various industries delayed its development as a 'pleasure beach', and its position, facing on to the Atlantic Ocean, set it within a sublime aesthetic. It was this aspect that attracted both the beatniks and the residents of the luxury studios. Those developments prevented the establishment of a 'front' like that along the harbour, where chip shops and amusement arcades dominate, but the beach has, nevertheless, been increasingly absorbed into the spatiality of popular holidays. The Tate may be seen as an attempt to counter that shift in socio-spatial arrangements.

The museum has been portrayed as a civilising mechanism and, as such, as a means of social control and the Tate St Ives can certainly be thought to perform such functions.[43] Like the Tate in Liverpool, it has a major economic, and thus social, position through the employment it offers and the extra visitors it attracts to St Ives. Its positioning in the town also enhances its potential as a civilising force. The realisation of the desire for the Tate to appeal to as wide an audience as possible is facilitated by its location in a holiday venue because, as a major cultural resource, it was immediately added to the itinerary of sights to be seen, or consumed, during a visit to the town. In this way, a far wider audience, from a broader range of class fractions, is exposed to the supposedly beneficial forces of

high culture and the Tate Gallery is able to continue its mission of popular improvement and control.

Drawing on Foucault and Gramsci, Tony Bennett has demonstrated how museums developed as spaces within which the individual both looked and was looked at and so demonstrated the legitimation of bourgeois power through the embodiment of 'the democratic aspiration of a society rendered transparent to its own controlling gaze.'[44] The form of the Tate St Ives extends this mutual social control through specular dominance outwards into its spatial environment as it offers the visitor a panoptic view of the town and, most particularly, of Porthmeor Beach. Through the objects on display and the architecture's framing of the view, the Tate seeks to re-establish the beach as an object of what John Urry calls the 'romantic gaze'. That is to say, it fixes Porthmeor within an aesthetic 'in which the emphasis is upon solitude, privacy and a personal, semi-spiritual relationship with the object of the gaze', in contrast to the 'collective gaze' that requires the crowd of the typical seaside resort.[45] With the possible exception of the Lowry-esque paintings of Alan Lowndes, representations of the carnival aspect of Porthmeor are conspicuously absent. Rather, the art and the gallery both present a discrete, civilised representation of it. Thus, the inversion of social convention that Shields associates with the beach is countered by a reassertion of the dominant, authorised culture.

A mechanism for social cohesion, the gallery tries to construct the image of a homogeneous constituency. As the Tate Gallery, national identity is one of the means by which it attempts to establish a shared, unifying culture. The painting with which the gallery was promoted, Ben Nicholson's *1943–45 (St Ives, Cornwall)*, with its Union Flag set against St Ives harbour, is an essay in the establishment of nationhood through regional identity. Similarly, the invocation of Alfred Wallis as a symbol of integrity also alludes to a rural Englishness. That the gallery was opened by Prince Charles – Duke of Cornwall as well as heir to the throne – is significant of its embodiment of the nation state's relationship with its margins. The very notion of regional outposts of a national gallery sought to bind the regions into a cohesive state at a time of growing friction between north and south, centre and periphery. The tension between local and wider cultures is reflected in the architecture's balance of modernist and vernacular styles and vocabularies.

In its bid to attract visitors from a class fraction rich in financial and cultural capital, the Tate St Ives counteracts the image of St Ives as 'spoilt' by locating it within a sublime aesthetic. In this way it is not only the representational art works that are set in relation to the surrounding environment. A determining context is also suggested for those later paintings and sculpture, by artists such as Patrick Heron and Peter Lanyon, which may be described as sublime abstractions. The gallery's elevated position and panoramic view frame a representation of the town as picturesque. Objectified and distanced, it is also fixed as continuous with the expanse of the sea. As Barthes said in relation to the Eiffel Tower: 'Habitually,

belvederes are outlooks upon nature ... so that the tourism of the "fine view" infal-
libly implies a naturist mythology ... the Tower makes the city into a kind of nature;
it constitutes the swarming of men into a landscape ... a harmony, a mitigation ... a
new nature.'[46]

Through the encircling sea, the quaint fishing village is accommodated within a
particular modernist framework. For, as Rosalind Krauss says, '[t]he sea is a special
kind of medium for modernism, because of its perfect isolation, its detachment
from the social, its sense of self-enclosure, and, above all, its opening onto a visual
plenitude that is somehow heightened and pure'.[47] In defiance of the masses who
crowd into the town, the Tate St Ives seeks to represent it as continuous with this
modernist detachment. The gallery defines St Ives as Downalong – the old village
at its heart, the beach and the sea. It turns its back on the Victorian terraces of the
local bourgeoisie and on the modern expansion of the town. Its denial of hetero-
geneity reflects St Ives's spatial arrangements: from the 1930s to the 1950s,
Downalong was redefined as a slum, cleaned up and largely taken over by the hol-
iday trade, while the indigenous population was moved to council housing estates
on the town's periphery. In its establishment of St Ives as a timeless object for visual
consumption, the Tate denies its economic and social realities. As is often the case
in tourism, the local people are reduced to a stereotype – symbolised here by the
figure of Alfred Wallis. By arranging St Ives into a harmonious visual pattern, the
gallery imposes a fictional social homogeneity upon the place.

The Tate St Ives's function is as an engine for economic regeneration through
its participation in the economy of tourism. That participation is both as an attrac-
tion in itself, offering an authentic presentation of 'St Ives' art, and as a means of
reinforcing the image of the town as an unspoilt, picturesque and exotic site. The
structure and siting of the gallery set the objects it displays within a locationally
determined interpretive framework. Reciprocally, the art and the architecture both
serve to define a particular representation of St Ives, the town. Tourism has been
discussed as a series of signs.[48] The Tate, through its presentation of works of art,
its framing of views of the town and the sea and its position, arranges a particular
set of such signs to reach a definition of the place 'St Ives'. That place, itself,
becomes a sign for a catalogue of touristic products: the seaside, the unspoilt coun-
tryside, a timeless community and rural authenticity. To borrow a concept from
Dean MacCannell, the Tate may be seen to curate St Ives through its management
of the 'gaze', objectifying the town and organising its spaces into a harmonious
image in which social heterogeneity is obscured.[49] Just as the gallery fits into a tra-
dition of the use of 'St Ives' art and artists as a tourist resource, so it reaffirms the
socio-economic relations of the production and consumption of the art and the
town from which it came. Its architecture facilitates the operation of those tech-
nologies through which the museum functions as a mechanism for social stability
and articulates the gallery's reassertion of a common national cultural identity
maintained through the denial of the class differences that the town's spatial geog-
raphy reflects.

Notes

I would like to thank Neil Sharp and, most especially, Michaela Giebelhausen for their comments on drafts of this text.

1 This echoes, to an extent, Jonathan Harris, 'Abstract Expressionism at the Tate Gallery Liverpool: region, reference, ratification', in David Thistlewood (ed.), *American Abstract Expressionism* (Liverpool: University of Liverpool and Tate Gallery Liverpool, 1993), pp. 97–109.

2 This definition derives from John Agnew, 'Representing space: space, scale and culture in social science', in James S. Duncan and David Ley (eds), *Place/Culture/Representation* (London and New York: Routledge, 1993), pp. 251–71; p. 263.

3 Rob Shields, *Places on the Margin: Alternative Geographies of Modernity* (London and New York: Routledge, 1991), p. 47.

4 For information on the history of the Tate St Ives project and building, see Janet Axten, *Gasworks to Gallery: The Story of Tate St Ives* (St Ives: privately published, 1995).

5 Architects' Report; quoted *ibid.*, p. 107.

6 Architects' Brief; quoted *ibid.*, p. 109.

7 *Ibid.*, p. 111.

8 *Ibid.*, p. 109.

9 *Ibid.*, p. 109.

10 David Hamilton Eddy, 'Introduction', in David Shalev and Michael Tooby, *Tate Gallery St Ives: The Building* (London: Tate Gallery Publishing, 1995), p. 5.

11 Peter Fuller, 'St Ives', *Artscribe*, 53 (May/June 1985), reprinted in Peter Fuller, *Modern Painters: Reflections on British Art*, ed. John MacDonald (London: Methuen, 1993), pp. 106–12; p. 106.

12 Stephen Greenberg, 'A gallery rooted in its context: appraisal', *Architects' Journal*, 197:25 (23 June 1993), p. 35.

13 Eldred Evans and David Shalev, 'A gallery rooted in its context: architects' account', *Architects' Journal*, 197:25 (23 June 1993), p. 29.

14 Shalev and Tooby, *Tate Gallery St Ives*, p. 28.

15 *Ibid.*, p. 28.

16 *Ibid.*, p. 11.

17 Greenberg, 'A gallery rooted in its context: appraisal', p. 35.

18 David Whiting in *Studio Pottery*; quoted in Axten, *Gasworks to Gallery*, p. 209.

19 Eldred Evans, quoted in Rory Coonan, 'A cliffhanger set in St Ives', *Observer*, 1 April 1990, p. 8.

20 Roland Barthes, 'The *Blue Guide*', in Barthes, *Mythologies*, trans. Annette Lavers (London: Vintage, 1993), pp. 74–7.

21 Roland Barthes, 'Myth today', in Barthes, *Mythologies*, trans. Annette Lavers (London: Vintage, 1993), pp. 109–59; p. 142.

22 Cornwall County Council, *Report of the Survey for the County Development Plan* (Truro: Cornwall County Council, 1950).

23 *St Ives Official Town Guide* (St Ives: St Ives Borough Council, 1953), unpaginated.

24 Denys Val Baker, *Britain's Art Colony by the Sea* (London: George Ronald, 1959).

25 Dean MacCannell, *The Tourist: A New Theory of the Leisure Class* (London: Macmillan, 1976).

26 *Ibid.*, p. 3.

27 *Ibid.*, p. 110.

28 See John Urry, *The Tourist Gaze: Leisure and Travel in Contemporary Societies* (London: Sage Publications, 1990).

29 Axten, *Gasworks to Gallery*, pp. 33–40.

30 Ronald Perry, Patricia Noble, Sue Howie, *The Economic Influences of the Arts and Crafts in Cornwall* (Truro: Cornwall County Council and South West Arts, 1985).

31 *Ibid.*, p. 4.

32 Michael Tooby, interview with the author, 11 February 1993.

33 Letter to St Ives Borough Council; quoted in *St Ives Times*, 1 February 1957, p. 1.

34 *St Ives Times*, 15 November 1957, p. 1.

35 Ben Nicholson, letter to J. R. M. Brumwell, 24 January 1956 (private collection).

36 Letter to *St Ives Times*, 8 October 1965, p. 5.

37 Editorial, *St Ives Times*, 14 April 1961, p. 4.

38 E. Mary Quick, letter, *St Ives Times*, 1 November 1963, p. 5.

39 Councillor Stevens quoted in 'Public urged to "Help Repel Beatniks"', *St Ives Times*, 21 April 1961, p. 1.

40 Reported in *St Ives Times*, 1 July 1960, p. 1.

41 Reported in *St Ives Times*, 30 July 1965, p. 1.

42 Shields, *Places on the Margin*, pp. 73–116.

43 See Tony Bennett, *The Birth of the Museum: History, Theory, Politics* (London and New York: Routledge, 1995) and Harris, 'Abstract Expressionism at the Tate Gallery Liverpool'.

44 Bennett, *The Birth of the Museum*, p. 101.

45 Urry, *The Tourist Gaze*, p. 45.

46 Roland Barthes, 'The Eiffel Tower', in Barthes, *Eiffel Tower and Other Mythologies*, trans. Richard Howard (Berkeley and London: University of California Press, 1979), pp. 3–17; p. 8.

47 Rosalind E. Krauss, *The Optical Unconscious* (Cambridge, Mass. and London: The MIT Press, 1993), p. 2.

48 MacCannell, *The Tourist*, p. 26.

49 Dean MacCannell, 'Landscapes', keynote lecture, Imagining Cornwall, conference, Falmouth School of Art and Design, September 1994.

PART II
VISIBLE HISTORIES –
INVISIBLE HISTORIES

'Passionless reformers': the museum and the city in utopia[1]

Nicole Pohl

Recent museum studies have revised the traditional approach to museum history and have instead developed an 'effective' historiography that places the museum within a larger context of knowledge and political power.[2] Within a Foucauldian methodological framework, the museum visitor is understood as 'the specifically subjected *object* of social and historical forces and determinations' and the exhibits, the museum building and its placement within an urban context are seen as part of a discursive system of political rationalities, which Foucault names *epistemes*.[3] The Medici collections in Florence recreated a 'world in miniature around the central figure of the prince who thus claimed dominion over the world symbolically as he did in reality', reinforcing the dominant position of the prince and the inferior subject position of the spectators/beholders.[4] Seventeenth-century collections such as the Repository of the Royal Society are representative of the contemporary urge 'to mathematize empirical knowledge', to create 'a universal science of order'.[5] The foundation of the *Musée Français* in the Louvre in 1793 drew on Enlightenment principles of progress and perfectibility, showing the triumph of 'liberty over tyranny' and 'philosophy over superstition'.[6] Developing from this democratic framework, the nineteenth-century museum evolves into an agent of the disciplinary society.

It is the purpose of this chapter to complement, but at the same time to problematise this reading in the light of contemporary critiques of Foucault's notion of transcendental power.[7] This chapter explores the role of the museum in literary utopias from the seventeenth to the twentieth century. Indeed, the nature of the genre as experimental epitomises the Foucauldian 'technologies of the self': the spatial, social and educative structures of utopian cities, states and communities all serve one purpose, to fashion the utopian subject. In fact, the museum in utopia not only reproduces but also amplifies the epistemic principles and shifts that have determined actual museum practices as outlined above. At the same time the genre raises fundamental questions about the museum's effective role as a handmaiden for government, domination and power.

When utopians conceive an ideal social and political structure, they subject every element of this society or community to the utopian philosophy. The physical setting such as geography and climate is central to the ideological make-up of the communities. In early modern geographical utopias, the physical environment is fertile, lavish and, more importantly, stable. It secures ample agriculture and food production, and moreover, provides an agreeable place for human beings, free from the basic anxieties of survival. On a smaller scale, the constructed environment, including architecture, has an established and significant function. In *Utopia & Anti-Utopia in Modern Times* Krishan Kumar writes that '[a]rchitecture has always been the most utopian of all the arts. It has a longstanding concern with the marriage of mathematical and human forms, the finding of a harmony and correspondence between the mathematical relations of the cosmos and the forms and functions of the human body.'[8] The geometrical city plans in Renaissance utopian literature are based on principles of harmony, rationality and uniformity. They not only reflect these basic values but also enforce them by regulating human interaction and social behaviour. Governmental and educational institutions are also given significant prominence and value in these utopian visions. In fact, the educative offices are the primary institutions in the utopian state.[9] Whilst geographical and chronological utopias differ in their investment in human agency and progress, both strands locate the utopian impulse in education and instruction. Education and civic instruction is used, in the case of chronological utopias, to affect social change and, in the case of both geographical and chronological utopias, to secure the results of that change. To rephrase the opening quotation, the utopian subject is the specifically subjected *object* of utopian principles. The utopian museum as an educational and reformative institution is thus an integral part of the utopian city. Its placement within the urban context, more prominent in the literary texts than its actual architecture or design, is indicative for the museum's political and social determination.

Three models can be identified[10]. The first model assigns a very determined reformative role to the museum. Francis Bacon's *New Atlantis* (1627) serves as an example for a utopian society where the political authority of an intellectual oligarchy is exhibited in a museum. A second model marks a more transparent propensity in utopias which, instead of declaring a specified space as a site of fashioning the utopian subject, universalises the reformatory task of the museum. It is not a specific or enclosed space that represents and enforces political power, but the whole urban environment is constructed to convey the utopian message. An archetypal example is Campanella's *City of the Sun* (1623). Johann Valentin Andreae's *Christianopolis* (1619) consolidates the first two models. Here a separate museological institution is an essential part of the city structure but, in tune with the socio-political constitution, embedded within the urban entirety.[11] The third model unveils the imaginary property of museums. In texts such as H. G. Wells's *The Time Machine* (1895) and William Morris's *News from Nowhere* (1890), the role of the museum as civic educator is deconstructed. Whilst the first two models place their utopias in a city state, in Wells and Morris the formerly urban museum

is now located within a post-apocalyptic, reclaimed rural landscape. It is an arte-fact of the past disconnected in meaning from the present. Its 'machinery of rep-resentation' is insignificant because it remains outside its specific historical and ideological determination.[12]

New Atlantis: A Worke Unfinished written by the Right Honourable Francis Lord Verulam, Viscount St Alban by Francis Bacon was posthumously published as part of the volume *Sylva Sylvarum* in 1627. It describes the accidental discovery of a fortified city state, Bensalem, located in the Pacific Ocean. The main body of the text consists of conversations between the unnamed narrator and different officials and citizens. These reveal, if insufficiently, the social and political structure of this utopian society as well as its complex foundation history. The monarchy had been founded by King Solamona nearly 2000 years previously. Economically and cultur-ally, Bensalem is, by choice, isolated and self-sufficient. Family life in Bensalem is hierarchical and regulated and guided by fundamentally Christian principles. However, every twelve years two ships are sent out to investigate the cultural and scientific progress of particular countries. Three individuals, Fellows of Salomon's House, remain under cover in these foreign cultures until they are taken home to report on their findings.

The fragment ends with a reference to two galleries: 'in one of these we place patterns and samples of all manner of the more rare and excellent inventions: in the other we place the statua's of all principal inventors.'[13] This museum is part of a larger institution, Salomon's House or the College of the Six Days' Works, a fic-tional precursor to the philosophical college founded in London in 1645 and the later Royal Society of 1660.[14] It unites a scientific community from different disci-plines within a defined hierarchical structure of fellows, novices and apprentices. The College is dispersed over several locations and is housed in institutes, labora-tories and industrial sites. Whilst Bacon is very unspecific in his description of Salomon's House, it is evidently not located in the centre of Bensalem. On the con-trary, Bacon emphasises the isolation and self-sufficiency of the scientific commu-nity. Although the 'end of our Foundation is the knowledge of Causes, and secret motions of things; and the enlarging of the bounds of the Human Empire, to the effecting of all things possible', the scientists withhold that 'which we think fit to keep secret'.[15] The text provides no information about the direct impact of these scientific accomplishments on Bensalem's society. Indeed, Bacon seems to indicate that the College was established in an already stable and self-sufficient society that needs no advancement. So what is the purpose of the College and of the museum that clearly served to promote philosophical and scientific achievements?

New Atlantis is, as Davis suggests, 'a community of self-regulating individuals, with a community of moral paragons, a perfect moral commonwealth'.[16] Whilst the Brethren do not have any direct political power, they exercise a greater moral authority. They 'retain the power of technological innovation and with it the capacity to alter the conditions of life, if not the structure of society'.[17] In agreement with the

conventions of the larger society, the Brethren manifest this particular authority in specific ceremonies and rites of which the museum is an essential part.[18]

Already in *The Advancement of Learning* (1605), Bacon likens 'inventors and authors of new arts, endowments, and commodities towards man's life' to the ancient gods.[19] The spectacle of the scientists in *New Atlantis* echoes this sanctification. Their attire is luxurious and episcopal. They are carried in a chariot,

> richly trapped in blue velvet embroidered; and two footmen on each side in the like attire. ... Next before the chariot went two men, bare-headed, in linen garments down to the foot, girt, and shoes of blue velvet; who carried the one a crosier, the other a pastoral staff like a sheephook; neither of them of metal, but the crosier of balmwood, the pastoral staff of cedar.[20]

The Brethren occupy a sanctified position in New Atlantis, a role that is only matched by the founder King Solamona himself. Accordingly, Salomon's house is 'dedicated to the study of the Works and Creatures of God', it institutes Faith through scientific knowledge.[21] Salomon's House is indeed 'the very eye of this kingdom'.[22] The metaphor of the eye marks both the centrality and the ubiquity of Salomon's College. However, the scientific insight passed on to the Atlantan citizens is restricted by ethics and scientific self-regulation.[23] Social rituals and ceremonials serve to distract from this partial vision. 'The peculiar complication of the ritualization surely has the quality of a self-referential system: it absorbs the mind of "the people" and keeps them busy.'[24] The 'eye of the kingdom' is enshrined in 'a modern version of a temple, the new gods being the inventors and scientists': the College of Salomon's House.[25] The politics of display in the museum equally follow principles of exclusion and partial vision. The galleries display the 'essence' of Atlantan scientific accomplishments and place these objects and statues side by side with less competent outsiders' achievements, especially 'books, instruments, and patterns in every kind' exhibiting the standard of the 'sciences, arts, manufactures, and inventions of all the world'.[26] The displays are chosen in terms of moral suitability and display of actual authority.

The Christmas revels at Grays Inn, *Gesta Grayorum*, of 1594 already advocate the idea of Salomon's house and a museum. A 'most perfect and general library', a 'garden to be built about with rooms, to stable in all rare beasts, and to cage in all rare birds', a 'huge cabinet, wherein whatsoever the hand of man, by exquisite art or engine, hath made rare in stuff, form or motion' and 'a Still-house so furnished with mills, instruments, furnaces, and vessels, as may be a Palace fit for a philosopher's stone' were to be models of 'the universal nature made private'.[27] The purpose of the exhibit is to erect a monument to the King's power and authority, which is so much more effective than political conquests.

> No conquest of Julius Caesar made him so remembered as the Calendar. Alexander the Great wrote to Aristotle upon the publishing of the Physicks, that he esteemed more of excellent men in knowledge, than in empire ... when all other miracles and

wonders shall cease, by reason that you shall have discovered their natural causes,
yourself shall be left the only miracle and wonder of the world.[28]

The museum in *New Atlantis* similarly serves the self-fashioning of the scientists as
omnipresent and omniscient. In *New Atlantis* Bacon appoints the museum as a fun-
damentally political agent. The reformative function of the museum is expressed in
its symbolic prominence and spatial ubiquity within the utopian city. It serves not
the political executive, but the true rulers of the Atlantan society: the scientists.

Tommaso Campanella took a more inclusive and radical approach to behaviour
management. His *City of the Sun* (1623), serves as the second model of the museum
in utopia. Whilst Bacon allocates a spatial and authoritative prominence to the
museum, Campanella expands the reformative role of the museum to the whole of
the city. The city becomes the museum. *The City of the Sun* was completed in 1602
during Campanella's incarceration in Naples from 1599 to 1626 on charges of
heresy.[29] Campanella's book follows the mode of dialogue between a Genoese sea-
captain and his host, the Grand Master of the Knights Hospitaller. On one of his
many travels, the sea-captain encounters the City of the Sun, a remote place in
Tapobrane, 'immediately under the equator'.[30] His explication identifies the
Solarian society as a fundamentally communist theocracy. The Prince Prelate is
called the Sun or Metaphysician. He is assisted by three Princes – Pon, Sin and
Mor – who regulate military affairs, sciences and the arts, procreation, education
and eugenics with the aid of a range of civil servants. The government of the City of
the Sun is clearly totalitarian. Whilst there seems to be no written constitution, the
juridical system is based on a set of ethical laws displayed on a copper plate on the
central temple building. Eugenics and the public education of children are based
on principles of collectivity and individual accountability. The pupils even live next
to the schools so they can continuously be supervised by the teachers.[31] There is no
private property and all customary institutions such as the family and marriage are
dissolved on the grounds that any form of private assets (including a wife) is coun-
terproductive to the collective. Offenders to this basic code are not punished in any
traditional sense but are re-educated to strengthen their collective spirit and self-
control. The custom of general confession serves to enhance the internalisation of
the rules and regulations of the City of the Sun. 'The emphasis is less on reducing
the incidence of crime, than on *making the lawbreaker aware of his or her responsi-
bility to the community*.'[32] *The City of the Sun* is thus a system that advances the spirit
of both collectivity and 'controlled individualism'.[33] It is based on the instructional
enforcement and internalisation of the ethical principles of the utopian society.
Appropriately, the technologies of the self are ubiquitous, in fact the whole city is
an intricate 'societal machine'.[34]

The Sun City is a radial city. Its centre is the seat of Sol, the Temple. The city is
fortified by seven concentric circles, which also accommodate the dwellings of the
Solarians. Given the focus on psychological conditioning and social engineering, it
is not surprising that the city walls are used for the education of the citizens.

Indeed, Campanella believed that the state should act as a pervasive educational institution infiltrating every aspect of the citizens' lives. He was a decided anti-Aristotelian and advocated Giordano Bruno's principles of direct observation and 'non-mediated knowledge' for the education of the Solarians.[35] The visual aids and objects displayed on the seven concentric walls follow the mnemotechnic principles of the early modern memory theatre.[36]

The art of memory is a mnemotechnic system based on the assumption that it is easier to remember places than facts. Facts are localised in a series of illusory places, memory *loci*, and are thus remembered in their order. At the end of the fifteenth century Giulio Camillo transformed the system radically by developing an actual structure: the memory theatre. It was to hold at least two people and was ornamented with images and drawings. The walls and cabinets held boxes full of objects, which related to some aspects of the physical environment. The spatial structure of the theatre rested on the 'seven pillars of Solomon's House of Wisdom', with seven celestial gates as the first memory *loci*.[37] Reversing the arrangement of the theatre, the spectator stands on the stage looking towards the auditorium, 'gazing at the images on the seven times seven gates on the seven rising grades'.[38] Giordano Bruno expanded this architectural memory system to a very complex and extensive encyclopedia. Frances A. Yates suggests that especially Bruno's *Figuratio Aristotelici physici auditus* and the *Torch of the Thirty Statues* serve as a model for Campanella's *City of the Sun*.[39] 'The city is divided into seven large circuits, named after the seven planets. Passage from one to the other is provided by four avenues and four gates facing the four points of the compass.'[40] The passage from the outer to the inner circle in Campanella's city is made via different levels and gates which divide the particular circuits. The walls carry educational murals, time lines and samples of metals, stones, minerals, fluids, specimens of trees and herbs and other objects, moving from the representation of mathematics on the inner wall of the first (inner) circuit, geography, social anthropology, geology, medicine, evolutionary biology, mechanical arts, 'founders of sciences and inventors of weapons' and culminating in a portrayal of Jesus Christ, the twelve Apostles, Caesar, Alexander and other famous historical and religious figures.[41] The innermost wall of the temple and the roof of the dome depict the stars and their motions through space. This encyclopedia is not finalised but is continuously perfected by new inventions and knowledge acquired through special ambassadors who travel the world under cover. These murals are used for the elementary education of the children but also for the continuous and indeed subliminal instruction of the adults. The end of all knowledge is to know God, the path through the circuits from the outside to the inside therefore leads the traveller straight to Sol.[42] Reiss suggests that in opposition to Bacon, the Solarians' will to know God 'cannot ... be directed toward a future in any historical sense, for the Deity is not accessible to such a concept of "natural" (or humanly ordered) history.'[43] On the other hand, the continuous accumulation of knowledge and the progressive history written into the seven circuits speak of that historical sense which also determines the instructive

principles of the Sun City. The education of the absolutely ideal Solarian is forever continuing, the existence of criminals and other offenders indicate the flaws and relapses of the technologies of the self.

In *The City of the Sun*, Tommaso Campanella extends the role of the museum to an extreme. Whilst Francis Bacon allocates a symbolically and spatially prominent role to the museum, Campanella turns the whole city into a museum. The exclusionary and limiting aspects of education and the censorship of knowledge that define Bacon's *New Atlantis*, are eradicated in *The City of the Sun*. Instead, a more universal scheme is introduced, which is inclusive on the one hand , but clearly totalitarian on the other. *The City of the Sun* illustrates, as Ernst Bloch already suggested, a 'utopia of ... anonymous order' ('Utopie ... der personenlosen Ordnung').[44]

Johann Valentin Andreae's *Christianopolis* (1619) consolidates Bacon's and Campanella's notions of the museum in utopia.[45] *Christianopolis* offers a portrayal of a utopian city state situated on a small island called Caphar Salama. Three concentric squares form the actual city, which is divided into neighbourhoods (see figures 42 and 43). The city is further divided into four strategically well-placed production areas. Additional farming land, woods and a moat for fish are placed outside the city walls. The extremely rationalised production process moves from the most outward square towards the manufactures and workshops in the inner squares. At the centre of Christianopolis is the College.

Similar to Campanella's *City of the Sun*, Christianopolis has a mixed governmental constitution. A triumvirate of governmental leaders seems to be chosen by the citizens on the basis of merit and intellectual excellence but exact procedures are not mentioned. Each of these leaders is responsible for

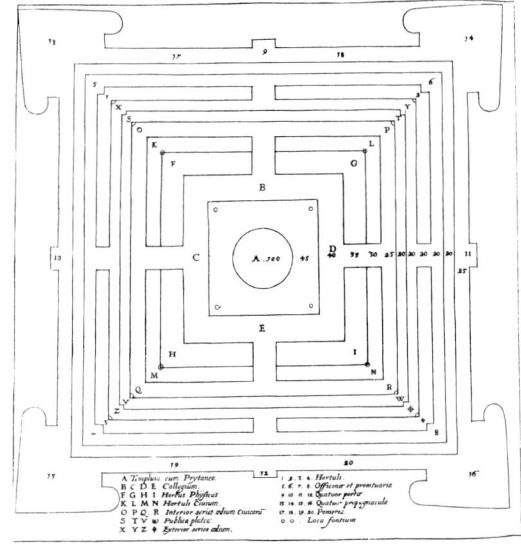

42 Bird's-eye view of Christianopolis and,
43 ground plan of Christianopolis

certain sections of the political government, such as education, religion and justice. Their reign is aided by a Senate of twenty-four citizens who are elected from the three ranks of society. There is no private ownership of houses and commodities.

The city is conceived as a wheel with streets leading to the centre which houses the academy. 'Here religion, justice, and learning', asserts Andreae, 'have their abode, and theirs is the control of the city; and eloquence has been given them as an interpreter.'[46] The education system is utilitarian and compulsory. The curriculum emphasises science as a means to acquire true knowledge about the world and God. Its achievements and progress provide the basis for rationalistic social engineering and thus a superior society. Another important factor in the curriculum is the study of history, which introduces the aspect of perfectibility and progress into the society of Christianopolis. 'Meanwhile, it is clearly evident that as many as are ignorant of past events, are likewise of little value in the present and unprepared for the future, however bold and arrogant they may be as to other things.'[47]

The students are boarders in state-run schools. 'Here they eat and sleep, and receive mental and physical training. ... As this is an institution for the public good, it is managed very agreeably as a common charge for all the citizens.'[48] The College houses different faculties and departments for primary, secondary and vocational schooling. Although there is a separate 'shop for pictorial art', natural history collections and laboratories with specific exhibits and libraries, Andreae made it very clear that museums should not exist as separate entities. Indeed, following Campanella and preceding Comenius' *Orbis Sensualium Pictus* (1685), Andreae envisaged the whole city as museum. 'For the city, besides being decorated all over with pictures representing the various phases of the earth, makes use of them especially in the instruction of the youth and for rendering learning more easy.'[49] These pictures are complemented by short commentaries on the exhibits. Zoological and botanical gardens are scattered throughout the city and function as both recreational and educational spaces.

Education is the principal activity in Christianopolis. It is the basis of a superior society consisting of intellectually and morally exceptional citizens. This basic theme is reflected in the spatial and symbolic placement of the main institution, the College. It is the heart of this utopian enterprise and, accordingly, occupies the most prominent position in Christianopolis. However, academic and moral instruction is not confined solely to the academy. The complex curriculum is expanded to the city itself with a range of visual materials, exhibits and libraries. The city of Christianopolis is not only a massive proto-industrial and self-sufficient workshop but also a large-scale museum with a very distinctive political agenda: the education of the utopian subject.

Nineteenth-century European utopianism differed in its scope and substance from early modern utopias. Generically, utopia developed from *eutopia* to *euchronia*, the latter emphasising history, progress and perfectibility. No more was

Utopia found on some remote island or planet but, instead was 'to be delivered by history itself, as the more or less inevitable consequence of its unfolding logic'.[50] Early nineteenth-century utopian socialism synthesised this Enlightenment belief with the utopian tradition of Campanella, Andreae, Bacon and More. Writers such as Etienne Cabet, Saint-Simon and Fourier in France and Robert Owen in England focused particularly on the conditions of early industrial society. Their propositions to conquer social and economic inequality and deprivation were founded on principles of co-operation, common ownership of the means of production and commodities, and in the case of Saint-Simon and Fourier, the abolition of traditional social structures such as marriage and the family. They saw these improvements and developments not only as necessary but, to echo the above quotation by Kumar, as the inevitable consequence of the unfolding logic of capitalism. Utopian socialism also inspired the emergence of factory towns and urban revival schemes that sought to improve the material conditions of the workers. This included new and hygienic housing schemes, co-operative shops, allotments and recreational facilities.[51] Education remained a prominent focus of these schemes and the museum managed to assert its role as a handmaiden to radical political and social planning.[52] However, serving as the third and last model in my analysis, another view is presented in utopian writings where the museum is exiled from the contemporary epistemological context. The process of knowing, the organising principles for knowledge, the exhibits, and even the city as a space become meaningless and mystifying.

In 1888, Edward Bellamy published his vision of a futuristic socialist society, *Looking Backward*. Apart from being a highly successful book, it inspired an extensive discussion amongst fellow utopians and socialists about the 'right' meaning of socialism and its appropriate implementation as a socio-economic practice. William Dean Howells responded with *A Traveler from Altruria* (1894), a specifically suburban interpretation of socialism as altruism. William Morris, too, saw the need to react to Bellamy's work with his *News from Nowhere* (1890). In his review of *Looking Backward*, Morris identified the issues that seem to separate him from Bellamy.

> I believe that the ideal of the future does not point to the lessening of men's energy by the reduction of labour to a minimum, but rather to the reduction of *pain in labour* to a minimum, so small that it will cease to be a pain ... The true incentive to useful and happy labour is and must be pleasure in the work itself.[53]

As Ruth Levitas suggests, Morris is to be read as 'a critique of alienated labour', not as 'a romantic piece of medievalist nostalgia'.[54] In all his writings, Morris imagines a world where his claims for a 'decent life' have been realised.

> First, a healthy body; second, an active mind in sympathy with the past, the present, and the future; thirdly, occupation fit for a healthy body and an active mind; and fourthly, a beautiful world to live in.[55]

A radical and indeed inevitable change of the means of production and principles of labour is complemented by 'educating people to a sense of their real capacities as men, so that they may be able to use to their own good the political power which is rapidly being thrust upon them'.[56] Indeed, Morris bases his whole socialist vision on education as an expression of an elemental utopian hope. However, para-doxically in *News from Nowhere* Morris describes a future socialist society in England that was brought about not by reform but a large-scale revolution. Late nineteenth-century economic and social conditions culminated in widespread poverty, economic instability, general strikes, the collapse of government and finally civil unrest. The 'great motive-power of the change was a longing for freedom and equality', to Morris, a basic human instinct.[57] The political activities by contemporary Socialist groups to whom Morris himself belonged proved simply ineffective.

In the spirit of reorientation and consolidation a new society was founded, based on principles of humanity and co-operation. The shock of the wars and revolution changed the outlook of the elders; education and improved social and economic conditions brought about a generation of Morris's unalienated and mentally healthy subjects. The beginning of a new life, as Morris entitles Chapter 18, is a new beginning, seemingly disengaged from the past. The future England as he described it in *News from Nowhere* is fundamentally an agrarian socialist state. William Guest, time traveller and Morris's fictional alter ego, wakes up one day in an England of the twenty-second century. Warmly welcomed by the townspeople of the area, Guest is escorted through this strange new world to Old Hammond, an erudite elder whose knowledge of history provides answers to all of Guest's ques-tions. This second part of the book recapitulates the history of the revolution and the formation of a new society. It also expands on Morris's ideas on education, eco-nomics and political representation.

The Thames valley of the twenty-second century is in complete contrast to its nineteenth-century equivalent. The metropolis has been replaced by villages and a mainly agricultural landscape. Industrial production is supplanted by small work-shops, the economy is based on an extensive barter system. 'It [England] is now a garden, where nothing is wasted and nothing is spoilt, with the necessary dwellings, sheds and workshops scattered up and down the country, all trim and neat and pretty.'[58] There are no schools and colleges and London's most grandiose museums, the National Gallery (founded 1824) and the British Museum (founded 1753), merely exist as obscure relics of the past. Given the basic socio-political structure of the new England and especially the holistic approach towards learning and education, the 'disciplinary museum' is expendable. Identified only by the nineteenth-century reader and the protagonist, the museum in *News from Nowhere* reveals its nature as a site for the 'self-display of bourgeois-democratic societies'.[59] In a socialist and fully egalitarian society such as Morris envisages, this form of institution has no place and, given the radical break with the past, no meaning for the citizens of a 'new' England.

> Edmund Husserl might have perhaps said that they [exhibits], by being placed in
> the museum, have lost their *noema*, that generalized form of meaningfulness which
> an object or artefact possesses as long as something in its appearance seems to
> promise a *continuation* of one sort or another: the plough is there to plough with, the
> book carries meaningful chains of symbols and is obviously intended to be read by
> somebody.[60]

Accordingly, Guest's guide, Dick, describes the National Gallery as 'an old
building built before the middle of the twentieth century ... It is called the National
Gallery; I have sometimes puzzled to what the name means: anyhow, nowadays
wherever there is a place where pictures are kept as curiosities permanently it is
called a National Gallery, perhaps after this one.'[61] Again, the British Museum is
mainly identified in terms of its architecture and the value of its collections: 'there
is plenty of labour and material in it'.[62] The hopes of the founders of the British
Museum to establish a museum 'for the general use and benefit of the public; ... for
public use of all posterity' are clearly thwarted.[63] The archetypal temple of the arts,
typified in the neoclassical structure of 1823, represented a specific historiography
of society and civilisation, which had no place in Morris's new world. On the con-
trary, the citizens of the 'new' England disengaged themselves consciously and
abruptly from this history that, in their view, embodied principles of inequality,
elitism, imperialism and exploitation. Instead, they reverted back to a preindustrial
society with principles of self-sufficiency, economic sustainability and egalitari-
anism manifested in a more 'native' Gothic style. This conscious disassociation is
echoed in the evaluation of history as an academic subject.

> 'Well,' said I, 'what else do they learn? I suppose they don't all learn history?' 'No,
> no,' said he; 'some don't care about it; in fact, I don't think many do. I have heard my
> great-grandfather say that it is mostly in periods of turmoil and strife and confusion
> that people care much about history; and you know,' said my friend, with an amiable
> smile, 'we are not like that now.'[64]

The great political and social rupture, the disengagement with the past and the
emergence of a political system that is based on economic and social equality, co-
operation and exchange leaves no place for institutions that are based on exclusion
and disciplinary technology. In Morris's visionary dream, the Victorian city and
museum must remain outside utopia.

A very different idea of history is presented by H. G. Wells in *The Time
Machine* (1895).[65] This scientific romance is most famous for its dystopian view of
the evolution of late nineteenth-century England into a static and degenerate
nation. Sharing concerns with Morris about the wide-ranging and long-term
social and economic consequences of Victorian industrialism, the class struggle
that Morris evaluated as an inevitable trigger for revolution is turned into evolu-
tionary warfare and the decline of mankind. The museum, or the Palace of the
Green Porcelain, becomes a symbol for this decline. It represents the end of
human history.

Wells describes a future society that is deeply divided. The Eloi, a childlike, peaceful race, live as an agricultural community in paradoxically futuristic urban tower blocks embedded in an edenic landscape. This urban vista is dominated by a decayed bronze temple in the shape of a sphinx. The Eloi, so speculates the narrator, are the climax of social evolution where due to most advantageous climatic, economic and social conditions, they developed a harmonious society. In contrast to Morris's utopia, which fosters creativity, agency and indeed personal enrichment, Wells's Eloi realm is clearly a static and regressive society. The other species, the Morlocks, live underground and have adapted to these conditions by growing hardy and strong, and developing nocturnal eyesight. At night, they surface to hunt stray Eloi. The time traveller rightly identifies this divided society as the result of nineteenth-century industrial capitalism where the capitalists and labourers evolve into two different and distinct species. But evolution has come to a standstill. The future that the time traveller encounters is in fact a dead end for humanity.

On his way to reclaim his time machine, the time traveller explores the city. This post-apocalyptic London displays several relics of its former existence: an ornate but ruined Palace of Green Porcelain. Its overwhelming entrance hall with several dinosaur skeletons, the intricate corridors with smaller and larger galleries on different floors and the collection ranging from palaeontological exhibits, geological, mineralogical and chemistry departments to a vast natural history collection is

44 Perspective of the Dinosaur Gallery, Natural History Museum, London, 1870–71; architect: Alfred Waterhouse

reminiscent of the Natural History Museum opened in South Kensington in 1881 (see figure 44).[66] Built to house the vast natural history collection of the British Museum, it was founded to display a 'comprehensive, philosophic, and connected view', an 'epitome' of natural history.[67] However, like the British Museum in *News from Nowhere*, the Palace is the site of a bygone epistemic order, which contains the possibility of this dystopian future by exhibiting the unfolding logic of evolution. However, as Gustafsson points out, the museum also contains exhibits that are part of the time traveller's own future. The museum is therefore not only a museum of the traveller's past and present, but a *future museum*.[68] If the future of humanity is the end of mankind, then the museum not only displays objects that have lost their meaning to the beholder, but 'objects without future'.

> There is no human use for them anymore since history, understood as human history, has clearly come to a dead end in this sterile war between two subhuman species who do not feel any curiosity anymore …
>
> They did not exist when our time traveler lived; they belonged to his future, and now they are gone and, in this time, they belong to a past which is definitely gone, too. They might as well have been imaginary objects.[69]

The museum as a once utopian site is transformed into an atopian void.

An effective history of the museum as proposed by Hooper-Greenhill discloses the disciplinary practices of the museum as a clearly political institution committed to enhance and implement structures of authority and power. A study of the museum in literary utopias complements but also complicates this reading of the museum. Francis Bacon's *New Atlantis*, Tommaso Campanella's *City of the Sun* and Johann Valentin Andreae's *Christianopolis* serve as models that allocate a specifically political role to the museum in their utopian city states. This crucial function is both enhanced and symbolised in the museum's spatial prominence within the urban context. However, a critical reading of utopian texts similarly unveils the limits of the role of the museum as a civic educator and therefore also highlights the implicit limitations of a strictly Foucauldian reading of museum history.[70] The examples of Morris and Wells show the possibility of the museum working in an ideological and social vacuum where the fundamental codes of the culture displayed in the museum are meaningless to the visitors/beholders. Both readings identify the museum as a space 'occupied by the symbolic and the imaginary – by "idealities" such as nature, absolute knowledge or absolute power'.[71] The museum itself is thus fundamentally utopian.

Notes

1 George Brown Goode, *Principles of Museum Administration* (1895), p. 71; quoted from Tony Bennett, *The Birth of the Museum: History, Theory, Politics* (London and New York: Routledge, 1995), p. 20.

2 Eilean Hooper-Greenhill, *Museums and the Shaping of Knowledge* (London: Routledge, 1992); Bennett, *The Birth of the Museum*.

3 Paul Smith, *Discerning the Subject* (Minneapolis: University of Minnesota Press, 1988), p. xxvii. Michel Foucault, *The Order of Things: An Archaeology of the Human Sciences* (New York: Random House, 1970).

4 Hooper-Greenhill, *Museums and the Shaping of Knowledge*, p. 64.

5 Foucault, *The Order of Things*, pp. 56–7.

6 Quoted in Hooper-Greenhill, *Museums and the Shaping of Knowledge*, p. 174.

7 See particularly Jürgen Habermas, *The Philosophical Discourse of Modernity: Twelve Lectures*, trans. F. Lawrence (Cambridge: Polity Press, 1987).

8 Krishan Kumar, *Utopia & Anti-Utopia in Modern Times* (Oxford: Blackwell, 1987), p. 5.

9 On utopia and education, see Gerald Gillespie, 'Education in utopia', in Hans-Gerd Rotzen (ed.), *Europäische Lehrdichtung* (Darmstadt: Wissenschaftliche Buch-gesellschaft, 1981), pp. 119–31; David Halpin, *Utopian Ideals, Democracy and the Politics of Education: An Inaugural Lecture* (London: Goldsmith College, 1997); Wilhelm Vosskamp, 'Utopian thinking and the concept of Bildung', in Klaus L. Berghahn and Reinhold Grimm (eds), *Utopian Vision, Technological Innovation and Poetic Imagination* (Heidelberg: Carl Winter Universitätsverlag, 1990), pp. 63–74.

10 These three models identify three distinct moments but not a chronological develop-ment in the history of the museum in utopia. However, my focus is on specifically urban utopias and, indeed, the *città felice* tradition does result in a prevalence of urban utopias and ideal city states in early modern literature. The celebration of the city as an ideal is challenged in the eighteenth century and results in more rural utopian visions or urban dystopias of the nineteenth and twentieth century.

11 In *Städte in Utopia: Die Idealstadt vom 15. bis zum 18. Jahrhundert* (Munich: C. H. Beck, 1989), Hanno-Walter Kruft argues for the distinction between utopian cities and ideal cities. Whilst I maintain this distinction, I want to emphasise their reciprocal incitement: the 'city of the future, of desire, of hope, of equality and social order was no different from the real city as *intended* by princes, theorized by treatises, and depicted by artists', as Franco Borsi rightly claimed; Franco Borsi, *Architecture and Utopia*, trans. Deke Dusinberre (Paris: Hazan, 1997), pp. 29–30.

12 Bennett, *The Birth of the Museum*, p. 46.

13 Francis Bacon, *New Atlantis and The Great Instauration*, ed. Jerry Weinberger (Wheeling, JL: Crofts Classics, 1989).

14 T. J. Reiss, *The Discourse of Modernism* (Ithaca: Cornell University Press, 1982), p. 187.

15 Bacon, *New Atlantis*, p. 71, p. 82.

16 J. C. Davis, *Utopia and the Ideal Society: A Study of English Utopian Writing 1516–1700* (Cambridge: Cambridge University Press, 1981), p. 119.

17 *Ibid.*, p. 120. On the aspect of censorship of knowledge see Klaus Reichert, 'The two faces of scientific progress: or, institution as utopia', in Berghahn and Grimm (eds), *Utopian Vision*, pp. 11–28.

18 Ludwig K. Pfeiffer, 'Wahrheit und Herrschaft: zum systematischen Problem in Bacons *New Atlantis*', in Klaus L. Berghahn and Hans Ulrich Seeber (eds), *Literarische Utopien von Morus bis zur Gegenwart* (Königstein: Athenäum, 1983), pp. 50–8; p. 54. A large part of *New Atlantis* clarifies social structures through the lengthy description of

social rites such as marriage and procreation. Accordingly, the reference to the
museum is part of a section on ordinances and rites.

19 Francis Bacon, *The Advancement of Learning*, ed. G. W. Kitchin (London: Everyman's Library, 1973), I.VII.1, p. 42.

20 Bacon, *New Atlantis*, pp. 69–70.

21 *Ibid.*, p. 58.

22 *Ibid.*, p. 48. On this point, see also Reiss, *The Discourse of Modernism*, p. 196.

23 On the aspect of self-regulation, see Reichert, 'The two faces of scientific progress'.

24 *Ibid.*, p. 26.

25 *Ibid.*, p. 21.

26 Bacon, *New Atlantis*, p. 59.

27 It is important to note that there is an epistemic shift between the museum in *Gesta Grayorum* and *New Atlantis*. The former is indebted to a representational system of collecting and display, whereas the latter introduces history and the notion of progress and perfectibility, thus pre-empting the modern *episteme*. See Francis Bacon, *Gesta Grayorum; or, The History of the High and Mighty Prince Henry ... who reigned and died, A. D. 1594. Together with a Masque, as it was presented (by his Highness's Command) for the Entertainment of Queen Elizabeth; who, with the Nobles of both Courts, was present thereat*, in Bacon, *Law Sports at Grays Inn*, ed. Basil Brown (New York: privately printed by the author, 1921), pp. 46–7.

28 *Ibid.*, pp. 46–7.

29 He revised the Italian manuscript in 1611, translated it into Latin and the first edition was published in 1623 in Frankfurt.

30 Tommaso Campanella, *The City of the Sun: A Poetical Dialogue*, trans. Daniel J. Donno (Berkeley: University of California Press, 1981), p. 27.

31 For a detailed analysis of the curriculum, see Robert T. Fisher, *Classical Utopian Theories of Education* (New York: Bookman Associates, 1963), ch. 4.

32 Thomas Renna, 'Campanella's *City of the Sun* and late Renaissance Italy', *Utopian Studies*, 10:1 (1999), pp. 13–25; p. 14.

33 Salvatore Calomino, 'Mechanism, diversity, and social progress: emblems of scientific reality in Campanella's *La città del sole*', in Berghahn and Grimm (eds), *Utopian Vision*, pp. 29–41; p. 30.

34 *Ibid.*, p. 30.

35 Reiss, *The Discourse of Modernism*, p. 169.

36 On the art of memory and the memory theatre, see Hooper-Greenhill, *Museums and the Shaping of Knowledge*, ch. 4; Frances A. Yates, *The Art of Memory* (London: Pimlico, 1996).

37 *Ibid.*, p. 142.

38 *Ibid.*, p. 141.

39 *Ibid.*, ch. 13.

40 Campanella, *City of the Sun*, p. 27.

41 *Ibid.*, p. 37.

42 At the same time, this journey curiously depicts a reverse evolution from great men to basic mathematics and not, as Reiss suggests, the other way around. Reiss, *The Discourse of Modernism*, p. 177.

43 *Ibid.*, p. 175.

44 Ernst Bloch, *Das Prinzip Hoffnung* (Frankfurt: Suhrkamp Verlag, 1985), p. 609 [my translation].

45 Andreae was clearly inspired by More and Campanella. More's *Utopia* was translated into German in 1612. Andreae also knew the work of Campanella and even translated some of his sonnets into German. See Davis, *Utopia and the Ideal Society*, p. 73, n. 26.

46 Johann Valentin Andreae, *Christianopolis: An Ideal State of the Seventeenth Century*, trans. Felix Emil Held (New York: Oxford University Press, 1916), p. 173.

47 *Ibid.*, p. 233.

48 *Ibid.*, p. 208.

49 *Ibid.*, p. 202.

50 Kumar, *Utopia & Anti-Utopia*, p. 45.

51 With some exceptions, utopian socialism mainly found its expression in political economies, pamphlets and communal experiments, less so in utopian fiction.

52 Some examples are: Stedman Whitwell, *Description of an Architectural Model from a Design by Stedman Whitwell, Esq. for a Community upon a Principle of United Interests, as advocated by Robert Owen, Esq.*, in *Cooperative Communities: Plans and Descriptions* (New York: Arno Press, 1972); [Edward Barnard Barsett], *Beta, The Model Town; or, The Right and Progressive Organization of Industry for the Production of Material and Moral Wealth* (Cambridge: printed for the author, 1869); Benjamin Ward Richardson, *Hygeia: A City of Health* (London: Macmillan and Co, 1876); G. Brown Goode, *The Principles of Museum Administration* (York: Coultas and Volans, 1895) and of course John Ruskin's plans for the Guild of Saint George in Sheffield. See Susan P. Casteras, "'The germ of a museum arranged first for 'workers in iron'": Ruskin's museological theories and the curating of the Saint George's museum', in Susan Phelps Gordon and Anthony Lacy Gully (eds), *John Ruskin and the Victorian Eye* (New York: Abrams, 1993), pp. 184–209.

53 William Morris, 'Looking Backward', in Morris, *Political Writings of William Morris*, ed. A. L. Morton (London: Lawrence and Wishart, 1984), pp. 247–53; p. 252.

54 Ruth Levitas, 'Who holds the hose: domestic labour in the work of Bellamy, Gilman and Morris', *Utopian Studies*, 6:1 (1995), pp. 65–84; pp. 76–7; Ruth Levitas, *The Concept of Utopia* (London: Philip Allan, 1990), ch. 5.

55 William Morris, 'How we live and how we might live', in Morris, *News from Nowhere and Selected Writings and Designs*, ed. Asa Briggs (Harmondsworth: Penguin, 1962), pp. 158–79; p. 179.

56 *Ibid.*, p. 178.

57 William Morris, *News from Nowhere*, in Morris, *News from Nowhere and Selected Writings and Designs*, ed. Asa Briggs (Harmondsworth: Penguin, 1962), pp. 183–301; p. 274. The point of Morris's seemingly pessimistic evaluation of nineteenth-century socialist organisations is to effect further political activism and utopian hope in a Blochian sense. See Levitas, *The Concept of Utopia*, pp. 119–23.

58 Morris, *News from Nowhere*, p. 245.

59 Bennett, *Birth of the Museum*, pp. 98–9.

60 Lars Gustafsson, 'The present as the museum of the future', in Berghahn and Grimm (eds), *Utopian Vision*, pp. 105–10; p. 107.

61 Morris, *News from Nowhere*, p. 220.

62 *Ibid.*, p. 226.

63 'An Act to incorporate the British Museum' (1753); quoted in J. Mordaunt Crook, *The British Museum* (London: Allen Lane, The Penguin Press, 1972), p. 39.

64 Morris, *News from Nowhere*, pp. 207–8.

65 H. G. Wells, *The Time Machine* (London: Book Club Associates, 1981).

66 Wells's description is imprecise. On the one hand, there is no 'customary hall' but a long gallery; on the other hand, Wells talks about the same room as a hall with dinosaur exhibits (Wells, *The Time Machine*, pp. 56–7). Waterhouse was indeed criticised for the labyrinth of multi-level galleries. See Mark Girouard, *Alfred Waterhouse and the Natural History Museum* (London: The British Museum (Natural History), 1981), p. 52.

67 *Ibid.*, p. 12.

68 Gustafsson, 'The present as the museum of the future', p. 107.

69 *Ibid.*, pp. 107–10.

70 Indeed, Tony Bennett's work already provides a critique and revision of Hooper-Greenhill's Foucauldian work.

71 Henri Lefebvre, *The Production of Space*, trans. Donald Nicholson-Smith (Oxford: Blackwells, 1991), p. 366.

7

The return of the Muses:
Edinburgh as a *Museion*

Volker M. Welter

In 1914, Kenelm Foss's Little Theatre in London advertised that Patrick Geddes (1854–1932), the Scottish biologist, sociologist, urban theorist and town planner, would deliver a lecture series with the title 'The Returning Gods'. The programme promised four lectures – 'Olympus in London', 'Arcadia in London', 'Athens in London', and 'Parnassus in London' – each of them dealing with 'modern Life and Ideals in ancient imagery'.[1] The lecture series never took place, for Geddes and his circle of energetic friends allegedly caused the owner of the Little Theatre to have a nervous breakdown.[2] However, the subject matter of the return of the Greek gods – together with the Muses – to the contemporary city stands right at the centre of Geddes's theory of city design.

When Geddes prepared the lecture series he could already look back on nearly thirty years of engagement with the fledgling profession of town planning. During his professional life Geddes worked in a variety of countries, amongst them Scotland, England, France, India and Palestine. Geddes's initial academic education was in biology, which he studied in the 1870s under Thomas H. Huxley (1825–95) in London, and in France. In these years, Geddes developed a life-long interest in the evolution of living beings and their interaction with the environment. At the same time he became interested not only in sociological studies such as the theories of the French sociologist Frédéric Le Play (1806–82) but also in Auguste Comte's (1798–1857) positivist Religion of Humanity. Towards the mid-1880s, when difficulties with his eyesight prevented Geddes continuing microscopic observations of single-cell organisms, he switched the focus of his studies to a larger scale – that of human life and its social organisation. Despite holding a chair in Botany at Dundee University College, Geddes made the study of human societies in their natural geographical and urban setting his main field of inquiry.

Geddes's driving intellectual goal was to reunite 'life' in a Bergsonian sense into a holistic whole, after the nineteenth century had torn it apart under the influence of Positivistic science. Life was for Geddes more than a mere biological function; it was a social activity that he felt should follow the principle of mutual

aid as developed by Geddes's acquaintance, the Russian Anarcho-geographer Pjotr Kropotkin (1842–1921). A society actively pursuing the aim of an integrated, co-operative life could, according to Geddes, take only one social and spatial form – that of the city.

One of the main models for Geddes's theory of the city of the future was the ancient Greek *polis*. When Geddes exhibited his *Cities and Town Planning Exhibition* for the first time in London in 1911, he included among the exhibits two prints, showing views of Athens and of Edinburgh.[3] The distant view of Athens emphasises the prominent position of the Acropolis above the actual town. In comparison, the print after Alexander Nasmyth's painting *Edinburgh from the West* (1821) reveals a striking similarity with Athens's topography. Both towns were dominated by a huge rock at their centre, the difference being that in Edinburgh the rock accommodated a Castle and not an assemblage of primarily religious buildings. From this comparison Geddes concluded that the city of the future required a dominant central urban core, raised above the urban fabric.

Geddes was interested not only in the geographical setting of the Greek *polis*, but also in its mythology, which depicts the Arcadian landscape of the *polis* as inhabited by both mortal citizens and the mythological figures of the Greek gods and Muses. Geddes interpreted the Greek gods as the embodiment of those ideals of beauty and wisdom for which humankind should strive.[4] The only way to achieve this goal, according to Geddes, was to engage in those activities that the Muses – the goddesses of the arts and sciences – symbolised. If mankind would listen attentively to the Muses, the first step towards the improvement of life would already be taken. Or, as Geddes wrote in the leaflet for his lecture series in London: 'Our town becomes a City indeed, with Acropolis and Temples, Academe and Forum, Stadium and Theatre. The Nine Modes of high activity which are latent in every life, and of its very essence, are awakened, freed, and energised'.[5]

This quotation describes neatly what Geddes expected the city of the future to be: a place in which cultural institutions and their respective buildings would stimulate the creation of a city by engaging the citizens in 'the Nine Modes of high activity'. With this term Geddes referred to those arts traditionally represented by the Muses: tragedy (Melpomene), dance and song (Terpsichore), astronomy (Urania), epic poetry (Calliope), lyric and love poetry (Erato), hymns, heroism and wisdom (Polyhymnia), music and lyrical verse (Euterpe), comedy and pastoral verse (Thalia), and, finally, history (Clio). Not surprisingly, temples, theatres, universities, and stadiums as spaces for these activities are recurring proposals in many of Geddes's city design reports. Geddes's interest in the Muses, however, acquires a particular focus if one takes into account the one institution that the above quotation does not mention, but which Geddes proposes in all of his city design reports: the museum.

In one of his earliest city design reports, for Dunfermline, Geddes proposed a new park with a central complex of old and new buildings, and open-air structures accommodating a variety of museums, amongst them a Nature Palace with four

natural history museums. Furthermore, an open-air museum of the history of labour was planned, which comprised a primitive historic village and a contemporary crafts village. Finally, Geddes's report suggested a History Palace and a number of art museums. These proposals were more than just a group of museums on an exceptionally huge scale. For Geddes, this assembly of museums was a conceptual tool that allowed the citizens of Dunfermline to develop a vision of the future of their own city. As Geddes stated in the report, 'since rapidly to recapitulate the main phases of the past is nature's way of passing beyond these, even of acquiring the impetus for passing in turn the present phase, it may well also be ours.'[6]

The key word in this quotation is 'to recapitulate', for Geddes refers with this verb to a biological law, which the German biologist Ernst Haeckel (1834–1919) had already put forward in the 1860s.[7] Geddes was acquainted with Haeckel since he had studied briefly under him at Jena University in the 1870s. Both men shared not only a fascination with Darwin's theory of evolution, but also a passionate belief in an ultimate, unifying principle of life; an idea Haeckel was to develop in his philosophy of Monism. Like many contemporary biologists, Haeckel was puzzled by the relation between the evolution of a species (phylogeny) and the development of an individual member of that species (ontogeny). By formulating what he called the fundamental biogenetic law, which stated that the ontogeny is the short and rapid recapitulation of the phylogeny, Haeckel suggested a causal relation between the long-term historical evolution of a species and the short-term contemporary growth of an individual organism.

Geddes transferred this biological law into town planning and urban design. He strongly advocated a survey of the history of a town before any future plan was conceived. The historical survey would help the citizens to discover that their future and that of subsequent generations was already incipient in the past. Each generation of citizens that had conducted their lives under the influence of the Muses had created material products and artefacts as the result of their labour and work. To discover the future meant for the contemporary generation of citizens a recapitulation of their city's history by reading these historic remnants interspersed in the urban fabric or collected in museums.

This methodological approach to the planning of a city allows one to understand Geddes's fascination with the symbolism of the Muses. The mother of the Muses is Memory; but memory – the remembrance of the history of a city – is also the first step towards the city's future. The recapitulation of history relies on surviving cultural and artistic human artefacts; but they are nothing else than products of the arts and sciences, realms watched over by the Muses. And as the Muses, as Hesiod points out in his poem *Theogony*, sing about past, present and future; these artefacts can do the same. Each human generation that is inspired by the Muses leaves a layer of artefacts in a city, which tells the next generation about their predecessors. For Geddes, the city considered as a collection of historical remnants was a place of the Muses. Etymologically, the term museum derives from *Museion*, a Greek word that refers in particular to a hill facing the Acropolis in Athens, but denotes generally everything

sacred to the Muses. Accordingly, a city designer could renew the dedication of a city to the Muses by 'designing, for the bettering cities of the opening future, their veritable "Museion"'.[8]

In the case of Dunfermline, Geddes intended to create a contemporary home for the Muses within a new park in the centre of the town. In 1903, Andrew Carnegie had gifted to his home town a large sum of money to be used for the well-being of Dunfermline's citizens. The municipality decided to spend the money on the creation of Pittencrieff Park and invited Geddes and the landscape architect Thomas Hayton Mawson (1861–1933) to submit competing designs, although neither plan was implemented.

Geddes's proposal resulted in a design for a park that focused a range of cultural institutions and museum buildings. In addition, Geddes envisaged botanic and zoological gardens, sports grounds, a men's gymnasium, and other educational and recreational facilities. However, the museums were the crucial elements, for their function was to stimulate and direct the engagement of the citizens with the past. The History Palace, a large municipal museum, probably best exemplifies Geddes's transfer of Haeckel's idea of recapitulation into architecture and urban design.

Geddes and George Shaw Aitken (1836–1921), the architect who made designs of all the buildings in the park, organised the museum as a long sequence of galleries following a strictly chronological order (see figure 45). The architecture reflects the internal order. The museum begins with a 'Celtic Tower', continues with Medieval and Renaissance buildings, and ends with a 'Tower of Outlook', which marks the transition to the twentieth century. Beside the chronological order, the design also expresses spatially the inter-relatedness of local and universal history because the three main storeys of the building present the history of different geographical areas. While the local history of Dunfermline occupies the upper floor, the two lower floors widen the frame of reference from Scotland on the middle floor to general or universal history on the ground floor. Geddes's concept for the History Palace was to create a three-dimensional, architectural system of co-ordinates. Effortlessly, a visitor could have recapitulated all of Dunfermline's history – on its own and in relation to Scotland and the world – by following the prescribed sequence or, indeed, any other route through the building.

Geddes recommended the establishment of similar museums, although of different sizes, in virtually all of his city design reports; but they were only a means to a much larger end. Geddes's interest in the recapitulation of the past was driven by the thought that the education of citizens about their city's history was a necessary precondition for all future improvements of the contemporary city. The museum was an intermediate step towards this goal. Regardless of the didactic perfection it could achieve, the museum ultimately remained an artificial collection of isolated artefacts, especially if compared with what existed in the urban fabric. An accurate observer of the contemporary city would become, in the words of Geddes, a 'fossil-hunter', who

45 Plan of the History Palace for Pittencrieff Park Dumferline, 1903; George Shaw Aitken for Patrick
Geddes. To the right the long building of the history museum. The course through the museum begins with
the Celtic galleries at the top and ends with an outlook tower gallery for the incipient twentieth century at
the other end. Adjacent to the History Palace to the left are recreational gardens and a block of craftsman
workshops

'makes for himself the delightful discovery that there is scattered through the everyday
city of to-day and yesterday the historic city of days long and longer gone by. He no
longer thinks history is only in the books, nor even in the museums with their relics.'[9]

Although he was strongly influenced by Carlyle's ideas on history, Geddes
rejected the proposal in *Sartor Resartus* that books will outlast cities and architec-
ture.[10] Rather, Geddes insisted that 'architecture ... is crystallized history',[11] and
that cities should ideally be 'Open-Air Museums of the Centuries – a series of sur-
viving buildings which would have something characteristic, if not of each genera-
tion or even century, at least of each great period of culture, each great phase of
social and civic life, each type and stage of national and European culture.'[12]

Accordingly, the *Museion* Geddes wished the city designer to conceive was not primarily a museum within a city, but ideally the entire city transformed into a place of the Muses; an idea Geddes himself aimed to realise in Edinburgh.

Geddes's goal was to stimulate the social evolution of Edinburgh's citizens, which in turn he hoped would lead to a new impulse in the evolution of the city. Between 1886, when Geddes moved into Edinburgh's Old Town, and circa 1900, when he shifted the focus of his activities gradually to London, Geddes worked mainly on the physical renewal of the Royal Mile, the main street in the Old Town. Geddes concentrated his efforts on the upper, western end of the street (see figure 46). In order to speed up the redevelopment of the street he also pursued projects at the eastern end, but there his initiatives never went much beyond an initial stage. However, at both ends of the street, Geddes erected new buildings and reconstructed older ones. Uninhibited by the contemporary debate about the ethical and historical correctness of attempts to conserve historic buildings, Geddes frankly adapted and even rebuilt historic buildings as long as he could give them a new lease of usage, which fitted into his overall vision of a revitalised Old Town. For Geddes, both new buildings and reconstructions of existing ones were complementary exhibits in the open-air museum of the centuries.

Nevertheless, the first building Geddes turned his attention to was an old structure. Although it dated from 1723–27, James Court barely qualified as a historic building when Geddes and his wife Anna took lodgings in one of the wings of the block in 1886. Originally, James Court had been a speculative tenement offering state-of-the-art housing in the Old Town prior to the planning of the New Town. During the nineteenth century it developed into one of the most appalling of the many slum buildings in Edinburgh. In typical philanthropic manner Geddes set out to improve the block by cleaning and whitewashing the courtyard and planting flowers in window boxes.

Beyond this, Geddes was interested in James Court due to its association with the philosopher David Hume. Even though the wing where Hume had rented a flat had burnt down in 1856, the association between the philosopher and the site continued to exist. By refurbishing the tenement block, Geddes hoped to keep alive the memory of one of the Court's most famous inhabitants. This was more than a nostalgic impulse, for remembering that a person as famous as Hume had lived in James Court was a reference to the social reality that once had dominated Edinburgh. Daily life in these blocks was characterised by very close contact between different social classes. These social conditions, Geddes argued, stimulated the philosopher's enlightened inquiries into the human mind and the possibilities of the improvement of the conditions of humankind. Restoring James Court was an attempt to reactivate this association – not for the sake of history but for the benefit of the contemporary city – by offering the building to the citizens of Edinburgh as an opportunity to recapitulate a decisive moment in the history of their city.

James Court was the most recent of the old buildings Geddes was involved with. Once he was established there, his interest focused on other buildings. In the

© Volker M Welter, 1999

KEY TO PLAN

▓ existing educational, cultural, religious municipal or other publicly accessible buildings

■ realised projects

◯ exact location of project unknown

☐ unrealised projects

--- unrealised façade redevelopment

▓ open space or public park

REALISED PROJECTS
(built, restored, owned by Geddes)

1 Ramsay Garden
2 Mound Place 1–2
3 Ramsay Lane Buildings
4 Outlook Tower and Garden
5 Canonball House
6 Boswell's Court
7 James Court
8 Lady Stair's House
9 Blackie House
10 Wardrop's Court
11 Old Edinburgh Art Shop
12 Riddle's Court and Close
13 Brodie's Close and 306 Lawnmarket
14 St Giles House

UNREALISED PROJECTS

I Ramsay Garden Studios
II Sculpture Gallery
III Tower Block
IV University Quadrangle
V Public Meeting Hall
VI Castlehill Building
VII National Library Extension

DECORATIVE/MONUMENT SCHEMES
[*] = realised

a Cast Iron Dragons [*]
b Witches Well [*]
c Scottish History Procession Sgrafitto
d Burning Bush Relief
e Three Witches/Star of David Panel [*]
f Thomas Carlyle Bust
g Robert Bruce Statue
h John Knox Statue
i William Wallace Statue
j St. Columba Statue
k 'Vivendo Discimus' Stone Carving [*]
l Cast Iron Dragons [*]
m John Stuart Blackie Portrait Medallion [*]

46 Plan showing Patrick Geddes's interventions in the urban fabric around the western part of the Royal Mile in the Old Town of Edinburgh between c.1887 and c.1898

following years Geddes bought, or convinced supporters of his ideas to buy, a number of historic buildings for the purpose of reconstruction. If Geddes personally acted as the owner, the property was often sold after completion of the reconstruction to fund the purchase of other buildings. Geddes was not working in a vacuum, as there were, of course, other initiatives aiming at improving the Old Town. Already in 1885, Geddes had been among the founders of the Edinburgh Social Union (ESU), a philanthropic association working towards the improvement of the social conditions in the Old Town. Having helped to set up the group, Geddes left it a year later, but continued to consider the ESU's work as being complementary to his own urban renewal concept. From 1892 onwards Geddes also made use of the legal and financial help available from the municipality of Edinburgh, when the city authorities began to implement the *1890 Housing of the Working Classes Act.*[13] Edinburgh council identified ten urban improvement areas and appointed in each area an individual with the task to oversee the improvement works. Geddes was assigned the responsibility for the Lawnmarket area. The fact that Geddes continually mixed his official position with private financial responsibilities emphasises how much his urban renewal work was a one-man crusade, driven by a strong personal idea about Edinburgh's future. His bankruptcy in 1896 brought most of his initiatives to a sudden end. His friends responded by setting up the Town and Gown Association, which was a share-issuing philanthropic company with the goal of rescuing and continuing Geddes's various schemes. The Town and Gown Association was partially successful in providing a new, more professional basis for Geddes's work in the Old Town; nevertheless, its foundation indicated the beginning of the end of his Edinburgh period.

Amongst the buildings Geddes managed to reconstruct between 1886 and circa 1900 are Blackie House (late seventeenth century) at North Bank Street, Lady Stair's House (early seventeenth century) between North Bank Street and Lawnmarket, Brodie's Close (late sixteenth / early seventeenth century) and Riddle's Court (sixteenth century), both at Lawnmarket, and Boswell's Court (circa sixteenth century) at Castlehill (see figure 46). Even without analysing the details of the history of each individual property, it becomes obvious that Geddes selected buildings that – if placed in their historical sequence – illustrated the development of the tenement and the respective housing and living conditions within the Old Town from roughly the sixteenth to the eighteenth century.

Going further back in history, the Middle Ages were of utmost importance to the idea of a city as an open-air museum of the centuries. Medieval Edinburgh had acquired an urban composition that reflected in Geddes's understanding the ideal social structure for any collective of citizens. Adopting a concept from the French sociologist Auguste Comte, Geddes considered a good society to be composed ideally of four social types: People, Chiefs, Intellectuals and Emotionals. The former two constituted what Comte and Geddes called the temporal powers, whereas the latter two formed the spiritual powers. Geddes never subscribed to the Marxist

notion of competing classes as the forces that shaped social reality; a concept he
rejected for being confrontational. Instead, Geddes adopted Comte's classification
of four social types in order to emphasise the potential for co-operation between
different social groups for the common good. The People were the ordinary citi-
zens, while the Chiefs were the political leaders and their peer group. With the
term Intellectuals, Geddes referred to those citizens who were engaged in con-
ceiving ideas for the better life of the future. For example, in the Middle Ages the
Intellectuals were the monks living in abbeys, whereas in Geddes's own time the
Intellectuals were to be found among natural scientists and academics. Finally,
Geddes classified under the heading of Emotionals all those citizens, like priests
and artists, whom he considered to be engaged in transferring into the wider social
and urban reality the ideas developed by the Intellectuals. The Emotionals were, so
to speak, the avant-garde of the incipient social change.

 This division of a city's inhabitants into four social types was for Geddes not an
abstract sociological concept. Rather, and this is the crucial point of his adaptation
of Comte's idea, Geddes related the social types to the urban fabric. He identified
particular institutions and their buildings with different social types. While
Geddes claimed that this model could be applied to every period in a city's history,
he always resorted to medieval Edinburgh as a particularly lucid illustration of his
claim. The urban geography of medieval Edinburgh expressed the division of a
society in the social types in nearly perfect form. The Castle at the western end of
the Royal Mile, Edinburgh's medieval High Street, represented the Chiefs. St
Giles Cathedral, half-way down the Royal Mile, symbolised the Emotionals. In
Holyrood Abbey at the eastern end of the street the Intellectuals had once been
accommodated. The ordinary town houses of the People surrounded these three
institutions and constituted the wider urban fabric. Obviously, this simplified and
idealised reading of the urban reality of medieval Edinburgh is open to criticism.
However, the consequences of this interpretation for Geddes's own initiatives in
urban renewal are of considerable importance in the context of this chapter.

 Medieval Edinburgh was, according to Geddes, a city rationally planned around
a central open and green space, the Lawnmarket. This space was surrounded by
individual town houses with narrow but long gardens at the back. The buildings
were dominated by gables and their façades structured by lofty balconies and airy
arcades; although no such house had survived the course of history. Thus while
Geddes could easily incorporate Edinburgh Castle, St Giles Cathedral and the
ruins of Holyrood Abbey into the concept of an open-air museum of the centuries,
a gap remained with regard to the medieval town house.

 In order to allow the contemporary citizens to recapitulate the medieval period
in its entirety, Geddes set out to close the gap by recreating medieval houses when-
ever the opportunity arose. Ramsay Garden (1892, 1893–94), Geddes's best-known
building project (see figure 47), is indebted to medieval architecture: irregular roof
line, quaint dormer windows, protruding wooden alcoves, oriel windows, harled
façades, circular stair towers; everything that can be understood as a reference to

the Middle Ages was included in the design by Geddes's architects, Stewart Henbest Capper (1859–1924) for the first phase, and Sydney Mitchell (1856–1930) and George Wilson (1845–1912) for the second phase of the project.

To the east of Ramsay Garden, Geddes planned to erect a copy of a medieval city gate, the Netherbow Port (see figure 47). The intention was to 'compensate to a great degree for the loss of those picturesque features' of the medieval city.[14] While Geddes failed to realise this tower, he succeeded in restoring another medieval feature to Edinburgh's urban architecture. With the arrival in the seventeenth and eighteenth centuries of tenement blocks in the Old Town, for example James Court, the irregular roof lines of older town houses, which normally comprised a series of gables, were replaced by straight cornices. Many of Geddes's interventions aimed at reverting this change.

The formal appearance of three Georgian tenements to the east of Ramsay Garden was modified by adding three gables and three wooden oriel windows (see figure 47). Blackie House, the seventeenth-century tenement block mentioned above, received an identical treatment in 1894. Again, the gables refer to the medieval roof form, whereas the oriel windows are a re-interpretation of the old wooden balconies. Rather than completing his contemporary version of medieval town houses with open arcades, Geddes and his architects opted in the case of Blackie House for a row of shops built on ground-floor level into the street space. Two years earlier, in 1892, Geddes and Henbest Capper had already incorporated the same mock-medieval elements – three gables, three oriel windows, and a row of ground-floor shops – in the design for Wardrop's Court in Lawnmarket. This was a five-storey speculative block, which unified under three new gables two reconstructed and refronted older buildings with a new one erected in an adjacent gap site to the right. The original design for the façade made references to medieval English and German architecture in the shape of the gables and with the half-timbered zone

47 Perspective view of The Mound, Edinburgh, from Ramsay Garden on the right to North Bank Street on the left, 1893; George Shaw Aitken. The view incorporates existing buildings, proposed new ones, and reconstructed façades. The tower between Ramsay Garden and the tall church spire indicates the location of the copy of the medieval city gate with which Patrick Geddes envisaged to crown his scheme

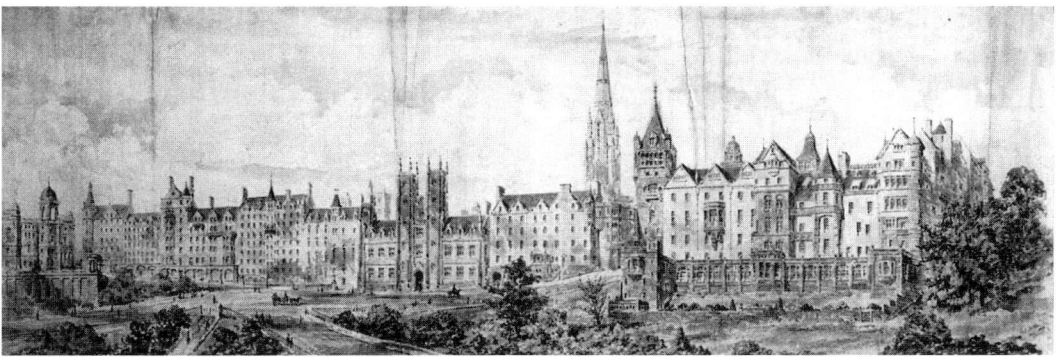

immediately underneath (see figure 48). When executed, this area was harled in an attempt to strengthen the Scottish character of the building.

Opposite Wardrop's Court, another of Geddes's reconstructed buildings can still be seen (see figure 46). Brodie's Close at the south side of Lawnmarket is a late sixteenth-century building, which was extended towards the street in the early seventeenth century by adding a new ashlar front with several stone gables. The neighbouring building to the east, which is of roughly the same age, had always retained its original harled façade. In 1898 Geddes and the Town and Gown Association purchased the upper floors of both buildings and subsequently reworked façades and roofs. The architect James Jerdan (circa 1841–1913) unified the two roofs by raising them to the same height. This reflects the internal changes, which created single floors of accommodation out of the upper levels in both buildings. Furthermore, Jerdan added above the ashlar front of the western building a series

48 Design for the façade of Wardrop's Court, Edinburgh, c. 1893; anonymous (probably S. Henbest Capper). The two bays to the left are the refronted older buildings, while the added new structure occupies a former gap site to the right. The asymmetrical placing of the gables indicates the new and old buildings unified behind the single façade

of dormer windows with a distinctly medieval character. Finally, the harled façade of the eastern building was restored, but care was taken to maintain all irregularities in surface, depth and geometry. Jerdan's design evokes the image of a single building with an ashlar front whose one half was overlaid at a later stage with a harled, pastiche medieval façade.

Geddes did not stop at the time of the Middle Ages in his attempt to make the past periods of Edinburgh's history available for recapitulation by the contemporary citizenship. In order to visualise Edinburgh's ancient history, however, he no longer relied on architecture but employed the applied arts. Geddes developed a sophisticated decorative scheme, which was incorporated in nearly all of the buildings he reconstructed or built new. One recurring theme was the Celtic history of Edinburgh and of Scotland. The painter John Duncan (1866–1945) recorded scenes from Scottish myths and legends on the walls of Ramsay Lodge, a block with student accommodation within Ramsay Garden. Similar thematic panels and wall paintings were executed by Charles Hodge Mackie (1862–1920), Mary R. Hill Burton (active 1885–98), and James Cadenhead (1858–1927) in Ramsay Garden, the Outlook Tower, purchased by Geddes in 1892, and St Giles House in St Giles Street, where Geddes had opened a student residence on two floors in 1895.[15]

The decorative scheme was not confined to interior designs in Geddes's property, but extended into the public realm. With his proposals for public monuments and works of art, however, Geddes enjoyed less success. One of the most spectacular ideas was a *sgrafitto* frieze of Scottish kings and queens Geddes conceived to decorate the blank walls of Castlehill Reservoir, located between the Outlook Tower and Ramsay Garden. William Gordon Burn Murdoch (1862–1939) published a design for the frieze that reminds one of the procession of famous Scots in the Scottish National Portrait Gallery, executed by William Hole (1846–1917) in 1898.[16] Geddes's and Burn Murdoch's scheme, however, had the advantage of being visible in the public space of the Old Town – the site where most of Edinburgh's history had actually happened – rather than being confined to the interior of a museum located within the New Town. Although the latter was in Geddes's understanding an integral part of Edinburgh's history, it was nevertheless erected on a-historical ground, which had not been built on before the mid-eighteenth century.

Easier to realise were decorative art works publicly visible on Geddes's own buildings. On several occasions Geddes used pairs of cast iron dragons as decorations on his buildings to evoke the legend of how King Arthur acquired the sword Excalibur. For example, dragons embellish the pend leading to the courtyard of Wardrop's Court and also the corners of Ramsay Lodge. These dragons are a reference to the story of King Arthur's opening of a cave next to the volcanic rock (Arthur's Seat) to the East of the Old Town. Two dragons that had slept in the cave fought with each other and the winning dragon sank down into the cave again. The next day this dragon rose in the form of the sword Excalibur from the surface of a nearby lake, Duddingston Loch.[17]

 A reference to the oldest period of Edinburgh's history was also incorporated
into some of the open spaces Geddes carved into the dense urban fabric of the Old
Town. Geddes stated that gardens like the one at Johnston Terrace, south of the
Castle, were actually located on the site of ancient cultivation terraces. The ear-
liest known inhabitants in the area of the Old Town had levelled the slopes under-
neath Castle Rock in order to create space for their gardens close to their
settlement. Later, these terraces became used for the foundations of the city walls.
Open spaces in such locations marked, according to Geddes, a return to the orig-
inal peaceful purpose of cultivation terraces for planting and gardening. They
allowed the citizens to recapitulate the earliest, most distant period of their city's
history, or, in the words of Geddes, 'what may have been a forgotten past: in this
case, the longest forgotten.'[18]

Bringing to a close this overview of some of Geddes's interventions along the Royal
Mile, it is obvious that Edinburgh's Old Town as an open-air museum of the cen-
turies was not a collection of examples of historic architecture, classified and pre-
sented in a chronological order, comparable for example to the exhibits in a
museum proper. Rather, the Old Town embodied a narrative that Geddes wished
to tell, and that the citizens could read, with the help of old and new buildings, dec-
orative sculpture and other works of art. This narrative centred on the four social
types, as adopted from Comte. Their co-operation formed the basis of all cities
throughout human history. Edinburgh was not unique, but nevertheless a particu-
larly good model of this creative symbiosis.
 In contrast to many late nineteenth-century museums proper, the city as an
open-air museum did not aim primarily at the self-improvement of the uneducated
or at providing opportunities for study and aesthetic enjoyment for the connois-
seur. Rather, the focus of Geddes's interventions in the Old Town was the educa-
tive improvement of a community of citizens, considered as an entity. The
narrative underpinning this educational intention was not self-revealing nor were
the exhibits of the open-air museum self-explanatory. Both required interpreta-
tion, which ties in with the usage of the various buildings Geddes was involved
with. Most of them belonged to the network of the University Hall of Residence,
which Geddes established in Edinburgh from 1887 onwards. In other buildings –
most notably those of the Ramsay Garden complex – Geddes offered studio spaces
for artists, and flats for university teachers and professors. Elsewhere, he accommo-
dated cultural and educational initiatives, amongst them the Old Edinburgh Art
School, the Old Edinburgh Art Shop, and the Outlook Tower as a regional and
sociological laboratory. Further ideas, like a public assembly hall in Castlehill
Reservoir or a museum of cultural history on an unknown site near Ramsay Garden
remained unrealised.
 The extent of Geddes's known proposals – realised and unrealised – bears witness
to the intended scale of his concept: the area around Lawnmarket was to undergo
profound and lasting change (see figure 46). An urban fabric that was historically

grown, but accidentally surviving, was transformed into a deliberate composition. Each old and new building, each monument and work of art was redefined as an exhibit of the open-air museum. Central to the concept were the artists, academics and students in Ramsay Garden and the University Hall of Residence, who – as the Intellectuals and Emotionals of the new Edinburgh – had a two-fold role. They were supposed to act as the interpreters of the exhibits embodied in the historic and contemporary city, thus telling the community about their past and present. Beyond this, they had a role in anticipating the future. Through their artistic, scientific and intellectual work they would implant artefacts in the urban fabric that were the first signs of the new Edinburgh as it emerged from its old shell.

Occasionally, Geddes described the final state of his renewal project of the Old Town as resulting in 'a group of houses, each with its different characteristic elements, and into these the appropriate exhibits of the Municipal Museum should be distributed, so that they would ... be understood as a series.'[19] Accordingly, the role of Edinburgh's historic core within the context of the entire city changed. With the return of the Muses the Old Town developed from a neglected historic town centre into a truly municipal museum. Municipal not because it was necessarily owned by the community, but for its importance for the functioning of the wider city. Like the Acropolis in the ancient *polis*, the Old Town as a *Museion* was to dominate visually the New Edinburgh situated in its Arcadian region.

Yet despite all the geographical, historic and mythological references that Geddes's concept employed, its central weakness remained: the reliance of the city as an open-air museum on two crucial factors. First, the concept required a stock of buildings, historical or new, and other artefacts created within the urban fabric which covered all the main historic periods of the city. Geddes and his supporters never managed to obtain such a lasting commitment from the municipality, let alone from Edinburgh's citizens. His own bankruptcy towards the end of the 1890s not only left the large building scheme around Ramsay Garden (see figure 47) uncompleted, but prevented the further realisation of his many ideas. Second, the city as an open-air museum relied on the skills of a narrator who could tell the story that unified all exhibits into an idea of the city. Without this story, the exhibits remained silent. Furthermore, without the constant mediation of the narrator, the prominent position the open-air museum held over the wider city was in danger of turning into a haphazard collection of historic and historicist buildings. Although located at the centre of the contemporary city, these exhibits had no necessary or viable connections to their surroundings beyond those Geddes had ascribed to them. Not surprisingly, with Geddes's more or less permanent departure from Edinburgh after 1900, many of his activities faltered, slowly but steadily, within the following years. His circle of supporters could not keep up the range of civic activities Geddes initiated around his projects. Many of the carefully nurtured open spaces reverted to unused plots of land, and Geddes's buildings became ordinary additions to Edinburgh's cityscape. The brief period of civic revival that Geddes initiated became another forgotten period in Edinburgh's past.

To adorn cities with museums, often in combination with other municipal and civic buildings, was a common proposal for the improvement of the contemporary city in the decades flanking the turn of the nineteenth century. Geddes's fascination with museums was not unusual in this regard. Likewise, a concern for historic buildings and cityscapes, grown out of an awareness of the threats modern capitalist development posed to both, was a standard feature of Geddes's time; witness William Morris's Society for the Protection of Ancient Buildings (S.P.A.B.) or the German *Heimatschutzbewegung*. However, Geddes was unique in combining both concerns in his theory of the city. By transforming existing historic cities into municipal open-air museums, he aimed at achieving a cultural expression of the ideal of a community of citizens as the most humane form of co-operation that human beings could achieve. The city as an open-air museum was not the creation of an early version of a theme park, but a stepping stone towards the city of the future, rooted in the past, but not confined to it.

Notes

I wish to thank the University Archives, University of Strathclyde Glasgow for granting permission to reproduce Figure 47 from *The Papers of Sir Patrick Geddes*, which are in the archive's custody. Figure 48 was made available by the courtesy of the Patrick Geddes Centre, Department of Architecture, University of Edinburgh. Finally, I have to express my gratitude to the students who participated in the Honours Course *Patrick Geddes, Architecture and the City* (1998–99), Department of Architecture, University of Edinburgh, for their research into individual buildings by Patrick Geddes. Especially Ella Coleman and George May, who investigated the history of Brodie's Close and Wardrop's Court respectively, and who provided some valuable new historical facts about both projects.

1 Patrick Geddes, *The Returning Gods* (London: n.p., 1914), p. 1.
2 Amelia Defries, *The Interpreter Geddes: The Man and his Gospel* (London: Routledge, 1927), p. 112.
3 See Volker M. Welter, 'Stages of an exhibition: the cities and town planning exhibition of Patrick Geddes', *Planning History*, 20:1 (1998), pp. 25–35. Also Volker M. Welter, *Collecting Cities – Images from Patrick Geddes' Cities and Town Planning Exhibition* (Glasgow: Collins Gallery, 1999). For illustrations of the two exhibits see Patrick Geddes, 'The civic survey of Edinburgh', in Royal Institute of British Architects (ed.), *Townplanning Conference London, 10–15 October 1910 Transactions* (London: RIBA, 1910), pp. 537–74.
4 See notes by Geddes for a lecture on Eugenics and human evolution to the biology group of the Fabian Society in London in 1908. University Archives, University of Strathclyde, Glasgow (hereafter SUA), T-GED 8/3/7.
5 Geddes, *The Returning Gods*, p. 1.
6 Patrick Geddes, *City Development: A Study of Parks, Gardens, and Culture-Institutes. A Report to the Carnegie Dunfermline Trust* (Edinburgh: Geddes and Company and Birmingham: Saint George Press, 1904), p. 122.
7 See Volker M. Welter, 'History, biology and city design – Patrick Geddes in Edinburgh', *Architectural History*, 6 (1996), pp. 61–82.

8 Patrick Geddes, *The Masque of Learning and its many Meanings. A Pageant of Education through the Ages: Devised and Interpreted by Patrick Geddes. Semi-Jubilee of University Hall 1912* (Edinburgh: Patrick Geddes and Colleagues, 1912), p. 19.

9 Patrick Geddes, 'Civic education and city development', *Contemporary Review*, 88 (1905), pp. 413–26; p. 417.

10 Thomas Carlyle, *Sartor Resartus*, eds Kerry McSweeney and Peter Sabor (Oxford: Oxford University Press, 1987), p. 132.

11 Patrick Geddes and Victor Branford, *Our Social Inheritance* (London: Williams & Norgate, 1919), p. 151.

12 Geddes, 'Civic education and city development', p. 418.

13 See Helen Meller, *Patrick Geddes: Social Evolutionist and City Planner* (London: Routledge, 1990), pp. 73–9.

14 SUA, T-GED 12/1/37, typescript with annotations by Patrick Geddes, 'The Aims of the Proposed Town and Gown Association', not dated [c.1896], p. 2.

15 See Elizabeth Cummings, '"A gleam of Renaissance hope": Edinburgh at the turn of the century', in Wendy Kaplan (ed.), *Scotland Creates 5000 Years of Art and Design* (London: Weidenfeld and Nicolson, 1990), pp. 149–61.

16 William Gordon Burn Murdoch, *A Procession of the Kings of Scotland from Duncan and Macbeth to George II and Prince Charles Stewart with the Principal Historical Characters in their proper Arms and Costumes. Designed and published by W. G. Burn Murdoch, at his Studio, Ramsay Garden* (Edinburgh: Patrick Geddes and Colleagues, 1902). Helen Smailes, *A Portrait Gallery for Scotland: The Foundation, Architecture and Mural Decoration of the National Portrait Gallery 1882–1906* (Edinburgh: Trustees of the National Galleries of Scotland, 1985).

17 Patrick Geddes, *Interpretation of the Pictures in the Common Room* (Edinburgh: n.p., 1928), p. 5.

18 Patrick Geddes, 'Beginnings survey of Edinburgh', *Scottish Geographical Magazine*, 35 (1919), pp. 281–98; p. 283.

19 SUA, T-GED 7/5/15, typescript by Patrick Geddes, 'Old Edinburgh: (Historic Mile). Municipal museums and old houses generally', n.d., p. 1.

The space of history: modern museums from Patrick Geddes to Le Corbusier

Anthony Vidler

The masses have four schools where they can be instructed in the high truths of art. These four schools are: the Museum, the Street, the Monument, and the Book (Criticism and the Newspaper). (Henry Provensal, *L'Art de demain*, 1904[1])

Modern museum

Of the four 'schools' listed by the architect Henry Provensal as instructive for the modern mass audience, that of the 'museum' was perhaps the most contested by modernist theory. The street, while condemned by the social and medical pathology of the late nineteenth-century city and turned over to traffic flows by modern urbanism, nevertheless had found its defenders from Camillo Sitte to Raymond Unwin. The newspaper's propaganda uses were evident to the avant-garde from the publication of Marinetti's *Foundation Manifesto of Futurism* in 1909. Even the monument, a term eschewed by proponents of universal space, was to be reformulated and given new status in an attempt to develop what Sigfried Giedion was to call a 'modern monumentality'. But the term 'modern museum' seemed to be a veritable oxymoron to critics convinced that this nineteenth-century institution par excellence had been finally outmoded by history itself.

What in the early nineteenth century had been, in Wolfgang Herrmann's words, 'one of the most progressive institutions of the age', a semi-sacred temple of art for the people, had become an emblem of regression and cultural reaction.[2] For modernists its classifications of art had become arid and sterile; its very institutional form and monumental aspect divided it from any living, much less popular, culture. For cultural conservatives, its now dusty rooms, thronged by an ill-educated populace, made appreciation of what works it did contain difficult if not impossible. Aesthetes and connoisseurs deplored the commercialisation and popularisation of masterpieces, while avant-garde reformers called for the reorganisation, if not the

destruction, of an outdated institution. Thus Provensal, whose *L'Art de demain*
would become favourite reading for Le Corbusier, himself denounced the museum
in terms that had become familiar by 1900:

> Nothing more lamentable, more sad even, than this agglomeration of masterpieces
> from different schools jostling their harmonies along the vast galleries that contain
> them. Further, all these marvels piled up in the pell-mell of dates and names give the
> impression of an arid and dry, even though historical, classification. The museum
> thus understood is no more than an empty skeleton, the cemetery of the arts, as
> Lamartine has well said.[3]

Twenty-five years later these sentiments were echoed by Paul Valéry in an essay
also to be noted by Le Corbusier.[4] Valéry, who was not, as he wrote, 'overly fond of
museums', was disturbed by the apparent conflict between individual pleasure and
'ideas of classification, conservation, and public utility'; he found the museum to be
a 'house of incoherence' with its 'strange organised disorder', which exhausted the
senses in its confusion of works, cancelling out any experience of particular value.[5]
Valéry objected to the passing of the individual collector and the loss of private con-
noisseurial space: in the face of a visiting public and so many works, each 'killing'
the other, it had become impossible to appreciate each single work of art on its own
terms, in solitude and personal familiarity.

 As such, the museum was interpreted as a symptom, if not the cause, of the mori-
bund state of the arts. A century of historicism had resulted in what Ernst Jünger in
1938 was to call a generalised 'musealen Trieb', or museum drive, which represented
'a face turned toward the things of death'.[6] If the great museums of Paris, Berlin and
London had supplanted the church as houses of veneration, so, Jünger ironically
noted, churches in their turn were visited as museums. 'It is all too easy to underrate
the power which the impulse behind the museum has attained (a power which is still
increasing), or of the area over which it operates', he concluded.[7] Hans Sedlmayr, in
turn, was to draw the obvious relation between 'the empire of the museum on the one
hand and the great funerary cults, the cults of the dead, on the other.'[8]

 These conservative sentiments had been anticipated in more radical terms since
the turn of the century by modernists such as Marinetti, who equated the museum
with death itself – 'Museums, cemeteries! ... Truly identical with their sinister
jostling of bodies that know one another not ... cemeteries of wasted efforts ... cal-
varies of crucified dreams ... ledgers of broken attempts' – and proposed a yearly
visit to the museum 'as one visits one's dead', to lay a wreath at the foot of 'the
Gioconda'.[9] Contemporary anxiety rendered the museum a danger to progress, a
kind of poison, redolent of decay. Marinetti's sentiments were adopted, with more
ambiguous intent, by the editors of *L'Esprit nouveau* eleven years later: 'Doit-on
brûler le Louvre?' they asked contentiously, receiving some thirty-seven replies, all
taking the question seriously.[10]

 Behind these attacks on the museum was, of course, a sense not simply that the
existing institutions were outdated, dedicated in Marinetti's words to 'the useless

administration of the past', but also that the very 'past' to which they had dedicated their representational and administrative efforts was in question. No longer the progressive instrument of nationalist and political revival and revolution, history had become, as Nietzsche had put it, a 'consuming fever', an illness rather than a cure. Instead of seeing the past as a potential future, 'man braces himself against the great and ever-increasing pressure of what is past: it pushes him down or bends him sideways, it encumbers his steps as a dark invisible burden which he would like to disown.'[11] Such a past had to be forgotten if it were not 'to become the grave digger of the present.'[12] Of the three kinds of historical thinking distinguished by Nietzsche – the monumental, the antiquarian and the critical – the dominance of the antiquarian posed a danger to the health of the culture. In the face of such attacks, the museum, emblem of Nietzsche's 'malady of history', if not consigned to the tender cares of Marinetti's 'good incendiaries', its cellars flooded by the canals of progress and its foundations sapped with the pickaxes and hammers of the new vandals, seemed to have come to the end of its useful life, at least in its form as a temple of culture inherited from the previous century.

Among those who still believed that some form of museum was an essential component of mass education, opinions sharply differed over how precisely to construct a modern museum that might restore life to dead artefacts. Some, like Provensal, found the remedy in a renewed and more accurate historicism that would set all objects displayed in a context that exactly reproduced their original milieu; 'to create an absolute ambience where the intimate life of these different epochs would be conserved intact, in thus resituating these fragmentations of art in their historical truth.'[13] In this, Provensal, together with many Hegelian idealists, was following the lead of earlier museographers such as Alexandre du Sommerard at the Musée de Cluny, and before him, Alexandre Lenoir at the Musée des Monuments Français.

Others, attacking the zeal for 'appropriate' settings that Theodor W. Adorno was later to describe as an excess of '[s]ensibility [that] wreaks even more havoc with art than does the hodge-podge of collections', called for a complete revision of the criteria by which objects were selected for display.[14] Here the late nineteenth-century emphasis on the arts and crafts, supported by historians and curators such as Alois Riegl in Vienna, was logically extended to include the everyday objects of the modern world. If, as Le Corbusier remarked, Pompeii 'constitute[d] the single true museum worthy of the name', then one should work to create 'a museum of our own day with objects of our own day'; he imagined a museum where 'all objects on exhibition had performed some real function':

> A plain jacket, a bowler hat, a well-made shoe. An electric light bulb with bayonet fixing; a radiator, a table cloth of fine white linen; our everyday drinking glasses, and bottles of various shapes (Champagne, Bordeaux) in which we keep our Mercurey, our Graves, or simply our *ordinaire* ... A number of bentwood chairs with caned seats like those invented by Thonet of Vienna, ... We will install in the museum a bathroom with its enamelled bath, its china bidet, its wash-basin, and its glittering taps of copper or nickel.[15]

In this vision of a museum of 'objet-types', reminiscent of the folk-art and craft museums that he had frequented in his youth – 'those good schools' of Cluny, Guimet, the Trocadéro in Paris; the ethnographic and archaeological museums of Florence, Athens, Naples and Pompeii – Le Corbusier worked to dissolve the boundaries between the museum and everyday life.[16] But rather than reifying the realm of the domestic interior as a space of collected history, Le Corbusier envisaged a transformation of this interior into a semipublic domain.[17] Thus, in his Esprit Nouveau pavilion of 1925, the carefully posed standard objects were neither 'museum pieces' nor decorative *bibelots*, but the repertory of use-types needed by modernity. The exposition house became in this way a miniature version of Le Corbusier's prototypical museum of useful things, where the intersection between the everyday and the eternal was complete. Historicism had been stopped in its tracks so to speak, and the perfected types of machine civilisation suspended out of time and in 'ineffable space', as enduring forms; in the light of Le Corbusier's eulogy of Pompeii, it was perhaps not incidental that many of his house types, beginning with the Maison La Roche-Jeanneret in 1925, were themselves based on Pompeian plans.

But the implications of Pompeii extended further. In the image of an entire city turned into a museum by a historical catastrophe, many critics of the nineteenth-century museum found a way to render a domain of once exclusive knowledge public and accessible to the masses. Here the entire urban and regional milieu, from the street to the countryside, became an object of the museological gaze and a potential agent of its own representation as a school of life. Beginning with the experiments of Patrick Geddes in Edinburgh, and impelled by the growing urban planning movement from the Paris Exposition Universelle of 1900 to the first World Congress of Cities in Ghent in 1913, the specific critique of the nineteenth-century museum was generalised as a questioning of the effects of historical restoration on the development of the city as a whole. If, as Alois Riegl intimated, all objects from the past were to be endowed with historical value, their preservation would prevent all change and development; if, on the other hand, the only criteria for preservation were 'newness value' and 'use value', little of aesthetic or historical value would be conserved.[18]

In the ensuing debates, which embraced the fate of monuments such as the Acropolis and the Campanile of Saint Mark's in Venice, as well as pervaded successive international town-planning congresses after 1910, a concept of the modern museum was formulated that joined the domestic to the public in the widest urban and regional context. This involved a fundamental redefinition of the museum's role: no longer dedicated solely to the preservation and exhibition of canonical works of art for uplift and inspiration, it was to function as an instrument of instruction, informing the new mass public about its own place in the world, its geographical, social, technological, and cultural potentialities. Joining an organic and historical view of city development to an insatiable will to classify all knowledge, and supported by the new social sciences, this notion of a 'museum

without boundaries' invoked every technological aid to display and disseminate its wisdom. In the imaginations of its principal theorists from Patrick Geddes to André Malraux, the new museum would be no more than a smoothly functioning optical apparatus, a gigantic and omniscient twentieth-century version of the panoramas and dioramas of the nineteenth century, but with a mobility and flexibility that would finally accommodate incessant change and growth. Whether a static rendering of universal geography, as in Geddes's Outlook Tower, or Malraux's vision of an infinitely mobile photography collection, the modern museum would combine all four of Provensal's 'schools' in a single conception, utilising and reformulating the book and its images, re-evaluating the notion of the monument for symbolic purposes, and most importantly reconstituting the public street as space of display. The museum thus created would, on the one hand, naturally adapt the spatial organisation of nineteenth-century expositions – the arcade, the gallery, the educational street – for modern purposes, and, on the other, endow the street with new life at a moment when its place in urbanism was threatened. Removed from its role as a functioning element of everyday urban life, the street would now take on an instructive instrumentality as a museum of the everyday, an instrument for the spectacle of modernity.

The city as museum

It was not by accident that the redefinition of the museum in its most radical sense was first undertaken by advocates of an Arts and Crafts revival who not only decried the elitist nature of the 'art' displayed in these secular temples, but also, following Ruskin and Morris, found a contradiction between the preservation of fragments of the past in museums and the wholesale destruction of historical monuments, districts and cities. Thus Robert de La Sizeranne, whose *Ruskin et la réligion de la beauté* of 1897 had introduced Proust to Ruskin, wrote in 1904 of those 'prisons of art' that seemed to have swallowed every cultural activity from Paris to Florence; for him the growth of museums of every kind was tragically and paradoxically linked to a corresponding increase in the demolition of historical monuments and quarters.[19] He cited as an example the destruction of the ramparts at Avignon and the simultaneous establishment of a museum of church history in the Papal Palace. The separation of art from life in the museum was simply a symptom of this blindness to the beauties of cities as a whole.

The biologist and geographer Patrick Geddes developed this position, opposing revolution with evolution. He argued that the question was not so much to do away with the past, but to relate it to the present in a way that would actively participate in the future. History, he stated, is 'the very essence of our growing sociological re-interpretation of the past to see its essential life as continuous into the present, and even beyond, and so to maintain the perennation of culture, the immortality of the social soul.'[20] History was not something that one 'mourns and meditates among the tombs', a late Romantic conceit that buried the past in relics

of funereal aspect; it was a new beginning, a realisation of the life history of a community.

This sentiment was expressed in the context of Geddes's effort to invent a true modern museum, one that would expose the citizen to an expanding chain of cultural, social and economic horizons, from the local, the regional, the national, thence to the world community. This effort had taken architectural form in 1892 with the purchase of an abandoned tower in Edinburgh. Outlook Tower, as Geddes renamed the building, became the symbolic and practical focus of his various experiments in regional and city surveys, urban education, and world unity. History would here be activated as an organic part of a universal geography.

The concept was simple enough: a visitor would be led to the top of the tower where a panorama of the city would display the complex morphology of the settlement and its relations to the surrounding countryside.[21] Then, as one descended from floor to floor, successive rooms would display the widening relationships between the town and the world. At Outlook Tower, Geddes was able to retain the observatory turret that had already been transformed into a kind of giant camera obscura by its former owner; 'for all practical purposes', Geddes wrote, 'you are inside the bellows of a huge photographic apparatus.'[22] A mirror projected on the wall the aspect toward which it was turned, literalising and focusing the more artificial versions of the panorama current earlier in the century. Below this was a terrace or 'prospect' from which the visitor could view the city from all sides. On this level, in the octagonal room that supported the observatory turret, were ranged astronomical charts, demonstrating the orbit of the earth, together with a hollow celestial globe or miniature planetarium, within which might be seen the pattern of the stars. Later Geddes installed an 'episcope' designed by the French geographer Paul Reclus, which presented images in depth, so that the visitor could 'see' through the earth along any selected path to its opposite point. Then followed the exhibition rooms in sequence, starting with Edinburgh, with a relief map of the city painted on the floor. Below this was a Scottish room, and this in turn led to an exhibition devoted to the countries where English was spoken – the Empire – thence to Europe, and finally, on the ground floor, to the world.

Punctuating this sequence were stained-glass windows designed by Geddes, which represented conceptual themes that summarised his doctrine: the obelisk or 'philosopher's stone', the 'tree of life', and the later widely reproduced 'valley section', all drawings owing much to the illustrations of William Lethaby's then recently published *Architecture, Mysticism and Myth*. Every aspect of culture was brought together from the locality to the world, arranged under the related categories of place, work and folk, a division Geddes had adopted from Frédéric Le Play's 'lieu – travail – famille' and extended to include the people as a whole.

As a museum, then, the tower was a kind of historical-geographical astronomical instrument, appropriately described by Alessandra Ponte as a 'thinking machine', a kind of modern *Wunderkammer* or theatre of memory.[23] Its functions were assured by the optical devices, from the periscope to the camera obscura and

the episcope, which were ranged from top to bottom. But as a building it virtually effaced itself, so to speak, by its very manner of use. This is to say that its 'monumental' effect as a tower was less important than its function of outlook. Guy de Maupassant's celebrated remark that he was pleased to lunch at the top of the Eiffel Tower because it was the only place in Paris where he was not forced to look at it found its logical counter-monumental corollary in Geddes's insistence on the processes of observation and movement, the living gaze that joins a locality to its region, the movement that parallels the mental sweep of a universal spatio-temporal imagination. The city, in Geddes's terms, was rendered alive to its citizens by virtue of this didactic apparatus that, rather than separating art from life, history from the present, brought back both as integral to the life of each inhabitant.

If Geddes's Outlook Tower was an instrument of the dissolution of the museum as monument, its effect was inevitably to turn the entire city that it surveyed into a museum of itself. Ruskin and his followers had been content to withdraw from the restoration fever of the late nineteenth century in order to allow historical monuments a decent death. For Geddes, however, there was no real dichotomy between his vision of a living city and the preservation of enough of the past to ensure continuity of tradition, historical understanding and cultural development. His biological sensibility insisted on the possibility of a conservative surgery that would at once allow for growth and conservation. In his proposals for the town of Dunfermline, funded by the Carnegie Foundation and published in 1904, he argued against preservation for its own, antiquarian sake, while also resisting wholesale demolition as based on oversimplified principles of civic improvement and hygiene. Rejecting criteria of merely archaeological interest or mere artistic romanticism, and refusing a return to the past or its imitation, he proposed a subtle model for reuse that would avoid the worst effects of the museum. Whereas the traditional museum 'begun as a paradise of beauty, lets in its serpent, and prepares its ruin',[24] and with 'its metal masterpieces in a glass case … answers but to stamp or scalp collecting', a careful reconstruction of old quarters would make them alive once more.[25] The preservation of historical monuments and masterpieces should, he argued, be replaced by attention to entire quarters and districts, the evidence of social life; old buildings might be cleaned rather than demolished, then restored and adapted to new uses. The values of the tourist, the antiquary, and the hygienist were to be supplanted by those of the evolutionist. In Geddes's plans, the old working class district of Dunfermline was transformed into a living museum of the crafts, where 'the children coming home from school look in at the open door' to see the sparks of a smithy that links them back to the Iron Age and forward to the present.[26] The evolving city of Geddes's post-Darwinian imagination would, of necessity, gently bring its historical fabric into modern usage – as a living museum of itself. Geddes cited the reconstruction of the medieval Crosby Hall in Chelsea as a university residence as an example of such 'renewal', 'preparing the future, not simply dignifying the present, commemorating the past.'[27]

Fragmenting the past

> Around these precious remains, which cover only a thousandth of its surface area, the
> city is in mortal agony, dying of congestion, crumbling with age ... Paris is no more
> the city of modern times! Do we wish to become the guardians of a museum? (Le
> Corbusier, 1931[28])

Against the evolutionist views of Geddes and his followers, however, the cata-
clysmic models of the modernist avant-gardes implied a more violent treatment of
the past. The quasi-nostalgic and organic view of culture espoused by Geddes was
seen as no more than an artificial extension into the present of the very 'museum
tradition' it attempted to replace.

The Symbolist novelist Joris-Karl Huysmans had already, well before the turn of
the century, proposed an ironic solution for the false monumentality and eclectic his-
toricism of his own day. Criticising the project for a Museum of Decorative Arts
planned for the former site of the Finance Ministry, burned down during the
Commune of 1871, he pointed out the paradox inherent in a museum of objects that
should be, by their nature, antihistorical. Against this, he expressed a preference for the
overgrown ruins that already occupied the site, this 'fallen down Roman palace, a
Babelesque fantasy, a Piranesian etching'. In ten years nature had created a picturesque
garden in the city, one that might, he suggested, be replicated throughout Paris:

> In place of giving architects monuments to build that they compose of bric-a-brac,
> taking here a piece of antiquity, there a bit of the Middle Ages ... would it not be better
> to employ them to purify and ennoble those which remain ... in burning them?[29]

He proposed burning the Stock Exchange, the Madeleine, the Ministry of War, the
Opera, and the Odéon, among other nineteenth-century monuments. His conclu-
sion was that '[f]ire is the essential artist of our time and that, pitiful as it is when it is
raw, the architecture of our century becomes imposing, almost superb, when it is
cooked.'[30]

Such a gastronomy of monumentality was, despite Huysmans's black humour, to
be taken to the letter by those for whom a static preservationism seemed to be stran-
gling the development of cities. As if to confirm Freud's perception that 'if we want
to represent historical sequence in spatial terms we can only do it by juxtaposition in
space: the same space cannot have two different contents', the ideal modernist
metropolis was conceived in direct opposition to its historical form.[31] The past was
now construed as a residue, retained in the shape of carefully selected fragments con-
trasting with the totality of the newly built present. Physical juxtaposition, aesthetic
contrast, a past brought under control and in the service of the present by means of
the process that Nietzsche had termed 'monumentalisation': such strategies, already
well-rehearsed under Haussmann, became all the more dramatic with the potential
eradication of all vestiges of the traditional urban fabric.

But whereas Haussmann had isolated the 'historical monument' in a carefully
designed setting that contrasted a fragment of the past with the fabric of the city,

reformulating the historical monument as a kind of found object in a field of housing, Le Corbusier proposed to replace the entire city with a continuous park. In this model, didactically illustrated in his Plan Voisin for Paris of 1925, the modern city became a system of mechanical infrastructures raised above nature, while the past, where it was not eradicated, was to be transformed, in an eighteenth-century manner, into ruin fragments set on the greensward.

> I wish it were possible for the reader, by an effort of imagination, to conceive what such a vertical city would be like; imagine all this junk, which till now has lain spread out over the soil like a dry crust, cleaned off and carted away and replaced by immense clear crystals of glass.[32]

The clearing away of such a *grouillement* (a word that evoked all the connotations of the ant swarms that, since Rousseau, had become a favourite metaphor of the anti-city movement) necessarily involved the removal of the entire historical fabric of the city. Yet Le Corbusier was unabashed in his claim that his project would have the very effect of *preserving* the past: 'the historical past, our common inheritance, is respected. More than that, it is *rescued*. The persistence of the present state of crisis must otherwise lead rapidly to the destruction of that past.'[33] Too great a mingling of past and present would, he argued, not only stifle the present but also, against the rules of history itself, anachronise the past. What had become a ruin should, after all, be appreciated as such. Le Corbusier drew a romantic picture of the isolated milieux of former ages: 'My dream is to see the Place de la Concorde empty once more, silent and lonely, and the Champs Élysées a quiet place to walk in. The "Voisin" scheme would isolate the whole of the ancient city and bring back peace and calm from Saint-Gervais to the Étoile.' This would, of course, involve the demolition of the districts of the Marais, the Archives, the Temple; but, he noted, the accident of his chosen grid would happily spare the churches, now surrounded not by houses and shops but by greenery.

> Similarly the 'Voisin' plan shows, still standing among the masses of foliage of the new parks, certain historical monuments, arcades, doorways, carefully preserved because they are pages out of history or works of art.
> Thus one might find, surrounded by green grass, an exciting and delightful relic such as, say, some fine Renaissance house, now to be used as a library, lecture hall or what not.

In this way the 'relics of the past' would be 'enshrine[d] ... harmoniously in a framework of trees and woods.' Le Corbusier thus proposed to literalise, in a positive sense, what had been, for much of the nineteenth century following Quatremère de Quincy, a metaphor critical of museums – a 'cemetery of the arts':

> For material things too must die, and these green parks with their relics are in some sort cemeteries, carefully tended, in which people may breathe, dream and learn. In this way the past becomes no longer dangerous to life, but finds instead its true place within it.[34]

With the city transformed into a cemetery of its own past, the museum in every traditional sense would disappear as a problem – in every sense, that is, save for the more universal goal of making it function as a didactic machine, a modern encyclopedia, an instrument of progress.

The metropolitan gaze

Viewed from such a Nietzschean distance, the city, as Manfredo Tafuri has noted, was now subjected to a gaze informed by the cultural mandarinism of the *flâneur* and the technological utopianism of the social engineer.[35] As exemplified in Le Corbusier's penthouse for Charles de Beistegui of 1929–31, this double vision of post-Surrealist poetics and rationalist planning took the form of rooms serviced by every kind of technological innovation – 'des installations électriques et mécaniques très compliquées' – side by side with appeals to the sacred, the mythical, and nostalgia for eighteenth-century splendour.[36] Sliding walls and windows were operated electrically; walls were transformed into moving screens; a wall of greenery in the garden was shaded by an electrical blind; a mobile projection screen served for private movies.[37] Le Corbusier proudly announced the utilisation of four thousand metres of electric cable. Every room was tightly insulated for sound, each space silent to the next. Juxtaposed against this technological sophistication, the eighteenth-century furniture, decorative motifs, and statues were lit by chandeliers containing only candles. Beistegui took pride in the absence of any electric light.

From this glittering and artificially controlled box, the view of Paris itself was equally controlled. From the first (the seventh) level, only the Arc de Triomphe was visible; on the eighth floor, the garden was surrounded by hedges of ivy and yew in such a way that 'one sees only a few of the sacred places of Paris: the Arc de Triomphe, the Eiffel Tower, the perspective of the Tuileries, Notre Dame and the church of Sacré-Coeur.'[38] Finally, on the upper level, the solarium was surrounded by high walls so that, in Le Corbusier's words, 'if one remained planted on one's feet, one saw absolutely nothing more than the grass, the four walls and the sky, with all the play of the clouds.'[39]

On one level, of course, this was a sophisticated game – 'evidently only for amusement' Le Corbusier admitted – but on another level, as Tafuri has argued, this combination of an appeal to sacred values linked to the precise functioning of technical operations was a preoccupation in Le Corbusier's urban projects that would remain consistent through to Chandigarh.[40] For our purposes, however, the Beistegui apartment represents a critical moment in the tension between the museum and the city, history and modernity. For between this rooftop fantasy, avant-garde plaything of a rich socialite, and the city above which it was planted, Le Corbusier provided a tenuous but significant link: a suspended spiral staircase rose from the entrance floor to a small oval cabin on the main (eighth-floor) terrace, and, enclosed in this windowless hut, an observer could view the entire panorama of Paris – through a periscope. Its lens raised above the level of the walls of the

solarium, its counterweight hung through the centre of the spiral staircase, this mechanism joined the 'sacred mountain' of the city outside to the hermetic *boîte à miracles* of the apartment interior. A giant camera obscura, the apartment represented the existing city to the spectator in controlled fragments, monumentalised set-pieces, as if, through the periscope, one was viewing the city-museum of the Plan Voisin, already in place, illusionistically realised by optical mechanisms. The modernist apartment was thereby seamlessly set in its proper context, all reminders of the intractability of the intervening city fabric effaced by the lens.

The notion of architecture as camera, as Beatriz Colomina has observed, the construction of the *machine à habiter* as a *machine à voir*, was a continuing refrain of Le Corbusier's work in the late 1920s.[41] In the context of the Beistegui apartment, however, it took on almost programmatic form, as the obsessive interiority of the space was calculated solely to construct the exteriority, not of the building itself, but of its inhabitant. It is as if the mechanism of the Outlook Tower had been reconstrued in modernist, if not Surrealist terms.

World museum

Comparison of these two periscopic views of the city, Geddes's Outlook Tower and Le Corbusier's Beistegui apartment, is perhaps warranted on more than coincidental grounds. For between 1928 and 1929 Le Corbusier and Pierre Jeanneret collaborated on a design for a Mundaneum, or world city for Geneva, a project envisaged by the Belgian educator Paul Otlet, who was himself a long-time friend and collaborator of Patrick Geddes and who had already been introduced to Le Corbusier in 1922 through Blaise Cendrars.[42]

This Cité Mondiale had been long in preparation, developed in several projects that Otlet and Geddes had planned in common since their first meeting at the Paris Exposition Universelle of 1900; it had been influenced by the grand plans drawn up by the architect Ernest Hébrard in accordance with the views of another 'world' thinker, Hendrik Christian Andersen, in 1912–13.[43] It had been assayed in numerous programmatic statements by Otlet beginning with his plan for a world centre to house his projected Union of International Associations in 1914, and continued with the exhibition organised by Otlet at the first World Congress of Cities held in Ghent in 1913 and with his founding of the Palais Mondial in Brussels in 1920 – all projects involving the active participation of Patrick Geddes.

Geddes had brought Otlet to lecture at his prototypical exhibition of world geography set up in the Trocadero for the Exposition Universelle of 1900; he had participated with him at Ghent, and, after the war, in 1921, and with preparations for a new association of nations in view, Geddes was to note that he was in Brussels 'busy with old friends Otlet and Lafontaine [the senator Henri La Fontaine] on the vast Exhibition Palace into which their "Tower" has grown', a clear reference to their collaboration on the first plans for the Cité Mondiale, and its debt to the ever-expanding project of the Outlook Tower.[44] This collaboration had been continued

in 1924.[45] The idea of a Mundaneum, posited for the first time in 1925, was fully developed by 1927 when Le Corbusier met Otlet in Geneva, and the architectural project was first published by Otlet in his pamphlet, *Mundaneum* in August 1928.

The central monumental element of this project was a Musée Mondial, described by Otlet as 'a demonstration of the present state of the world, of its complex mechanism, of its co-operative life.' This museum was planned as a visualisation of 'the vast content of the world', and so conceived as a synthesis of all previous museum types: 'the essential elements of a geographical and historical museum, a scientific and teaching museum, a commercial and social museum, and a museum of civilisation and culture.'[46] A totalising encyclopedic and synthetic collection would present to the population of the world a panoramic portrait of 'the grand and elevated impressions generated by the discovery of the vast universe in which we move.'[47]

In Otlet's formulation, little was to be retained of the traditional concept of the museum save for its complete accessibility. Certainly it would be dedicated to the presentation of objects and materials, but its primary goal was to 'visualise the ideas, the feelings, the intentions behind the things it explains.'[48] To this end, Otlet's conception approached what, for André Malraux, would become the essential characteristic of a modern collection:

> It will be an 'Idearium'. Objects will be collected and conserved, but it will not be necessary for them to be rare or precious, copies and reproductions being sufficient to support ideas ... The documents will be submitted all the time to more and more synthetic criticism and elaboration. The exposition will be constant. This will be a 'Useum'.[49]

Thus the primary task of the museographer was to be that of impersonal and systematic classification – a work already commenced by Otlet's own bibliographic organisation – of the objects together with their textual and oral explication.

Responding to Otlet's explicit requirement for an architecture of 'speaking stones', where all 'monuments are symbols' (a sentiment already elaborated by Valéry), Le Corbusier conceived of a Mundaneum that was 'by its mass, its extent, its power of expression with stones organised harmoniously ... truly a monument', the logical culmination of all the monumental complexes of history, taking its place 'in the uninterrupted line of works and monuments that have continuously exalted human grandeur and have been the expression of the spirit.'[50] It is well known that this monumentality aroused almost immediate attacks from the Left, disturbed at the evident symbolic and seemingly non-functional, if not archaising, form of the museum. In the present context, it is sufficient to note the way in which Le Corbusier accomplished a complex synthesis of the ideas not only of Otlet himself, but also of Patrick Geddes and Paul Valéry, ideas that were here incorporated in a 'solution' that brilliantly joined the 'four schools' of Provensal into a single spatial order. In the simple formal gesture of the spiralling stepped pyramid, the Musée Mondial fused the street – internalised as in a nineteenth-century arcade, and

divided like a cathedral into three 'naves' – with the book and the museum to form a modern monument that once and for all stabilised historical development and celebrated its final denouement in an 'eternal' present.

As described by Le Corbusier and Pierre Jeanneret in the concluding section of Paul Otlet's brochure, the Musée Mondial was to be placed on the high plateau overlooking Geneva; this site 'furnished, on the four cardinal points, the most majestic spectacles'.[51] Indeed, the whole composition was, in Corbusier's words, 'comme une borne gigantesque', a gigantic boundary stone or marker; the diagonals of the museum themselves were directed toward the cardinal points, and the museum stood at the highest point of the site, to all intents and purposes like a giant version of Palladio's Villa Rotonda.

In Le Corbusier's and Otlet's description, the museum was dedicated to the exposition of '*L'homme* dans le *temps* et dans le *lieu*', which translated in concrete terms to 'l'oeuvre, le lieu, le temps', a direct transformation, not surprisingly, of Patrick Geddes's own triadic organisation, derived from Le Play, 'place, work, family'. But in place of the vertical organisation of Geddes, which juxtaposed the tower to its horizontal 'prospect' or outlook, Le Corbusier aligned the three categories in parallel in order to 'synchronise' them by means of 'an instantaneous visualisation'. Here post-Bergsonian time is represented by a spatial synchronicity that places the categories side by side in three parallel naves:

> In one nave, the work of humanity, brought to us by tradition, the piety of memory or archaeology; in the adjacent nave there are all the documents that will define the time, the history of that precise moment, visualised by diagrams, original images, scientific reconstitutions, and so on. And against this, the third nave with all that it will show us of the place, its different conditions, its natural or artificial products, etc.

In order to ensure the uninterrupted development of this triple 'déroulement' or unfolding, Le Corbusier conceived of the museum as a continuous spiral, at once a natural 'organic' form and a mechanism that would 'express the uninterrupted succession of the enlarging links of the chain'. It was also, not coincidentally, the form that allowed for a continuous version of the traditional panorama or diorama, no longer presented in frontal or circular form, but now followed by the observer in an unending sequence of spirals: 'The diorama becomes more and more vast and more and more precise.' The pyramid further allowed for the space to enlarge from top to bottom, reflecting the development of world civilisation and human knowledge.

Thus, like Geddes's Outlook Tower, the Musée Mondial was entered from the top. In Le Corbusier's initial project, the visitor had to climb up a 2,500m-long spiral ramp on the exterior that overlooked the views surrounding the city, which themselves enlarged until at the summit 'the site was there, in its entirety, panoramic'. From the Alps to the lake and the Rhône River flowing to the sea, the valley section was explained in all its totality. Only by this route could the visitor enter the museum.

Le Corbusier graphically described the major exhibits, from the 'pictures of the gestation of the world' to the modern metropolis, not accidentally a progression that marked the development of architecture in parallel with that of civilisation:

> Here is the first man! Here his skull, there a number of skulls of fearful men.
> There is the skull of man, evolved with his forehead like a dome.
> Here are tombs.
> Grave mounds.
> Organisations of stones in the form of architecture. Man is *architect*! His function is to order.
> The civilisations:
> The pots and weapons of the Myceneans.
> This Egyptian bas-relief.
> This Chaldean granite.
> This Cypriot stone.
> There is a Fate carved by Phidias.
> The head of Caesar.
> That of Nero.
> A porch of a Roman basilica.
> A cathedral porch.
> Giotto.
> Michelangelo and Rembrandt.
> Grünewald and Poussin.
> El Greco, Spain, Columbus, America, the Incas and the bloody pre-Columbian splendours.
> The Sun King, his men and their works.
> All Europe enlightened.
> The portraits of Rousseau and Voltaire.
> Marat, Robespierre, Guillotin, Charlotte Corday, Bonaparte, Napoleon.
> Goya and the Spanish court.
> The growth of the United States, the birth of new nations.
> Haussmann, Napoleon III and the plan of Paris.

If we ignore the somewhat peculiar nature of this 'history' of civilisation – one which, in Le Corbusier's description, oscillates between a world history of art and a Corbusian apotheosis of urbanism; which is as fascinated by the Revolution as it is by the Empire; and which somewhat abruptly concludes with Haussmann's Paris – we might note that, in outline at least, the programme replicates the vertical descent of Geddes, from the panoramic outlook – the camera – to the 'world'.

The Sacrarium

But there were even closer correspondences between the two projects. These were manifested in the way that Le Corbusier imagined the termination of his grand route of civilisation. Le Corbusier proposed that, on descending to earth, the visitor would be presented with a circular enclosure, 'a high smooth wall that contains

something: the Sacrarium.' This Sacrarium had been a part of Otlet's original pro-
gramme, but it was not necessarily, interestingly enough, tied to the world
museum; as Otlet described it, it was to be a 'complementary institution', one of
four dedicated respectively to 'La Nature (Naturalia)', 'Les Sports (Stadium)',
'L'Art (Artes)', and 'La Spiritualité (Sacrarium)'. It was to be the site of a univer-
salising religious experience, the modernist religion of the Enlightenment cult of
the Supreme Being. The common element of all religions, Otlet argued, was the
'principle of ethics, tendency toward the more and more elevated ideal, expression
of the supreme link between the self and the universe.'[52] In absorbing this pro-
gramme within that of the museum, Le Corbusier was thus giving a unique status
to one of four 'virtues', another of which was directly concerned with the arts. The
explanation for this architectural adoption of the Sacrarium is intimated in Le
Corbusier's own description.

Set in the heart of an artificial forest of columns like some abandoned Druidic
temple, the cylindrical enclosure of the Sacrarium was 'smooth and silent', self-
contained. Around the perimeter of the enclosure was a series of statues of religious
figures, each one cut from stone quarried from their place of birth and the epochs of
their life, created by sculptors who were at the same time believers. These were the
statues of '*des grand initiés* in which humanity, in the course of its journey, incar-
nated all its mystical strength, its need of elevation, abnegation, and altruism.'[53]
Here Le Corbusier made an unambiguous reference to what we know to be one of
his founding texts, Edouard Schuré's *Les Grands Initiés* of 1889.[54]

Schuré's eclectic but influential 'history' of initiatory cults, influenced by his
friendship with Richard Wagner and Friedrich Nietzsche, had attracted many fin-
de-siècle post-Wagnerians, among them Rudolf Steiner, who was to work closely
with Schuré up to World War One. The roll call of religious fathers whose cults
were founded on the revelation of secret initiations – from Rama through Krishna,
Hermes, Moses, Orpheus, Pythagoras, and Plato to Jesus – appealed to a genera-
tion of artists disillusioned with mass religion and institutionalised secularism.
Implied in Schuré's 'historical' survey was the idea of the artist as grand priest of a
renewed temple-cult, disseminator of spiritual life from Orphic sites scattered
through sacred landscapes. Building on the Nietzschean hope for a renewed
dialectic of Dionysius and Apollo, Schuré spoke of the influence of Orpheus, whose
cult of the sun was celebrated in a temple set on a sacred mountain '[a]t the
entrance of which [stood] a peristyle of four Dorian columns, its enormous shafts
outlined against a dark portico.' It was an architecture worthy of a 'plastic religion'
inherited from Amphion 'who, according to allegorical legend put the stones in
movement with his songs and built temples with the sounds of his lyre'.[55]

Architects from Olbrich to Le Corbusier were to dream of building that 'little
city of the elect' described by Schuré, which was to house the educational centre of
Pythagoras, where '[t]he white home of the initiate brothers stood on a hill among
cypress and olive trees', with at its centre a circular Temple of the Muses. Here 'ini-
tiates would be taught the tetragram, a secret science of numbers, more alive than

any secular mathematics'.[56] We know from Paul Turner's study of Le Corbusier's annotations in his own copy of *Les Grands Initiés* how much Schuré's attention to numerology interested him.[57] In these mystical buildings architecture spoke a language which, as Schuré noted, was allegorical, derived from the temples of Karnak, Jupiter, Delphi, and Eleusis. Schuré's narrative culminated with a description of the Acropolis, where the doctrines of Sophocles (also an artist, as he noted) recounted by Plato were built in stone by Pericles. Echoing Wagner and Nietzsche, the French student of the mystics saw '[t]he light of dawn [as it] touched the terraces of the houses, the columns and pediments of the temples'.[58]

Le Corbusier's reference to Schuré in the central space of the Musée Mondial, while on one level a return to his student reading, coincided with the program of a world museum as it had been developed by Patrick Geddes under the influence of Otlet. Geddes, seeking a religious foundation for his early espousal of universal geography, had also received a copy of Schuré's tract with enthusiasm in 1902.[59] Anticipating his later passion for Eastern religions, he suggested a modification of the Outlook Tower, by then transformed into what he called a generalised Tower of Thought and Action. This tower, he noted, 'needs a corresponding basement and not merely that of Arts and Sciences in general as hitherto but a *sub-basement* or a *catacomb proper* in which the Life of Feeling similarly be recognized.' '[W]e have the Temple', he concluded, 'but what of the Mysteries?'[60] In posing this question he was seconded by Otlet, who thence conceived the Sacrarium as an integral part of his Cité Mondiale.

Le Corbusier's architectural contribution was not only to centre the Sacrarium in the museum, but to seize on the obvious plan relations between his own type-form and that of the *ur*-type of the nineteenth-century museum – Schinkel's Altes Museum in Berlin. The circular Sacrarium emerges as the modern equivalent of Schinkel's 'Pantheon', itself surrounded by examples of the best statuary of all time: the atemporal centre of aesthetic value within a historically envisaged route through a chronologically arranged museum. Like Schinkel in the chronological layout of galleries around his central Pantheon, Le Corbusier also worked to spatialise time, so to speak, wrapping his temporal spiral around this 'sacred' centre of universal values.

The terrestrial globe

The Musée Mondial displayed its programmatic affiliations to Geddes's tower in a final gesture: the siting, at its exit, of a giant terrestrial globe bathed in a light intensified by its contrast with the darkness of the pyramid's initiatory interior:

> Leaving this enclosure [of great initiators], [the visitor] moves toward the cruel light of the parvis. There is set up an object, an elegant mechanism, a terrestrial globe, modeled and painted: "This is our domain ... at least up to now", it says.
> He mounts the stair that leads him to the interior of the globe. There are the stars, in the moving vault of the Planetarium.[61]

In making this proposal, Le Corbusier and Otlet were evidently referring to a long tradition of such 'didactic' globes stretching from Etienne-Louis Boullée's Cenotaph for Newton (1784) and Henri Saint-Simon's Temple of Newton (1802); but their more immediate point of departure was the globe envisaged by Geddes's friend and colleague, the geographer Elisée Reclus for the Exposition Universelle of 1900 in Paris.

This 'Great Globe of the World' was to form the centre of Geddes's dreams of world education and peace. Reclus – anarchist, Communard and geographer – had, since the publication of his synthetic work *La Terre* in 1868–69 and his subsequent exile in 1872, laboured on his monumental, nineteen-volume *Nouvelle géographie universelle* which he completed in 1894. In 1895, as professor of geography at the New University of Brussels, he had called for the construction of a symbol of world unity and brotherhood in the form of a giant relief globe at a scale of 1:100,000, or some 420 feet in diameter.[62] Geddes had met Reclus in the early 1890s, and had helped to anonymously publish his nephew's strongly pro-Dreyfus book in 1895. Beginning in 1898 Geddes worked to raise money for the construction of the Great Globe for the Exposition Universelle of 1900.[63] In the event, the globe designed by the architect Bonnier in 1900 differed somewhat from the didactic machine imagined by Reclus, but its image marked all successive world's fairs, including the New York World's Fair of 1939. An upper floor of the Trocadéro, overlooking the globe, was converted into a miniature, Parisian, Outlook Tower, with accompanying lectures and seminars by Henri Bergson, Paul Otlet and the economist Charles Gide. The project for a world globe was to appear once more in Geddes's plan for a 'Tower of Regional Survey', published in the *Scottish Geographical Magazine*, in March 1902, designed for the National Institute of Geography of Great Britain by the architect Paul Louis Alberet. This 250ft-high, 60ft-square tower (76m high by 18m square) was to have been flanked by a lecture hall and exhibition gallery and fronted by a huge model of the celestial and terrestrial globe designed by the architect Galeron.

It is therefore possible to say that the complicated museological vision of Geddes, first sketched in Edinburgh, was to receive its most logical architectural formulation in Le Corbusier's project for the Musée Mondial. Through Geddes, by way of Otlet, Le Corbusier was enabled to 'return' to a number of preoccupations in architecture and urbanism that he had developed between 1907 and 1910 in response to his reading of Provensal and Schuré. The Musée Mondial thus appears as a complex synthesis of Reclus's and Geddes's geographical didacticism, informed by a more than superficial fascination with the potential unifying force of a new world 'religion', an Orphic dream of romanticism revived in a post-Nietzschean guise.

Monument/instrument

According to the *Grande Encyclopédie*, the first museum in the modern sense of the word (that is to say the first public collection) was founded 27 July 1793, in France, by the Convention. The origin of the modern museum would thus have been linked with the development of the guillotine. (Georges Bataille, *Documents*, 1930[64])

In Georges Bataille's juxtaposition of the Musée du Louvre and the guillotine, the invention of the public museum, a monument dedicated to the exposition of the past, is associated with the machine invented to erase all traces of *ancien-régime* history. The representation and display of history is thereby implicitly equated with erasure and death; the 'death' of the past, entombed in the galleries of the museum, is compared to the literal execution of the enemies of the Revolution. Although this image was not new, and indeed dated to the Revolution itself – Quatremère de Quincy had argued against what he termed 'those cemeteries of the arts' that had been established to house the fragments and deracinated art objects created by vandalism and conquest – in the context of the 1930s, Bataille's cutting equation took on new force.

Indeed, Bataille's metonymy posed the fundamental question of the museum's appropriate representation as a public building type. Was it, like a cemetery or tomb, to be endowed with appropriately monumental symbolism, or was it, like the guillotine, simply a machine that would – transparently, so to speak – operate on behalf of the systematic control of memory? As Bataille understood it, the modern museum was caught between its architectural condition as *monument à mémoire* and its public function as *machine à mémoire*, between, that is, the Louvre and the guillotine.

In this sense, Le Corbusier's Musée Mondial incorporated, in a way that was immediately recognised by its critics, all the difficulties of the notion 'modern museum', suspended as it were between sacred monument and technological instrument.[65] Noting the critical reaction of the Left in Germany and Czechoslovakia, articulated most precisely by Karel Teige, Le Corbusier wrote in 1930:

> The plans for the World City have provoked violent criticism from the far left of architecture in German countries. I was accused of academism. The projects of the buildings are strictly utilitarian, as *functional* as the rigor of a machine; especially the helicoidal World Museum, so violently incriminated, and the library and exhibit rooms, and the University, and the building for the International Associations. They are built according to the latest technical formulas, their form is in each case an organism. That organism confers an attitude on them. We have composed with these different attitudes, placing them together in a vast landscape and uniting them with a concerted, thought-out, mathematical, regulating diagram, bringing harmony and unity.
>
> The plans for the World City, with its buildings that are real machines, bring a certain magnificence in which some wish at all costs to find archaeological inspirations. But, from my point of view, this quality of harmony comes from more than a simple response to a well-propounded utilitarian problem. I attribute it purely and simply to a certain state of lyricism.[66]

Yet it was evidently not only, as Le Corbusier claimed, a response to the overtly monumental form of the pyramid that led to charges of academicism and of archaeological reference. Other pyramidal Babel-like structures dedicated to equally

idealistic ends had been proposed without arousing such controversy: one has only to think of such spiral memorials as Rodin's Tower of Labour, Tatlin's Tower or G. Iakulov's less constructivist and more baroque Monument to the Twenty-Six Commissaires Killed at Baku of 1923, published in *L'Architecture vivante*, in spring 1926.[67] Nor could the mounting criticism have anticipated the close relationship between archaeology and fascism that would develop in the early 1930s in the work of Albert Speer and his circle, devotees of historical 'reconstructions' of Babylon. Rather, it was a criticism of Le Corbusier's apparently culturally elitist and reformist programme as a whole.

From the point of view of a partisan of the *Neue Sachlichkeit* such as Karel Teige, Le Corbusier's project suffered from an uneasy alliance of art and science.[68] In Teige's terms, the Musée Mondial was definitively a *monument* and not an *instrument*, a 'scientific solution of the exact tasks of rational construction.' As an artistic solution of artistic problems, it took its place naturally in the long history of cult monuments, whether Egyptian, Babylonian, Assyrian, Mayan, Aztec or Peruvian, whence its axonometric view had the 'effect ... of an archaeological site'. Relying on metaphysics more than physics, it demonstrated precisely that 'error of monumentality' that always surfaced when '[a]n artistic solution of a metaphysical, abstractly speculative task [was approached] by means of monumental composition'. Embedded in Corbusian theory – Teige cited the already difficult assimilation of the 'house-palace' – the project simply reverted to a historicism and academicism that was the inevitable outcome of a programme conceived by small 'intellectual coteries'. The aesthetic object, the '*Reissbrett-ornamentik*', claimed Teige, had no place in modern society. He summed up the dilemma of monumentality concisely:

> Monumental and votive architecture, dedicated to whatever memorial of revolution and liberation; all present-day triumphal arches, festive halls, tombs, palaces and castles result in monstrosities.

The blatant symbolic content of the Musée Mondial was finally epitomised most directly by the presence of the Sacrarium; Teige was ironically perplexed as to 'how a "Sacrarium" got into a town of modern science'.

Le Corbusier himself, however, disagreed, continuing to present the Mundaneum project as the product of a pure and simple rationalism: 'Here we are concerned from the architectural point of view with an experiment in high architecture, whose monumentality is not sought in archaeological or academic formulas, but in the simple grouping, according to a preconceived rhythm, of utilitarian buildings themselves conceived with the most complete rationalism.'[69]

But this was, as Le Corbusier well knew, conveniently to ignore that the resulting form, the pyramid, had long been associated with the symbolic origin of architecture itself. The pyramid, for Teige as for Bataille, was first and foremost an aesthetic and cultural symbol bound to religious practices and not a machine. The simple mechanisation or functionalisation of such a form was not, in these terms, a

sufficient critique of formalism; nor was the translation of a horizontal sequence of museum rooms into a new Tower of Babel enough to bury the connotations that, ever since Hegel published his *Lectures in Aesthetics*, had been bound to the symbol of the vertical spiral. In this way, and paradoxically enough, the modernist effort to dissolve the historical and monumental connotations of the museum through the agency of a universalising gaze foundered at the point where such a gaze demanded an architecturally expressive form of its own.

Notes

This chapter is dedicated to Alan Colquhoun, a friend, valued interlocutor, and colleague for over twenty years, whose work on the historicist roots of modernism has profoundly influenced its writing.

1 Henry Provensal, *L'Art de demain: vers l'harmonie intégrale* (Paris: Perrin, 1904), p. 117 [my translation].

2 Wolfgang Herrmann, *Deutsche Baukunst des 19. und 20. Jahrhunderts*, vol. 1 (Breslau, 1932), cited by Hans Sedlmayr, *Art in Crisis: The Lost Centre*, trans. Brian Battershaw (London: Hollis and Carter, 1957), pp. 27–8.

3 Henry Provensal, *L'Art de demain*, p. 116 [my translation]. For Provensal a 'modern museum' was the essential responsibility of municipalities and the state, and should be constituted with serious attention to the techniques of display and classification. He suggested the reconstitution of environments within which the different works of art might be seen in their 'original' context, 'a positive ambiance where the intimate life of different epochs would be conserved intact, in this way replacing these fragmentations of art in their historical truth.'

4 According to Pierre Saddy, Le Corbusier read the chapter 'Le Problème des musées' in Paul Valéry's *Pièces sur l'art* and underlined the remark, 'Peinture et Sculpture: leur mère est morte, leur mère Architecture.' Only one other article was underlined in the margins, 'Les Fresques de Paul Véronèse', the other pages remaining uncut. Pierre Saddy (ed.), *Le Corbusier: le passé à réaction poétique* (Paris: Caisse nationale des Monuments historiques et des Sites, 1988), p. 240 [exhibition held at the Hôtel de Sully, December 1987 – March 1988].

5 Paul Valéry, 'Le Problème des musées', in Valéry, *Pièces sur l'art* (Paris: Maurice Darantiere, 1931), pp. 147–56; pp. 149–50 and p. 152 [my translation].

6 Ernst Jünger, *Das abenteuerliche Herz* (Hamburg, 1938), cited by Sedlmayr, *Art in Crisis*, p. 32.

7 *Ibid.*, p. 31.

8 *Ibid.*, p. 31.

9 F. T. Marinetti, *Selected Writings*, ed. R. W. Flint (New York: Farrar, Straus and Giroux, 1972), p. 42.

10 In an 'inquiry' anticipating those of the Surrealists in the late 1920s, the editors posed the question and included a form letter for responses in *L'Esprit nouveau*, 3 (December 1920). Replies were published in number 6 (March 1921), pp. 11–8, and number 8 (May 1921), pp. 960–2. Among the respondents were Charles Lalo, Juan Gris, Maurice Raynal, and Vincent Huidobro.

11 Friedrich Nietzsche, 'On the uses and disadvantages of history for life', in Nietzsche, *Untimely Meditations*, trans. R. J. Hollingdale (Cambridge: Cambridge University Press, 1983), pp. 57–123; p. 61.

12 *Ibid.*, p. 62.

13 Provensal, *L'Art de demain*, p. 116.

14 Theodor W. Adorno, 'Valéry Proust Museum', in Adorno, *Prisms*, trans. Samuel and Shierry Weber (Cambridge, Mass.: The MIT Press, 1981), pp. 173–85; p. 175.

15 Le Corbusier, *The Decorative Art of Today*, trans. James I. Dunnett (London: The Architectural Press, 1987), p. 17; preceding quotations *ibid.*, pp. 16–17.

16 See Saddy, *Le Corbusier*, p. 135. Le Corbusier published his reminiscences under the title 'Les Certitudes des musées', in *L'Esprit nouveau*, 1924 and reprinted them in *The Decorative Art of Today* in the chapter 'Confessions': 'From the museums I acquired certainties without holes, without snares. The works there are like integral numbers, and the conversation is without pretence: intimacy is at the discretion of the questioner – the work always answers the questions put. Works in museums are good schools.' (pp. 197–8)

17 As Adorno remarked, Marcel Proust had also compared domestic settings ('the masterpieces observed during dinner') to the environment of the museum ('where the rooms, in their sober abstinence from all decorative detail, symbolize the inner spaces into which the artist withdraws to create the work'); Le Corbusier seems to have merged the latter into the former in order to create a species of domestic museum. See Adorno, 'Valéry Proust Museum', p. 179.

18 See Alois Riegl, 'The modern cult of monuments: its character and its origin', trans. Kurt W. Forster and Diane Ghirardo, *Oppositions*, 25 (autumn 1982), pp. 21–51.

19 Robert de La Sizeranne, 'Les Prisons de l'art', in La Sizeranne, *Les Questions esthétiques contemporaines* (Paris: Librairie Hachette et Cie, 1904), pp. 213–64.

20 Patrick Geddes, *Cities in Evolution: An Introduction to the Town Planning Movement and to the Study of Civics* (London: Williams & Norgate, 1915), p. 372; as is the following quotation.

21 For a detailed description, see Philip Boardman, *The Worlds of Patrick Geddes: Biologist, Town-planner, Re-educator, Peace-warrior* (London: Routledge and Kegan Paul, 1978), pp. 136–45.

22 Quoted in *ibid.*, p. 139.

23 See Alessandra Ponte, 'Thinking machines: from the Outlook Tower to the City of the World', in *Lotus International*, 35 (1982), pp. 46–51.

24 Patrick Geddes, *City Development: A Study of Parks, Gardens, and Culture-Institutes. A Report to the Carnegie Dunfermline Trust* (Edinburgh and Westminster: Geddes and Company and Birmingham: Saint George Press, 1904), p. 171.

25 *Ibid.*, p. 131.

26 *Ibid.*, p. 131.

27 Geddes, *Cities in Evolution*, p. 375. Symbolically enough for Geddes, Crosby Hall had been built on the site of Thomas More's garden, making it a fitting emblem for a renewed utopianism.

28 Le Corbusier to the organising committee of the International Building Exhibition, Berlin, 1931, in reaction to the French government's photographic exposition of the historical sites of Paris; quoted in Maximilien Gauthier, *Le Corbusier ou l'architecture au service de l'homme* (Paris: Denoël, 1944), p. 247 [my translation].

29 Joris-Karl Huysmans, 'Le Musée des arts décoratifs et l'architecture cuite', in Huysmans, *L'Art moderne: certains* (Paris: Union Générale d'Editions, 1975), p. 399 [my translation].

30 *Ibid.*, p. 399 [my translation].

31 Sigmund Freud, *Civilization and its Discontents* (New York: W. W. Norton, 1962), p. 19.

32 Le Corbusier, *The City of Tomorrow and its Planning*, trans. Frederick Etchells (New York: Dover Publications, 1987), p. 281.

33 *Ibid.*, p. 287; as are the following quotations.

34 *Ibid.*, pp. 287–8.

35 Manfredo Tafuri, '"*Machine et mémoire*": the city in the work of Le Corbusier', in H. Allen Brooks (ed.), *Le Corbusier: The Garland Essays* (New York and London: Garland, 1987), pp. 203–18.

36 Le Corbusier, *Oeuvre complète*, 8 vols, vol. 2, 1929–1934 (Basle, Berlin and Boston: Birkhäuser, 1999), p. 53. For another analysis of the Beistegui apartment, see Pierre Saddy, 'Le Corbusier chez les riches: l'appartement Charles de Beistegui', in *Architecture, Mouvement, Continuité*, 49 (September 1979), pp. 57–70.

37 Saddy, 'Le Corbusier chez les riches', p. 70, quotes Charles de Beistegui in an interview of March 1931 with Roger Baschet of *Plaisir de France*: 'this apartment was not intended to be inhabited, but to serve as a frame for the kind of great fêtes that they once knew how to give under the sparkling light of innumerable chandeliers' [my translation].

38 Le Corbusier, *Oeuvre complète*, vol. 2, p. 56 [my translation].

39 *Ibid.*, p. 54 [my translation].

40 Tafuri, '"*Machine et mémoire*"', p. 203.

41 Beatriz Colomina, 'The split wall: domestic voyeurism', in Colomina (ed.), *Sexuality and Space* (Princeton, NJ: Princeton Architectural Press, 1992), pp. 73–128; esp. pp. 107–12.

42 For a comprehensive and thoroughly researched account of the historical antecedents and architectural planning of the Cité Mondiale, see Giuliano Gresleri and Dario Matteoni, *La città mondiale: Andersen, Hébrard, Otlet, Le Corbusier* (Venice: Marsilio, 1982).

43 Hendrik Christian Andersen and Ernest M. Hébrard, *Création d'un centre mondial de communication* (Paris: n.p., 1913).

44 Boardman, *The Worlds of Patrick Geddes*, p. 326.

45 *Ibid.*, pp. 326–47.

46 Paul Otlet and Le Corbusier, *Mundaneum* (Brussels: Union des Associations Internationales, Palais Mondial, 1928), pp. 7–10 [my translation].

47 *Ibid.*, p. 10 [my translation].

48 *Ibid.*, p. 10 [my translation].

49 *Ibid.*, p. 10 [my translation].

50 *Ibid.*, p. 18; pp. 26–7. [my translation].

51 *Ibid.*, p. 30. This description was repeated under the heading 'Mundaneum', in *L'Architecture vivante*, summer 1929, pp. 27–32; all following quotations are taken from there [my translation].

52 Otlet and Le Corbusier, *Mundaneum*, p. 18 [my translation].

53 *Ibid.*, p. 39 [my translation].

54 Edouard Schuré, *Les Grands Initiés* (Paris: Perrin, 1889).

55 Edouard Schuré, *The Great Initiates: A Study of the Secret History of Religions*, trans. Gloria Raspberry, intro. Paul M. Allen (New York: Harper & Row, 1980), pp. 232 and 227.

56 *Ibid.*, p. 300.

57 Paul V. Turner, *La Formation de Le Corbusier: idéalisme et mouvement moderne* (Paris: Macula, 1987), pp. 32–36.

58 Schuré, *The Great Initiates*, p. 383.

59 As noted in Boardman, *The Worlds of Patrick Geddes*, p. 194.

60 *Ibid.*, p. 194.

61 Le Corbusier, 'Mundaneum', p. 32.

62 See 'G. G.', *Projet de construction d'un globe terrestre à l'échelle du cent-millième* (Paris: Société nouvelle, 1895) and Elisée Reclus, *L'Enseignement de la géographie, globes, disques globulaires et reliefs* (Brussels: Vve F. Larcier, 1902).

63 Reclus had already been informed, in April 1886, by the anarchist Peter Kropotkin that Geddes had purchased a flat in the working-class quarter of Edinburgh. See Elie and Elisée Reclus, *Renouveau d'un cité* (Paris: édition de la *Société nouvelle*, 1896). The tract of Paul Reclus, son of Elisée's brother Elie, was published under the pseudonym of Georges Guyou.

64 Georges Bataille, 'Musée', in *Documents*, 5 (1930), p. 300; reprinted in *Oeuvres complètes*, vol. 1, *Premiers écrits*, ed. Michel Foucault (Paris: Gallimard, 1970), pp. 239–40; p. 239 [my translation].

65 See Saddy (ed.), *Le Corbusier*, pp. 42–53, with a translation of Karel Teige's text 'Réponse à Le Corbusier', first published in *Musaion*, 2 (1931). For a discussion of the debate that opened in Prague following Teige's lead, see Aléna Kubova, 'Le Mundaneum, erreur architecturale?', in Saddy (ed.), *Le Corbusier*, pp. 48–50.

66 Le Corbusier, *Precisions on the Present State of Architecture and City Planning: With an American Prologue, a Brazilian Corollary Followed by the Temperature of Paris and the Atmosphere of Moscow*, trans. Edith Schreiber Aujame (Cambridge, Mass. and London: The MIT Press, 1991), p. 219.

67 For a discussion of the possible influences on this pyramidal obsession in Le Corbusier, see Saddy (ed.), *Le Corbusier* and Gresleri and Matteoni, *La città mondiale*. The similarity between the Musée Mondial and the Ziggurat of Khorsabad (a form also used by Andersen and Hébrard in their project of 1910 for a world city, published in 1913) was already noted by Catherine Courtiau, 'La Cité Internationale, 1927–1931', in Isabelle Charollais and André Ducret (eds), *Le Corbusier à Genève 1922–1932: projects et réalisations* (Lausanne: Payot, 1997), pp. 53–69.

68 Karel Teige, 'Mundaneum', trans. Ladislav and Elizabeth Holovsky and Lubamir Dolezel, *Oppositions*, 4 (October 1974), pp. 83–92; all following quotations are taken from pp. 88–90. This criticism was first published in *Stavba*, 7 (1929).

69 Le Corbusier, 'Mundaneum', p. 27.

Brasília, a national capital without a national museum

Valerie Fraser

In 1956 the Latin American correspondent of the *Architectural Review*, reporting on the winning design for a new Museum of Modern Art for Caracas by Oscar Niemeyer, commented that museums of modern art, like university cities, had become a constituent feature of contemporary Latin American architecture.[1] All the more strange, therefore, that the city of Brasília on which work began precisely in 1956, did not include plans for a major museum. In his competition entry for the design of Brasília the winning architect Lúcio Costa declared that the new city must, of course, be orderly and efficient, 'but also a city of vitality and charm, conducive to reverie and intellectual speculation, capable of becoming not only the seat of Government, the administrative headquarters of the nation, but also a centre of culture which will attract to it the finest and most perceptive intellects in the country'. He argued that 'it should be conceived of ... not as an *urbs* ... but as a *civitas*, having the virtues and attributes appropriate to a true capital city.'[2] Costa's urban scheme was to include government palaces and ministries, a cathedral, a university, and industrial, financial, commercial, hotel and residential quarters. He designated an area for the 'Entertainment Centre' which, as he put it 'has something in it of Piccadilly Circus, Times Square and the Champs Elysées', and was to include cafés, theatres and a national opera house. Between this central entertainments district and the university was to be a cultural centre comprising 'Museums, Library, Planetarium, Academies, Institutes etc' but the museums mentioned here were evidently envisaged as part of the complex as a whole, not as a special focus of civic or national pride. Unlike the national opera, the cultural centre was not part of the initial building works, and Brasília still has no museum of national significance. This essay explores the question of whether this was accident, design or force of circumstance.

The idea of moving the capital of Brazil from the overcrowded coastal port of Rio de Janeiro to a new site in the interior had been suggested as early as 1789 when as part of the resistance to Portuguese rule the inhabitants of the mining province of Minas Gerais proposed a new capital, free from associations with the colonial

regime.[3] The idea surfaced periodically during the nineteenth century, again linked to Republican aspirations, until the young Brazilian Republic designated a great tract of land in the central Brazilian plateau as the 'future federal district' within which the new capital was to be sited, a determination enshrined in the Constitution of 1891. During the 1940s and early 1950s successive presidents again paid lip service to the idea of a new capital, commissioning surveys and reports until in 1955 an appropriate location was determined within the designated federal district on a rectangular site at the confluence of two rivers; but the possibility of building a city and transferring the capital still seemed a long way off. Then, later that same year, during his 1955 presidential election campaign, Juscelino Kubitschek made the realisation of Brasília his central election promise. In fact he claimed not to have considered it seriously until someone asked him about it at a political rally in Goiás and on the spur of the moment he declared 'I will implement the Constitution'.[4] This may be part of the subsequent mythologisation of Brasília but President Kubitschek was as good as his word. The timing was hardly auspicious: President Vargas' suicide in 1954 had left the country in political turmoil and Kubitschek was elected by so slim a majority that the army had to intervene to suppress a coup before he could be formally instated in 1956, but Kubitschek was determined, energetic and charismatic. He knew that if he did not make enough progress on Brasília during his five-year term of office the project would be abandoned by his successor. 'Fifty Years' Progress in Five' was his famous slogan and he succeeded in increasing industrial production by 80 per cent with an economic growth rate of 7 per cent a year. At the end of Kubitschek's five years Brazil had a self-sufficient motor industry, a national airline, and a brand new modern capital city.[5]

A new capital city, but without a major museum. The lack of plans for a national museum for Brasília is curious given the preoccupation with museums elsewhere in Latin America, as noted earlier. It is even more curious in that the design for the Museo de Arte Nacional in Caracas to which the *Architectural Review* refers was by Brazilian architect Oscar Niemeyer, a long-standing friend of Kubitschek who was closely involved in discussions on the lay-out and architecture of the new capital from the beginning. He it was who had recommended that the urban scheme be decided by competition, but Niemeyer was also an old friend of Costa, and a member of the jury, so the competition result is hardly surprising (as Le Corbusier later remarked of architectural competitions: 'Classic method of choosing your own favorites behind a reassuring "anonymity"').[6] In fact it is hard to imagine that Kubitschek, Niemeyer and Costa did not discuss the whole project together in great detail from the outset. Niemeyer had just won the competition for his design for the new museum in Caracas; Costa was a man of immense erudition, a passionate modernist, but also an enthusiastic advocate of the art and architecture of colonial Brazil, who in 1933, in what must be one of the first such cases in the world, was behind the government decision to declare the entire colonial city of Ouro Preto in Minas Gerais a national monument. Kubitschek was a strong

supporter of cultural and educational projects. In other words all three of the prime movers in the plans for Brasília would have had reasons to promote a scheme for a major national museum as an important part of the project, and yet not one of them did so.

The history of national museums in Latin America has yet to be written but for our purposes a few details will help to provide a context for the case of Brasília. In general terms the nineteenth century saw the creation of museums of national and natural history which were replaced in importance in the early years of the twentieth century by museums of fine art. This is true of both Spanish and Portuguese America even though their respective histories are rather different. In Spanish America the creation of museums of national and natural history was an integral part of the process of national construction that followed independence from Spain in the early years of the nineteenth century. The heroes of independence wanted to have their deeds commemorated in some public and permanent form, and they were also interested in asserting control over the new national territory by means of a thorough knowledge of its geography, geology, flora and fauna. In Chile, for example, which achieved independence in 1810, a museum of national history was founded in 1811[7] and in 1813 the liberator Bernardo O'Higgins began promoting the idea of a museum of Chilean natural history.[8] Archaeological and ethnographic material also began to attract attention. In Peru, even before independence from Spain was secure, a decree of 1822 forbade the export of antiquities and recommended the foundation of a national museum.[9] In 1825 Mexico's first president, Guadalupe Victoria, founded the first national museum, a collection of archaeological material which was housed in the university.[10] Elsewhere too, while decrees did not always translate into reality, there seems to have been a general consensus that museums had an important role to play in moulding the identity of a new nation.

Paradoxically, however, political independence from Spain resulted in an increased dependence on France as the cultural role model. French urban planners redesigned the cities, French architects built palaces for the rich, and French artists came to direct the newly founded Academies of Art. These academies promoted the copying of European models and, where possible, they assembled collections of works of art suitable for this purpose (preferably French), often by donation from patriotic benefactors. Also the academies led to the professionalisation of artistic practice, the loosening of ties between artists and the Church, and the diversification of artistic patronage. Therefore the developing interest in collecting European art for pedagogical reasons, together with the increasing richness and diversity of home-grown art led, in turn, to a shift in interest from museums of natural and national history to museums of art. Chile again provides an early example in the Museo Nacional de Bellas Artes (National Museum of Fine Arts) in Santiago: founded by decree in 1880, it is one of the oldest such museums in Latin America. As well as Chilean art the collection includes Italian Renaissance drawings, paintings from the Italian, Dutch and Flemish schools of the sixteenth and seventeenth centuries, and a collection of drawings of Chile by the German traveller-artist

49 Museo Nacional de Bellas Artes (now Galería de Arte Nacional), Caracas, 1935; architect: Carlos Raúl Villanueva

Mauricio Rugendas.[11] Later the Palacio de Bellas Artes (Palace of Fine Arts) was built to house it. Designed by a French architect in the style of the Petit Trianon, it was inaugurated in 1910 to coincide with the celebrations marking the centenary of Independence.[12]

In Mexico after the Revolution of 1910 the half-built national theatre, begun in 1904 under the dictatorship of Porfirio Díaz, was redesignated the Palace of Fine Arts. Although designed by an Italian, Adamo Boardi, the inspiration for this building had again been French, this time the Paris Opéra.[13] Although it remained a theatre, the interior was adapted to serve as showcase for Mexican culture, the grand lobbies and foyers providing space for permanent and temporary art exhibitions. It was a long time in construction, finally opening its doors in 1934 to a heterogeneous interior design incorporating neo-Maya architectural detail and murals by the three most famous of the Mexican artists of the day, Diego Rivera, David Alfaro Siqueiros and José Clemente Orozco. In the same year Argentina inaugurated a new building to house its Museo Nacional de Bellas Artes (National Museum of Fine Arts) in Buenos Aires,[14] and in the following year, 1935, one of the last acts of President Vicente Gómez of Venezuela was to decree the construction of Venezuela's first purpose-built national museum, the Museo Nacional de Bellas Artes, in Caracas (see figure 49).[15] This was designed by Carlos Raúl Villanueva (trained at the Ecole des Beaux Arts in Paris) in an elegant neoclassical style, and was again a symbol of national aspiration. It is significant that in all these examples the new museum was located outside the older city centre, simultaneously demonstrating and promoting up-market urban expansion. From the beginning of the century museums were recognised as central features of city planning.

Brazil, as so often, is both like and unlike the rest of Latin America. To start with, its history is very different. In 1808, at the time when other countries were struggling to establish their independence from Spain, the King of Portugal moved from Lisbon to Brazil and made Rio de Janeiro into the capital of the Portuguese Empire.

This regime survived throughout the nineteenth century until the last Emperor abdicated in 1899 after a brief experiment as President of the Republic of Brazil. In terms of cultural influence, however, Brazil was as dominated by France as anywhere else. On the transfer of the court to Rio the Portuguese aristocracy brought with them a wave of French tastes and fashions, and in 1816 the French Artistic Mission – a boat-load of painters, sculptors, architects, musicians and craftsmen – arrived to found the imperial academy.[16] They also brought a collection of more than fifty works of art (also French) to serve as models for students, a collection which provided the foundation for the later Museu Nacional de Belas Artes (National Museum of Fine Arts). From 1908 this increasingly prestigious collection was housed in the new Academy of Fine Arts building on Avenida Rio Branco; as elsewhere in Latin America the design was derived from a Parisian prototype, in this case that of the Louvre, and the location was part of a deliberate programme of urban reorientation towards the south.[17] Brazil's National Museum had been founded by the Emperor himself in 1818 using as a basis the royal collection of specimens that had been sent from Brazil to Portugal during the previous two centuries and which returned to Rio de Janeiro with the court. Since 1892 the National Museum has been housed in a former royal palace (known locally as the Tropical Versailles; see figure 50) and its collections reflect its origins: palaeontology, anthropology, zoology and archaeology including, interestingly, a section of antiquities from Mexico and Peru.[18]

Until the mid-twentieth century the history of museums in Brazil was thus much like that elsewhere in Latin America, with the fine art collections gradually gaining prestige at the expense of the older museums of national and natural history, but the 1950s marked a significant change of gear. The first important development was the foundation of Rio's Museu de Arte Moderna (Museum of Modern Art, known by the acronym MAM) in 1948 (see figure 51). It was initially housed a block away from the Academy of Fine Arts, in part of the ground floor of the revolutionary Ministry of Education building designed in 1936 by a team that included Lúcio Costa, Oscar Niemeyer and Affonso Reidy and for which Le Corbusier acted as consultant. In 1952 it was assigned its present site on the landfill beside Gloria Bay, again representing the southerly expansion of the city; the building was designed by Affonso Reidy in 1954, and Juscelino Kubitschek was a member of the consultative team. It was inaugurated in 1958 during his presidency and completed in 1962.[19] The MAM is radical both architecturally and conceptually, and would have been among the most important examples referred to by the *Architectural Review* Latin America correspondent in 1956. The main exhibition block is rectilinear in plan, raised on pairs of V-shaped *pilotis*, the outer arms of which extend the full height of the building to create in effect an oblique colonnade. The ceiling is suspended from the roof beams, allowing the lateral walls to be made from continuous glass panelling and the exhibition space itself fully open-plan. Reidy designed it to be as little like a traditional museum as possible: he wanted it to be a vital educational and social force, rather than, as he put it, 'a passive organism'.[20] It incorporated an art school, a theatre and a

50 Museu Nacional, previously Palácio de São Cristóvão, 1809, Rio de Janeiro

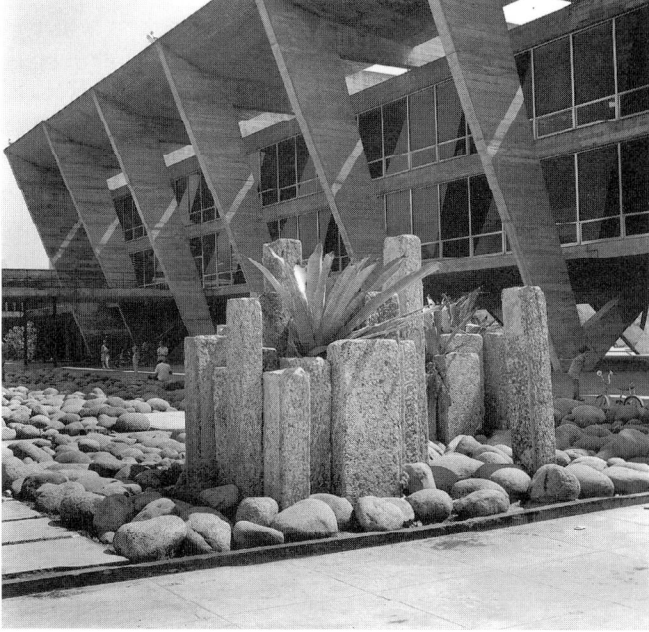

51 Museu de Arte Moderno (MAM), Rio de Janeiro, 1954–62; architect: Affonso Reidy

restaurant as well as the museum, and the architectural emphasis is on transparency. The structure allows for uninterrupted views of the bay and mountains, both beneath and through the main body of the complex. It housed a magnificent range of modern Brazilian and non-Brazilian art, including works by Miró, Picasso, Dalí, Klee and Torres-García, almost all of which were destroyed in a disastrous fire of 1978.

By 1954, however, Rio de Janeiro was not the only Brazilian city to boast important museums and a rich cultural life. São Paulo was Brazil's fast-growing second city and during the decade prior to the foundation of Brasília it was to challenge Rio in two ways within the field of fine arts: with the foundation of the São Paulo

Museu de Arte (Museum of Art, known as MASP) in 1947,[21] and with the first International Bienal of São Paulo in 1951.[22] The challenge could perhaps be seen as dating back to São Paulo's famous Week of Modern Art in 1922, but this week of avant-garde exhibitions and events, designed to awaken the coffee barons from their customary cultural conservatism, had had little long-term impact. The Museum of Art was a project better suited to their tastes. It was founded by the media magnate Francisco de Assis Chateaubriand who determined to establish in Brazil a collection of Old Master paintings of international significance.[23] He succeeded. He put a lot of his own money in to begin with, he enticed David Rockefeller to contribute US$ 40,000,[24] and he persuaded wealthy Brazilians, not just from São Paulo but from all over the country, to buy works of art in return for media coverage of their generosity. Chateaubriand and the museum's first Director Pietro Maria Bardi bought paintings *via* European and North American dealers, and within the first five years they had acquired works by Titian, Bronzino, Bosch, Rembrandt, Frans Hals, Velázquez, Constable, Gainsborough, Goya, Delacroix, Courbet, Manet, Cézanne, Renoir, Degas, Van Gogh, Lautrec, Gauguin, Léger, Utrillo, Bonnard, Picasso, Modigliani and Ernst. Initially the collection was housed in the headquarters of Chateaubriand's *Diários Associados* newspapers but in 1957 work began on a permanent home for the museum. Lina Bo Bardi's striking design, a large glazed box suspended from two great red arches above an open public area at street level, developed a number of ideas from Reidy's MAM in Rio, including the emphasis on the social and educational aspects, and the decision to hang the works in open-plan galleries with glass walls to allow visitors to see the outside world, and vice versa (see figures 52 and 53).[25] It was opened by HM Queen Elizabeth II in 1968. The Bienal, on the other hand, took up the radical intentions of the Week of Modern Art in more than architectural terms, and soon established itself as a leading international forum for modern art. The second Bienal of 1953 was already what has been called 'one of the most comprehensive exhibitions of modern Western art ever mounted', with for example a room of works by Picasso, including *Guernica*, a room of Klee, of de Stijl and Mondrian, a room of Italian Futurists, of Constructivism, and of Americans such as Calder and de Kooning.[26] And it was housed in an architectural complex designed by Oscar Niemeyer.

So at the time of Brasília's foundation Brazil had a number of outstanding collections housed in purpose-built museums in both traditional and modern styles. Rio de Janeiro and São Paulo were both thriving cultural centres, with major museums and a wealth of other lesser collections. Therefore, at one level the obvious explanation for the absence of a major national museum in Brasília is that it was not practicable to create a new museum of sufficient importance: it would have been extremely unpopular had there been any attempt to transfer one or more of the existing museums to the new capital, and it would have been extremely expensive and time-consuming to have tried to assemble – either by purchase or donation or both – a collection to rival that of either the MAM in Rio or the MASP. If a major collection of fine art was not feasible, the other possibility was a museum combining

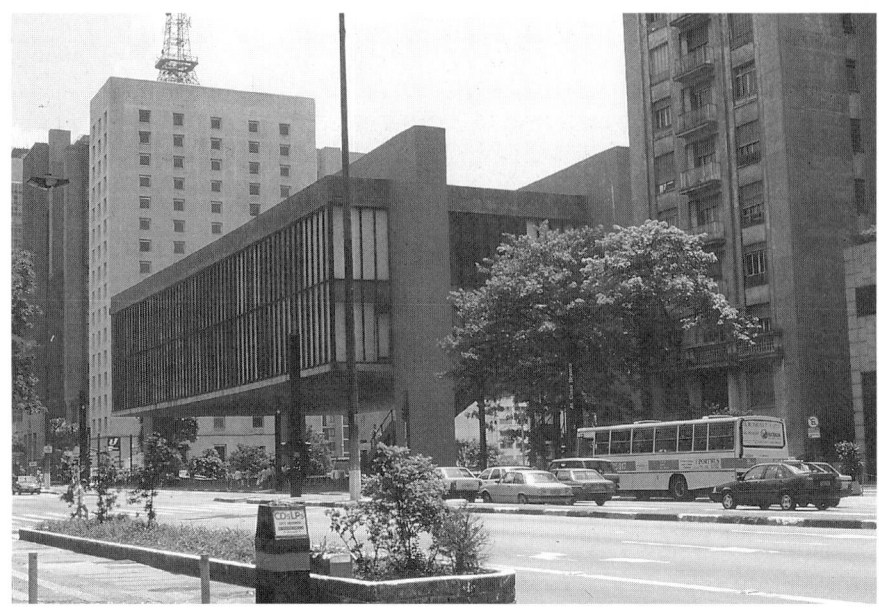

52 Museu de Arte de São Paulo (MASP), São Paulo, 1957–68; architect: Lina Bo Bardi

53 Interior, Museu de Arte de São Paulo, São Paulo

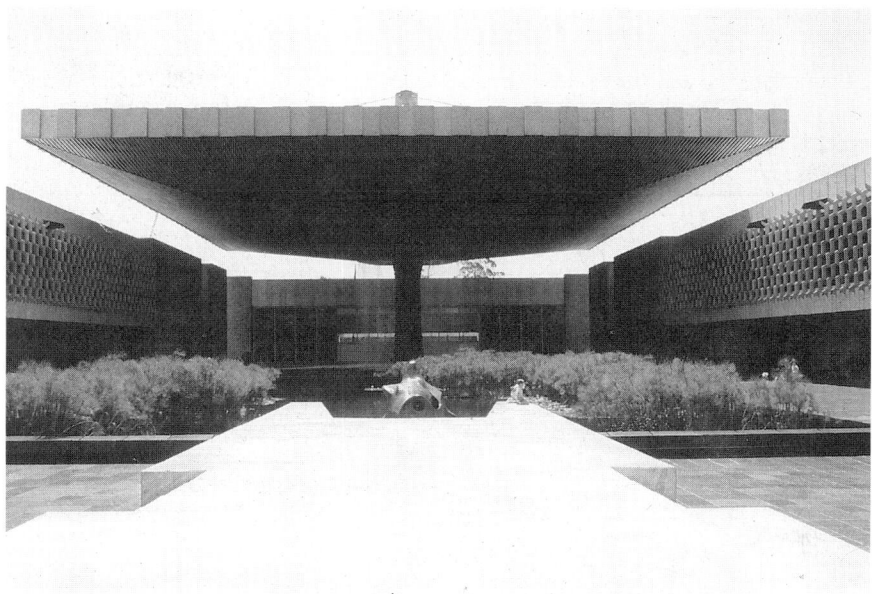

54 Museo Nacional de Arqueología y Antropología (MNAA), Mexico City, 1960–64;
architect: Pedro Ramírez Váquez

natural history, ethnography and national history, a museum that would provide a
panorama of the history, geography, flora, fauna, peoples and cultures of Brazil.

As we have seen, however, enthusiasm had moved away from this type of mate-
rial and towards collections of fine art, although Mexico makes an interesting com-
parison in this context. Mexico's first major modern museum in architectural
terms was the famous Museo Nacional de Arqueología y Antropología (National
Museum of Archaeology and Anthropology, MNAA) on which work began in 1960
(see figure 54).[27] Post-Independence and especially post-Revolutionary Mexico
found strength in the knowledge that it possessed a rich and ancient past, cultures
which, in line with traditional Mediterranean-orientated archaeology, expressed
themselves in monumental stone architecture and sculpture. The purpose of the
MNAA was to link this impressive material with the present – the Olmec, Zapotec
and Aztec artefacts with the equally diverse customs and cultures of contemporary
Mexican Indians – in the setting of a modern museum as part of a larger nationalist
project. In this area Brazil could not compete. It had no stony antiquity comparable
to that of Mexico to provide material for an archaeological museum full of statues,
stelae, altars and stone tablets that could suggest a past equivalent to that of Greece
or Rome or Egypt, and although Amazonian culture might have been of interest to
some a display of the tools and accoutrements of tribal peoples was hardly appro-
priate to a new capital designed to conquer the interior, a national symbol of
modernity and progress.

But I believe that the reasons for the lack of a major national museum in Brasília are by no means all negative. Museums involve a celebration of and nostalgia for the past and Brasília was deliberately created as a place with no history, no past, no pre-conceptions, because it was intended to mark a new beginning for Brazil.[28] In his Report Costa makes no mention of Brazil or Brazil's history apart from a prefatory reference to the original suggestion by 'the Patriarch' José Bonifacio in 1823 that the capital of Brazil should be transferred to the state of Goiás and rechristened Brasília. Brasília was deliberately designed to be a break with the past. It has been described as a negation of Brazil's traditional crowded, organic and disorderly urban forms, and of Brazil's condition of underdevelopment, so evident in the *favelas* of the larger cities.[29] Neither does Costa's plan make any reference to the history and theory of town planning, past or present, on which it draws, although it was evidently conceived as a modernist city very much in line with the Le Corbusian tenets of the Congrès Internationaux d'Architecture Moderne (CIAM) Charter of Athens of 1933.[30]

Costa's Plano Piloto for Brasília is clearly based on the four functions of the city as defined by the Charter of Athens: dwellings, recreation, work and transport (see figure 55).[31] The 'work' function in the plan for Brasília is dominated by the work-ings of government: the government palace, the supreme court and the congress building are grouped around the triangular Plaça dos Três Poderes (Plaza of the Three Powers) at the apex of the monumental axis (see figure 56). Down this mon-umental axis are arranged other key buildings: the government ministries, the cathedral and, at the far end, the headquarters of the army, all laid out amongst endless grassy parks. The dwellings are arranged along a transverse axis, which crosses the monumental axis at its mid point, and the transport system, which in Brasília means a network of roads, highways and superhighways, links these two zones of work and residence together with a gigantic interchange at the central crossing point. The fourth function, recreation, is understood largely in terms of sport, with facilities incorporated into the residential districts and areas of park-land. Costa's centralised entertainments district, including a national opera house, theatres, cinemas, bars and cafés, is located at the point at which the monumental or 'work' axis crosses the 'dwelling' axis.

It is interesting just how compelling a mantra the four functions of the city has been in twentieth-century thinking on urban planning and development and yet how limited and limiting a framework it provides. In practice, plans based on these four functions prioritise work, housing, and the communication between them, while recreation is interpreted largely as sport and so in spatial terms it is slotted into the spare green spaces between the other three functions. Education does not fit easily into one of the four functions and so, to an even greater degree than recre-ation, it tends to be marginalised. In *The Radiant City* of 1935 Le Corbusier in fact relegates education to separate satellites outside the central urban complex.[32] In *The City of Tomorrow* of 1924, however, before the idea of the four functions had solidified, Le Corbusier included, near the centre of his Contemporary City, a

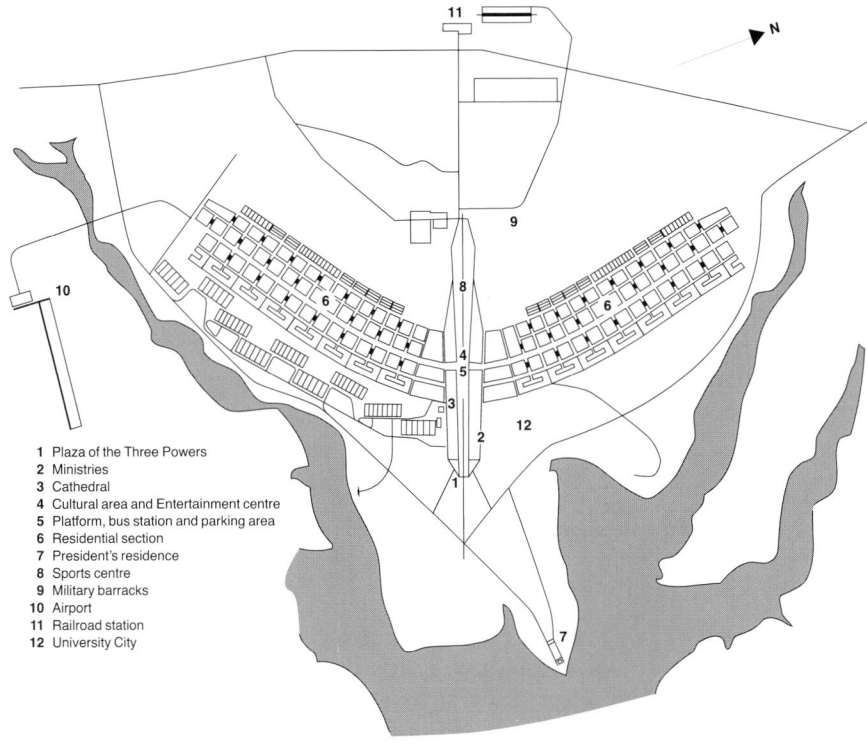

1 Plaza of the Three Powers
2 Ministries
3 Cathedral
4 Cultural area and Entertainment centre
5 Platform, bus station and parking area
6 Residential section
7 President's residence
8 Sports centre
9 Military barracks
10 Airport
11 Railroad station
12 University City

55 Plan, Brasília. Adapted from Willy Stäubli, *Brasília* (London: Leonard Hill, 1966)

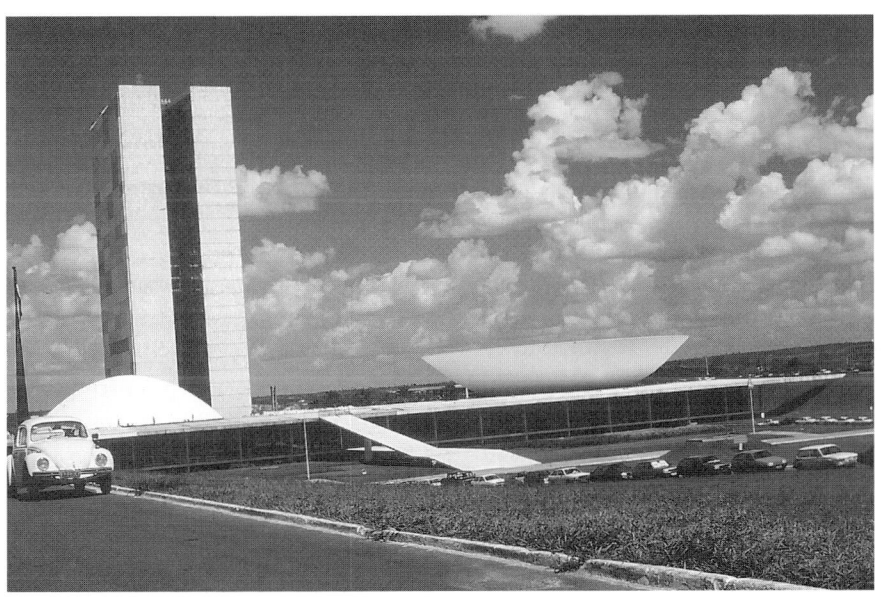

56 View of monumental centre, Brasília

district that was to comprise 'Educational and Civic Centres, Universities, Museums of Art and Industry, Public Services, County Hall' as well as extensive sports grounds.[33] But *The City of Tomorrow* also sows the seeds for the later simplification. Dividing the day neatly into eight hours' sleep, eight hours' work and eight hours' recreation Le Corbusier interprets the last as sport and accordingly requires that the city planner ensure that sporting facilities are available within walking distance of everyone's home.[34] Apart from sport, the only other recreational activity he seems to acknowledge, apart from growing vegetables, is that of relaxing on the patio or 'hanging garden' in the fresh air, enjoying the view (presumably of others playing tennis), and listening to music on the gramophone; the other civic, communal and educational activities are not mentioned again.[35] José Luis Sert, whose *Can our Cities Survive?* of 1942 is a sort of exegesis of CIAM beliefs and of the 1933 Athens Charter in particular, at some points seems to extend the four functions to allow for rather more than work, rest, travel and play.

> Strategic sites in the city should be occupied by civic centers with facilities designed to stimulate the noblest propensities of the spirit – places for advanced research, for meditation, for the contemplation of works of art, for the cultivation of the mind.[36]

This implies, as in Le Corbusier, that museums might be included in such civic centres but Sert too leaves the idea unexplored. The following sentence suggests, somewhat obscurely, that the lay-out of the city also had a part to play: 'Throughout the whole city, the most diverse elements composing the urban whole should conform to the scale imposed by man, providing scope for his highest aspirations.'[37]

The idea that the urban environment itself could 'stimulate the noblest propensities of the spirit' is of course central to Le Corbusier's thinking. In the Plan Voisin for Paris included in *The City of Tomorrow* he describes how the improvements will look once the disorderly old city centre is cleared away: 'imagine all this junk, which till now has lain spread over the soil like a dry crust, cleaned off and carted away and replaced by immense clear crystals of glass'.[38] He envisages 'the majestic rhythm of vertical surfaces receding into the distance in a noble perspective and outlining pure forms. From one skyscraper to another the relationship of voids to solids is established.'[39] In fact his vision of the new Paris also has museum-like features, where the past is, as he terms it, 'rescued'.[40] The slums and 'junk' will be cleared away but the old churches will be preserved as isolated monuments, 'surrounded by verdure: what could be more charming! ... Similarly the "Voisin" plan shows, still standing among the masses of foliage of the new parks, certain historical monuments, arcades, doorways, carefully preserved because they are pages out of history or works of art.'[41] In this way the Voisin scheme 'safeguards the relics of the past and enshrines them harmoniously in a framework of trees and woods. For material things too must die, and these green parks with their relics are in some sort cemeteries, carefully tended, in which people may breathe, dream and learn.'[42] The architecture of past and present alike is conceived as forms in space, like a sculpture

park where the individual can wander at will and appreciate the architecture as an observer, either as historically evocative or as pure form. It is an extraordinary vision of a city.

Holston has argued that Brasília was designed as a modernist city in that it was to be a complete break both with the past, and also with the present in its urban manifestations elsewhere in Brazil. He also argues that it was a modernist city in that, at least as far as the organisation of housing was concerned, it was intended to function as a 'social condenser' where the effect of the rich and poor living together would be, it was believed, to reduce the differences between them.[43] In his Report Costa's view was that the grouping of the housing blocks 'will, while favouring coexistence of social groups, avoid any undue and undesirable stratification of society'.[44] Brasília is also perhaps a modernist city in that it was an attempt to reject the cultural and social hierarchies implied by museums. This would make the fact that it is without a museum into a virtue rather than an absence, as an application of the anti-museum ideology of so many modernists. After all, the Futurists had proclaimed as early as 1909 that they would 'destroy the museums, libraries, academies of every kind'.[45]

Le Corbusier is again an important figure here. Costa and Niemeyer would have been very familiar with Le Corbusier's disdain for all things academic and stuffy from his writings, from his lectures in Rio and São Paulo in 1929, and from working with him on the Ministry of Education building in Rio in 1937.[46] The influence of Le Corbusier's iconoclastic attitudes can be seen in Costa's own essay of 1936 justifying the new (Le Corbusian) architecture, where he condemns 'the artificialities of fake academic grandeur', preferring the truthfulness of the plain forms that result from the application of modern construction techniques.[47] Le Corbusier's attitudes are notoriously flexible and although as we have seen in 1924 he had suggested that architectural 'relics' could be preserved amongst the crystal towers of his modern plan for the centre of Paris, the following year, in *The Decorative Art of Today*, he argued that 'nothing from the past is directly of use to us' and attacked museums because they 'are not a fundamental component of human life like bread, drink, religion, orthography'.[48] He condemned them for presenting a very partial and elitist view of history, preserving only what has been considered, arbitrarily, to be rare and precious.[49] Museums were a manifestation of a lack of confidence and direction from which earlier cultures had not suffered.

Interestingly, too, the development of museums is related to the fragmentation of the arts. Costa saw as the high points of cultural history those rare moments when 'architecture, sculpture and painting formed one cohesive body, a living organism, impossible to disaggregate'.[50] Only once paintings have moved from the walls on to canvases can they be collected and privatised. The modernist city could provide an opportunity to return to a fully integrated, more democratic form of artistic expression. In Latin America, as in post-Revolutionary Russia, this strand of thinking led to the promotion of public forms of artistic expression, of which the most famous example was the Mexican muralist movement where art

was introduced first on to internal walls in public buildings and then on to the
street façades.

The desire for a more democratic, accessible type of art springs from the same
roots as the desire for a more democratic and inclusive education system which lay
behind the University City projects in Latin America; and of course these, the
most ambitious *ex nihilo* urban developments in Latin America apart from
Brasília, provided an ideal venue for public art integrated into the urban environ-
ment. In the University City of Mexico on which work began in 1950 the plan-
ners' intentions were clear: the urban environment should include art as a part of
the overall educational experience. The results are not entirely successful – the
architecture and murals sometimes engage in rather uncomfortably aggressive
debate – but it was an enormously influential manifestation of the principle of art
as an integral part of urban space, art on the street, as a part of daily experience.[51]
In Venezuela where in 1944 plans were drawn up for the University City of
Caracas, the impetus was similar. The dictator Marcos Pérez Jiménez is not gen-
erally remembered for his enlightened policies but he supported architect Carlos
Raúl Villanueva's ambitious plans to build a University City that would also be an
educationally enriching environment. Villanueva once said that just as lions
belong in the jungle and not in zoos, so art belongs on the street and not in
museums, and he put the principle into practice in his architectural designs for
the university.[52] He commissioned works from a range of Venezuelan and other
artists, including Léger, Vasarely, Arp, Pevsner and Calder, and designed the
buildings to act as a setting for murals, mosaics and sculpture in a way that gen-
uinely succeeds in blurring the boundaries between architecture and art, and in
integrating art into the urban context.

Brasília was in many ways a development of ideas explored in these University
Cities. It was designed as a complete, life-enhancing environment. Like the
University Cities only on a larger scale, it was intended to encourage the growth of
a new type of society that would in turn encourage the social, technological and
economic development of the country as a whole; somewhat paradoxically, the
modernist city would lead to the modernisation of the nation. Le Corbusier's idea
that 'architecture and city planning can be great educators' was widely believed.[53]
Plans for Brasília did not, however, include plans for integrating the arts of painting
and sculpture. This issue was debated during an Extraordinary Congress of Art
Critics who visited the city in September of 1959 and William Holford, a key
member of the jury that decided on Costa's plan in 1956, was among their number.
His views on the matter, published the following year in Niemeyer's influential Le
Corbusian journal *Módulo*, make it clear that he opposed any 'artificial synthesis of
the arts'. He pointed out that Le Corbusier had argued, in relation to the chapel at
Ronchamp, that 'architecture is itself a synthesis of the arts'. His views are worth
quoting at length because they almost certainly represent those of Niemeyer and
Costa, who would have found it hard to argue against the possibility of lucrative
commissions for fellow-Brazilians:

Where an architect has already produced a unity of plan and function, such as Brasília, it would be folly to open a Pandora's box of discordant symbols, to break that unity. One must surely wait for individual works of art to grow with the populated city, and out of it. They cannot be satisfactorily displayed, like advertisements, in advance. The city is for men, and among them will be artists. At this stage one cannot commission large numbers of works of art; one can only create the conditions in which art can flourish.[54]

Costa and Niemeyer talk about Brasília in the same way that Le Corbusier talks about the Plan Voisin, rather as a sculpture park, where the plan and the architecture are not so much experienced, as observed and appreciated for their formal qualities from a position of detachment. Of his architecture for Brasília Niemeyer said that his

> special concern was to find – without functional limitations – a beautiful clear-cut structure that would define the characteristics of the main buildings … within the indispensable criterion of simplicity and nobility … Plastic beauty alone is the guiding, dominating spirit, with its permanent message of grace and poetry.[55]

When describing his congress building the emphasis is very much on abstract visual qualities: 'architecture was made to function in urbanization, in building volumes, in open spaces, in visual depth, in perspective and, particularly, in the attempt to give it an outspoken monumental aspect by simplifying its elements and adopting pure geometric features.'[56] Costa, in his Report, seems to stand even further removed from the physical reality of the built environment in repeatedly stressing the importance of the visibility of the twin axes. He gives various reasons for setting the cathedral back from the monumental axis or mall, but the most important 'is of an architectural nature: the Mall's perspective must be undisturbed up to a point beyond the central platform, where the two radial arteries cross each other.'[57] And in a particularly telling passage that concludes his description of the entertainment centre and the bus station, centrally located above the intersection of the two axes, he writes:

> One-way traffic forces the buses to make a detour on leaving the road under the platform; this gives the travellers their last view of the monumental radial artery before the bus enters the residential artery, and is a psychologically satisfactory way of saying farewell to the national Capital.[58]

Costa evidently envisages the capital as somewhere to be admired from afar; its plan, the primordial sign of the cross on the empty landscape, is ornamented with pure abstract forms, beautiful in their noble simplicity, which can best be appreciated from a distance. When Simone de Beauvoir visited Brasília she recognised this empty park-like feel, remarking acerbically, '[w]hat possible interest could there be in wandering about?'[59]

The two most frequent criticisms of Brasília are that Niemeyer's architecture is no more than monumental sculpture, and that it is all on such a gigantic scale that

the visitor to the monumental centre is dwarfed by the vistas, the huge plazas, and the imposing buildings. If, however, taking these two together, Brasília is understood as an enormous sculpture park then perhaps it makes better sense: a complete environment, where architecture assumes both the visual qualities of abstract painting and the volumetric qualities of geometric sculpture to produce a modern version of the fully integrated artistic milieu Costa admired, a sort of monumental museum. In fact in an exhibition on Brasília in the Grand Palais in Paris in 1963 architectural elements from the most important buildings in Brasília were displayed 'like statuary' (see figure 57). The phrase is Niemeyer's own, and it was he, perhaps not surprisingly, who designed the exhibition.[60] This is a cerebral view of architecture, an architecture which, as Le Corbusier would have it, could 'magnify ideas'.[61] Brasília was built on an ambitious scale and was intended to magnify Brazil and the Brazilians' view of themselves. As we have seen, Costa and Niemeyer adhered to the doctrines of Le Corbusier and the CIAM in believing that architecture and city planning were the supreme expression and essential basis of all civilised society. The CIAM Charter of Athens had stressed the importance of both architecture and plan: 'architecture is responsible for the well-being and beauty of the city. It is architecture that sees to its creation and improvement, and it is architecture's task to choose and distribute the various elements whose felicitous proportions will constitute a harmonious and lasting work.'[62] Nevertheless 'the soul of the city will be brought to life by the lucidity of the plan.'[63]

In any consideration of Brasília the plan is of paramount importance. While Costa, Niemeyer and Kubitschek sought to distance Brasília from the past and from the rest of Brazil, they simultaneously sought to implant it into the soul of Brazil and to nurture for it a mytho-history that was both suitably autonomous and specific to the site and also sufficiently general to capture the imagination of the nation. This process began with Kubitschek's apparently unpremeditated decision to build the city and was reinforced by Costa's apparently spontaneous idea for the

57 Sketch by Oscar Niemeyer for the installation of the Brasília exhibition in the Grand Palais, Paris, 1963, showing the columns of the Alvorada and Planalto palaces and of the cathedral

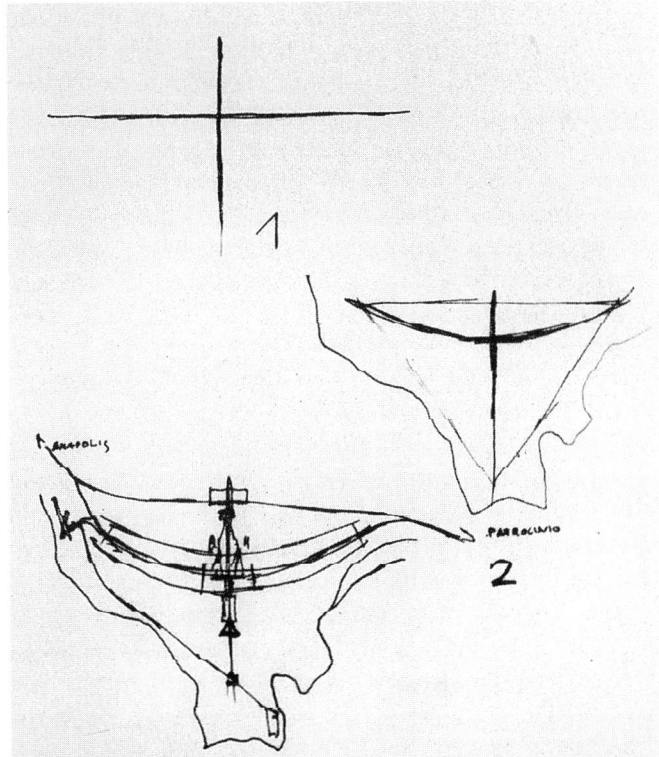

58 Lúcio Costa's first
sketches, *Plano Piloto*,
Brasília, 1956

plan. At the beginning of his report he apologises for the cursory nature of his com-
petition entry, explaining 'I am merely liberating my mind from a possible solution
which sprang to it as a complete picture, but one which I had not sought.'[64] The
plan was to be the making of Brasília as the locus of myth. 'It was born of that initial
gesture which anyone would make when pointing to a given place, or taking posses-
sion of it: the drawing of two axes crossing each other at right angles, in the sign of
the Cross' (see figure 58).[65] Brasília is thus an act of creation and possession; it also
marks the heart of Brazil, the crossroads at which the country will come together,
from where the new Brazil will grow. Costa then modified his rectilinear cross by
making the transverse arm curved, both to adapt it to the local topography and also
'to make the sign fit into the equilateral triangle which outlines the area to be
urbanized' combining different elements in a mythicised idea of unity.[66]

Costa's curved north–south axis animates the design in a remarkable way,
opening it up to the most diverse readings. The plan has proved to be – at a symbolic
level at least – phenomenally successful. Some capital cities are rendered distinctive
by their ancient origins, while others – Buenos Aires or Paris – for their well-estab-
lished reputations as centres of culture and sophistication. Closer to home Rio de
Janeiro, the capital Brasília was to replace, is associated with the hedonism of carnival

and with its singularly dramatic landscape features. Brasília could of course lay no claim to history or to culture, high or popular, nor were the empty *cerrado* scrub lands of the high plateau of the Federal district, or even the vast, beautiful skies sufficient to give a topographical identity to the city. Costa's plan, however, does. It is most commonly described as an aeroplane, the Plaza of the Three Powers the cockpit, the ministries the passenger seats and the curved north–south residential districts, of course, the wings. As a city dominated by its system of highways for cars and shaped like an aeroplane it neatly combines two key images of modernity, and points to the improved communications between the various regions of Brazil and with the rest of the world that Brasília was designed to promote.

But Costa's plan has also been described as a bird, a more poetic metaphor for the city, suggesting, beauty, grace and liberty. And as a butterfly. In Costa's preliminary sketch of the cross with curved arms enclosed within a triangle it is also, more subversively but unmistakably, a bow and arrow. Even the way in which Costa has traced over the lines again, thickening and coarsening them, suggests a primitive petroglyphic character, as if to remind the ultra-modern city that there is an alternative and much more ancient history of Brazil which can never be completely eradicated. This same multivalent cross-within-triangle sketch also evokes both the crucifix and Leonardo's Vitruvian man, an anthropomorphic form with its extremities touching the corners of the geometrical shape. Originally Brasília's image was that of a very masculine place, built and inhabited by gutsy frontiersmen, but more recently this has given way to a gentler, more domestic idea, reflecting the way Brasília has been accepted and incorporated into Brazil's sense of itself. As a mark of this domestication of Brasília it is perhaps not surprising, therefore, to find that the plan has now been subjected to yet another reading: that of a perfectly formed woman, reclining with arms outstretched, and, in guide-book language, 'sensually bathed in the brilliance of a tropical sun'.[67] Savage, modern, natural, mechanical, male, female: the imagery of Brasília's plan is all inclusive. It is interesting too that several of the key buildings in the monumental heart of Brasília have generated iconographic interpretations based on simple formal assonance. The famous linked towers of the National Congress offices are seen as representing an H for Humanity, the military headquarters are M-shaped, while the cathedral is variously described as an inverted chalice, or as praying hands, or as a crown. In this way Brasília has developed its own myths and meanings, which are perhaps a substitute for the more orthodox history and heterogeneous mix of buildings, including museums, that provide older cities with a sense of identity.

Kubitschek, Costa and Niemeyer intended Brasília as a rejection of Brazil's condition of underdevelopment, as a rejection of the social and cultural hierarchies of the past. Brasília represented the new Brazil of the future. If, in line with modernist theories, the art of the past has nothing to offer to the future, a museum of such art would undermine the theory on which Brasília was built. A museum of modern art would not be appropriate either, on two counts: first, to put modern art into a museum inevitably implies changing it from an art of the present to an art of the

past. Second, since modernism also implies the democratisation of culture then to establish a museum of modern art in a modernist city would be a contradiction in terms. The alternative, to bring art – in the sense of painting and sculpture – out on to the streets, was not addressed in the planning of Brasília: of the few pieces of sculpture designed for the monumental centre only one or two are now of more than historical interest, and for a national symbol such as Brasília it would have been inappropriate to have imported foreign works as Villanueva had done in the University City in Caracas. This was obviously very important to Kubitschek, who could proudly boast that

> the architectural features of Brasília … reflect the high degree of civilization in my country, just as Greek and Latin architecture and sculpture reflected the magnitude of Greek and Roman civilizations. We imported neither architects nor town-planning experts to design Brasília. We planned and built it with our own native talents – Niemeyer and Lúcio Costa – and the laborers who erected it, from the contractor down to the 'candango' (unskilled workers from the drought-ridden northeast of Brazil), were all our own people. This is why Brasília depicts, more eloquently than words can convey, our level of civilization and our enterprising spirit.[68]

This I suggest is why Brasília was designed without a museum. Rome and Athens were seen as works of art in their own right, places which were understood, rightly or wrongly, to have had no need for museums. So too Brasília represented the nation's culture: in line with Le Corbusier's ideas, the architecture was pure and self-sufficient, the city itself encoded all the meaning it needed.

Forty years on and Brasília still has no significant national museums. As if to under-line its self-sufficiency and cultural autonomy the two small museums on the mon-umental axis are the Museum of the City of Brasília and the Kubitschek Memorial Museum, both of which celebrate the (virgin) birth of the city. The former was part of Costa's plan; it is located beneath the Plaza of the Three Powers – the cockpit of the plane, the head of the bird – and has as its focal point a large model of the city, with plans and photographs of its construction. This is now complemented further down the monumental axis by the Kubitschek Memorial Museum, which includes a mortuary chapel with Kubitschek's tomb, and a museum with medals, memora-bilia and photographs of Kubitschek overseeing the construction of Brasília. On the street outside the museum stands Kubitschek's own Ford Galaxy, enshrined in a perspex box (see figure 59). These museums pay very little attention to the subse-quent history of the city. Brasília was intended as an inspiring modernist environ-ment, where the perfection of its plan and its architecture would render museums unnecessary. In practice, as Holston has argued, the citizens have subverted the original intentions by adapting the housing blocks to suit their own ideas of social and domestic life, while the monumental centre has, in effect, become a museum of modern architecture and of modernity, all laid out to acres of grass as in a sculpture park. As Le Corbusier said, 'material things too must die, and these green parks

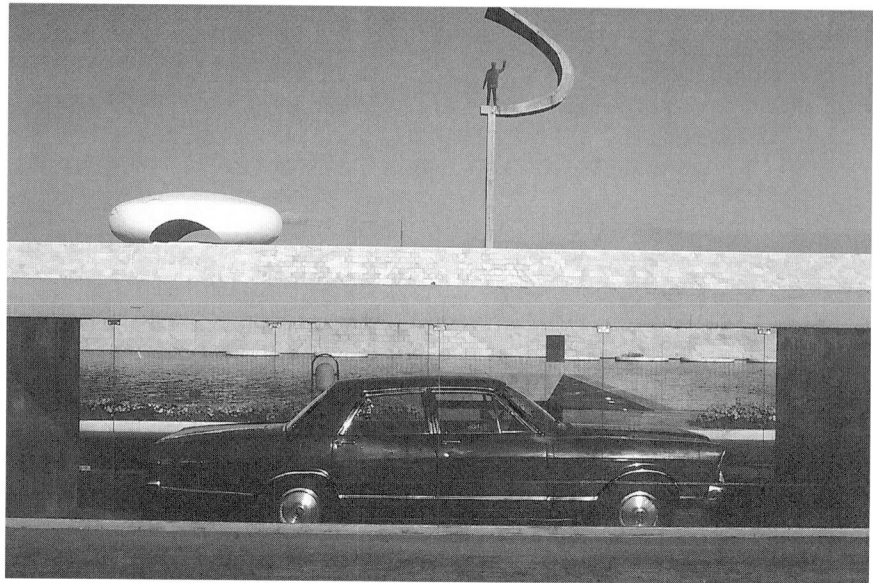

59 Juscelino Kubitschek's Ford Galaxy, preserved at the entrance to the Kubitschek Memorial Museum, Brásilia

with their relics are in some sort cemeteries, carefully tended, in which people may breathe, dream and learn.'[69]

Notes

A version of this essay was delivered at the conference *Images of Power: National Iconographies, Culture and the State in Latin America*, Institute of Latin American Studies, London May 2001. My research has been supported by the British Academy, the Leverhulme Trust, and the University of Essex Research Endowment Fund and I acknowledge their help with gratitude.

 1 M. Santiago, 'Museum in Caracas', *Architectural Review*, 119 (1956), p. 273.
 2 Costa's Report is printed in full by William Holford, the English representative on the jury, in 'Brasilia: a new capital for Brazil', *Architectural Review*, 122 (1957), pp. 394–402; pp. 399–402.
 3 Norma Evenson, 'Brasilia: "Yesterday's City of Tomorrow"', in H. W. Eldridge (ed.), *World Capitals* (New York: Anchor Press/ Doubleday, 1975), pp. 470–506; pp. 472–3.
 4 *Ibid.*, pp. 474–5.
 5 Simon Collier, Harold Blakemore, Thomas Skidmore (eds), *The Cambridge Encyclopedia of Latin America and the Caribbean* (Cambridge: Cambridge University Press, 1985), p. 272. I discuss the building of Brasília in more detail in *Building the New World: Modern Architecture in Latin America 1930–1970* (London and New York: Verso, 2000), ch. 3.

6 Le Corbusier, *When the Cathedrals were White* (New York: Reynal and Hitchcock, 1947), p. 21.

7 Miguel Laborde, *Santiago: lugares con historia* (Santiago: Contrapunto, 1990), p. 25.

8 Grete Mostny, *Los museos de Chile* (Santiago: Editorial Nacional Gabriela Mistral, 1975), p. 16.

9 Rogger Ravines, *Los museos del Perú* (Lima: Instituto Nacional de Cultura, 1989), p. 23.

10 Flor Palma Flores, *Museos de la ciudad de México, guía ilustrada / Museums of Mexico City, Illustrated Guide* (Mexico DF: Editorial Trillas, 1996), p. 7.

11 Mostny, *Los museos de Chile*, p. 51.

12 Laborde, *Santiago*, p. 110.

13 Palma Flores, *Museos de la ciudad de México*, p. 43.

14 The museum was founded in 1895. Alberto Petrina (ed.), *Buenos Aires: Guía de Arquitectura* (Seville: Agencia Española de Cooperación Internacional / Junta de Andalusía and Buenos Aires: Municipalidad de la Ciudad de Buenos Aires, 1994), p. 186.

15 Iris Peruga, *Museo Nacional de Bellas Artes de Caracas cincuentenario: una historia* (Caracas: Museo Nacional de Arte, 1988), p. 16.

16 Stanton Loomis Catlin, 'Traveller-reporter artists and the empirical tradition in post-independence Latin American art', in Dawn Ades, *Art in Latin America: The Modern Era 1820–1980* (London: South Bank Centre and New Haven: Yale University Press, 1989), pp. 41–61; p. 48.

17 *Rio de Janeiro* (Rio de Janeiro: Michelin, 1990), p. 179.

18 *Ibid.*, pp. 203–4.

19 Klaus Franck, *The Works of Affonso Eduardo Reidy* (London: Tiranti, 1960), p. 66; Yves Bruand, *Arquitetura Contemporânea no Brasil* (São Paulo: Editorial Perspectiva, 1981), pp. 237–40.

20 *Rio de Janeiro*, p. 217.

21 Pietro Maria Bardi *et al.*, *Museum of Art: São Paulo* (New York: Newsweek and Mondadori, 1981), p. 9.

22 Leonor Amarante, *As Bienais de São Paulo 1951–1987* (São Paulo: Projeto, 1989), p. 12.

23 Bardi *et al.*, *Museum of Art: São Paulo*, p. 12.

24 Paula Cabo, *Resignifying Modernity: Clark, Oiticica and Categories of the Modern in Brazil* (PhD thesis, University of Essex, 1996), p. 87.

25 Lina Bo Bardi and Aldo Van Eyck, *Museu de Arte de São Paulo / São Paulo Art Museum* (São Paulo: Editorial Blau, 1997).

26 Guy Brett, 'A radical leap', in Ades, *Art in Latin America*, pp. 253–83; pp. 254–5.

27 Gilbert Chase, *Contemporary Art in Latin America* (New York: Free Press, 1970), p. 235.

28 James Holston, *The Modernist City: An Anthropological Critique of Brasília* (Chicago: Chicago University Press, 1989), p. 65.

29 *Ibid.*, p. 25.

30 *Ibid.*, pp. 31–58.

31 'CIAM: Charter Of Athens: tenets', in Ulrich Conrads (ed.), *Programmes and Manifestoes on Twentieth-Century Architecture* (London: Lund Humphries, 1970), pp. 137–45; p. 139. See also José Luis Sert, *Can our Cities Survive? An ABC of Urban Problems, their Analysis, their Solutions* (Cambridge, Mass.: Harvard University Press, 1944).

32 Kenneth Frampton, *Modern Architecture: A Critical History* (London: Thames and Hudson, 1992), p. 180.

33 Le Corbusier, *The City of Tomorrow and its Planning*, trans. Frederick Etchells (New York: Dover Publications, 1987), p. 174.

34 *Ibid.*, p. 199.

35 *Ibid.*, p. 205.

36 Sert, *Can our Cities Survive?*, p. 229.

37 *Ibid.*, p. 229.

38 Le Corbusier, *The City of Tomorrow*, p. 281.

39 *Ibid.*, p. 282.

40 *Ibid.*, p. 287.

41 *Ibid.*, p. 287.

42 *Ibid.*, p. 287.

43 Holston, *The Modernist City*, p. 38.

44 Holford, 'Brasilia: a new capital for Brazil', p. 401.

45 Filippo Tommaso Marinetti, 'Manifesto of Futurism', in Charles Harrison and Paul Wood (eds), *Art in Theory 1900–1990: An Anthology of Changing Ideas* (Oxford: Blackwell Publishers, 1992), pp. 147–9; p. 147.

46 These were published in 1930; Le Corbusier, *Precisions on the Present State of Architecture and City Planning: With an American Prologue, a Brazilian Corollary Followed by the Temperature of Paris and the Atmosphere of Moscow*, trans. Edith Schreiber Aujame (Cambridge, Mass. and London: The MIT Press, 1991).

47 Lúcio Costa, 'Razões da nova arquitetura' [1936] in Alberto Xavier (ed.), *Arquitetura Moderna Brasileira: Depoimento de uma Geração* (São Paulo: Associação Brasileira de Ensino de Arquitetura, 1987), p. 37.

48 Le Corbusier, *The Decorative Art of Today*, trans. James I. Dunnett (London: The Architectural Press, 1987), p. 16.

49 *Ibid.*, p. 18.

50 Costa, 'Razões da nova arquitetura' p. 29; Le Corbusier pursues a similar line in 1937 in *When the Cathedrals were White*.

51 Jorge Alberto Manrique, 'El Futuro Radiante: La Ciudad Universitaria', in Fernando González Gortázar (ed.), *La Arquitectura Mexicana Del Siglo XX* (Mexico DF: Consejo Nacional para la Cultura y las Artes, 1994), pp. 125–47.

52 *Obras de arte de la Ciudad Universitaria de Caracas* (Caracas: Universidad Central de Venezuela, 1991), p. 82.

53 Le Corbusier, *When the Cathedrals were White*, p. 37.

54 William Holford, 'Problems and perspectives of Brasilia', *Módulo*, 17 (April 1960), unpaginated English translation of the main Portuguese text. The title of this journal, founded by Niemeyer, makes his debt to Le Corbusier's *Le Modulor* quite clear.

55 Evenson, 'Brasilia: "Yesterday's City of Tomorrow"', p. 498.

56 Willy Stäubli, *Brasília* (London: Leonard Hill, 1966), p. 23.

57 Holford, 'Brasilia: a new capital for Brazil', p. 400.

58 *Ibid.*, p. 400.

59 Quoted in 'Planned cities, capital punishments', *The Economist*, 20 December 1997, pp. 81–3; p. 83.

60 Oscar Niemeyer, 'Exposição de Brasília em Paris', *Módulo*, 33 (June 1963), pp. 8–11; p. 8.

61 Le Corbusier, *Precisions*, p. 218.
62 'CIAM: Charter of Athens: tenets', in Conrads (ed.), *Programmes and Manifestoes*, p. 144.
63 *Ibid.*, p. 142.
64 Holford, 'Brasilia: a new capital for Brazil', p. 399.
65 *Ibid.*, p. 399.
66 *Ibid.*, p. 399.
67 José Osório Naves (ed.) *Brasília Tourist Guide* (Brasília: Nova Imagem, 1995), p. 4.
68 Juscelino Kubitschek, foreword to Stäubli, *Brasília*, p. 7.
69 Le Corbusier, *The City of Tomorrow*, p. 287.

10

'Where oppositions disintegrate and grow complicated': the Maeght Foundation[1]

Jan Birksted

It was André Malraux who, in 1963, inaugurated the illumination of the Acropolis.[2] In 1964, only one year later, André Malraux referred to the Acropolis in an opening address at another inauguration: 'It was by a night such as this that they listened to the silence that followed the sound of the last chisels carving the Parthenon'.[3] The occasion for this reference was the opening of the Maeght Foundation at Saint-Paul de Vence, commissioned in the late 1950s by Marguerite and Aimé Maeght of the Maeght Gallery in Paris, by Josép Lluis Sert who had previously designed the Pavilion of Republican Spain at the 1937 Paris Universal Exposition for which Miró painted *Peasant in Revolt* and Picasso *Guernica*. The Maeght Foundation was designed and built between 1958 and 1964.[4]

In line with Malraux's invocation of the Acropolis as a basic cultural '*lieu de mémoire*', the Maeght Foundation is clearly a place that memorialises the Acropolis.[5] It too lies elevated on a hilltop overlooking the distant sparkling Mediterranean, is dedicated to a divinity, and inextricably unites architecture with sculpture. The site of the Acropolis was of course also a high point in the Congrès Internationaux d'Architecture Moderne (CIAM) IV trip to Greece in 1933, which forged indissoluble future friendships and collaborations between Le Corbusier, Giedion, Sert, Léger, and many others.[6] Sert was eventually to become President of CIAM, and to embody in his work the notion of a 'Mediterranean architecture'.[7] And in describing the Maeght Foundation, Sert himself drew the implicit parallel not just with the geographical site of the Acropolis visited during CIAM IV – which he described as 'a foundation in St. Paul de Vence on land between snow-peaked Alps and the Mediterranean'[8] – but also with its character as a place of union of all the arts:

> I was concerned from the time I started architecture studies with the relationship between the arts – the places in a modern city where they could come together. In the noisy chaos of our cities, it has become increasingly difficult to indulge in contemplation.[9]

So, for Sert, the design of the Maeght Foundation was the perfect occasion for trying to 'imagine how the arts and architecture could come together' in places other than the big museums and for developing his ideas about Mediterranean architecture.[10] Indeed, André Malraux himself, in his inaugural speech, insisted that the Maeght Foundation 'is in no way a museum', and he continued that 'here something is being attempted that never was before: to create a universe in which modern art can find a true home.'[11] Finally, for Sert, the Acropolis was also a model for an authentic modern monumentality to which he aspired:

> Monuments are human landmarks which ... form a link between the past and the future ... a monument being the integration of the work of the planner, architect, painter, sculptor, and landscapist, demands close collaboration between all of them.[12]

And, in line with this, the Maeght Foundation was indeed the outcome of a co-operative, or at least interactive, process between Sert, Aimé Maeght and several of the artists who exhibited with the Maeght Gallery in Paris, such as Braque, Chagall, Giacometti, Léger, Miró, Bury, Tal-Coat, Ubac and others. After the death of their son Bernard, Aimé and Marguerite Maeght were encouraged by Léger and Braque to undertake something that would bring them a new lease of life. Following a long period of reflection and a visit to Miró's recently completed studio, designed by Sert near Palma de Majorca, they asked Sert to consider designing for them an art foundation: a centre where artists and writers could live and work. This was to include exhibition spaces, workshops and studios, a house for a director, as well as residences for Braque and Chagall, and an open-air performance area based on designs by Kandinsky. A long and at times tortuous period of design was to follow, punctuated by financial crises, serious illnesses, and the deaths of Braque and of Léger. Artists contributed specific works to the Foundation: Braque created a stained-glass window and Ubac a series of engraved slate-reliefs for the chapel, Braque and Chagall designed mosaics, while Tal-Coat conceived a mosaic for the wall surrounding the entrance pine-grove, and Miró created a mural and wall-reliefs. Giacometti was involved in the plans for exhibiting his sculptures in an outside courtyard. He was also consulted in the plans for a room specifically designed to show his work; so was Braque. Calder produced a work for the entrance courtyard. But perhaps the single artist who contributed most was Miró, since he created a garden: Miró's Labyrinth. After the inauguration of the Maeght Foundation in July 1964, Miró continued to work on the Labyrinth, to which were added several sculptures. In subsequent years, Pol Bury added a water sculpture in the entrance grove, and Diego Giacometti designed door-handles and lights, as well as furniture and fittings for the restaurant.

The overall plan was to provide optimal exhibition spaces specifically suited to the works destined to be displayed in them. To achieve this, the artists were consulted during the design process. The buildings at the Maeght Foundation consist of two groups linked by a central hall: on one side lies a quadrangle, the so-called

60 The Cloister, the Maeght Foundation, St-Paul de Vence, 1958–64; architect: Josép Lluis Sert

Cloister (see figure 60), around an inner courtyard, and on the other side is a large double-height exhibition hall, the so-called Town Hall (see figure 61). In the Braque rooms at the Maeght Foundation, for example, there is a strong emphasis on spatial organisation and lighting conditions. Braque's two rooms are small; one of them is the smallest exhibition space in the whole Maeght Foundation. Their smallness is emphasised by the two adjoining rooms, which are the very largest ones in the Cloister. The intimate scale of the Braque rooms reflects his notion that 'in the still-life you have tactile, I might almost say a manual space ... In tactile space you measure the distance separating you from the object, whereas in visual space you measure the distance separating things from each other.'[13] Braque specifically described how '[i]n a still-life space is tactile, even manual, while the space of a landscape is a visual space.'[14] And these two small rooms also have windows opening directly on to the landscape. If we turn to the light conditions, we see how one of these rooms is flooded with reflections through a glass wall from the surface of the Braque pool outside (see figure 62). This light, typical of reflections from a rippling water surface, creates undulations on the ceiling. These light-effects are strongly reminiscent of Braque's idea of 'folded space' as developed in the *Studio* series of paintings which were exhibited in these rooms: paintings whose foreground and background spaces are so strongly layered that they seem to shift optically. In addition, one window faces east and therefore creates light movement in the morning. On the opposite side of this very small room, is a west-facing window, therefore also subject to fluid light conditions, here those of the late-afternoon and

evening light. We know how Braque was attentive to changing light conditions and movement and 'always preferred to work in shifting, filtered light. The studios built to his specifications faced south, as opposed to the northern exposures of traditional studios which yielded a harder, steadier light.'[15]

In Braque's second exhibition room, the edges are lit up while the centre is left in shadow to create a tripartite layering of light conditions: overhead daylight along the edges with darkness in between. These alternating light conditions are created by the roof construction since the central longitudinal barrel-vaults are solid and function as beams spanning the full length of the room, while the two lateral barrel vaults are light-captors. A further feature particular to the two Braque rooms is their relationship to each other. All other rooms in the Cloister are well-defined enclosures, and clearly articulated from each other through staircases or entrances. But the two Braque rooms are not: one room stands in an ambiguous relationship to the outside in two respects. The Braque pool outside seems to penetrate into the space of the room; a line of vision flows across this room through the two facing

61 The central corridor and the Town Hall, the Maeght Foundation, St-Paul de Vence

62 The Braque pool and rooms, the Maeght Foundation, St-Paul de Vence

windows. But, in addition, the single wall dividing these two rooms can be read differently, depending from which side it is seen: from the smaller space, it reads as a single partition dividing the larger and more enclosed space; but from the larger room, it reads as forming part of a pair of walls. And yet from another point of view the larger room itself reads as a transitory space, inserted between two views of the courtyard: the first view from the entrance corridor and the second view from the smaller room.

Thus the two Braque rooms – on the basis of the numerous shifting and complex relations between each other, between inside and outside spaces, in relation to other surrounding rooms, and in terms of variable light conditions – are reminiscent of Braque's concern that 'before introducing objects into his paintings he had to create a spatial complex in which they could exist'.[16] The relationship of the paintings as objects to the exhibition spaces mirrors the relationship of the objects in the paintings to the painted spaces. That these exhibition spaces were important to Braque is clear from his interviews with André Verdet, to whom he spoke about the Maeght Foundation.[17] And of course Josép Lluis Sert knew Braque well since, in addition to being friends, he had already designed a house for Braque, over which he spent a great deal of time, carefully rendering the drawings with colour-pencils, and detailing both internal spaces and landscape features in relation to each other.[18]

From these Braque exhibition rooms, based on the rejection of purely visual perspective, let us turn to the Giacometti room, the longest in the Cloister since it runs the full length of one side of the quadrangle. Here, length and distance and perspective are emphasised by the form of the room and its enclosing continuous walls. Two door-openings are both to one side, so interfering minimally with this unified enclosure. Length and perspective are also emphasised by the continuous rhythm of regular light and shade along the full length of the room, created by transversal light-capturing barrel-vaults. It is this same sense of enclosure and (one-point) perspective that we find in the Giacometti Terrace, also rectangular, long and enclosed on three sides. Again, the space of the Giacometti Terrace is perspectival, directed towards the Mediterranean panorama (see figure 63). The detail of the water-channel running towards the horizon emphasises this. On either side of the main entrance to the Giacometti Terrace, a wall creates a sense of enclosure: the blank brick wall of the Cloister faces the extremely large elevation of the Town Hall (see figure 64). The composition and materials of these boundaries emphasise mass: the blind brick wall on one side facing the large elevation of sun-shading claustra on the other. These two spaces therefore emphasise mass and volume, and they are reminiscent of those many drawings by Giacometti of enclosed spaces surrounded by walls, and the arrangement of the sculptures in them are reminiscent of the many sculptural groups that he worked on during his life. We also have evidence from other sources of his involvement in placing his sculptures in their environments: 'Giacometti studied the arrangement of the works carefully, noticing minor details, and from this resulted an infinity of views and a multiplicity of perspectives ... His

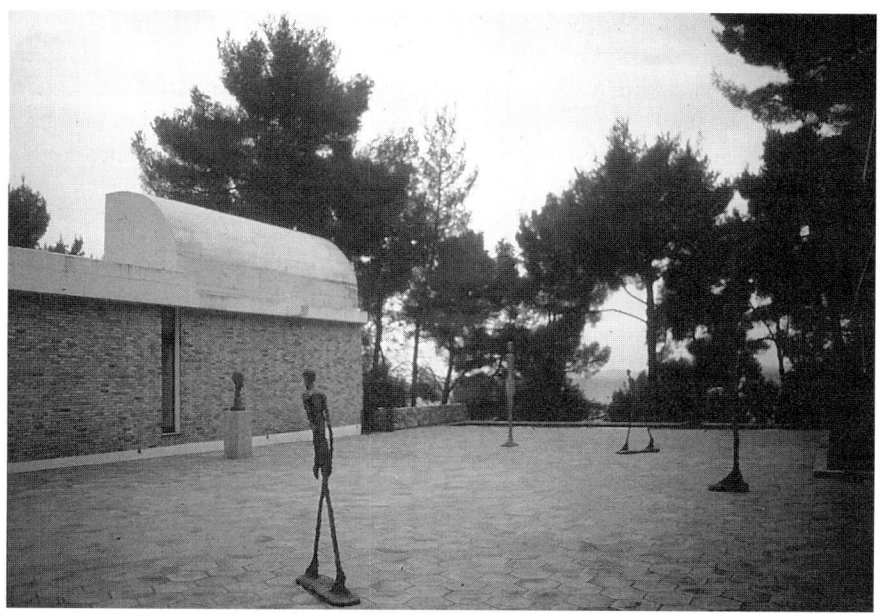

63 The Giacometti Terrace, the Maeght Foundation, St-Paul de Vence

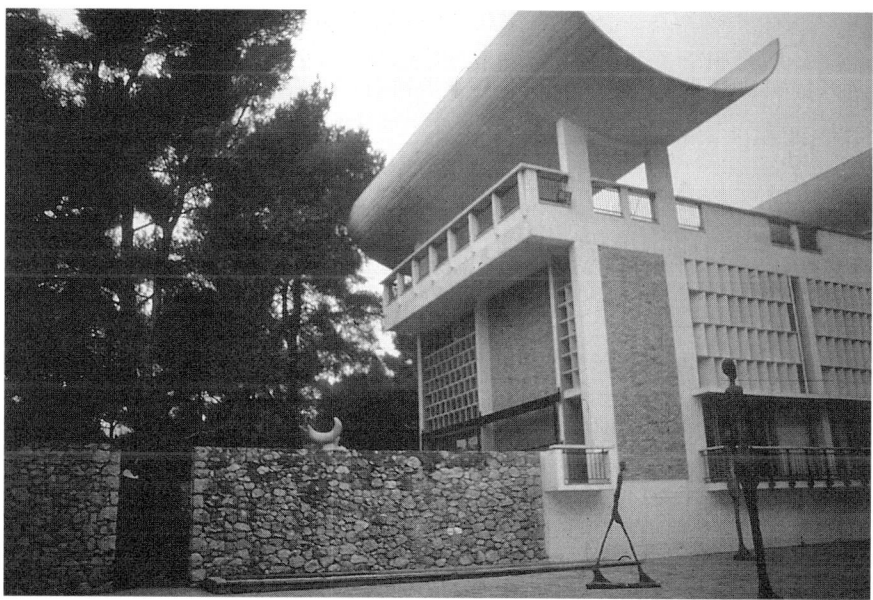

64 The Giacometti Terrace with entrance to the Miró Labyrinth, the Maeght Foundation, St-Paul de Vence

arrangements of his sculptures constituted in itself a sculpture'.[19] Indeed, at the
Maeght Foundation, something extraordinary happened at the time of the installa-
tion in preparation for the inauguration: when Giacometti had completed the instal-
lation, he was struck by the visual power of the Mediterranean panorama – the hills
and mountains, the villages and coastal towns, the ocean – which he felt over-
whelmed his sculptures, and he started to thicken them with clay and to paint them.[20]
Giacometti was thus acutely aware of the setting of his sculptural installations. Here
again, we know that Giacometti and Sert discussed plans for these exhibition spaces
which Giacometti referred to as 'la mia sala e la piazza' (my room and piazza).[21] What
then are the qualities of these exhibition spaces?

Giacometti has described the experiences that transformed his vision: 'On that
day – I still remember exactly how I walked out into the Boulevard Montparnasse –
I saw the boulevard as I had never seen it before ... Everything was different. The
depth of space metamorphosed the people, the trees'.[22] And, describing a similar
experience while he was watching people, Giacometti remarked they 'shot up into
existence ... They seemed immense to me, all out of proportion to normal size'.[23]
Central to Giacometti's sculptural concern with space and distance, size and per-
spective, mass and immateriality, is also the importance of movement, since weight
and balance are a function of such gravity
and movement. Giacometti described how,
for him, a man walking in the street weighs
less than a man lying down who has fainted,
because he is in equilibrium on his feet. It is
precisely these spatial qualities that are
found in 'la mia sala e la piazza', whose uni-
fied scale, sense of direction and enclosure
contrasts with, and highlights, the walking
sculptures with their differing scales and
sizes, their multi-directionality and their
sense of mobility.

65 The Miró Labyrinth, the Maeght
Foundation, St-Paul de Vence

Then, from the Giacometti Terrace, we
enter Miró's garden, the Labyrinth. Here,
strange beasts – the Solar Bird, the Lunar
Bird, the Lizard – intermingle with trees
and plants on different terraced levels (see
figure 65). In the Labyrinth, like in his
paintings, Miró develops his notion of fields
of space in which objects merge with the
background.[24] As one sits on one of the
stone benches in the Labyrinth, a sur-
prising feature common to all these gar-
goyles, beasts, and creatures appears:
immobility. It is this feature which is

central to Miró, who himself said: 'Immobility strikes me. This bottle, this glass, a big stone on a deserted beach – these are motionless things, but they set loose great movements in my mind ... Immobility makes me think of great spaces in which movements take place that do not stop at a given moment, movements that have no end.'[25]

So, just as the spaces and the light of the Cloister match Braque's work, and the Giacometti terrace matches its Giacometti sculptures, so the Miró Labyrinth embodies Miró's concept of space. The first visual aspect of the Maeght Foundation is therefore how it extends the multiple spatial visions of the art works on display. For Sert, this was the second time, after the 1937 Pavilion for Republican Spain, that he worked with artists on the design of a building. For Aimé Maeght, this was an attempt at 'integrating the arts into modern life, at collaboration between artists and an architect'.[26]

The second visual feature of the Maeght Foundation concerns the relationship of internal and external spaces which can be traced back to the design process. Sert describes this as follows:

> These spaces will exhibit work by Braque, Miró, Chagall, Giacometti, etc. They open on to courtyards and outdoor spaces that are designed for showing sculptures, mosaics, etc., by these same artists, thus creating a direct link between the covered and the open spaces.[27]

After initial designs, the sizes and location of the buildings were laid out and then moved around the site and studied. In this way, the many different levels of the site were noticed and made use of. Bastlund, who worked for Sert at the time, has described how

> [i]t was decided that the plan of the Maeght Foundation would rather resemble that of a small village, and that volumes would be many and differentiated. The outside spaces around the buildings would be well defined so as to be used as extra exhibition rooms or patios. Utmost use would be made of the sloping site. The garden extensions would be part of the museum itself. The artists represented in the Galerie Maeght would contribute pieces especially designed for the gardens, courts and interiors.[28]

The Maeght Foundation is thus systematically planned as a sequence of interior and exterior spaces, all of which play an equally active structuring role. The usual basic opposition between unified interior space and unified exterior space is replaced by a variety of spaces along an inside–outside continuum: some interior spaces are external in character; some exterior spaces are internal in character. The very notion of external space and of internal space becomes not a description of where they are but a description of their spatial quality. The surrounding gardens, courtyards, groves and terraces, and the different views towards the landscape, together with the exhibition rooms form a complex spectrum of spaces. These encompass internal interior spaces, external interior spaces, internal exterior spaces and external exterior spaces.[29]

66 The entrance pine grove with the Chapel, the Maeght Foundation, St-Paul de Vence

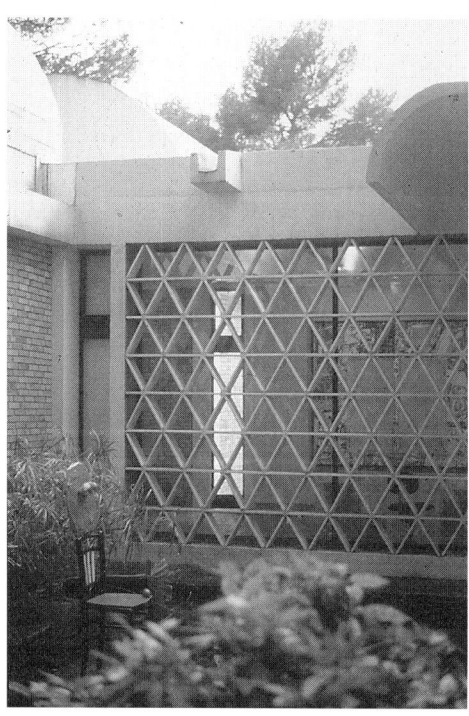

67 The central corridor, the Maeght
Foundation, St-Paul de Vence

Let me turn to the third visual feature of
the Maeght Foundation. The entrance from
the north opens into a pine grove – shaded,
green and cool – enclosed by a wall (see
figure 66). The Cloister follows closely the
different ground levels; different room
heights are due to different floor levels, fol-
lowing these site levels. To the right lies a
large three-floor building surmounted by
two parabolic rain-collectors. The Town
Hall consists essentially of one very large
double-height exhibition room.[30] An
entrance corridor links the Town Hall to the
Cloister, which also separates the entrance
pine grove to the north from the south-
facing paved Giacometti Terrace (see figure
67). In the corridor, the north-facing wall
consists of a double screen of white glazed
volcanic stone and of glass. The south-
facing wall is constructed of solid masonry.
And this corridor is clearly articulated both
from the Cloister and from the Town Hall
by vertical windows at the masonry-junc-
tions. Here we begin to see how the Maeght

Foundation is structured. Every space and element is clearly expressed in contrast to the others: the north and south corridor walls, the Cloister and the Town Hall, the northern pine grove and the southern Giacometti Terrace. These oppositions continue. The corridor terminates in the Cloister with a glass door giving on to a level courtyard, but at the Town Hall end it opens on to an internal vertical stair-case. The multiplication of such oppositions in plan and in section continues throughout at the Maeght Foundation. Synthesis is constituted by systematic oppositions: solid versus transparent, a sequence of rooms versus a megaron, stairs built into the ground versus open-tread cantilevered stairs rising to the roof, hori-zontality versus verticality, enclosure versus panorama, paved terrace versus planted courtyard, etc. Thus all three visual and spatial features of the Maeght Foundation – the varieties of spatial visions, the gradations of exterior to interior to external to internal spaces and the multiplicity of binary oppositions – emphasise complexity to the point of potential fragmentation. Simultaneously, the variety, complexity and multiplicity of the architectonic and circulatory oppositions gen-erate an active and therefore participatory architectural experience. And it was pre-cisely such a participatory experience that was sought at the Maeght Foundation.

Bastlund described how, during the design, the plan of the Maeght Foundation evolved as a small village with its paved piazzas and planted courtyards.[31] The first image operative at the Maeght Foundation is that of the village – varied, complex and multiple. Indeed, from the very beginning, Aimé and Marguerite Maeght dreamt of a meeting-place where artists, the public and art could interact, thus specifically not a traditional museum. And André Malraux, in his inaugural speech in July 1964, had stated that 'this is not a museum'. Layered unto this initial metaphor of the village are two subsidiary metaphors: the Town Hall – it is there-fore also a place of civic and democratic urbanity – and the Cloister – it is therefore also a place of peace and reflection. Marguerite and Aimé Maeght specifically wrote to Sert about the notions of cloister and of town hall as ones important to them. And the metaphors of village and the subsidiary metaphors of town hall and of cloister conjure up democratic urbanity, participatory collaboration, peaceful cre-ativity.[32] Through these metaphors, the Maeght Foundation proposes a vision of a new harmonious life integrating art, architecture and landscape, and a model for an alternative society based on collaboration. The Maeght Foundation – like the work of Braque, Giacometti and Miró – posits new forms of subjective experience.[33] Thus it proposes new forms of social life and a new concept of the subject.

But it is in the garden designed by Miró, the Labyrinth, that another metaphor is spun (see figure 68). The title of Miró's garden sets in motion an imaginary world of ancient Greek mythology.[34] According to this mythology, Ariadne revealed to Theseus the plan of the labyrinth, designed by the mythical first architect Daedalus, so that he was able to overcome the Minotaur and to slay it. Then, using a thread Ariadne had given him, which he had trailed behind him, he found his way back to the entrance of the labyrinth and returned to Ariadne. By the labyrinth entrance, Daedalus then built for them a dance-floor where they were re-united

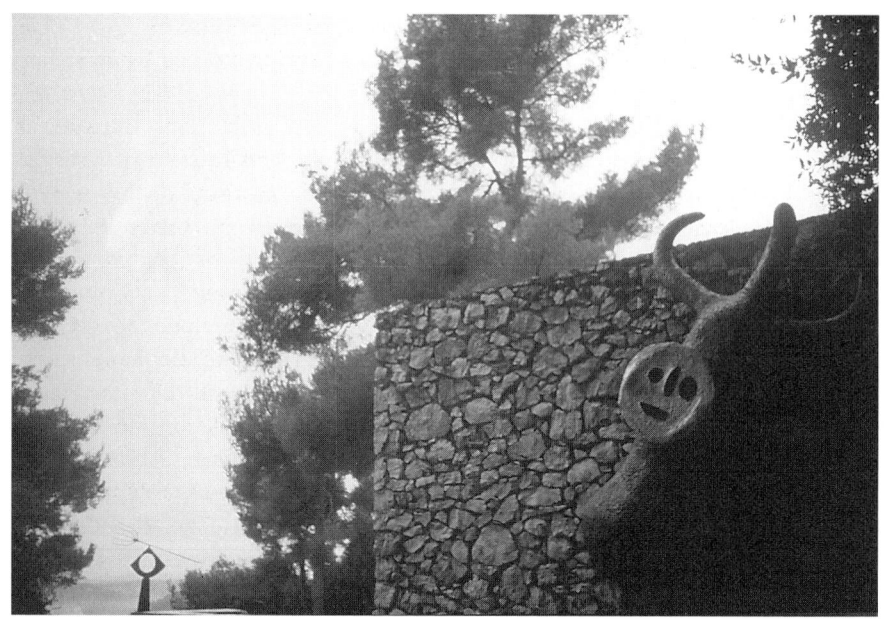

68 The Miró Labyrinth, the Maeght Foundation, St-Paul de Vence.

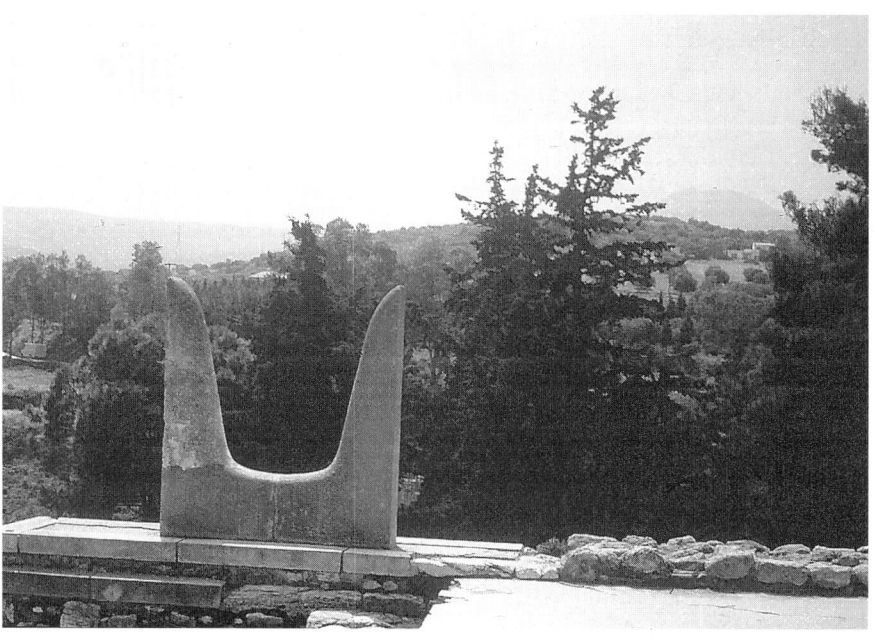

69 Detail from King Minos' Palace, Knossos, Crete

and performed a courtship dance.[35] These references to the labyrinth and to Daedalus bring to mind the location where these mythical events took place: King Minos' palace at Knossos in Crete (see figure 69). Here begin more metaphors. The Maeght Foundation, like King Minos' Palace at Knossos, is a palace (see figure 70). Indeed, at the time, Sert was looking at plans of ancient palaces, and the Maeght Foundation incorporates both purpose-made bricks identical in size to those of the Villa Hadriana, and, at the entrance, travertine. The meaning of this second metaphor, the palace, combines with the first, the village, to create a new level of meaning: the village as palace. But, furthermore, the myth of Knossos and of Daedalus raises a third level of meaning. Since Daedalus is the mythical first architect and since Knossos is, in architectural history, the paradigmatic location of three architectural typologies – the megaron, the labyrinth and the monumental staircase – the Maeght Foundation is also a reflection on architectural history and a prototype for a new typology; that is, a meditation on the relationship between past, present and future.[36]

But the Palace of Minos at Knossos raises other associations too. Minoan culture, in the Western cultural imagination, represents a harmonious resolution of art with architecture and with landscape, a harmonious balance of nature and culture. Recent scholars have been very appreciative of the qualities of Minoan art. For example, Bruce Allsopp found '[t]heir art ... was highly ... sophisticated decorative art ... Very often it was more perceptive and subtle ... and with a reverence and tenderness which is all too rare in our own age.'[37] And Roland Martin argued that '[t]hey divide and animate space, release it from all restrictions, free it to respond to the dynamism of life, modulate it, soften and sharpen it to provide a setting for a society in which both men and women appear to have led full and joyous lives.'[38] This cultural association with Minoan civilisation continues today. In a recent study, Rodney Castleden wrote about the creativity and originality of Minoan culture: 'It is ... this vigorous vitality and immediacy that gives Minoan works of art their distinctively Minoan flavour.'[39] Minoan culture stands, in the Western cultural imagination, for an alternative, for a way of life unalienated and undivided. This belief in a mythical 'otherness' continues today: Camille Paglia writes

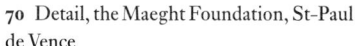

70 Detail, the Maeght Foundation, St-Paul de Vence

that '[t]he last major western society to worship female powers was Minoan Crete.'[40] In addition, King Minos' palace at Knossos, and the Minoan culture that flourished there, were of course very much in the news in the 1950s just prior to the design of the Maeght Foundation, since it was then that Michael Ventris, architect and linguist, managed to decipher Minoan Linear B Script, described as the 'second Everest of archaeology' after Champollion's deciphering of Egyptian hieroglyphics.[41]

We have thus seen so far several metaphors: the Maeght Foundation is village, town hall, cloister, labyrinth and palace. The juxtapositions between these metaphors generate new clusters of meaning, such as the village as palace. But we also observed in the empirical material that the multiplicity and complexity of the spatial and visual organisation of the Maeght Foundation borders on fragmentation and disintegration. However, the Knossos reference is not just a single image but a sequential and cohesive narrative, the story of an ancient myth. Not merely a visual allegory, we are in a world of parabola, 'the extension of the idea of allegory into a complete narrative'.[42] The thorough working of the Minoan parabola aims to eliminate fragmentation by the achievement of an overall narrative structure. Indeed, throughout the Maeght Foundation, we find that references to the Palace of Knossos are carried through into the most minute detail in terms of plans, sections, elevations, construction and ornamentation. But this narrative of Knossos and Minoan civilisation remains secretive. It is of course alluded to in Miró's Labyrinth, but never made explicit anywhere else. The multiple, intricate and pervasive references throughout the Maeght Foundation need detective-like unravelling. The narrative has been worked over with extreme care, but secretively. This mirrors the cultural meaning of the Palace of Minos and of Minoan civilisation, which stand not just for an ideal alternative but also for mystery, unreadability and uncertainty. Even Freud, typical of cultural meanings in this respect, chose to compare his exploration of 'the dark continent' to 'the discovery ... of the Minoan-Mycenean civilization behind the civilization of Greece.'[43] We begin to see here the contradictory and paradoxical load of the visual metaphor of the Palace of Minos: ideal but obscure.[44]

Thus paradox, polarity and attempts at reconciliation are the themes.[45] The Maeght Foundation is where the village is a palace and the village-as-palace is a model and an alternative – but this model and this alternative is secretive and impossible to know. The Maeght Foundation proposes a new subject and models it on a dead civilisation. There is here that same 'continued impossibility of reconciling the world of fiction with the actual world'[46] that describes irony: 'The act of irony ... relates to its source only in terms of distance and difference and allows for no end, for no totality.'[47] The meanings of the myth of Minoa are multiple and interactive like unstable irony 'in which the truth asserted or implied is that no stable reconstruction can be made out of the ruins revealed through the irony.'[48] Thus, as Paul de Man writes, '[i]rony divides the flow of temporal experience into a past that is pure mystification and a future that remains harassed forever by a

relapse within the inauthentic. It can know this inauthenticity but can never over-
come it.'[49] There would be only one way out: 'a leap out of language into faith'.[50]
This leap into faith would be the allegorical solution, since allegory is 'capable of
engendering duration as the illusion of a continuity that it knows to be illu-
sionary.'[51] Indeed, André Malraux, at the inauguration of the Maeght Foundation,
had proclaimed that 'here something is being attempted – through intuition and
through passion – that never has before: to create both a new world in which
modern art can find a true home and a continuity with the past, that other world
which would have been thought of as supernatural'.[52] And it was at the Maeght
Foundation that Malraux exhibited *The Museum Without Walls*.[53] As we have seen,
the Maeght Foundation was conceptualised as village but also modelled on a pre-
Hellenic palace, historically seen as an alternative to the classical model. As both
village and palace and alternative, the Maeght Foundation generates its meaning
through the conflation of several metaphors: the place where art makes village into
palace is an alternative to the traditional museum. Indeed, the Maeght Foundation
avoids the prevailing museum orthodoxy, and the prevailing usual assumptions, of
being 'a place of self-effacing spaces, a building not tremendously assertive and
with a pleasant feeling of neutrality where architectural incident is discrete and
where art comes first'.[54]

The historical references, however, can only be detected through the unravelling
of complex narrative referential structures. Thus a signifier of exclusion carries a
signified of inclusion.[55] At the Maeght Foundation, Sert thus explored the instabil-
ities of labyrinthine polar opposites that 'simultaneously incorporate order and dis-
order, clarity and confusion, unity and multiplicity, artistry and chaos'.[56] But, also,
Daedalus and Icarus discovered to their cost what happens when one flies too
high.[57] Sert felt he had seen this happen to Le Corbusier after the United Nations
project when he wrote that the 'fall of Icarus lands his dreams in the East River'.[58] It
was also by 1969 that Constant and the Situationist International had both chal-
lenged many architectural ideas and redefined the idea of the labyrinth as 'the play-
town of homo ludens, the décor for a new mass culture',[59] which stood in total
opposition to Aimé Maeght's original idea whereby 'the Maeght Foundation
should be a place of creativity, a sort of Villa Medici'.[60] Constant declared that '[w]e
also reject the establishment of buildings in a fixed landscape that now passes for
the new urbanism'[61] and '[t]he *homo ludens* of the future society will not have to
make art, for he can be creative in the practice of his daily life.'[62] Five years after the
inauguration of the Maeght Foundation in 1964 when André Malraux had referred
to the Acropolis in his opening address – '[i]t was by a night such as this that they
listened to the silence that followed the sound of the last chisels carving the
Parthenon'[63] – Aimé Maeght described how '[s]ometimes I feel a bit lonely in this
artist's paradise'.[64]

It was of course the Acropolis that Le Corbusier had described and remem-
bered, in particular the 'clear, clean, intensive, economical, violent Parthenon –
that cry hurled into a landscape made of grace and terror. That monument to

strength and purity.'[65] Yet, as Hollier points out, 'Athens is born by freeing itself from its archaic past (Crete), symbolized by this hybrid, simultaneously man and bull – the Minotaur',[66] the very Minotaur of which the Maeght Foundation tells the story. Thus behind the Acropolis lie Mycenae and Knossos. Behind the Modern Movement's fascination with the Acropolis, lie Knossos and Mycenae. And when one considers that clear image of the Acropolis, it was historically in any case 'an instant of precarious balance. Even as its founding metaphors were being articulated, they were being unravelled.'[67]

Just as the Acropolis stood in a precarious balance to Mycenae and to Knossos, so the Maeght Foundation stands in a precarious balance to the Acropolis, and to the notions of art foundation and museum. The Maeght Foundation has become the museum of an art foundation: simultaneously allegorical and ironic. While the modern museum tends to be a paradigmatic site of either allegory or of irony, the Maeght Foundation, like its model the labyrinth, is both: 'the space where oppositions disintegrate and grow complicated, where diacritical couples are unbalanced and perverted'.[68]

Notes

1 Denis Hollier, *Against Architecture: The Writings of Georges Bataille* (Cambridge, Mass. and London: The MIT Press, 1989), p. 58.

2 For André Malraux's inaugural speech, see André Malraux, *Oeuvres complètes*, vol. 3 (Paris: Gallimard, 1996), pp. 921–4.

3 André Malraux, Maeght Foundation inaugural speech, in C. Chambon, *La Fondation Marguerite et Aimé Maeght* (Paris: Maeght Editeur, 1994), pp. 48–56; p. 56 [my translation].

4 For a general description of the Maeght Foundation, see *ibid*, 48–56.

5 For the term 'lieu de mémoire', see M. Mosser and P. Nys (eds), *Le Jardin, art et lieu de mémoire* (Vassivière-en-Limousin: Les Editions de L'Imprimeur, 1995).

6 In later years, Sert described how, at CIAM IV, 'older, better known members of the Congress such as Moser, Van Eesteren, Giedion, Le Corbusier, Aalto, and Moholy-Nagy were always available to participate in debates at any hour of the day and the warm nights of that Mediterranean summer ... I was part of a young group of architects from Barcelona who had just finished our professional studies. This was for some of us the first opportunity to hear and talk to the founders of the modern movement.' Josép Lluis Sert, 'The Athens Charter', Document D1, Josép Lluis Sert Archives, Special Collections, Frances Loeb Library, Graduate School of Design, Harvard University.

7 See Antonio Pizza (ed.), *J. Ll. Sert and Mediterranean Culture* (Exhibition Catalogue, Barcelona Museum of Modern Art, n.d.).

8 Josép Lluis Sert, 'Meeting Places for the Arts', Document D 78, Josép Lluis Sert Archives, Special Collections, Frances Loeb Library, Graduate School of Design, Harvard University.

9 *Ibid.*

10 *Ibid.*

11 Malraux, Maeght Foundation inaugural speech, p. 52 [my translation].

12 J. L. Sert, F. Léger and S. Giedion, 'Nine points on monumentality', in Joan Ockman (ed.), *Architecture Culture 1943–1968: A Documentary Anthology* (New York: Columbia Books on Architecture and Rizzoli, 1993), pp. 29–30.

13 Braque quoted in Edwin Mullins, *Braque* (London: Thames and Hudson, 1968), p. 41.

14 Braque quoted in John Golding, 'The late paintings: an introduction', in J. Golding, S. Bowness and I. Monod-Fontaine (eds), *Braque: The Late Works* (London: The Royal Academy of Arts and New Haven and London: Yale University Press, 1977), pp. 1–14; p. 14.

15 *Ibid.*, p. 8.

16 *Ibid.*, p. 11.

17 Braque spoke during interviews to André Verdet about the Maeght Foundation: 'la réalisation dont il [Braque] m'entretenait souvent lors de mes visites rue du Douanier: 'Où en est-on? Ça pousse là-bas, les choses? Maeght, c'est un obstiné, un têtu ... Nous lui devons ce Musée, ça compte'; Braque quoted in André Verdet, *Entretiens, notes et écrits sur la peinture: Braque, Léger, Matisse, Picasso* (Paris: Editions Galilée, 1978), pp. 49–50.

18 Braque died and this house was never built.

19 Bo Boustedt, 'Quand Giacometti plaçait lui-même ses sculptures', *XXème siècle*, 33 (1969), pp. 21–36; pp. 25–8 [my translation].

20 Personal communication from Daniel Gervis, Paris.

21 Giacometti letter to his family, Paris, 23 June 1964, in the archives of the Kunsthaus Zürich (kindly brought to my attention by Dr Christian Klemm).

22 Giacometti quoted in Reinhold Hohl, *Alberto Giacometti: Sculpture, Painting, Drawing* (London: Thames and Hudson, 1972), p. 209.

23 Giacometti quoted in *ibid.*, p. 138.

24 See Barbara Rose, *Miró in America* (Houston: Museum of Fine Arts, 1982). This figure/ground merging has been described also for the work of other artists at the Maeght Foundation. It was singled out by Jacques Dupin (poet, critic and director of the Maeght Gallery in the 1950s) as a crucial feature of Miró's work. It is thus a feature which is important to the Maeght Foundation *in toto*.

25 Joan Miró, *Yo trabajo como un hortelano* (Barcelona: Editorial Gustavo Gili, S.A., 1964), p. 40 [my translation].

26 Aimé Maeght unpublished interview with Michel Ragon in January 1969. In collection of Maeght Gallery, Paris [my translation].

27 J. L. Sert, 'La Fondation Maeght – Musée de Saint Paul de Vence', text written by Sert between 1959 and 1962, courtesy of the Special Collections, Loeb Library, Graduate School of Design, Harvard University [my translation].

28 Knud Bastlund, *José Luis Sert: Architecture, City Planning, Urban Design* (London: Thames and Hudson, 1967), p. 170. Questions of authorship are also complex at the Maeght Foundation.

29 Knud Bastlund's role here is crucial. The drawings by Bastlund of the *Maison du Directeur* indicate clearly how the design evolved. In the *Maison du Directeur*, for example, the outside external terrace walls seem to continue inside the building, in the form of the masonry balustrades and the organic shape of the fireplace. These have since been demolished. Both Robert Campbell (personal communication) and Ola Wedebrunn (personal communication) have confirmed Bastlund's perfectionism.

30 The Town Hall also contains offices, services, a sales outlet, etc.

31 See Bastlund, *Sert*, p. 170.

32 These values were deeply significant to Sert: they were the values also sought in the 1937 Pavilion for Republican Spain.

33 Not only does the work of these artists themselves question Renaissance notions of perspectival space and of logocentrism, but they were part of networks which comprised writers and philosophers who questioned these same assumptions, such as René Char, Martin Heidegger, Jacques Dupin, Jacques Kober, Henri Maldiney, etc. It is at this time, of course, that Merleau-Ponty, too, was writing.

34 In Sert's collection of antique and ancient artefacts, only one from Greece is included: a vase from Minoan Crete. In the Maeght archives, there is a postcard dated April 1966 from Saul Steinberg, another Maeght Gallery artist, addressed to the Maeghts which reads 'Greetings and Souvenirs de Crète – qui se ressemble un peu à St. Paul'.

35 The notion of the *chora* follows this questioning of the figure/ground relationship since the *chora* is both the dance-floor and the dance.

36 For a description of how Le Corbusier's work at La Tourette in the 1950s – just before the Maeght Foundation – involved labyrinthine ideas, see Alberto Pérez-Gómez and Louise Pelletier, *Architectural Representation and the Perspective Hinge* (Cambridge, Mass. and London: The MIT Press, 1997). Father Couturier was also friends with the Maeght family and some of their artists (Léger worked on a church commission for Couturier). See Rodney Castleden, *The Knossos Labyrinth: A New View of the 'Palace of Minos' at Knossos* (London and New York: Routledge, 1990).

37 Allsopp was writing at the time of the creation of the Maeght Foundation. Bruce Allsopp, *A History of Classical Architecture* (London: Sir Isaac Pitman & Sons, 1962), p. 25.

38 Roland Martin, *Greek Architecture* (London: Faber & Faber, 1988), p. 33.

39 Rodney Castleden, *Minoans: Life in Bronze Age Crete* (London and New York: Routledge, 1993), p. 167.

40 Camille Paglia, *Sexual Personae: Art and Decadence from Nefertiti to Emily Dickinson* (New Haven and London: Yale University Press, 1990), p. 8.

41 See Leonard Cottrell, *The Bull of Minos* (London: Evans Brothers Ltd., 1953). The book was revised 1955 and reprinted another six times between 1955 and 1964, the year of the inauguration of the Maeght Foundation. See also John Chadwick, *Reading the Past: Linear B and Related Scripts* (London: British Museum Publications, 1987).

42 Bacry, Patrick, *Les Figures de style et autres procédés stylistiques* (Paris: Belin, 1992), p. 73 [my translation].

43 Sigmund Freud, 'Female sexuality', in Freud, *The Standard Edition of the Complete Psychological Works of Sigmund Freud*, vol. 21 (London: The Hogarth Press and the Institute of Psycho-Analysis, 1961), pp. 221–43; p. 226.

44 There are many other such multiple meanings. Minoan civilisation is also known for having left no literature of any description. Minoan Linear B was used only for bookkeeping: 'There are lists of places, of people, of amounts of commodities, of deities even, yet no *comment* on any of them': Castleden, *Minoans*, p. 178. And Alsop quotes Sterling Dow: 'With their interest in astonishingly petty details, the tablets show a bookkeeping-shopkeeping mentality': Joseph Alsop, *From the Silent Earth: A Report on the Greek Bronze Age* (London: Secker and Warburg, 1965), p. 123. A similar mentality has been ascribed to the founders of the Maeght Foundation by others and by themselves; interview with Adrien Maeght and interviews recorded in *Du coté de chez les Maeght*, ORTF film by Pierre Dumayet, 1973.

45 We see here again the hidden theme of *ekphrasis*, of overcoming. See also W. J. T. Mitchell, *Picture Theory* (Chicago and London: Chicago University Press, 1994).

46 Paul De Man, *Blindness & Insight: Essays in the Rhetoric of Contemporary Criticism* (London: Methuen, 1983), p. 218.

47 *Ibid.*, p. 222.

48 Wayne C. Booth, *A Rhetoric of Irony* (Chicago and London: University of Chicago Press, 1974), p. 240.

49 De Man, *Blindness & Insight*, p. 222.

50 *Ibid.*, p. 223.

51 *Ibid.*, p. 226.

52 André Malraux, Maeght Foundation inaugural speech, p. 52 [my translation].

53 *Le Musée imaginaire* was shown there in 1973.

54 Quotation from Recorded Proceedings of the Architects' Forum, The Tate Gallery, 27 October 1993, Tate Gallery Archives.

55 Hollier, *Against Architecture*, p. 58.

56 Penelope Reed Doob, *The Idea of the Labyrinth from Classical Antiquity through the Middle Ages* (Ithaca and London: Cornell University Press, 1990), p. 1.

57 See Alberto Pérez-Goméz, 'The myth of Daedalus', *AA Files*, 10 (1985), pp. 49–52.

58 Sert quoted in Eduard F. Sekler and William Curtis, *Le Corbusier at Work: The Genesis of the Carpenter Center for the Visual Arts* (Cambridge, Mass. and London: Harvard University Press, 1978), p. viii.

59 Constant, 'On traveling', in Mark Wigley, *Constant's New Babylon: The Hyper-Architecture of Desire* (Rotterdam: 010 Publishers, 1998), pp. 200–1; p. 201.

60 Aimé Maeght unpublished interview with Michel Ragon in January 1969. Collection Maeght Galerie, Paris.

61 Constant, 'The great game to come', in Ockman (ed.), *Architecture Culture*, p. 315.

62 Constant, quoted in introduction to 'The great game to come', in *ibid.*, p. 314.

63 André Malraux, Maeght Foundation inaugural speech, p. 56 [my translation].

64 Aimé Maeght unpublished interview with Michel Ragon in January 1969. Collection Maeght Gallery, Paris.

65 Le Corbusier, *New World of Space* (New York: Reynal & Hitchcock and Boston: The Institute of Contemporary Art, 1948), p. 66.

66 Hollier, *Against Architecture*, p. 61.

67 Donald Preziosi, *Rethinking Art History: Meditations on a Coy Science* (New Haven and London: Yale University Press, 1989), p. 178.

68 Hollier, *Against Architecture*, p. 58.

Select bibliography

This bibliography does not contain historical articles, newspaper articles, primary source material or archival material, all of which can be found in the notes of the relevant chapters.

Adorno, Theodor, 'Valéry Proust Museum', in Adorno, *Prisms*, trans. Samuel and Shierry Weber (Cambridge, Mass.: The MIT Press, 1981), pp. 173–85.

Agnew, John, 'Representing space: space, scale and culture in social science', in James S. Duncan and David Ley (eds), *Place/Culture/Representation* (London and New York: Routledge, 1993), pp. 251–71.

Allsopp, Bruce, *A History of Classical Architecture* (London: Sir Isaac Pitman & Sons, 1962).

Alpers, Svetlana, 'The museum as a way of seeing', in Ivan Karp and Steven D. Lavine (eds), *Exhibiting Cultures: The Poetics and Politics of Museum Display* (Washington: Smithsonian Institute Press, 1991), pp. 25–32.

Alsop, Joseph, *From the Silent Earth: A Report on the Greek Bronze Age* (London: Seeker and Warburg, 1965).

Amarante, Leonor, *As Bienais de São Paulo 1951–1987* (São Paulo: Projeto, 1989).

Andersen, Hendrik Christian and Hébrard, Ernest M., *Création d'un centre mondial de communication* (Paris: no publisher, 1913).

Andreae, Johann Valentin, *Christianopolis: An Ideal State of the Seventeenth Century*, trans. Felix Emil Held (New York: Oxford University Press, 1916).

Appleby, J. H., 'Robert Erskine: Scottish pioneer of Russian natural history', *Archives of Natural History*, 10:3 (1983), pp. 377–98.

Axten, Janet, *Gasworks to Gallery: The Story of Tate St Ives* (St Ives: privately published, 1995).

Bacon, Francis, *Gesta Grayorum; or, The History of the High and Mighty Prince Henry ... who reigned and died, A. D. 1594. Together with a Masque, as it was presented (by his Highness's Command) for the Entertainment of Queen Elizabeth; who, with the Nobles of both Courts, was present thereat*, in Bacon, *Law Sports at Grays Inn*, ed. Basil Brown (New York: privately printed by the author, 1921).

Bacon, Francis, *The Advancement of Learning*, ed. G. W. Kitchin (London: Everyman's Library, 1973).

Bacon, Francis, *New Atlantis and The Great Instauration*, ed. Jerry Weinberger (Wheeling, IL: Crofts Classics, 1989).

Bacry, Patrick, *Les Figures de style et autres procédés stylistiques* (Paris: Belin, 1992).

Baker, Denys Val, *Britain's Art Colony by the Sea* (London: George Ronald, 1959).

Bal, Mieke, *Double Exposures: The Subject of Cultural Analysis* (London and New York: Routledge, 1990).

Balser, Frolinde, 'Frankfurt am Main in der Nachkriegszeit und bis 1989', in Frankfurter Historische Kommission (ed.), *Frankfurt am Main: Die Geschichte der Stadt in neun Beiträgen* (= Veröffentlichungen der Frankfurter Historischen Kommission, 17) (Sigmaringen: Jan Thorbecke Verlag, 1991), pp. 521–78.

Bardi, Lina Bo and Van Eyck, Aldo, *Museu de Arte de São Paulo / São Paulo Art Museum* (São Paulo: Editorial Blau, 1997).

Bardi, Pietro Maria *et al.*, *Museum of Art: São Paulo* (New York: Newsweek and Mondadori, 1981).

[Barsett, Edward Barnard], *Beta, The Model Town; or, The Right and Progressive Organization of Industry for the Production of Material and Moral Wealth* (Cambridge, Mass.: printed for the author, 1869).

Bartetzko, Dieter, 'Money, mammon and the Frankfurt miracle', *World Architecture*, 3 (1989), pp. 52–5.

Barthes, Roland, 'The Eiffel Tower', in Barthes, *Eiffel Tower and Other Mythologies*, trans. Richard Howard (Berkeley and London: University of California Press, 1979), pp. 3–17.

Barthes, Roland, *Mythologies*, trans. Annette Lavers (London: Vintage, 1993).

Bastlund, Knud, *José Luis Sert: Architecture, City Planning, Urban Design* (London: Thames and Hudson, 1967).

Bataille, Georges, 'Musée', in Bataille, *Oeuvres complètes*, vol. 1, *Premiers écrits*, ed. Michel Foucault (Paris: Gallimard, 1970), pp. 239–40.

Baudrillard, Jean, 'The system of collecting', in John Elsner and Roger Cardinal (eds), *The Cultures of Collecting* (London: Reaktion Books, 1994), pp. 7–24.

Bauer, Margit, Beck, Herbert, Herbst, Arnulf *et al.*, *Entwurf für einen Museumsentwicklungsplan der städtischen Museen in Frankfurt am Main* (Frankfurt am Main: Dezernat Kultur und Freizeit, 1979).

Baumann, Zygmut, 'Desert spectacular', in Keith Tester (ed.), *The Flâneur* (London and New York: Routledge, 1994), pp. 138–57.

Baxandall, Michael, 'Exhibiting intention: some preconditions of the visual display of culturally purposeful objects', in Ivan Karp and Steven D. Lavine (eds), *Exhibiting Cultures: The Poetics and Politics of Museum Display* (Washington: Smithsonian Institute Press, 1991), pp. 33–41.

Beckett, J. C., *The Anglo-Irish Tradition* (Belfast: Blackstaff Press, 1976).

Benjamin, Walter, 'The work of art in the age of mechanical reproduction', in Benjamin, *Illuminations*, ed. Hannah Arendt, trans. Harry Zorn (London: Fontana, 1973), pp. 219–53.

Benjamin, Walter, *The Arcades Project* (Cambridge, Mass. and London: The Belknap Press of Harvard University Press, 1999).

Bennett, Bruce, *Place, Region and Community* (Townsville: James Cook University Press, 1985).

Bennett, Jim and Mandelbrote, Scott, *The Garden, the Ark, the Tower, the Temple: Biblical Methaphors of Knowledge in Early Modern Europe* (Oxford: Museum of the History of Science, in association with the Bodleian Library, 1998).

Bennett, Tony, *The Birth of the Museum: History, Theory, Politics* (London and New York: Routledge, 1995).

Bergmann, Eckart, 'Der Königsplatz – Forum und Denkmal', in Klaus Vierneisel and Gottlieb Leinz (eds), *Glyptothek München 1830–1980* (Munich: Glyptothek München, 1980), pp. 296–309.

Bergvelt, E. and Kistemaker, R. (eds), *De wereld binnen handbereik: Nederlandse kunst- en rariteitenverzamelingen 1585–1735* (Zwolle: Waanders and Amsterdam: Amsterdams Historisch Museum, 1992).

Bew, Paul, *Ideology and the Irish Question: Ulster Unionism and Irish Nationalism 1912–1916* (Oxford: Clarendon Press, 1994).

Bloch, Ernst, *Das Prinzip Hoffnung* (Frankfurt: Suhrkamp Verlag, 1985).

Boardman, Philip, *The Worlds of Patrick Geddes: Biologist, Town-planner, Re-educator, Peace-warrior* (London: Routledge and Kegan Paul, 1978).

Bodkin, Thomas, *Hugh Lane and his Pictures* (Dublin: Stationery Office, 1956).

Booth, Wayne C., *A Rhetoric of Irony* (Chicago and London: University of Chicago Press, 1974).

Borsi, Franco, *Architecture and Utopia*, trans. Deke Dusinberre (Paris: Hazan, 1997).

Boustedt, Bo, 'Quand Giacometti plaçait lui-même ses sculptures', *XXème siècle*, 33 (1969), pp. 21–36.

Brauerhoch, Frank-Olaf, 'Das Prinzip Museum: Wechselwirkungen zwischen Institution und Kulturpolitik', in Frank-Olaf Brauerhoch (ed.), *Frankfurt am Main: Stadt, Soziologie und Kultur* (Frankfurt am Main: Vervuert Verlag, 1991), pp. 107–22.

Brauerhoch, Frank-Olaf, *Das Museum und die Stadt* (Münster: Westfälisches Dampfboot, 1993).

Brauerhoch, Frank-Olaf; Brüchert, Oliver; Resch, Christine; Steinert, Heinz, *Die Frankfurter Museen und ihr Publikum: Eine Untersuchung an zehn städtischen Museen* (Frankfurt: Johann Wolfgang Goethe Universität, 1994).

Brett, Guy, 'A radical leap', in Dawn Ades, *Art in Latin America: The Modern Era 1820–1920* (London: South Bank Centre and New Haven: Yale University Press, 1989), pp. 253–83.

Brown, David (ed.), *St Ives 1939–64: Twenty Five Years of Painting, Sculpture and Pottery* (London: Tate Gallery, 1985).

Brown, Jane, *Lutyens and the Edwardians: An English Architect and his Clients* (London: Viking, 1996).

Bruand, Yves, *Arquitetura Contemporânea no Brasil* (São Paulo: Editorial Perspectiva, 1981).

Bruggen, Coosje van, *Frank O. Gehry: Guggenheim Museum Bilbao* (New York: Guggenheim Museum Publications, 1997).

Buck-Morss, Susan, 'The flaneur, the sandwichman and the whore: the politics of loitering', *New German Critique*, 39 (1986), pp. 99–141.

Burn Murdoch, William Gordon, *A Procession of the Kings of Scotland from Duncan and Macbeth to George II and Prince Charles Stewart with the Principal Historical Characters in their proper Arms and Costumes. Designed and published by W. G. Burn Murdoch, at his Studio, Ramsay Garden* (Edinburgh: Patrick Geddes and Colleagues, 1902).

Cabo, Paula, *Resignifying Modernity: Clark, Oiticica and Categories of the Modern in Brazil* (PhD thesis, University of Essex, 1996).

Cairns, David and Richards, Shaun, *Writing Ireland: Colonialism, Nationalism and Culture* (Manchester: Manchester University Press, 1988).

Calomino, Salvatore, 'Mechanism, diversity, and social progress: emblems of scientific reality in Campanella's *La città del sole*', in Klaus L. Berghahn and Reinhold Grimm (eds), *Utopian Vision, Technological Innovation and Poetic Imagination* (Heidelberg: Carl Winter Universitätsverlag, 1990), pp. 29–41.

Campanella, Tommaso, *The City of the Sun: A Poetical Dialogue*, trans. Daniel J. Donno (Berkeley: University of California Press, 1981).

Carlyle, Thomas, *Sartor Resartus*, ed. Kerry McSweeney and Peter Sabor (Oxford: Oxford University Press, 1987).

Carter, Paul, *The Road to Botany Bay: An Essay in Spatial History* (London: Faber and Faber, 1987).

Casteras, Susan P., '"The germ of a museum arranged first for 'workers in iron'": Ruskin's museological theories and the curating of the Saint George's museum', in Susan Phelps Gordon and Anthony Lacy Gully (eds), *John Ruskin and the Victorian Eye* (New York: Abrams, 1993), pp. 184–209.

Castleden, Rodney, *The Knossos Labyrinth: A New View of the 'Palace of Minos' at Knossos* (London and New York: Routledge, 1990).

Castleden, Rodney, *Minoans: Life in Bronze Age Crete* (London and New York: Routledge, 1993).

Catlin, Stanton Loomis, 'Traveller-reporter artists and the empirical tradition in post-independence Latin American art', in Dawn Ades, *Art in Latin America: The Modern Era 1820–1980* (London: South Bank Centre and New Haven: Yale University Press, 1989), pp. 41–61.

Certeau, Michel de, *The Practice of Everyday Life* (Berkeley: University of California Press, 1988).

Chadwick, John, *Reading the Past: Linear B and Related Scripts* (London: British Museum Publications, 1987).

Chambon, C., *La Fondation Marguerite et Aimé Maeght* (Paris: Maeght Editeur, 1994).

Chatman, Seymour, *Story and Discourse: Narrative Structure in Fiction and Film* (Ithaca and London: Cornell University Press, 1978).

Collier, Simon; Blakemore, Harold; Skidmore, Thomas (eds), *The Cambridge Encyclopedia of Latin America and the Caribbean* (Cambridge: Cambridge University Press, 1985).

Colomina, Beatriz, 'The split wall: domestic voyeurism', in Colomina (ed.), *Sexuality and Space* (Princeton: Princeton Architectural Press, 1992), pp. 73–128.

Conrads, Ulrich (ed.), *Programmes and Manifestoes on Twentieth-Century Architecture* (London: Lund Humphries, 1970).

Conservation Plan: Western Australian Museum: Historical Significance and Historical Conservation Policies (Nedlands: Centre for Western Australian History, University of Western Australia, 1992).

Cottrell, Leonard, *The Bull of Minos* (London: Evans Brothers, 1953).

Courtiau, Catherine, 'La cité internationale 1927–1931', in Isabelle Charollais and André Ducret (eds), *Le Corbusier à Genève 1922–1932: projects et réalisations* (Lausanne: Payot, 1987), pp. 53–69.

Cracraft, James, *The Petrine Revolution in Russian Architecture* (Chicago and London: The University of Chicago Press, 1988).

Cracraft, James, *The Petrine Revolution in Russian Imagery* (Chicago and London: The University of Chicago Press, 1997).

Crimp, Douglas, *On the Museum's Ruins* (Cambridge, Mass.: The MIT Press, 1993).

Crook, J. Mordaunt, *The British Museum* (London: Allen Lane, The Penguin Press, 1972).

Cummings, Elizabeth, "'A gleam of Renaissance hope": Edinburgh at the turn of the century', in Wendy Kaplan (ed.), *Scotland Creates 5000 Years of Art and Design* (London: Weidenfeld and Nicolson, 1990), pp. 149–61.

Daly, Mary E., *Dublin: The Deposed Capital: A Social and Economic History 1860–1914* (Cork: Cork University Press, 1984).

Davey, Peter, 'Rationalism is not enough', *Architectural Review*, 182:10 (1987), pp. 71–4.

Davis, Douglas, *The Museum Transformed: Design and Culture in the Post-Pompidou Age* (New York: Abbeville Press, 1990).

Davis, J. C., *Utopia and the Ideal Society: A Study of English Utopian Writing 1516–1700* (Cambridge: Cambridge University Press, 1981).

Dawson, Layla, 'Museum Fest', *Building Design*, 1008 (19 October 1990), pp. 32–3.

De Man, Paul, *Blindness & Insight: Essays in the Rhetoric of Contemporary Criticism* (London: Methuen, 1983).

Debord, Guy, *The Society of the Spectacle* (New York: Zone Books, 1995).

Defries, Amelia, *The Interpreter Geddes: The Man and his Gospel* (London: Routledge, 1927).

Delroy, Anne, 'Pragmatics and progress: the evolution of the Perth museum at the turn of the century', *Museums Australia Journal*, 2–3 (1992), pp. 9–18.

Dittscheid, H.-Chr., 'Le musée Fridericianum à Kassel (1769–1779): un incunable de la construction du musée au siècle des Lumières', in E. Pommier (ed.), *Les Musées en Europe à la veille de l'ouverture du Louvre: Actes du colloque organisé par le service culturel du musée du Louvre à l'occasion de la commémoration du bicentenaire de l'ouverture du Louvre les 3, 4 et 5 juin 1993* (Paris: Klincksieck, 1995), pp. 157–211.

Doob, Penelope Reed, *The Idea of the Labyrinth from Classical Antiquity through the Middle Ages* (Ithaca and London: Cornell University Press, 1990).

Dublin Corporation, *Dublin Ireland's Capital: The Official Handbook to the City of Dublin* (Dublin: Dublin Corporation, c. 1913).

Dudley, Leavitt, *Architectural Illustration* (New Jersey: Prentice-Hall Inc., 1977).

Duncan, Carol and Wallach, Alan, 'The universal survey museum', *Art History*, 3 (1980), pp. 448–69.

Duncan, Carol, *Civilizing Rituals: Inside the Public Art Museum* (London and New York: Routledge, 1995).

Dunster, David, 'History city', *Architects' Journal*, 190:19 (1989), pp. 34–41 and pp. 46–55.

Durand, Jean-Nicolas-Louis, *Précis of the Lectures on Architecture*, intro. Antoine Picon, trans. David Britt (Los Angeles: The Getty Research Institute, 2000).

Durth, Werner, *Die Inszenierung der Alltagswelt: Zur Kritik der Stadtgestaltung*, 2nd edition (Braunschweig and Wiesbaden: Friedrich Vieweg & Sohn, 1987).

Eagleton, Terry, *Heathcliff and the Great Hunger: Studies in Irish Culture* (London: Verso, 1995).

Eco, Umberto, 'Function and sign: semiotics of architecture', in M. Gottdiener and Alexandros Ph. Lagopoulos (eds), *The City and the Sign: An Introduction to Urban Semiotics* (New York: Columbia University Press, 1986), pp. 55–86.

Egorov, I. A., *The Architectural Planning of St Petersburg* (Athens: Ohio University Press, 1969).

Ellin, Nan, *Postmodern Urbanism*, revised edition (New York: Princeton Architectural Press, 1999).

Evans, Robin, *The Fabrication of Virtue: English Prison Architecture 1750–1840* (Cambridge: Cambridge University Press, 1982).

Evenson, Norma, 'Brasilia: "Yesterday's City of Tomorrow"', in H. W. Eldridge (ed.), *World Capitals* (New York: Anchor Press/Doubleday, 1975), pp. 470–506.

Fisher, Robert T., *Classical Utopian Theories of Education* (New York: Bookman Associates, 1963).

Flagge, Ingeborg, 'Museum für Jüdische Geschichte', *Der Architekt*, 5 (1986), p. 214.

Fliedl, Gottfried, 'Testamentskultur: Musealisierung und Kompensation', in Wolfgang Zacharias (ed.), *Zeitphänomen Musealisierung: Das Verschwinden der Gegenwart und die Konstruktion der Erinnerung* (Essen: Klartext Verlag, 1990), pp. 166–79.

Flores, Flor Palma, *Museos de la ciudad de México, guía ilustrada / Museums of Mexico City, Illustrated Guide* (Mexico DF: Editorial Trillas, 1996).

Forsman, Erik, *Karl Friedrich Schinkel: Bauwerke und Baugedanken* (Munich and Zurich: Schnell & Steiner, 1981).

Foster, R. F., *W. B. Yeates: A Life*, vol. 1, *The Apprentice Mage* (Oxford: Oxford University Press, 1997).

Foucault, Michel, *The Order of Things: An Archaeology of the Human Sciences* (New York: Random House, 1970).

Foucault, Michel, 'Nietzsche, genealogy, history', in P. Rabinow (ed.), *The Foucault Reader: An Introduction to Foucault's Thought* (Harmondsworth: Penguin Books, 1984), pp. 76–100.

Foucault, Michel, *Discipline and Punish: The Birth of the Prison*, trans. Alan Sheridan (Harmondsworth: Penguin Books, 1991).

Frampton, Kenneth, 'Richard Meier's Museum für Kunsthandwerk', in Der Magistrat der Stadt Frankfurt am Main (ed.), *Museum für Kunsthandwerk Frankfurt am Main*, 3rd edition (Frankfurt am Main: Johannes Weisbecker, 1988), pp. 46–51.

Frampton, Kenneth, *Modern Architecture: A Critical History* (London: Thames and Hudson, 1992).

Franck, Klaus, *The Works of Affonso Eduardo Reidy* (London: Tiranti, 1960).

Fraser, Valerie, *Building the New World: Modern Architecture in Latin America 1930–1970* (London and New York: Verso, 2000).

Freud, Sigmund, 'Female sexuality', in *The Standard Edition of the Complete Psychological Works of Sigmund Freud*, vol. 21 (London: The Hogarth Press and the Institute of Psycho-Analysis, 1961), pp. 221–43.

Freud, Sigmund, *Civilization and its Discontents* (New York: W. W. Norton, 1962).

Fuller, Peter, *Modern Painters: Reflections on British Art*, ed. John MacDonald (London: Methuen, 1993).

'G. G.', *Projet de construction d'un globe terrestre à l'echelle du cent-millième* (Paris: Société nouvelle, 1895).

Galloway, David, 'From Bankfurt to Frankfurt: a cash & carry renaissance, *Art in America*, 75 (1987), pp. 152–9.

Gauthier, Maximilien, *Le Corbusier ou l'architecture au service de l'homme* (Paris: Denoël, 1944).

Geddes, Patrick, *City Development: A Study of Parks, Gardens, and Culture-Institutes. A Report to the Carnegie Dunfermline Trust* (Edinburgh and Westminster: Geddes and Company and Birmingham: Saint George Press, 1904).

Geddes, Patrick, 'Civic education and city development', *Contemporary Review*, 88 (1905), pp. 413–26.

Geddes, Patrick, 'The civic survey of Edinburgh', in Royal Institute of British Architects (ed.), *Townplanning Conference London, 10–15 October 1910 Transactions* (London: RIBA, 1910), pp. 537–74.

Geddes, Patrick, *The Masque of Learning and its many Meanings: A Pageant of Education through the Ages devised and interpreted by Patrick Geddes. Semi-Jubilee of University Hall 1912* (Edinburgh: Patrick Geddes and Colleagues, 1912).

Geddes, Patrick, *The Returning Gods* (London: no publisher, 1914).

Geddes, Patrick, *Cities in Evolution: An Introduction to the Town Planning Movement and to the Study of Civics* (London: Williams & Norgate, 1915).

Geddes, Patrick, 'Beginnings survey of Edinburgh', *Scottish Geographical Magazine*, 35 (1919), pp. 281–98.

Geddes, Patrick, *Interpretation of the Pictures in the Common Room* (Edinburgh: no publisher, 1928).

Geddes, Patrick and Branford, Victor, *Our Social Inheritance* (London: Williams & Norgate, 1919).

The Georgian Society, *Records of Eighteenth-Century Domestic Architecture and Decoration in Dublin*, 5 vols (Dublin: Dublin University Press, 1909–13).

Gillespie, Gerald, 'Education in utopia', in Hans-Gerd Rotzen (ed.), *Europäische Lehrdichtung* (Darmstadt: Wissenschaftliche Buchgesellschaft, 1981), pp. 119–31.

Girouard, Mark, *Alfred Waterhouse and the Natural History Museum* (London: The British Museum (Natural History), 1981).

Golding, J; Bowness, S.; Monod-Fontaine, I. (eds), *Braque: The Late Works* (London: The Royal Academy of Arts, and New Haven and London: Yale University Press, 1977).

Goode, G. Brown, *The Principles of Museum Administration* (York: Coultas and Volans, 1895).

Gortázar, Fernando González (ed.), *La Arquitectura Mexicana Del Siglo XX* (Mexico DF: Consejo Nacional para la Cultura y las Artes, 1994).

Gregory, Isabella Augusta, *Hugh Lane's Life and Achievement with some Account of the Dublin Galleries* (London: John Murray, 1921).

Gresleri, Giuliano and Matteoni, Dario, *La città mondiale: Andersen, Hébrard, Otlet, Le Corbusier* (Venice: Marsilio, 1982).

Griffiths, Tom, *Hunters and Collectors: The Antiquarian Imagination in Australia* (Cambridge: Cambridge University Press, 1996).

Guerrier, W., *Leibniz in seinen Beziehungen zu Russland und Peter dem Grossen* (St Petersburg and Leipzig: Kaiserliche Akademie der Wissenschaften, 1873).

Gustafsson, Lars, 'The present as the museum of the future', in Klaus L. Berghahn and Reinhold Grimm (eds), *Utopian Vision, Technological Innovation and Poetic Imagination* (Heidelberg: Carl Winter Universitätsverlag, 1990), pp. 105–10.

Habermas, Jürgen, *The Philosophical Discourse of Modernity: Twelve Lectures*, trans. F. Lawrence (Cambridge: Polity Press, 1987).

Hackett Hall: Detailed Conservation Policies Report (Perth: The Western Australian Building Management Authority, 1995).

Halpin, David, *Utopian Ideals, Democracy and the Politics of Education: An Inaugural Lecture* (London: Goldsmith College, 1997).

Hansert, Andreas, *Bürgerkultur und Kulturpolitik in Frankfurt am Main: Eine historisch-soziologische Rekonstruktion* (= Studien zur Frankfurter Geschichte, 33) (Frankfurt: Verlag Waldemar Kramer, 1992).

Harris, Jonathan, 'Abstract Expressionism at the Tate Gallery Liverpool: region, reference, ratification', in David Thistlewood (ed.), *American Abstract Expressionism* (Liverpool: University of Liverpool and Tate Gallery Liverpool, 1993), pp. 97–109.

Haverkampf, Hans Erhard, 'Frankfurt: ein Aschenputtel-Mythos?', *Jahrbuch für Architektur* (1984), *Das neue Frankfurt*, vol. 1, p. 7.

Haverkampf, Hans Erhard and Burgard, Roland, 'Museums in Frankfurt-am-Main', *The International Journal of Museum Management and Curatorship*, 5 (1986), pp. 13–18.

Hoffmann, Hilmar, 'Das demokratische Museum', in Hoffmann, *Kultur für Alle: Perspektiven und Modelle*, extended and revised edition (Frankfurt am Main: S. Fischer Verlag, 1981), pp. 129–40.

Hoffmann, Hilmar, 'Erlebnisraum Museumsufer', in Deutsches Architekturmuseum (ed.), *Deutsches Architekturmuseum Frankfurt am Main: Festschrift zur Eröffnung am 1. Juli 1984* (Frankfurt am Main: Stadt Frankfurt am Main, Dezernat für Kultur und Freizeit, Amt für Wissenschaft und Kunst, 1984), pp. 13–18.

Hoffmann, Hilmar, 'Frankfurt's new museum landscape', in V. M. Lampugnani (ed.), *Museum Architecture in Frankfurt 1980–1990* (Munich: Prestel, 1990), pp. 13–20.

Hohl, Reinhold, *Alberto Giacometti: Sculpture, Painting, Drawing* (London: Thames and Hudson, 1972).

Holford, William, 'Brasilia: a new capital for Brazil', *Architectural Review*, 122 (1957), pp. 394–402.

Hollein, Hans, 'Das neue Museum für Moderne Kunst in Frankfurt am Main', in Museum für Moderne Kunst (ed.), *Museum für Moderne Kunst Frankfurt am Main: Publikation zum Richtfest am 13. Juli 1988* (Frankfurt: Amt für Wissenschaft und Kunst, 1988), pp. 10–11.

Hollier, Denis, *Against Architecture: The Writings of Georges Bataille* (Cambridge, Mass. and London: The MIT Press, 1989).

Holston, James, *The Modernist City: An Anthropological Critique of Brasília* (Chicago: Chicago University Press, 1989).

Hooghe, Romeyn de, 'Uitlegging der Tytelplaat', in L. Vincent, *Wondertooneel der Nature* (Amsterdam: François Halma, 1706).

Hooper-Greenhill, Eilean, *Museums and the Shaping of Knowledge* (London and New York: Routledge, 1992).

Hugh Lane Municipal Gallery of Modern Art, *Images and Insights* (HLMGMA: Dublin, 1993).

Hughes, Robert, *The Fatal Shore: A History of the Transportation of Convicts to Australia 1787–1868* (London: Collins Harvill, 1987).

Hunter, Ian, *Culture and Government: The Emergence of Literary Education* (Basingstoke: Macmillan Press, 1988).

Hussey, Christopher, *The Life of Sir Edward Lutyens* (London: Country Life Ltd, 1950).

Huysmans, Joris-Karl, *L'Art moderne: certains* (Paris: Union Générale d'Editions, 1975).

Irish Georgian Society, *Some Irish Georgian Architecture 1715–1830* (Dublin: Irish Georgian Society, 1970).

Jacobs, Jane, *The Death and Life of Great American Cities* (New York: Vintage, 1961).

Jaeger, Falk, 'Das Jüdische Museum in Frankfurt am Main: Effekt und Aura', *Bauwelt*, 80 (1989), pp. 1478–84.

Jencks, Charles, 'In the steps of Vasari: Charles Jencks interviews Heinrich Klotz', *AD*, 55 (1985), pp. 9–16.

Jencks, Charles, 'The contemporary museum', *AD Profile*, 130 (1997), pp. 9–13.

Jesberg, Paulgerd, 'Das Frankfurter Museumsufer', *Deutsche Bauzeitschrift*, 38:10 (1990), pp. 1356–7.

Juckel, Lothar and Praeckel, Diedrich (eds), *Stadtgestalt Frankfurt: Speers Beiträge zur Stadtentwicklung am Main 1964–1995* (Stuttgart: Deutsche Verlagsanstalt, 1996).

Jüdisches Museum Frankfurt am Main (Munich and New York: Prestel Verlag, 1997).

Kasinitz, Philip (ed.), *Metropolis: Center and Symbol of our Times* (New York: New York University Press, 1995).

Kearns, K. C., *Georgian Dublin: Ireland's Imperilled Architectural Heritage* (Newton Abbot: David & Charles, 1983).

Kiberd, Declan, *Inventing Ireland: The Literature of the Modern Nation* (London: Vintage, 1995).

Klamt, Johann-Christian, *Sternwarte und Museum im Zeitalter der Aufklärung: der Mathematische Turm zu Kremsmünster 1749–1758* (Mainz: Verlag Philipp von Zabern, 1999).

Kleihues, Josef Paul, 'Konzeption und Detail: conception and detail', in Der Magistrat der Stadt Frankfurt am Main (ed.), *Museum für Vor- und Frühgeschichte Frankfurt am Main* (Frankfurt am Main: E. Henssler KG Graphischer Betrieb, 1989), pp. 59–107.

Klotz, Heinrich, 'Das Neue Frankfurt', in *Jahrbuch für Architektur* (1984), *Das Neue Frankfurt*, vol. 1, pp. 8–15.

Klotz, Heinrich (ed.), *Die Revision der Moderne: Postmoderne Architektur 1960–1980* (Munich: Prestel Verlag, 1984).

Klotz, Heinrich and Krase, Waltraud, *Neue Museumsbauten in der Bundesrepublik Deutschland / New Museum Buildings in the Federal Republic of Germany* (Stuttgart: Klett-Cotta, 1985).

Krauss, Rosalind E., *The Optical Unconscious* (Cambridge, Mass. and London: The MIT Press, 1993).

Krauss, Rosalind E., 'Postmodernism's museum without walls', in R. Greenberg, B. W. Ferguson, S. Nairne (eds), *Thinking about Exhibitions* (London and New York: Routledge, 1996), pp. 341–8.

Kriller, Beatrix and Kugler, Georg, *Das Kunsthistorische Museum: Die Architektur und Ausstattung. Idee und Wirklichkeit des Gesamtkunstwerkes* (Vienna: Christian Brandstätter Verlag, 1991).

Kruft, Hanno-Walter, *Städte in Utopia: Die Idealstadt vom 15. bis zum 18. Jahrhundert* (Munich: C. H. Beck, 1989).

Kumar, Krishan, *Utopia & Anti-Utopia in Modern Times* (Oxford: Blackwell, 1987).

Kyle, Peter and Walker, Meredith, *The Illustrated Burra Charter* (Sydney: Australian ICOMOS, Australian Heritage Commission, 1992).

La Sizeranne, Robert de, 'Les Prisons de l'art', in La Sizeranne, *Les Questions esthétiques contemporaines* (Paris: Librairie Hachette et Cⁱᵉ, 1904), pp. 213–64.

Laborde, Miguel, *Santiago: lugares con historia* (Santiago: Contrapunto, 1990).

Lampugnani, Vittorio Magnago (ed.), *Museum Architecture in Frankfurt 1980–1990* (Munich: Prestel, 1990).

Laugier, Marc-Antoine, *An Essay on Architecture* (London: T. Osborne and Shipton, 1755).

Le Corbusier, *When the Cathedrals were White* (New York: Reynal and Hitchcock, 1947).

Le Corbusier, *New World of Space* (New York: Reynal & Hitchcock and Boston: The Institute of Contemporary Art, 1948).

Le Corbusier, *The Decorative Art of Today*, trans. James I. Dunnett (London: The Architectural Press, 1987).

Le Corbusier, *The City of Tomorrow and its Planning*, trans. Frederick Etchells (New York: Dover Publications, 1987)

Le Corbusier, *Precisions on the Present State of Architecture and City Planning: With an American Prologue, a Brazilian Corollary Followed by the Temperature of Paris and the Atmosphere of Moscow*, trans. Edith Schreiber Aujame (Cambridge, Mass. and London: The MIT Press, 1991).

Le Corbusier, *Oeuvre complète*, 8 vols, vol. 2, 1929–1934 (Basle, Berlin and Boston: Birkhäuser Publishers, 1999).

Lefebvre, Henri, *The Production of Space*, trans. Donald Nicholson-Smith (Oxford: Blackwells, 1991).

Lefebvre, Henri, 'The specificity of the city', in Lefebvre, *Writings on Cities*, trans. and ed. Eleonore Kofman and Elizabeth Lebas (Oxford: Blackwell Publishers, 1996), pp. 100–3.

Levin, Michael D., *The Modern Museum: Temple or Showroom* (Jerusalem: Dvir Publishing House, 1983).

Levitas, Ruth, *The Concept of Utopia* (London: Philip Allan, 1990).

Levitas, Ruth, 'Who holds the hose: domestic labour in the work of Bellamy, Gilman and Morris', *Utopian Studies*, 6:1 (1995), pp. 65–84.

Lloyd, David, *Nationalism and Minor Literature: James Clarence Mangan and the Emergence of Irish Cultural Nationalism* (Berkeley and London: University of California Press, 1987).

Lloyd, David, *Anomalous States: Irish Writing and the Post-Colonial Moment* (Dublin: Lilliput Press, 1993).

Lorente, J. Pedro, *Cathedrals of Urban Modernity: The First Museums of Contemporary Art 1800–1930* (Aldershot: Ashgate, 1998).

Lowenthal, David, *Antipodean and Other Museums* (= *Working Papers in Australian Studies*, no. 66) (London: Sir Robert Menzies Centre for Australian Studies, University College London, 1991).

Lühning, Felix, *Der Gottorfer Globus und das Globushaus im "Newen Werck": Dokumentation und Rekonstruktion eines frühbarocken Welttheaters* (= *Gottorf im Glanz des Barock: Kunst und Kultur am Schleswiger Hof 1544–1713*, vol. 4) (Schleswig: Schleswig-Holsteinisches Landesmuseum, 1997).

Lyons, F. S. L., *Culture and Anarchy in Ireland 1890–1939* (Oxford: Oxford University Press, 1979).

MacCannell, Dean, *The Tourist: A New Theory of the Leisure Class* (London: Macmillan, 1976).

MacGregor, Arthur, '"A magazin of all manner of inventions": museums in the quest of "Solomon's House" in seventeenth-century England', *Journal of the History of Collections*, 1:2 (1989), pp. 207–12.

Mack, Gerhard, *Art Museums into the Twenty-First Century* (Basle, Berlin and Boston: Birkhäuser, 1999).

Der Magistrat der Stadt Frankfurt am Main (ed.), *Museum für Vor- und Frühgeschichte: Architekturwettbewerb für den Wiederaufbau. Eine Dokumentation des Hochbauamts der Stadt Frankfurt am Main* (Frankfurt: Hochbauamt, 1985).

Maleuvre, Didier, *Museum Memories: History, Technology, Art* (Stanford: Stanford University Press, 1999).

Malraux, André, *Oeuvres complètes*, vol. 3 (Paris: Gallimard, 1996).

Marinetti, Filippo Tommaso, *Selected Writings*, ed. R. W. Flint (New York: Farrar, Straus and Giroux, 1972).

Marinetti, Filippo Tommaso, 'Manifesto of Futurism', in Charles Harrison and Paul Wood (eds), *Art in Theory 1900–1990: An Anthology of Changing Ideas* (Oxford: Blackwell Publishers, 1992), pp. 147–9.

Martin, Marijke; Wagenaar, Cor; Welkamp, Annette (eds), *Alessandro and Francesco Mendini, Philippe Starck, Michele de Lucchi, Coop Himmelb(l)au in Groningen* (Groningen: Groninger Museum, n.d.).

Martin, Otto, *Zur Ikonologie der deutschen Museumsarchitektur zu Beginn des zweiten Kaiserreiches* (PhD thesis, Johannes-Gutenberg-Universität, Mainz, 1983).

Martin, Roland, *Greek Architecture* (London: Faber & Faber, 1988).

Meier, Richard, 'Architect's statement', in Der Magistrat der Stadt Frankfurt am Main (ed.), *Museum für Kunsthandwerk Frankfurt am Main*, 3rd edition (Frankfurt am Main: Johannes Weisbecker, 1988), pp. 63–80.

Meier-Arendt, Walter, 'The Museum für Vor- und Frühgeschichte and its collections', in Der Magistrat der Stadt Frankfurt am Main (ed.), *Museum für Vor- und Frühgeschichte Frankfurt am Main* (Frankfurt am Main: E. Henssler KG Graphischer Betrieb, 1989), pp. 21–2.

Meijers, Debora J., 'De Kunstkamera van Peter de Grote. De Nederlandse bijdrage aan een nieuw type museum', in R. Kistemaker, N. Kopaneva, A. Overbeek (eds), *Peter de Grote in Holland: Culturele en wetenschappelijke betrekkingen tussen Rusland en Nederland ten tijde van tsaar Peter de Grote* (Bussum: Thoth and Amsterdams Historisch Museum, 1996), pp. 22–36.

Meller, Helen, *Patrick Geddes: Social Evolutionist and City Planner* (London: Routledge, 1990).

Miró, Joan, *Yo trabajo como un hortelano* (Barcelona: Editorial Gustavo Gili, S.A., 1964).

Mitchell, W. J. T., *Picture Theory* (Chicago and London: Chicago University Press, 1994).

Mitscherlich, Alexander, *Die Unwirtlichkeit unserer Städte: Anstiftung zum Unfrieden*, special edition (Frankfurt am Main: Suhrkamp Verlag, 1996).

Montaner, Josep M., *New Museums* (London: Architecture Design and Technology Press, 1990).

Moore, Rowan and Ryan, Raymund, *Building Tate Modern: Herzog & de Meuron Transforming Giles Gilbert Scott* (London: Tate Gallery, 2000).

Morris, William, *News from Nowhere and Selected Writings and Designs*, ed. Asa Briggs (Harmondsworth: Penguin, 1962).

Morris, William, 'Looking Backward', in *Political Writings of William Morris*, ed. A. L. Morton (London: Lawrence and Wishart, 1984), pp. 247–53.

Mosser, M. and Nys, P. (eds), *Le Jardin, art et lieu de mémoire* (Vassivière-en-Limousin: Les Editions de L'Imprimeur, 1995).

Mostny, Grete, *Los museos de Chile* (Santiago: Editorial Nacional Gabriela Mistral, 1975).

Müller, K., 'Gottfried Wilhelm Leibniz und Nicolaas Witsen', *Sitzungsberichte der deutschen Akademie der Wissenschaften zu Berlin, Klasse für Philosophie, Geschichte, Staats-, Rechts- und Wirtschaftswissenschaften*, 1:1 (1955), pp. 1–45.

Müller-Raemisch, Hans Reiner; Peter, Joachim; Weiß, Erhard, *Frankfurt: Stadt in der Entwicklung*, Sonderdruck der Stadt Frankfurt am Main, Dezernat Planung und Bau (Basle and Berlin: Länderdienst Verlag, n. d. [1966–68]).

Müller-Raemisch, Hans-Reiner, *Frankfurt am Main: Stadtentwicklung und Planungsgeschichte seit 1945* (Frankfurt and New York: Campus Verlag, 1998).

Muensterberger, Werner, *Collecting: An Unruly Passion* (Princeton: Princeton University Press, 1994).

Mullins, Edwin, *Braque* (London: Thames and Hudson, 1968).

Mumford, Lewis, *The City in History* (Harmondsworth: Penguin Books, 1975).

Municipal Gallery of Modern Art, *Illustrated Catalogue with Biographical and Critical Notes* (Dublin: Municipal Gallery of Modern Art, 1908).

Musei imperialis Petropolitani vol. i–ii, 2 vols (St Petersburg: Typis Academiae Scientiarum Petropolitanae, 1741–45).

The Museum of Western Australia: A Statement of Significance and Conservation Proposal (Perth: Building Management Authority of Western Australia, 1990).

Naves, José Osório (ed.), *Brasília Tourist Guide* (Brasília: Nova Imagem, 1995).

Neickel, C. F., *Museographia oder Anleitung zum rechten Begriff und nützlicher Anleitung der Museorum oder Raritäten-Kammern* (Leipzig and Breslau: Michael Hubert, 1727).

Neverov, Oleg, '"His Majesty's cabinet" and Peter I's *Kunstkammer*', in Oliver Impey and Arthur MacGregor (eds), *The Origins of Museums: The Cabinet of Curiosities in Sixteenth- and Seventeenth-Century Europe* (Oxford: Clarendon Press, 1985), pp. 54–61.

Newhouse, Victoria, *Towards a New Museum* (New York: The Monacelli Press, 1998).

Niemeyer, Oscar, 'Exposição de Brasília em Paris', *Módulo*, 33 (June 1963), pp. 8–11.

Nietzsche, Friedrich, 'On the uses and disadvantages of history for life', in Nietzsche, *Untimely Meditations*, trans. R. J. Hollingdale (Cambridge: Cambridge University Press, 1983), pp. 57–123.

O'Brien, Joseph V., *'Dear Dirty Dublin': A City in Distress 1899–1916* (Berkeley and London: University of California Press, 1982).

O'Callaghan, Margaret, *British High Politics and a Nationalist Ireland: Criminality, Land the Law under Foster and Balfour* (Cork: Cork University Press, 1994).

Obras de Arte de la Ciudad Universitaria de Caracas (Caracas: Universidad Central de Venezuela, 1991).

Ockman, Joan (ed.), *Architecture Culture 1943–1968: A Documentary Anthology* (New York: Columbia Books on Architecture and Rizzoli, 1993).

The Old Perth Gaol (Perth: Western Australian Museum Publication, 1982).

Otlet, Paul and Le Corbusier, *Mundaneum* (Brussels: Union des Associations Internationales, Palais Mondial, August 1928).

Paglia, Camille, *Sexual Personae: Art and Decadence from Nefertiti to Emily Dickinson* (New Haven and London: Yale University Press, 1990).

Pearce, Susan M., *Museums, Objects and Collections* (Leicester: Leicester University Press, 1992).

Pearce, Susan M., *On Collecting: An Investigation into Collecting in the European Tradition* (London and New York: Routledge, 1995).

Pehnt, Wolfgang, 'Goethehaus versus Paulskirche. Wiederaufbau und Neugestaltung nach 1945', in Beat Wyss (ed.), *Bildfälle: Die Moderne im Zwielicht* (Zurich and Munich: Verlag für Architektur Artemis, 1990), pp. 127–36.

Pekarski, P., *Naoeka i literatoera v Rossii pri Petre Velikom* (St Petersburg: 1862; reprinted by Oriental Research Partners, Cambridge, 1972).

Pérez-Goméz, Alberto, 'The myth of Daedalus', *AA Files*, 10 (1985), pp. 49–52.

Pérez-Gómez, Alberto and Pelletier, Louise, *Architectural Representation and the Perspective Hinge* (Cambridge, Mass. and London: The MIT Press, 1997).

Perry, Ronald; Noble, Patricia; Howie, Sue, *The Economic Influences of the Arts and Crafts in Cornwall* (Truro: Cornwall County Council and South West Arts, 1985).

Peruga, Iris, *Museo Nacional de Bellas Artes de Caracas Cincuentenario: una historia* (Caracas: Museo Nacional de Arte, 1988).

Peters, M., 'Nicolaes Witsen and Gijsbert Cuper: two seventeenth-century Dutch burgomasters and their Gordian knot', *Lias*, 16:1 (1989), pp. 111–50.

Petrina, Alberta (ed.), *Buenos Aires: Guía de Arquitectura* (Sevilla: Agencia Española de Cooperación Internacional/Junta de Andalusía and Buenos Aires: Municipalidad de la Ciudad de Buenos Aires, 1994).

Pevsner, Nikolaus, *A History of Building Types* (London: Thames and Hudson, 1976).

Pfeiffer, Ludwig K., 'Wahrheit und Herrschaft: zum systematischen Problem in Bacons *New Atlantis*', in Klaus L. Berghahn and Hans Ulrich Seeber (eds), *Literarische Utopien von Morus bis zur Gegenwart* (Königstein: Athenäum, 1983), pp. 50–8.

Pizza, Antonio (ed.), *J. Ll. Sert and Mediterranean Culture* (Exhibition Catalogue, Barcelona Museum of Modern Art, n.d.).

Plagemann, Volker, *Das deutsche Kunstmuseum 1790–1870* (Munich: Prestel Verlag, 1967).

Poeschel, Sabine, *Studien zur Ikonographie der Erdteile in der Kunst des 16.–18. Jahrhunderts* (München: Scaneg, 1985).

Ponte, Alessandra, 'Thinking machines: from the Outlook Tower to the City of the World', *Lotus International*, 35 (1982), pp. 46–51.

Preziosi, Donald, *Rethinking Art History: Meditations on a Coy Science* (New Haven and London: Yale University Press, 1989).

Provensal, Henry, *L'Art de demain: Vers l'harmonie intégrale* (Paris: Perrin, 1904).

Ravines, Rogger, *Los museos del Perú* (Lima: Instituto Nacional de Cultura, 1989).

Reclus, Elisée, *L'Enseignement de la géographie, globes, disques globulaires et reliefs* (Brussels: Vve F. Larcier, 1902).

Reclus, Elie and Elisée, *Renouveau d'un cité* (Paris: édition de la *Société nouvelle*, June 1896).

Reichert, Klaus, 'The two faces of scientific progress: or, institution as utopia', in Klaus L. Berghahn and Reinhold Grimm (eds), *Utopian Vision, Technological Innovation and Poetic Imagination* (Heidelberg: Carl Winter Universitätsverlag, 1990), pp. 11–28.

Reiss, T. J., *The Discourse of Modernism* (Ithaca: Cornell University Press, 1982).

Renna, Thomas, 'Campanella's *City of the Sun* and late Renaissance Italy', *Utopian Studies*, 10:1 (1999), pp. 13–25.

A Report on the Assessment of Cultural Heritage Significance for the Western Australian Museum – Historian's Report (Perth: Heritage Council of Western Australia and University of Western Australia, 1992).

Richardson, Benjamin Ward, *Hygeia: A City of Health* (London: Macmillan and Co, 1876).

Riegl, Alois, 'The modern cult of monuments: its character and its origin', trans. Kurt W. Forster and Diane Ghirardo, *Oppositions*, 25 (autumn 1982), pp. 21–51.

Rio de Janeiro (Rio de Janeiro: Michelin, 1990).

Rose, Barbara, *Miró in America* (Houston: Museum of Fine Arts, 1982).

Rossi, Aldo, *The Architecture of the City* (Cambridge, Mass. and London: The MIT Press, 1982).

Rothery, Sean, *Ireland and the New Architecture 1900–1940* (Dublin: Lilliput Press, 1991).

Rowe, Colin and Koetter, Fred, *Collage City* (Cambridge, Mass. and London: The MIT Press, 1978).

Ryan, Simon, *The Cartographic Eye: How Explorers Saw Australia* (Cambridge: Cambridge University Press, 1996).

Sabbagh, Karl, *Power into Art: The Making of Tate Modern* (Harmondsworth: Penguin Books, 2001).

Saddy, Pierre, 'Le Corbusier chez les riches: l'appartement Charles de Beistegui', *Architecture, Mouvement, Continuité*, 49 (September 1979), pp. 57–70.

Saddy, Pierre (ed.), *Le Corbusier: le passé à réaction poétique* (Paris: Caisse nationale des Monuments historiques et des Sites, 1988).

Santiago, M., 'Museum in Caracas', *Architectural Review*, 119 (1956), p. 273.

Scheicher, E., 'De vorstelijke Kunst- und Wunderkammer', in E. Bergvelt, D. J. Meijers, M. Rijnders (eds), *Verzamelen: Van rariteitenkabinet tot kunstmuseum* (Heerlen and Houten: Open University and Gaade, 1993), pp. 15–36.

Schmidt, Dorothea, 'Das "Leonische" Zeitalter: Notizen zur zeitgenössischen Kritik an Leo von Klenze', in Klaus Vierneisel and Gottlieb Leinz (eds), *Glyptothek München 1830–1980* (München: Glyptothek München, 1980), pp. 284–95.

Scholz, Carola, *Eine Stadt wird verkauft: Stadtentwicklung und Stadtmarketing – zur Produktion des Standort-Images am Beispiel Frankfurt* (Frankfurt: isp-Verlag, 1989).

[Schumacher, Johann Daniel], *Gebäude der Kayserlichen Academie der Wissenschaften, Bibliothec und Kunst-Cammer in St Petersburg* (St Petersburg: Kayserliche Academie der Wissenschaften, n.d. [1744]).

Schuré, Edouard, *The Great Initiates: A Study of the Secret History of Religions*, trans. Gloria Raspberry, intro. Paul M. Allen (New York: Harper & Row, 1980).

Sedlmayr, Hans, *Art in Crisis: The Lost Centre*, trans. Brian Battershaw (London: Hollis and Carter, 1957).

Sekler, Eduard F. and Curtis, William, *Le Corbusier at Work: The Genesis of the Carpenter Center for the Visual Arts* (Cambridge, Mass. and London: Harvard University Press, 1978).

Sert, José Luis, *Can Our Cities Survive? An ABC of Urban Problems, their Analysis, their Solutions* (Cambridge, Mass.: Harvard University Press, 1944).

Shalev, David and Tooby, Michael, *Tate Gallery St Ives: The Building* (London: Tate Gallery Publishing, 1995).

Sheehy, Jeanne, *The Rediscovery of Ireland's Past: The Celtic Revival 1830–1930* (London: Thames and Hudson, 1980).

Sherman, Daniel, 'Quatremère/Benjamin/Marx: art museums, aura, and commodity fetishism', in Irit Rogoff and Daniel Sherman (eds), *Museum Culture: Histories, Discourses and Spectacles* (London and New York: Routledge, 1994), pp. 123–43.

Shields, Rob, *Places on the Margin: Alternative Geographies of Modernity* (London and New York: Routledge, 1991).

Smailes, Helen, *A Portrait Gallery for Scotland: The Foundation, Architecture and Mural Decoration of the National Portrait Gallery 1882–1906* (Edinburgh: Trustees of the National Galleries of Scotland, 1985).

Smith, Paul, *Discerning the Subject* (Minneapolis: University of Minnesota Press, 1988).

Speerplan, *Gesamtplan Museumsufer: Situationsanalyse, Oktober 1980*, 2nd, revised edition (Frankfurt: Der Magistrat, November 1980).

Spickernagel, Ellen and Walbe, Brigitte (eds), *Das Museum: Lernort kontra Musentempel* (Giessen: Anabas-Verlag, 1976).

Stannage, Charles Thomas, *The People of Perth: A Social History of Western Australia's Capital City* (Perth: Perth City Council, 1979).

Stanyukovich, T. V., *Koenstkamera peterboergskoj Akademii Naoek* (Moskow and Leningrad: Academy of Sciences USSR, 1953).

Stäubli, Willy, *Brasília* (London: Leonard Hill, 1966).

Steele, James (ed.), *Museum Builders* (London: Academy Editions, 1994).

Stephenson, Andrew, '"An anatomy of taste": Samuel Courtauld and debates about art patronage and modernism in Britain in the inter-war years', in John House *et al.*, *Impressionism for England: Samuel Courtauld as Patron and Collector* (London: Courtauld Institute Galleries, 1994), pp. 35–46.

Stow, Randolf, *The Merry-Go-Round in the Sea* (Harmondsworth: Penguin Books, 1980).

Szambien, Werner, 'Die Berliner Museumsinsel und ihre Stellung in der internationalen Museumspolitik des 19. Jahrhunderts', in Zentralinstitut für Kunstgeschichte München (ed.), *Berlins Museen: Geschichte und Zukunft* (Munich: Deutscher Kunstverlag, 1994), pp. 45–50.

Tafuri, Manfredo, '"*Machine et mémoire*": the city in the work of Le Corbusier', in H. Allen Brooks (ed.), *Le Corbusier: The Garland Essays* (New York and London: Garland, 1987), pp. 203–18.

Tanner, Howard (ed.), *Architects of Australia* (Melbourne and New York: Macmillan Press, 1981).

Taylor, Brandon, 'From penitentiary to temple of art: early metaphors of improvement at the Millbank Tate', in Marcia Pointon (ed.), *Art Apart: Art Institutions and Ideology across England and North America* (Manchester and New York: Manchester University Press, 1994), pp. 9–32.

Teige, Karel, 'Mundaneum', trans. Ladislav and Elizabeth Holovsky and Lubamir Dolezel, *Oppositions*, 4 (October 1974), pp. 83–92.

Turner, Paul V., *La Formation de Le Corbusier: idéalisme et mouvement moderne* (Paris: Macula, 1987).

Urry, John, *The Tourist Gaze: Leisure and Travel in Contemporary Societies* (London: Sage Publications, 1990).

Uslar, Jochen von (ed.), *Kulturpolitik des Deutschen Städtetages: Empfehlungen und Stellungnahmen von 1952 bis 1978* (= Reihe C, DST-Beiträge zur Bildungspolitik, Heft 11) (Cologne: Deutscher Städtetag, 1979).

Valéry, Paul, 'Le problème des musées', in Valéry, *Pièces sur l'art* (Paris: Maurice Darantiere, 1931), pp. 147–56.

Verdet, André, *Entretiens, notes et écrits sur la peinture: Braque, Léger, Matisse, Picasso* (Paris: Editions Galilée, 1978).

Vincent, L., *Het tweede deel of vervolg van het Wondertooneel der Natuur* (Amsterdam: François Halma, 1715).

Vosskamp, Wilhelm, 'Utopian thinking and the concept of Bildung', in Klaus L. Berghahn and Reinhold Grimm (eds), *Utopian Vision, Technological Innovation and Poetic Imagination* (Heidelberg: Carl Winter Universitätsverlag, 1990), pp. 63–74.

Wallmann, Walter, 'Rede zur Eröffnung des Deutschen Architekturmuseums', in Deutsches Architekturmuseum (ed.), *Deutsches Architekturmuseum Frankfurt am Main: Festschrift zur Eröffnung am 1. Juli 1984* (Frankfurt am Main: Stadt Frankfurt am Main, Dezernat für Kultur und Freizeit, Amt für Wissenschaft und Kunst, 1984), pp. 5–10.

Waterfield, Giles (ed.), *Palaces of Art: Art Galleries in Britain 1790–1990* (London: Dulwich Picture Gallery, 1991).

Wells, H. G., *The Time Machine* (London: Book Club Associates, 1981).

Welter, Volker M., 'History, biology and city design – Patrick Geddes in Edinburgh', *Architectural History*, 6 (1996), pp. 61–82.

Welter, Volker M., 'Stages of an exhibition: the cities and town planning exhibition of Patrick Geddes', *Planning History*, 20:1 (1998), pp. 25–35.

Welter, Volker M., *Collecting Cities – Images from Patrick Geddes' Cities and Town Planning Exhibition* (Glasgow: Collins Gallery, 1999).

Werner, Frank, 'Der Wettbewerb für das Museum für Kunsthandwerk in Frankfurt am Main', *Jahrbuch für Architektur* (1984), *Das neue Frankfurt*, vol. 1, pp. 22–52.

Western Australian Museum Site Redevelopment Report (Perth: Building Management Authority of Western Australia and the Heritage Council of Western Australia, 1995–96).

Weyel, Birgit, *Ist Frankfurt eine amusische Stadt? Bildende Kunst und Kunstpolitik in Frankfurt am Main nach dem Zweiten Weltkrieg bis zum Ende der fünfziger Jahre* (Frankfurt: Peter Lang Europäischer Verlag der Wissenschaften, 1996).

White, Hayden, 'The value of narrativity in the representation of reality', in J. Appleby, E. Covington, D. Hoyt, M. Licham and A. Sneider (eds), *Knowledge and Postmodernism in Historical Perspective* (London and New York: Routledge, 1996), pp. 395–407.

White, Terence De Vere, *The Anglo-Irish* (London: Victor Gollancz, 1972).

Whitwell, Stedman, *Description of an Architectural Model from a Design by Stedman Whitwell, Esq. for a Community upon a Principle of United Interests, as advocated by Robert Owen, Esq.*, in *Cooperative Communities: Plans and Descriptions* (New York: Arno Press, 1972).

Wigley, Mark, *Constant's New Babylon: The Hyper-Architecture of Desire* (Rotterdam: 010 Publishers, 1998).

Williams, Harold M. *et al.*, *Making Architecture: The Getty Center* (Los Angeles: J. Paul Getty Trust, 1997).

Woodwood, Bernard, 'The Western Australian Museum and Art Gallery, Perth', *Museums Journal*, December 1903, pp. 180–7.

Xavier, Alberto (ed.), *Arquitetura Moderna Brasileira: Depoimento de uma Geração* (São Paulo: Associação Brasileira de Ensino de Arquitetura, 1987).

Yates, Frances A., *The Art of Memory* (London: Pimlico, 1996).

Zohlen, Gerwin, 'Flaneure oder die Gegenwartsnarrheit der Schriftsteller', in Martin Wentz (ed.), *Stadtplanung in Frankfurt: Wohnen, Arbeiten, Verkehr* (Frankfurt and New York: Campus Verlag, 1991), pp. 177–83.

Zulaika, Joseba, 'The seduction of Bilbao', *architecture*, 86:12 (1997), pp. 60–3.

Index

Note: 'n.' after a page reference indicates the number of a note on that page. Page numbers in *italics* refer to illustrations.